David Dunn
Film

The Fountainheads

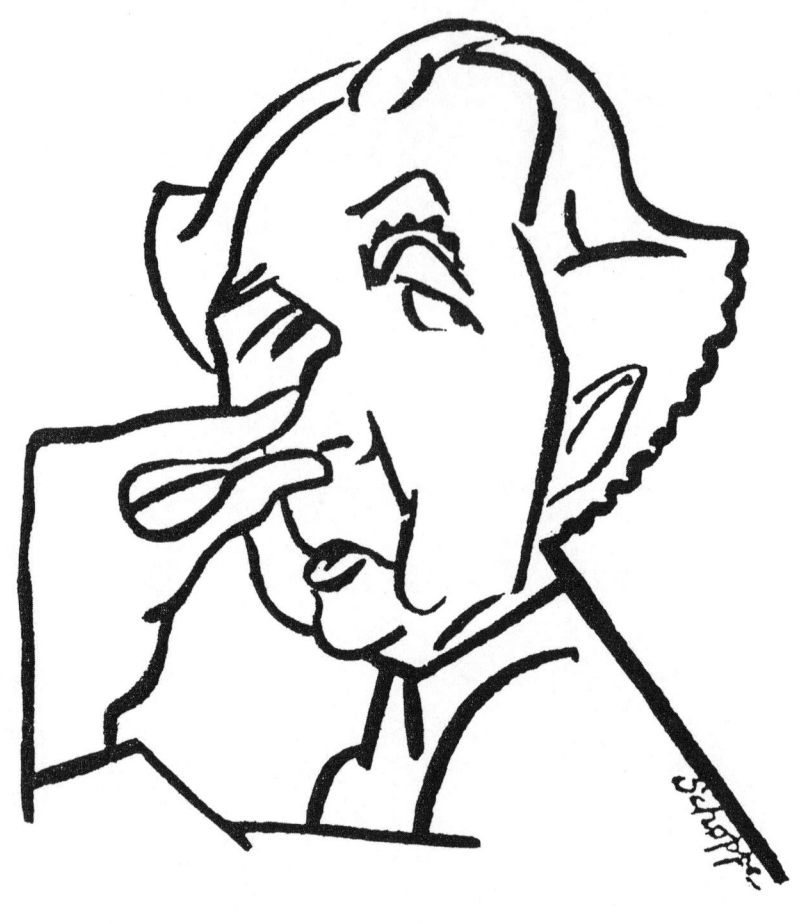

"Wisconsin Valentine." Frank Lloyd Wright's opinion of American cities and especially Los Angeles as interpreted by Schoppe in 1937. From Johnson (1990).

The Fountainheads

Wright, Rand, the FBI and Hollywood

Donald Leslie Johnson

McFarland & Company, Inc., Publishers
Jefferson, North Carolina, and London

The letters, writings and drawings of Frank Lloyd Wright are ©2003 The Frank Lloyd Wright Foundation, Scottsdale, Arizona: The Wright Archive herein.

Textual material and stills of *The Fountainhead* were supplied by USC Warner Bros. Archives, School of Cinema-Television, University of Southern California, ©Warner Bros. and AOL Time Warner: USC Warner herein.

Letters of Ayn Rand, ©1995 by the estate of Ayn Rand, are quoted with their permission, and that of Penguin Putnam Inc., New York City.

LIBRARY OF CONGRESS CATALOGUING-IN-PUBLICATION DATA

Johnson, Donald Leslie.
The fountainheads : Wright, Rand, the FBI and Hollywood / Donald Leslie Johnson.
p. cm.
Includes bibliographical references and index.

ISBN 0-7864-1958-X (illustrated case binding : 50# alkaline paper)

1. Rand, Ayn. Fountainhead. 2. Rand, Ayn — Friends and associates. 3. Rand, Ayn — Film and video adaptations.
4. Wright, Frank, Lloyd, 1867–1959 — Influence.
5. Wright, Frank Lloyd, 1867–1959 — Friends and associates.
6. United States. Federal Bureau of Investigation — History — 20th century. 7. United States. Congress. House. Committee on Un-American Activities — History.
8. Motion picture plays — History and criticism. 9. Hollywood (Los Angeles, Calif.) — Biography. 10. Architects in motion pictures.
11. Architects in literature. I. Title.
PS3535.A547F6936 2005 813'.52 — dc22 2004022346

British Library cataloguing data are available

©2005 Donald Leslie Johnson. All rights reserved

No part of this book may be reproduced or transmitted in any form or by any means, electronic or mechanical, including photocopying or recording, or by any information storage and retrieval system, without permission in writing from the publisher.

On the cover: Ayn Rand, 1948 (© *Warner Bros. and AOL Time Warner*); Frank Lloyd Wright, ca. 1950 (*photograph by Ed Obma, Dodgeville, Wisconsin*; *Wright Archives*); office building model designed by the fictional Roark.

Manufactured in the United States of America

McFarland & Company, Inc., Publishers
Box 611, Jefferson, North Carolina 28640
www.mcfarlandpub.com

To my wife, the weaver
Sonya Hasselberg-Johnson

Work Song

I'll live
as I'll work
as I am!
No work in Fashion for Sham
nor to Favor forsworn
wear mask crest or thorn
My Work as befitteth a man
My work
work that befitteth the man

I'll work
as I'll think
as I am!
No thought of Fashion or Sham
nor for Fortune the jade
serve vile gods-of-trade
My Thought as beseemeth a man
My thought
thought that beseemeth the man

I'll think
as I'll act
as I am!
No deed in Fashion for Sham
nor for Fame e'er man made
sheath the naked white blade
My Act as becometh a man
My act
acts that becometh the man

I'll act as I'll die
as I am!
No slave of Fashion or Sham
of my Freedom proud
hers to shrive guard or shroud
My Life as betideth the man
My life
Aye! whatever betideth the Man.

— Frank Lloyd Wright, 1896

Acknowledgments

An academic cannot satisfactorily conduct historical research for more than 20 years without help, not least that offered by the many writers and scholars whose published works and dissertations have been a source of knowledge and inspiration. They are identified in the references and notes. Additionally, it is with great joy and gratitude that I acknowledge the generosity, encouragement or assistance of the following people and organizations.

The Frank Lloyd Wright Foundation and Archive, in particular Bruce Brooks Pfeiffer and Indira Berndtson in Scottsdale, Arizona, and related holdings at the Getty Center, Archives of the History of Art, Santa Monica, including information supplied from the Wright papers and letters. The foundation has liberally allowed me access to its archives and those held by the Getty Center since the mid–1970s.

The University of Southern California, Archives of the Performing Arts of the School of Cinema-Television, Doheny Library, especially Leith Adams, who was archivist in the 1980s, and lately a prompt and pleasant Randi Hokett, for access to the Warner Brothers Archives (USC Warner Bros), which includes the Jack L. Warner Papers and Arrowhead Production Company papers. Also AOL Time Warner and Jeremy Williams at Warner Brothers Studio, who without fuss gave permissions related to various Warner Brothers stills and documents that are so vital to the book.

Equally vital, the Federal Bureau of Investigation, the U.S. Department of the Army (Intelligence and Security Command, G-2 Section), the U.S. Department of the Navy and Office of Naval Intelligence, and the U.S. Department of Justice, promptly supplied copies of F.L. Wright's and related files that I requested under Freedom of Information provisions. These provisions do a great deal toward helping to ensure a free, open and evolving democratic society.

The University of California, Los Angeles, Special Collections, especially Anne Craiger in the Manuscripts Library for access to and copies of the Lloyd Wright Papers, and Lloyd Wright's son Eric Lloyd Wright for permission to access and publish material.

The library staff at Flinders University, Adelaide, especially those in reference, interlibrary loan, and the Multimedia Unit (visual images), and academic colleagues at the University of South Australia and the Center for Settlement Studies. The Academy of Motion Picture Arts and Sciences, Margaret Herrick Library, especially the willing archivists Janet Lorenz and Samuel A. Gill. The British Film Institute, Lon-

don, England, and the efficient Janet Byrne and Katherine Oakes in the Stills Department. Staff in the Manuscript Section of the Library of Congress, Washington, D.C.; at Oxford University Press; and at Knopf Publishers. People at the Ayn Rand Institute responded with alacrity.

Staff at the Avery Art and Architecture Library, Columbia University, New York City; at the Museum of Modern Art, Department of Film, New York City, in the 1980s and 1990s (during production of this book the film archive was sealed in storage); at the Burnham and Ryerson Libraries, Art Institute of Chicago; at the Northwest Architectural Archives and Manuscript Division (especially Alan Lathrop), University Libraries, University of Minnesota; at the University of Wyoming, American Heritage Collection, University Library; at the University of Utah, Taylor Woolley Collection, University Library; at Knight Library and University Archives, University of Oregon; at the Wisconsin Historical Society, Madison; and John Hoffmann with the Carl Sandburg Collection, University of Illinois, Urbana.

In Seattle the University of Washington's College of Architecture and Urban Planning for a visiting scholar's position in 1987 and 1990 and informally on many occasions before and since, and my former boss, Betty Wagner, college librarian.

In the Los Angeles area, Tony Gonzalez (student of the movie or *The Fountainhead* and a diligent assistant), Jock de Swart (an excellent guide), Kathryn Smith, Jeffrey Chusid (then [1987] curator of the Freeman house), Robert Sweeney (then curator of the Rudolph Schindler house), Joel Silver (owner of the Storer house), G. Oliver Brown (then owner of the Ennis house), and volunteer staff at the Barnsdall house, "Hollyhock"; Thomas Hines at the University of California, Julius Shulman in Beverly Hills, and Deborah Marriott at Twentieth Century Fox; Ivy Kwong and Roberta Herrera Burch at MGM Clip-Still; in the Santa Barbara area, Dr. Gerald Groff and the late David Gebhard at the University of California.

In Phoenix, Arizona, Carol Sowers, who promptly answered my inquiries; in Austin, Texas, Anthony Alofsin; in Washington state, Tom Rickard in Lakewood (Tacoma), and Marilyn Kelloniemi and the late Paul Hasselberg in Seattle; in Orlando, Florida, my son Adam Kaare Johnson.

In Adelaide, Australia, Janet and Peter Philips for studied criticism, staff of the Mortlock Collection and at the State Library of South Australia, Donald Langmead and Christine Garnaut; in Perth, Christopher Vernon; in Melbourne, Miles Lewis and Jeff Turnbull.

A thank you to Patricia Neal (now not in Hollywood) for good wishes. No other principal participants in the motion picture of *The Fountainhead* are alive.

The U.S. National Endowment for the Humanities provided a grant in 1990 to study relevant material in archives and museums; thanks also to the national Australian Research Committee; and to Flinders University and the University of South Australia, each for a number of research and travel grants.

And a big thank you to the people and organizations that granted permission to reproduce photographs and use quotations. They are identified in the illustrations' captions, appendices, and elsewhere as appropriate.

And to Sonya, thank you for all that is worthwhile.

I am. I think. I will.

What must I say besides? These are the words. This is the answer....

This, my body and spirit, this is the end of the quest. I wished to know the meaning of things. I am the meaning. I wished to find a warrant for being. I need no warrant for being, and no word of sanction upon my being. I am the warrant and the sanction....

My happiness is not the means to any end. It is the end. It is its own goal. It is its own purpose.

Neither am I the means to any end others may wish to accomplish. I am not a tool for their use.... I am not a sacrifice on their altars....

I guard my treasures: my thought, my will, my freedom. And the greatest of these is freedom.

I owe nothing to my brothers, nor do I gather debts from them. I ask none to live for me, nor do I live for any others. I covet no man's soul, nor is my soul theirs to covet.

— Ayn Rand, 1937

Contents

Acknowledgments vii
Preface 1

Part I: Wright
 1. Frank Lloyd Wright 5
 2. Spring Green, Chicago, Tokyo, Los Angeles 7
 3. Southwest Architecture 12
 4. Spring Green, Scottsdale, Moscow, London and Beyond 20

Part II: Rand
 5. Ayn Rand 31
 6. St. Petersburg, Petrograd, Leningrad, Chicago 32
 7. Hollywood 36

Part III: Wright and Rand
 8. New York City 43
 9. Roark and Wright 54
 10. Rand's Neutra House 60
 11. Wright's Rand House 66

Part IV: Filmland, Wright and Rand
 12. Preproduction 1944 73
 13. Redding, New York City, Hollywood 76
 14. Washington, D.C., Hollywood, Paranoia and HUAC 82
 15. The Movie Revived 100
 16. Hollywood Clients 110
 17. Hollywood Friends 121
 18. *The Fountainhead*'s Visual Images 132
 19. Hollywood Clients, the 1950s 159

Part V: Fountainheads
 20. Conclusions 173

Appendix A. Film Outline 179
Appendix B. Book Synopsis 181
Appendix C. Film Credits 184
Appendix D. Frank Capra's Bleeding-Heart Liberals 185
Appendix E. Mrs. Walsh's Extracts 187
Appendix F. Red Charge, Marin County, 1957 188

Chapter Notes 191
References 207
Filmography 215
Index 221

Preface

There has been much irregular speculation concerning the affinity or otherwise of the protagonists investigated in this book; about Frank Lloyd Wright's publicly exposed life, his architectural productivity in southern California, his relations with Ayn Rand; about Rand's popular novel *The Fountainhead* of 1943, a proposed motion picture of it in 1944, and its production in 1948 and 1949; about the Federal Bureau of Investigation's role in and exacerbation of events related to Wright, Rand and the movie; and about Hollywood as it centered on, highlighted and irritated affairs between our subjects or other people or labor unions and the movie studios or investigations by the U.S. Department of Justice.

Wright and Rand first met in 1937 when he was 70 and she 32. He had just returned from a professional and social sojourn in the capital city of the Soviet Union's empire, Moscow. Fleeing that empire 11 years before their meeting, Rand had emigrated from Leningrad to the United States with the expressed purpose of writing motion picture scenarios and scripts for production in Hollywood.

The practical and philosophical reasons for Wright's and Rand's rather uncommon association (friendship is not the appropriate word), for making a movie of *The Fountainhead* and for the architectural and set designs prepared for it, were peculiar yet in all ways reflective of the moment nationally and therefore by the arts. And Wright and Rand held often explained beliefs that seemed in accord yet were in fact antithetical and irritated each other; so too their personalities.

More importantly, following the 1939–1945 war, an excessively tense situation developed in the world driven by frightening confrontational antagonisms between the so-called Western nations and an expansionistic USSR that threatened the death of life on earth. Hollywood, Wright and Rand participated in the ensuing verbal and physical matches that entangled everyone and, in the void created by congressional apathy, challenged cherished American principles: freedom of association, freedom of expression, freedom of silence. The U.S. Congress's House Un-American Activities Committee (HUAC) and the Department of Justice's FBI protectively if controversially colluded to save America only to abuse those freedoms.

This book studies those relationships and entrapments, those beliefs and actions as they affected certain artistic products related to Wright and Rand at the moment: architectural, literary and cinematic. In that pursuit and among other issues this book also explores (and confirms) the popular belief that Rand's hero in the book

was based on how Wright conducted his life and on his architectural ideas; discovers that Wright was unfairly tracked by the FBI and HUAC and lost architectural commissions as a result; and reveals that his lifestyle as structured by a strong religious and individualistic philosophy was an accepted burden carried publicly in the face of much derision. While he knew that the United States was the first nation created on philosophical assumptions, he wondered if it too would join history's host of nations that had collapsed from within as a result, he opined, of greed for power, money and political inelasticity. Expressions of this fear were also wrongly interpreted. So too was Rand's narcissistic philosophy, or at least its early presentation as a notion about the supremacy of ego but not her hatred of Communism.

This study looks at preproduction adventures and then exposes the production designs for *The Fountainhead* movie as dissembling and as bold contradictions to Rand's blunt, inflexible text, to Wright's transcendent pragmatism and even to the FBI's protective myopia. In movies the visual information is paramount but too often more easily misunderstood than the verbal.

Part I

Wright

1

Frank Lloyd Wright

Frank Lincoln Wright was a child of the undulating prairies and deciduous forests of northern Midwest America. Nurtured in southern Wisconsin, during his adolescent years he explored suburban mysteries and nature's delights in and around Madison. He was born of parents with English, Welsh, and New England backgrounds, and both parents' families were deeply committed to farming, education and religion. From his mother, a teacher (like her two sisters) whose father's family, the Joneses, and a brother were Unitarian preachers and farmers from Wales, he learned to respect the natural world yet gained a desire, almost a craving, for recognition. From a line of Baptist ministers, his New England father, a musician, teacher and lecturer, was also a Baptist clergyman who in mid-life on the northern prairies converted to Unitarianism. He endowed Wright with a love of art and artistic sensibilities, especially for literature and music. From his uncle, the Reverend Dr. Jenkin Jones, he discovered the universality of man and learned to learn.[1]

Summer jobs were found on uncles' farms near Spring Green, a village not far from Madison, where Wright attended school. Then at age 19 he was allowed to enter the University of Wisconsin in March 1886 as a "special student," probably because he had not completed high school. During two terms at university he worked part time as a factotum in the office of engineer Alan Conover. It seems that family finan-

Frank Lloyd Wright ca. 1950, portrait by Ed Obma of Dodgeville, Wisconsin. Courtesy of the Wright Archive.

cial difficulties in the wake of his parents' divorce in 1885 required son Frank to seek full-time employment and anticipate a profession.

Wright moved to Chicago sometime early in 1887, at age 20, informally changed his name to Frank Lloyd, and began working for a family friend, the likable architect and Unitarian layman Joseph L. Silsbee. Wright worked in that office (and briefly in two others) until one year later, when he was accepted into the large and prestigious architectural firm of Dankmar Adler and Louis Sullivan. When the economic depression of 1893 strangled commerce nationwide and then throughout the world, he was among others dismissed by the firm. Now thoroughly trained, Wright immediately opened an office.

2

Spring Green, Chicago, Tokyo, Los Angeles

Any lessons Wright may have learned about elemental or sophisticated architectural design processes would have come from engineer Conover and architects Silsbee and Adler. From Adler and Conover — and from his farmer uncles — Wright learned practical and constructional aspects of buildings. From Silsbee and Sullivan he came to understand not only characteristics but also the intrinsic meaning of architectural styles, and conjointly from Sullivan the poverty of relying on historicism and precedents. Sullivan's major contribution to Wright's schooling was not in design methodology, but in the philosophic premise for and epistemology of architecture.[1] The influence of Silsbee and Adler was more prophetically useful than that of Sullivan. During formative professional years Wright was, after all, more consummately a practical architect than a verbal theorist. He did not combine architecture and words until confident of his resolutions as they were constructed and possessed by their owners. That confidence was not personally satisfied until after certain resolves.

It was in 1898 that Wright's designs matured as a result of a methodology composed of two superior parts. First there was the regional, geographical expression of living on the horizontally open prairie that he first devised in 1897 for the Winslow stables (Figure 2.1) and later reapplied with philosophic rigor to the human-scaled River Forest Golf Clubhouse (1898). These buildings mark the beginning of the domestic Wright School. Second was the realization that nondomestic buildings required a different aesthetic system. That was first expressed in the office addition to his Oak Park, Illinois, house, also of 1898. With these two theoretical resolutions he created a series of wonderful, low-profile prairie houses and the cubic marvels of the Larkin office building (1903–05), in Buffalo, New York, and Unity Temple (1905–08), in Oak Park, (Figure 2.2), to mention but two.[2]

The creation and exploitation of the horizontally composed houses conjointly with the blocklike buildings was an exciting professional and artistic experience. But an ordinary family and cloistered suburban life where office and home were one, a full professional practice became, he confessed, boring and tiring. He wanted to physically, intellectually, and emotionally free himself and find new personal pleasures and fresh philosophic horizons. His friendship with Mrs. Mamah Cheney, wife

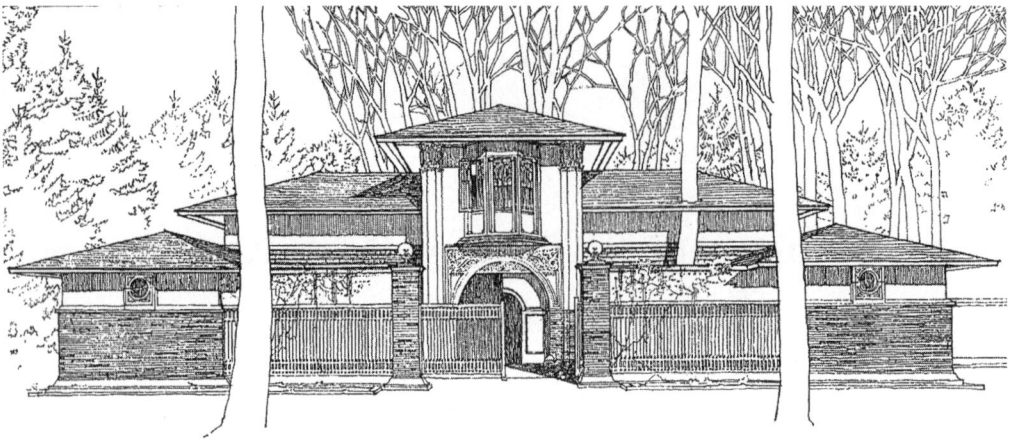

Figure 2.1. Winslow stables, River Forest, Illinois, ca. 1897, perspective drawing as published in Wright (1910).

of a client only a block away from his house and office at Oak Park, proved a liberating influence. When in 1909 Cheney was offered a temporary teaching position in Germany, the lovers abandoned families and the ambience of suburbia to flee to urban centers in Europe.

While residing in northern Italy Wright, his son Frank Junior, and draftsman Tayler Woolley revised or otherwise prepared his now famous monographs for the Berlin publisher Wasmuth, five in all. They were eagerly studied by young European architects after being brought to their attention by persuaded Berliners and the venerable Dutch architect H.P. Berlage and colleague Jan Wils.[3] On returning to the United States in late 1910, Wright and Cheney announced their free association—much to the horror of Midwesterners—and began constructing a new house on Wrights' grandparents' farm lands at Spring Green. When complete it was called Taliesin, after an ancient, elusive Welsh bard.

In time his practice revived moderately and, while most architectural designs were rather prosaic in comparison to those of previous decades, one building was prophetically influential on events in Europe after the war to end all wars. It was the linear, planar, and cubic abstraction he created for Midway Gardens, Chicago (Figure 2.3), a restaurant, beer garden and nightclub (of sorts) designed in 1913.[4]

Then a tragedy occurred. At Taliesin in 1914, Mamah Cheney, together with two of her children (ages 10 and 11) and four employees were murdered by a cook. Within months, obviously under stress and perhaps in desperation, Wright took up with a divorcee, Miriam Noel. Before completion of Midway he was offered a commission to design and supervise construction of the emperor's new Imperial Hotel in Tokyo, a task that engaged Wright in Japan for most of the period from 1917 to 1922.

After years of argumentative toing and froing, in 1924 Wright and Miriam married, only to separate after a few months. Her morphine addiction caused a wearying, unpredictable personality. It was in late 1924 that Wright met another divorcee,

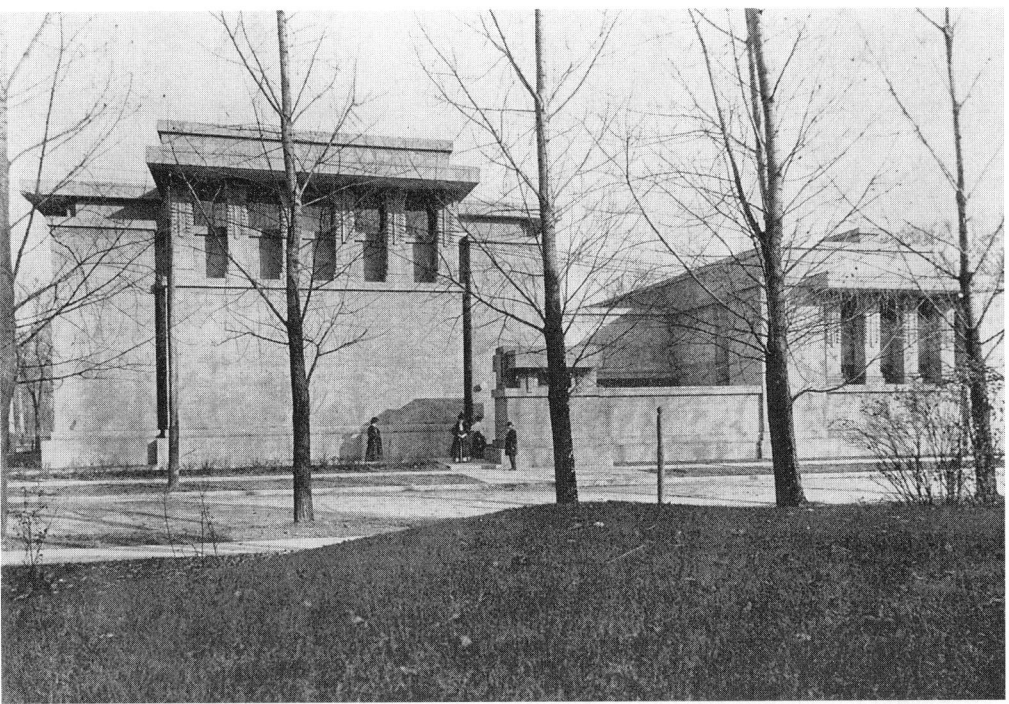

Figure 2.2. Unity Temple, Oak Park, Illinois, 1905–08, photograph ca. 1909, as published in Wright (1911). Similar views appeared in *Architectural Forum*, January 1938.

Olgivanna Hinzenberg, 30 years his junior, from Montenegro, the Caucasus, and Paris. When it became known they were sexual partners, Noel instigated bitter recriminations over the next four years.

Yet it was during the 1920s that Wright gained critical professional attention in Europe, mainly as a result of Dutch enthusiasm, German attention followed by French curiosity. Four prestigious publications of his words and works were issued from Amsterdam in 1921 and 1925, one from Berlin in 1926, and one from France in 1928.[5] It was no surprise, then, when in 1927 he was made an honorary member of the Belgian Royal Academy of Fine Art and shortly thereafter an "extraordinary" member of the German Academy of Fine Art. However, these were bright accolades in what was then a dimly lit career. No honors of a similar kind — or architectural commissions — were offered by fellow Americans. As a result he began to petulantly repeat to all who would listen that he was ignored in his own land. No doubt his absence in Tokyo for most of 1917–1922 and the public exposure of convoluted marital difficulties since 1910 were causes. The latter was partly resolved in 1927 when Noel allowed a divorce. One year later Wright and Olgivanna were married at La Jolla, California, a union that would remain firm to the end.

Having been harassed (he has said) by lawyers, banks, the press, judges, and U.S. Marshals and with practically no work for many years, there was obviously little income, his debts reaching over $43,000. So, in 1928 a bank took possession of his assets including Taliesin. Friends, family, and former clients formed Frank Lloyd

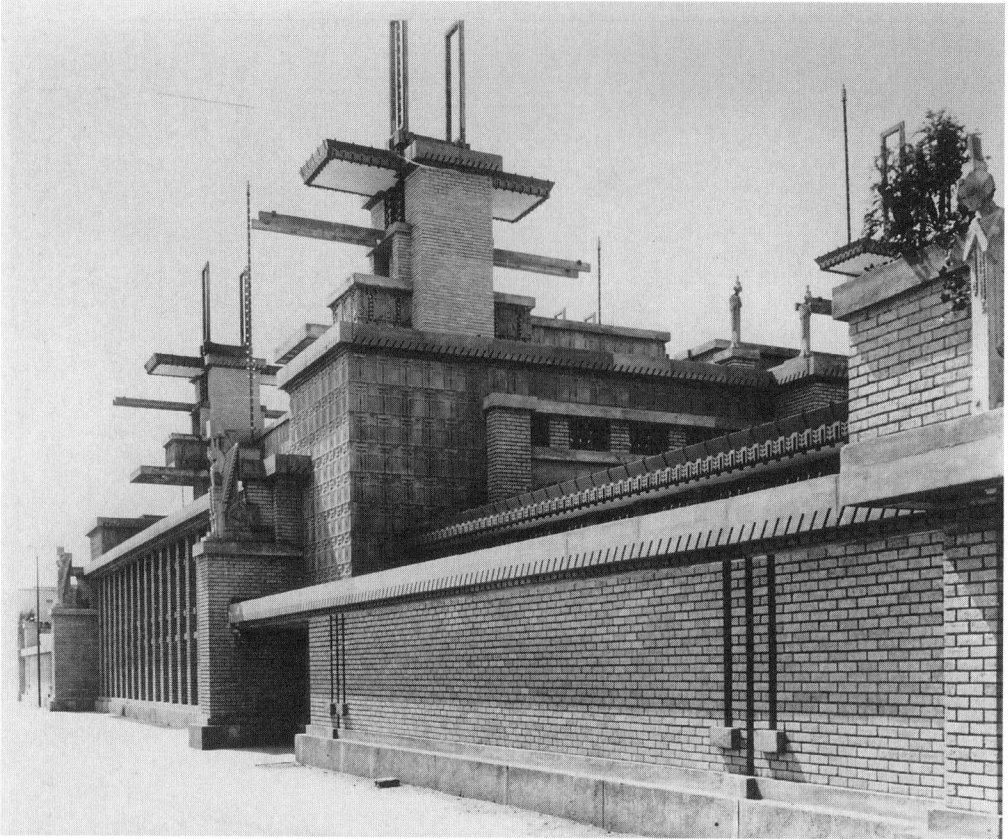

Figure 2.3. Midway Gardens, Chicago, Illinois, 1913–14, demolished in 1929, public entrance to tavern and winter garden, photograph ca. 1914 as published in *National Architect*, March 1915. Courtesy of the Wright Archive.

Wright, Incorporated. Debts were paid, and Wright returned to Taliesin and began rebuilding a familial life and promoting the new man rededicated to professional practice. Darwin Martin, an incorporator and a former client, knew the stock would prove to be "worthless," implying Wright would not repay investors.[6] There is no record of repayment: in fact, Wright's feeble story as told later was that the value of $57,000 of personal, nonbearer stock vanished with the 1929 economic crash.[7]

But when and how had Wright become so intimately involved in sunny southern California and with showy Hollywood? Around 1911 his architect sons John and Lloyd had settled in San Diego. John worked for Harrison Albright while Lloyd was employed by another architect, the imaginative Irving Gill. (Wright senior and Gill had worked together in the Chicago office of Adler and Sullivan before Gill moved to southern California in 1893, probably also laid off.) John stayed in California for a few years, then worked for his father in Tokyo before finding an architectural position in northern Indiana. Lloyd settled in Los Angeles in 1919, in the beginning to assist his father. Over the following 50 years he became intimately involved with artists of all sorts in music, literature, film and theater. Through those sometimes

hedonistic circles and others, he developed a steady landscape and architectural practice.[8]

Wright's initial contact with the American Southwest was in 1915 when visiting his sons, Gill, and the Panama-Pacific Exposition in San Diego. While there, apparently he was asked to design a moving picture theater or perhaps just a front facade; only a perspective is extant. At the end of 1915 and while she was living in Chicago, Aline Barnsdall asked him to design a legitimate "little theater." When she settled (more or less) in Hollywood ca. 1917, she asked him to design a house, artists' colony, and other buildings.[9] Through Barnsdall's—and son Lloyd's—Los Angeles circles of artists and left-wing radicals, Wright obtained a few commissions, but real prospects failed to mature.[10]

As we shall learn, Wright became further involved in southern California as a result of an infatuation with movies and Hollywood people and of receiving a variety of architectural projects during ensuing decades. For example, between 1915 and 1936 he received 28 commissions for architectural works in California, of which eight were built, all in the Los Angeles area except the overly contrived Hanna house in Palo Alto (1936–37). The other seven, together with a few unbuilt projects, were among many stimulating theoretical challenges. He also visited the area as a result of lecturing, mounting exhibitions, designing buildings, and enjoying visits with an extended family.

3

Southwest Architecture

Wright's earliest designs for the Los Angeles area were an architectural response to the greater region, its peculiar geography and ethnographic history. Yet the Barnsdall house "Hollyhock" (1919–1922) (Figure 3.1) has been identified by some historians and observers as pre–Columbian, as Mesoamerican, as Mayan, the proposition repeated willy-nilly. However, the floor plan is not pre–Columbian, the interior spaces, the physical enclosure, the massing, proportional systems, and colors are not Mayan, and it is not built of stone. It is not a religious or governmental building. The interior rooms, spaces and decoration are typically Wrightian. The precast concrete abstracted hollyhocks (a late addition in the design process) standing on an exterior band or string course at door-head height are not Mayan; neither was a similar motif used by the Maya. It is quite incorrect and certainly naive to suggest one building is a copy of—or derived from—another simply because a few pieces of sculpture or one or two minor architectural aspects (such as a canted attic) look something like a picture (yes, a picture) of an exotic predecessor.[1]

The Wrights were unequivocal. In his 1932 autobiography Wright said that Hollyhock was a "natural house, naturally built; native to the region of California."[2] His son Lloyd, who worked on the house for many years, confirmed that his "father's conception of the house ... reflects the Southwest." In a paraphrase of his father's words Lloyd said that Hollyhock was meant "to reflect a mesa silhouette as originated by the Pueblo Indians."[3] The words are clarified by the house itself.

The influence on their father of the architect's sons will always be problematical, perhaps less so in Lloyd's case. As young men in San Diego, Lloyd and John lived in a house designed by Irving Gill, and Wright visited Gill in 1915. John has stated that Southwestern Native American architecture had the "solid integrity of America," that it was truly American and that Gill had "tuned in to" that same "vital Source" as had his father.[4] The truth is vice versa; Wright tuned in as had Gill 12 years earlier, or around 1907. Wright has admitted that Gill had carried "on a line of experimentation along his [Wright's] own lines" and "developed a technique more 'adobe' and Indian than mine," that is, more adobe than Wright's.[5] Again father and son agreed when Lloyd said that Gill

> for years worked alone here [in southern California] to create [a] simplified structure in a land of heat and dust of suitable materials, plaster, concrete, and cement. Sanitary

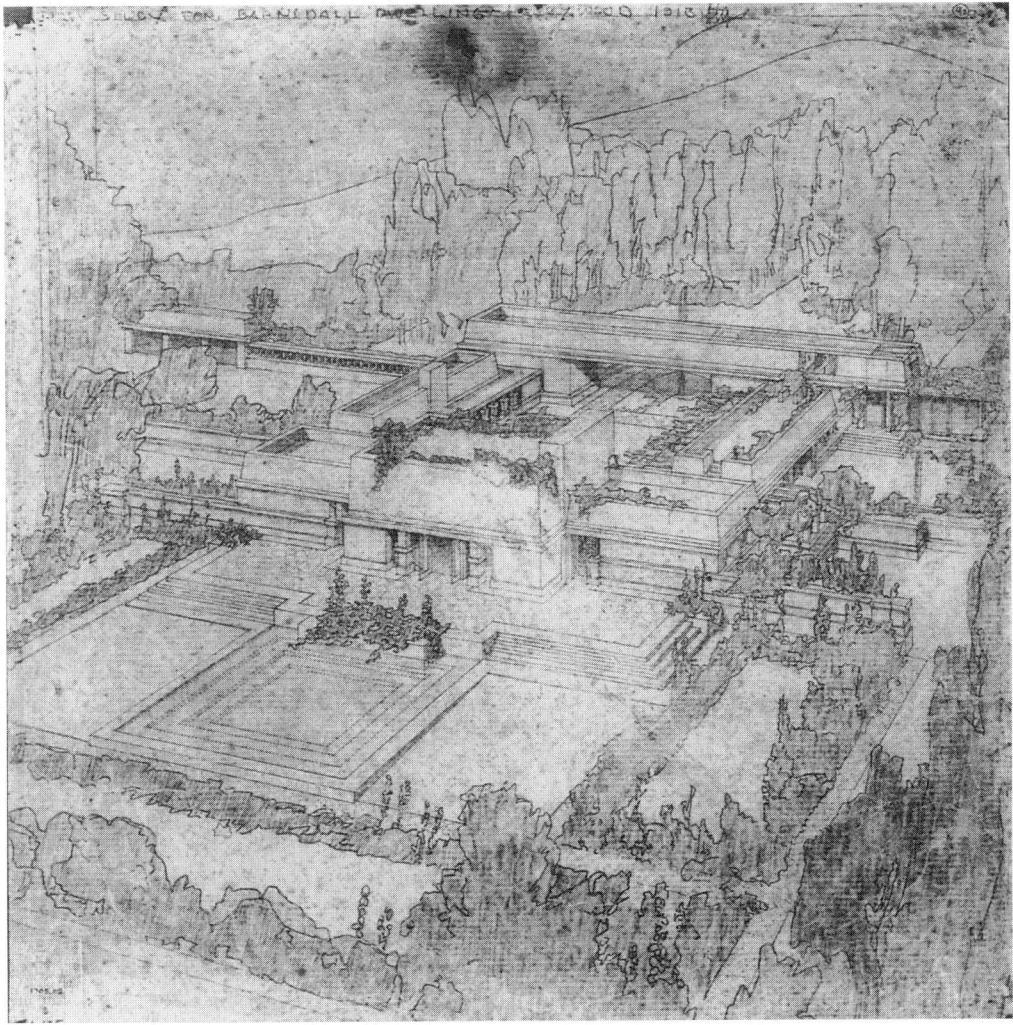

Figure 3.1. "Hollyhock," the Aline Barnsdall house, Hollywood, California, 1919–1921, aerial perspective drawing; ©2003 the Wright Archive.

and Cool.... Alive to his environment and what it meant and to the changing times in his efforts toward standardizing and simplifying structure and assemblage.[6]

The traditional plain stone or adobe and mud-stucco Indian architecture of New Mexico and Arizona and Gill's concrete and stucco buildings in the Los Angeles and San Diego areas were the opposite of Wright's decorated baroque creations prior to 1919. The "simplified structures" alive to their environment began not so much with Hollyhock as with the later Sachse and Lowes house projects of 1922 and, conceptually, the concrete block houses of 1923–25.

The role of the Viennese emigrant and architect Rudolph Schindler adds another consolidating consideration. While living in Chicago in 1915, Schindler had made a

pilgrimage to New Mexico, Arizona, and southern California. He sketched native buildings and even made some house designs based on the exterior appearance of pueblo architecture. In 1919 Wright sent Schindler to Los Angeles to supervise document preparation and construction of Barnsdall's Hollyhock and to assume management of Wright's new West-Coast office. After 1919 Schindler and Gill became friends, sharing ideas. What intrigues a historian is the scenario that Schindler, Gill and Lloyd persuaded, by word and deed, Wright Senior as to the desirability of a more obviously regional architecture rather than relying on previous designs in iron-stained wood or dark brick for the blue-and-green northern climes. Prior to 1919, prior to Schindler, Gill and Lloyd, nothing even hints of Wright's future southern California designs.

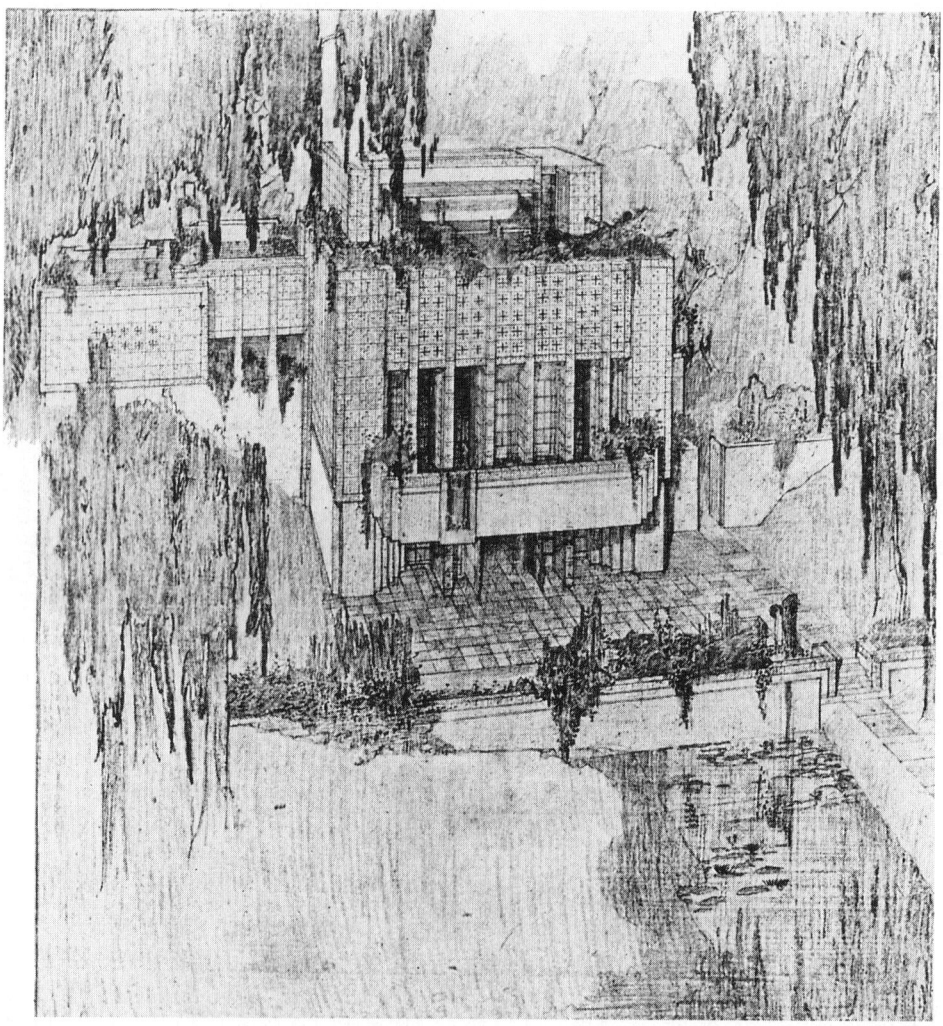

Figure 3.2. Alice Millard House, Pasadena, California, 1923–24, aerial perspective drawing; ©2003 the Wright Archive. A similar photographic view appeared in *Architectural Forum*, January 1938.

3. *Southwest Architecture* 15

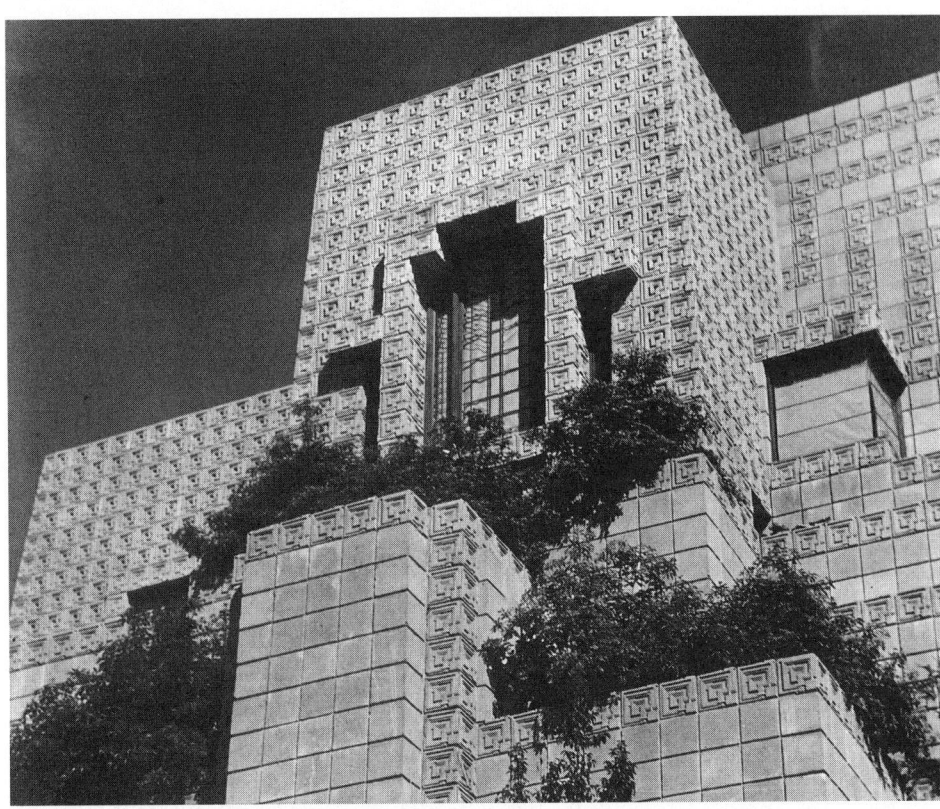

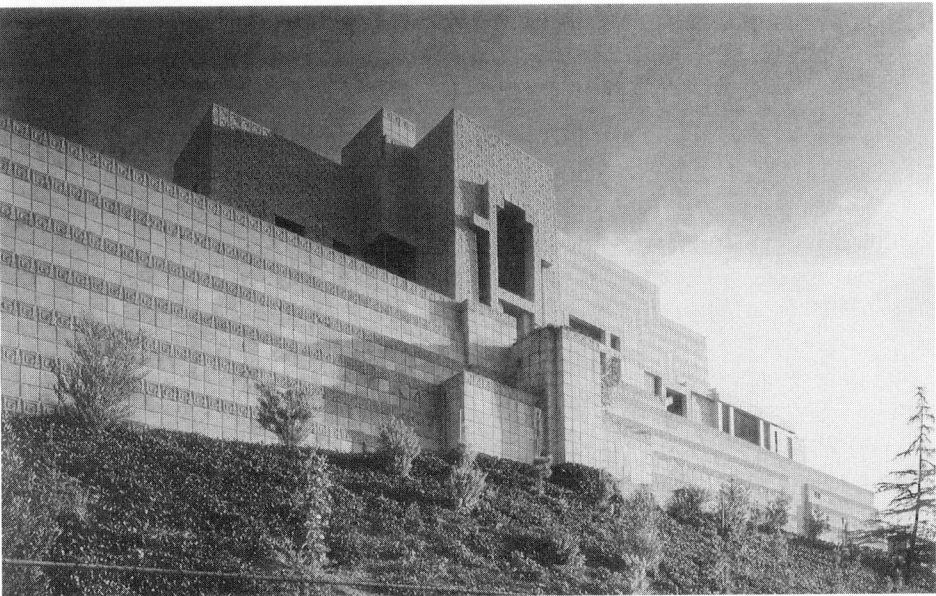

Figure 3.3 and 3.3A. Charles Ennis house, Los Angeles, California, 1923–25, photograph 3.3 as it appeared in *Record*, August 1928. Courtesy of the Wright Archive.

Other buildings were built on Olive Hill. A director's quarters and a studio house of 1920 were completed. Parts of the buildings looked like some of the designs Schindler came to know as a student under the influence of Otto Wagner in Vienna. At Olive Hill they are jarringly juxtaposed to some bulky Wrightian elements.[7] Schindler and Lloyd had much to do with the houses. A kindergarten of Wright's design of 1923 was started but not finished. The three men also prepared plans for a legitimate theater and a movie house (both more obviously by Wright) and terrace houses and shops, all for Barnsdall and to have been located here and there around the circular base of Olive Hill's high mound. But these came to naught.[8]

On returning permanently from Japan Wright was desperately in need of work, of an income. In 1923 he submitted to oil magnate Edward Doheny a speculative proposal for a gargantuan resort in the hills and ravines beside Los Angles. Doheny ignored it. Wright tried in 1923 and 1924 to interest investors in a "summer colony" on the shores of Lake Tahoe, but no one responded to the scheme or the out-of-the-ordinary resort buildings. He did receive two commissions from A.M. Johnson (of Chicago) for a large house in California's Death Valley and a massive Chicago skyscraper, but they too failed to materialize. And so did another house for Barnsdall in Beverly Hills and other minor commissions or speculations.

While these were interesting, often large projects, four smallish yet significant houses were constructed: Alice Millard's in Pasadena, John Storer's and Charles Ennis's on hills above Los Angeles, and Samuel Freeman's in the Hollywood hills. Millard's and Storer's were designed in 1923 and completed in 1924; Freeman's and Ennis's in 1924–1925. All were constructed with walls of a concrete block that Wright called "textile." The name "textile" for his blocks was taken from a name given by National Fireproofing Company (Natco) to a hollow clay masonry product of 1915 onward. For the block's initial design Wright borrowed aspects of a "knitlock" concrete block system invented in 1916–17 by architects Walter and Marion Griffin, former employees of Wright then practicing in Melbourne, Australia.[9] Lloyd picked up the Griffins' idea for his knit blocks in 1921–22, and his father then carried on with textile blocks in 1923. (See figures 3.2 and 3.3.)

The family of Mrs. Leah Lovell, Mrs. Freeman's sister, built houses designed by Rudolph Schindler and Richard Neutra. They were conceptually similar, Schindler's the predecessor, but singular in execution. His was constructed in concrete in situ in 1927–28, Neutra's in steel frame in 1928–29. It was through Aline Barnsdall's theater circle that the two families and architects met. The Freemans and Barnsdall shared left-wing political and social ideologies, and Aline held soirees for those of similar convictions and included film people. Wright said that "They said in Hollywood, Aline Barnsdall was a Bolshevik — a 'parlor Bolshevik,' said some." He added that she lived "soft" like a "princess in aristocratic seclusion" while asserting "proletariat" and, oddly, "hard" ideas.[10]

Although of similar construction, each of the four textile-block houses was unique, including their walls of differently relief-patterned blocks. Each building fit the notion of a simple blocklike massing as found in the Southwest Indian and Spanish colonial traditions that had inspired Gill, son Lloyd, and Hollyhock. The new block architecture of these four houses was a "flourishing sentimentality into which

[the traditions] were born," Wright observed.[11] With their textured exterior surfaces they seem only less obviously derivative of the Southwest Indian system, their simple rectangular forms the critical factor. Father and son agreed: Their "standardized concrete construction" system was "designed specially for California and inspired by the California environment."[12]

One of Wright's unbuilt house designs of 1922 was for Mrs. G.P. Lowes. Its walls would have been stucco over hollow clay bricks similar to Hollyhock. Its appearance, however, was of a modern adobe, composed of rectangular elements clearly expressing functional parts (Figure 3.4) and predecessor to the proposed terrace, houses for Barnsdall to have been built beside Olive Hill. However, after losing the commission and with only modest alterations, a few months later Wright's Lowes design was slightly revised to become Storer's house. Further, plans for the second Barnsdall house of 1923 were schematically similar to the Ennis house.[13]

Around 1924 Wright grudgingly abandoned southern California and returned to Spring Green. He had seen and experienced enough of Los Angeles, he said, and was "disgusted." The manmade environment was so "shallow," a "sea of cheap expedient," of tasteful neo-eclectic "illusion." He felt that if he were "to stay longer [he] too would be knocked down cheap."[14] The words were a pathetic offering in retrospect of professional failure. Were Wisconsinans or Chicagoans any different? Anyway, there were designs for an unbuilt school in 1928 and an unbuilt apartment building in Los Angeles for the communist propagandist Elizabeth Noble in 1930.[15]

Figure 3.4. G.P. Lowes house, Eagle Rock, California, 1922, project, perspective drawing inscribed "J[ohn] Ll W Taliesin Dec. 22," as published in Wendingen (1925).

The Noble scheme predicted some architectural and aesthetic elements to appear later in the 1930s and, as we shall learn, for a Rand house in the 1940s.

Wright's second career began with his return from Europe in 1910 while 1928 marks its end. During those years he received the highest national and international esteem while in tandem experiencing horrific personal tragedy, society's scorn, and professional isolation. It seems that he once again decided that the quiet of rural Wisconsin on manorial land with familiar environments was the correct place to begin sharing a new life with a new wife.

Architecturally, however, the third career began on a dusty yet prickly Southwest desert. After a decade when few architectural commissions were built and not many more prepared, ex–Oak Park draftsman Albert C. McArthur asked his former boss to help prepare design and specification documents for an Arizona Biltmore resort hotel near a Phoenix suburb. The hotel, built of textile blocks from 1927 to 1930, was financed by the Los Angeles Biltmore people. Warren and Charles McArthur were on the board of the Arizona Biltmore Corporation. Warren had built a house designed by Wright in 1892, and Charles was Albert's father.

While working for McArthur in Phoenix, in 1928 Wright met Dr. Alexander Chandler, and among other topics they discussed the feasibility of constructing a desert hotel (to compete with the Biltmore) to be located near the doctor's own resort town of Chandler, just south of Phoenix. Wright suggested it be called "San Marcos in the Desert" and be constructed of textile blocks. Rather than having his large entourage of family, servants, and architectural staff staying in a stuffy hotel or rented rooms, Chandler allowed Wright to build temporary living and working quarters on wilderness desert land near the site for San Marcos. They were designed in a few days' spontaneous effort, built quickly by Wright and staff during the winter of 1928–1929, and named "Ocotillo" after the desert plant. (See figure 3.5.)

At Ocotillo Wright wished people to gather and share dream-planning in the stimulating clear airs of a high desert. At the walled enclave's geographic center was

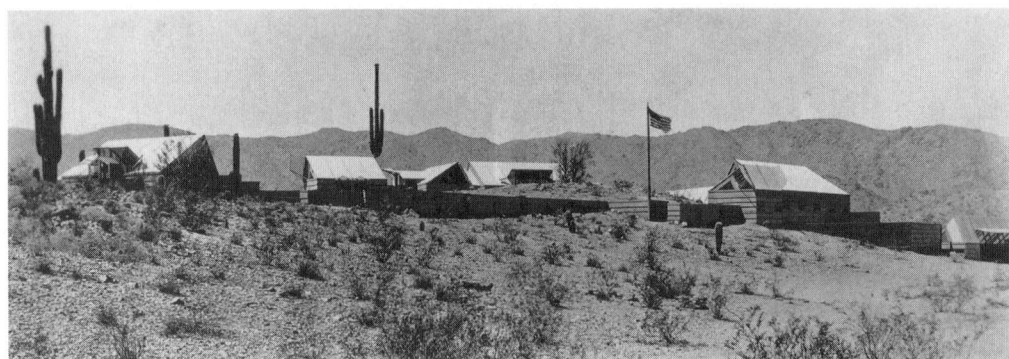

Figure 3.5. Ocotillo or Desert Camp, temporary residence and studio for Wright near Chandler, Arizona, 1928–29, photograph 1929. Abandoned 1929, then vandalized. Courtesy of the Wright Archive. Many photographs appeared in *Architectural Forum*, January 1938.

a sacred fire. Beside it was a special place for Wright to sit and face his immediate people. Around that loosely defined center were cabins and places for gardens, dining and attendant kitchen activities, electrical plant, garage, studio, bunkroom, guest room, and the Wrights' suite of rooms. All cabins had timber floors and half-walls that were roofed with canvas. They were part of an enclosing rose-colored timber wall that prohibited undesirable animals and alien thoughts entry to the compound. The rationalization of form, materials and site was extraordinarily simple yet conceptually profound and reductively essential, a liberation from all past and current conventions.[16]

By the last week of May 1929 everyone had left Ocotillo Camp except a caretaker. The drawing and specification documents for San Marcos in the Desert were finished. Only Dr. Chandler's signature was needed to proceed — when the New York stock market crashed. Rather than receiving a fee of $40,000, Wright faced a personal deficit of over $15,000. As proposed, San Marcos was an interesting use of textile blocks placed on concrete platforms forced into the land yet possessing the visual character of an extensive stone pueblo, the cubic, rectilinear and angular effects boldly abstracted.

With the collapse of the economy and Chandler's hotel project, Ocotillo was abandoned. The Wright entourage returned to Spring Green, and the compound fell prey to climate, decay, neglect, and thieves. Was it an unjust end? Of Ocotillo Wright said, confusingly,

> I never grieve long now that some work of mine has met its end; *has had short life* [he emphasized], even though it happens that a better one cannot take its place, consoled by the thought that any *design* has far-reaching effect, today, because of our machine [that] so easily gives it, as a design, to the mind's eye of all.

The ephemeral Ocotillo was, he continued, a "modest illustration of a great theme."[17] Indeed. Comparison of it to the orderly but romantic (his word) Tokyo hotel, Hollyhock, the Arizona Biltmore, and other designs of ca. 1917–1929 was valuable to Wright. The earlier products were inhibited, in varying degrees derivative (less San Marcos), and narrowly conceived (almost contrived to meet preconceptions), while stiffly formal and elaborately decorative.

Plain Ocotillo was founded on principles that encouraged Wright to freely, expressively and unaffectedly respond to given geographical and program conditions. Therefore, with Ocotillo and then for the next 25 years or so, Wright's architecture became new with *each* building.

4

Spring Green, Scottsdale, Moscow, London and Beyond

In the 1930s Western civilization was trapped between and threatened by economic despair and political anarchy. The protagonist was authoritarianism as dictated by the political left and right. Wright's greatest fear was the subjugation of his country by the collectivism demanded by extremes of the socialist left. To thwart that perceived danger certain measures were undertaken. He set out to establish a new life not bound by the northern prairies but extending nationwide. To bring in money and secure cheap labor he began a school — a traditional atelier — that would train people not just in building construction and the art of architecture but also in his social, religious and political beliefs. He publicly censured the collectivists and conversely continued a long verbal campaign against a blinkered traditionalism in art as fostered by the conservative right. And he publicly spoke against wars, that of 1939–1945 and all others.

Around 1930 Wright and Olgivanna's marriage was secure and financial debts were covered, but they were without income. If he was to repay those who had faith in his potential to again develop a sustaining architectural practice, he desperately needed commissions. Not only had he been besmirched by the press off and on since 1909, but the disastrous financial collapse in 1929 had taken its toll on the whole of the architectural profession. Competition was fierce and required him to find other sources of income. Writing, lecturing, and exhibiting were not only platforms to advance his art as a practical application of a nationalistic philosophy, but were the means of obtaining royalties and fees.

Each of the measures was by degree and manner acted upon by focusing on one consuming, self-preserving desire: to use his talent and fame to refurbish the great, evolving American dream of individual liberty. It impelled his third career. But he could not rely on the curious distortions of the lingering legend of Wright. Rather, it was necessary to create a newly active man, the practitioner, and correct the popular opinion abroad that he was merely a historical or social curiosity, a perception that had haunted him since his affair with Mamah Cheney. He had to formulate by word and deed the positive impression of relevance. Only then would his ideas find acceptance and attract clients.[1]

Of these undertakings perhaps the most urgent was an autobiography. It was

conceived as not only a personal history but also a polemical treatise outlining a life devoted to high principles and a primer of a supporting architectural theory. It became a catharsis but not a confessional, and a venue to lecture about the evils of fascism and collectivism, both formulas that restricted the joys of an individual artist bonded to a transcendentalism of his own concoction. He extolled the correctness of individualism as the basis of a properly conducted life in a properly motivated nation that shunned the plutocrat and bureaucrat, both motivated by power, in favor of a true democracy. He worked on the book off and on for about four years, and in 1932 *An Autobiography* was released. In spite of its awkward language and because it seemed honest, it proved to be one of America's more popular autobiographies. (Rand was enthralled by it.) When once again architectural commissions fell off during the war, he revised and enlarged it for rerelease in 1943.[2]

Another undertaking was to expose the architecture and theory of the European Modern Movement as illegitimate. In 1928 Wright began persistent, undisguised protestations against the socialist emphasis of the movement and its demand for an international, culturally neutral architectural aesthetic. For instance, there was an exhibition at the New York Museum of Modern Art in which Wright reluctantly participated. Included were a few American architects associated with the Europeans' international style as well as the by-then-familiar continentals: Le Corbusier of France, J.J.P. Oud of Holland, and the Germans Walter Gropius and Mies van der Rohe. Oddly, most space was given to Wright. The catalog was called *Modern Architects*, and a companion book of strangely contrived aesthetic principles by Philip Johnson and Henry-Russell Hitchcock (two organizers) was titled *The International Style*.

By being included among the cubic-box crowd of the socialist left, Wright believed there was an implication he was in some way associated or identified with — or approved of — the architectural style and therefore with its corollary, the ambitions of communism or other extremes of socialism. He publicly rejected that implication.

The exhibition opened in February 1932. After seeing the catalog Wright responded that April: "I find myself standing now against ... the so-called international style."[3]

Some of his reasoning went as follows:

> Do you think that ... any aesthetic formula forced upon this work of ours in this country can do more than stultify this reasonable hope for a life of the soul?
> A creative architecture [for] America can only mean an architecture for the individual.
> The community interest of the United States is not communism or communistic as the internationalists' formula for a "style" presents itself. Its language aside, communistic the proposition is. Communistic in communism's most objectionable phase: the sterility of the individual its end if not its aim.

Indeed, if a formula were to be instituted by a central authority, by definition his architecture would become forbidden as nonconforming. Continuing, he announced he was "sickened by capitalistic centralization [the New Deal] but not so sick" that

he and America "need confess impotence by embracing a communistic exterior discipline in architecture to kill finally what spontaneous life we have left."[4]

His awkward words outlined arguments to be paraded in essays, interviews, and lectures through to his life's end. He also expressed a belief that the European architectural "formula" was irrational, "imposed," stale, rigid, exotic, and therefore not American. It foreshadowed a second manneristic eclecticism, yet another cultural colonialism by Europeans. At times he called it a perversion of ideas he had expressed verbally and in architecture as early as 1908 and in Europe in 1910, 1911, 1925, and 1931. Of the architecture available to his country for selection—*if* eclecticism be the means—should not the American who was creating an American architecture be the obvious choice for America? If ideas were important, then his were the more valuable because their root, their radicalism was found in the concept and place of America. In that sense it was indigenous.

Wright made certain that his architectural ideas were almost continually on display somewhere in America during the 1930s and thereafter. On two occasions, for example, exhibitions of his work traveled around Europe, first 1931–32, then 1952–53 followed by venues in the United States, Mexico and Japan. In all promotions in each country he called for a transcendental interpretation by the people for their own peculiar needs fitted to their own traditions and national aspirations. In support he referred to the lifestyle as practiced by his Taliesin Fellowship. During the 1930s almost the entirety of his published writing, mainly for the popular press and common architectural magazines, was directed to promoting his social philosophy, not to discourse about architecture per se. This was unfortunate because his worldwide stature had been gained as a result of his architecture, not of his inadequately expressed personal social, economic and political ideas.

In the 1930s individualism was a central plank of a lofty platform from which Wright looked down upon the internationalists and hidebound proponents of fascism and conservatism. Individualism was the only means to an evolving creativity in art, in life. He repeated and argued the point with passion and varying degrees of clarity. In addition, politics, art theory, artists' will, architectural style, and nationalism were vibrantly—if often confusingly—mixed with his attitude to the hegemony of European modernism, especially that produced by the Paris-based architect Le Corbusier as the perceived titular mentor.

Wright's architecture supported his verbalized theories; his designs were always made in response to given problems; the solution resided internally, organically. Knitted to this natural fact was the ultimate architectural and social response. During the prairie years Wright's buildings were, as we have noted, of two types: the house low and spreading, or the nondomestic, proportionally square-volumed building. He maintained that each building must organically reflect its functional character. However, within each type, each of his designs appeared rather similar, a Wright style. Generally, the same can be said of his designs of the 1920s.

However, beginning in 1929 with Ocotillo Camp, we have seen that his architecture became a more vital proposition than previously. Each building became a unique architectural and social entity, each a singular response to a given program, to social conditions and site peculiarities. This reality distinguished his architecture

of the ensuing decade. Also, it quite noticeably separated him from the traditional eclecticism of conservatives, from the central European modernists, and sadly from most of his American colleagues. In the 1930s they were smitten with historicism or with the Modern Movement. After 1945 the movement's style was such that each anonymous box or rectangular slab could — and did — stand anywhere in the world, supposedly fitting any and all internal necessities or social conditions. Wright believed this was ridiculous.

Not shy or hesitant, Wright openly and aggressively challenged his beloved America (in the 1930s he started to call it "Usonia" because of the other Americas and the Union of South Africa) to see the reality of the political proposition at the core of the anonymous international aesthetic. He was perhaps the only well-known architect to publicly and vigorously do so.[5] He lost friends, gained few, and was at times socially and professionally ostracized. But he persisted with evangelistic zeal. Therefore all of his architectural and verbal work after about 1929 expressed his holistic philosophy. That included Broadacre City of 1930–35.

Since the mid–1930s Broadacre has been widely discussed, more than has been generally realized. Comment and analysis about it as a historical phenomenon continued until recently, when its physical form and regional disposition were revealed. That evidence confirms that Broadacre was a concept meant to reinforce and reinterpret the Jeffersonian tradition of rurality and to encourage a return to a democratic village life with all its implications. Villages were to be scattered about the vast North American landscape on an imprecise 20-mile grid, disposed by such compatible determinants as work, travel, industry, population density, and other internal or regional conditions. Decentralized villages were to drain the big cities and be self-sufficient, yet remain part of an invigorated twentieth century arts and crafts movement.[6]

Promotion of Broadacre City took many forms. On one occasion listeners were upset when Wright railed against Los Angeles, an easy target. In February 1937 he gave a talk to its inhabitants telling them about organic architecture and decentralization via the concept of Broadacre as a means to limit L.A.'s expedient real-estate booms in suburbs. Schoppe's cartoon "Wisconsin Valentine" expressed Wright's indelicacies rather well.

Some of Wright's buildings post–1935 were supposedly part of the Broadacre scheme, designed not only for the client but also to fit his village as laid out in model form. Probably the most interesting was his second significant commission in the 1930s, the Johnson Wax administration building (1937–39). The company was in many ways an ideal Broadacre corporation. It was decentralized with manufacturing plants throughout North America and in some foreign countries; its headquarters were in a small city; it was product oriented and not devoted solely to marketing; and it conducted its own research. Wright failed to convince Johnson to shift manufacturing and begin building a Broadacre City. So in a grimy, urban industrial area of Racine, Wisconsin, Wright created one of his more famous works (Figure 4.1), dynamic in form if not functionally coherent.[7]

Two years before the Johnson commission came to Wright he was asked to design a country house for Edgar Kaufmann on Bear Run Creek near Pittsburgh,

Figure 4.1. S.C. Johnson Administration Building, 1937–39, and Research Tower, 1947–1956, Racine, Wisconsin, photograph ca. 1956. Courtesy of the S.C. Johnson Company. Other and similar views were published in *Architectural Forum*, January 1938 and January 1948.

Pennsylvania. There he created Fallingwater, probably the most significant house of the twentieth century (Figure 4.2). Together with Fallingwater of 1935, consider only these works by Wright: 1929, Ocotillo Camp[8]; 1937, the Johnson building[9]; 1937, "Taliesin in the Desert" (his new house in Arizona, widely publicized); and the Pauson sisters' house in Phoenix of 1939–1940 (Figure 4.3). Each ranks among the more important architectural works of the century, each remarkably and naturally different from the others and a rebuff to the internationalists' repetitive boxes and the conservatives' Roman temples. Three were Southwestern buildings, while all responded individually to program and environment.

Comparison of these works with the internationalists' products was inevitable. Wright had done the exercise and found them wanting. He accepted only the milestones by Mies van der Rohe: the German Pavilion at Barcelona (1927–28) and later the more formal Farnsworth house at Plano, Illinois (1946–1951).[10] But then van der Rohe's ascetic architecture never fit comfortably with his European confederates.

Most of the office and drafting work for Wright's commissions was accomplished by an entourage of acolytes, those people who paid to work for him. The school, as he wished it to be known, had been actively pursued since in 1928. It was first intended to be an art school, then an arts and crafts school, then an apprentice and school program of crafts related to architecture, then a school for architecture apprentices alone. When the expectation of being aligned with a university was disappointed — and that occurred early in planning — and financial support failed to appear, the

Figure 4.2. Kaufmann house, "Fallingwater," at Bear Run, Pennsylvania, 1935–37, photograph from November 1937 by Hedrich Blessing, probably the most widely published photograph of the house. As published in *Architectural Forum*, January 1938.

scheme soon became centered around Wright's home, Taliesin, located on family farms at Spring Green.

However, there would have been no need for the school if all had gone well with his personal and professional affairs, if his architectural practice had been full and complete; but it was not. When the Taliesin Fellowship was begun in 1932, the practical motive for it was financial.

From the outset Wright hoped that the Dutch architect H.T. Wijdeveld of Amsterdam would participate as director. The energetic Dutchman, also an editor of *Wendingen*, made the long journey to Spring Green in 1931 to talk over the proposition, but the two architects were not sympatico. However, the Taliesin fellowship as realized in concept and formal application was measurably and impressively influenced by Wijdeveld's ideas. Even the term "fellowship" was borrowed from the Amsterdamer.[11]

The streams of events that flowed together to make the turbulent river of Wright's career had sprung from a vision. If there had been uncertainty about the course, by December 1933 a destination was more or less apparent and intention was firm. Wright and Olgivanna believed "the day" had come for the

Figure 4.3. Pauson sisters' house, Phoenix, Arizona, 1939–1940, destroyed by fire in 1943, perspective drawing. ©2003 the Wright Archive. Other photographs of ca. 1940 appeared in *Architecural Forum*, January 1948.

> rejection of the too many minor traditions in favor of [a] great elemental tradition that is decentralization; [it] sees a going forward in new spirit to the ground [to the earth] as the basis for a good life that sets the human soul free above artificial anxieties and all vicarious powers, able and willing to work again as the first condition of true gentility.

Their fellowship, their Taliesin school

> sees work itself where there is something growing and living in it as not only the salt and savor of existence but as the opportunity for bringing "heaven" decently back to earth where it really belongs. Taliesin sees art as not less than ever the expression of a way of life in this machine age if its civilization is to live.[12]

The international professional community was ready to give recognition not only to Wright's polemical efforts in the 1930s but also to his seminal work of 1898–1924. He was, after all, a creator of the methods and philosophies of modernism. Three events closed the decade.

First, he was invited to be a guest of the First All-Union Congress of Soviet Architects, held in June 1937. The invitation was issued perhaps because of his public criticism of America after the stock market crashed in 1929, but most assuredly because of his celebrity. At the time his practice was in limbo, and the Kaufmann and Johnson buildings were not yet published. The Moscow meeting was called by the Soviet Union's architects' union in direct response to threats by the Communist Party. It demanded that the profession publicly declare allegiance to the party, to Stalin, and to the artistic concept of socialist realism. In architectural terms this meant, strangely enough, a revival of Greaco-Roman elements. It also meant that the

vital and prophetically artistic and novel creative efforts in the USSR of the 1920s and early 1930s were no longer acceptable.

Wright enjoyed the party's architects' congress, his warm reception, and his roles as patriarch and keynote speaker. On returning to Wisconsin he wrote of his trip for American and Soviet publications, ignoring the murderous purges conducted by Stalinistic socialism, and saying much in favor of Stalin personally and the Soviets, and about his mission to Moscow. All these comments were very controversial of course, and odd contradictions to his earlier exclamations.[13]

Second was an invitation in 1938 to give a series of lectures in London as holder of the Sir George Watson Chair of the Sulgrave Manor Board—a singular honor announced to great acclamation in 1939. Third (and after accolades from Belgium and Germany) was his receipt in 1941 of the prestigious Gold Medal of the Royal Institute of British Architects. The American professional community failed to honor Wright until 1949, when they presented him with their gold medal: By then he had been practicing professionally and astounding the art world for 62 years.

Also on his return from the Soviet Union, Wright received a letter from the author and playwright Ayn Rand. He did not reply.

Part II

Rand

5

Ayn Rand

"When I am questioned about myself," Rand has said plainly,

> Don't ask me about my family, my childhood, my friends or my feelings. Ask me about the things I think. It is the content of a person's brain, not the accidental details of his life, that determines his character. My own character is in the pages of *The Fountainhead*. For anyone who wishes to know me, that is essential.

But in the words of Chris Sciabarra, "Rand's self-portrait here verges on the reification of her intellect as a disembodied abstract," when in fact her ideas "cannot be fully understood without an appreciation of their historical context." To put it another way is to ask: Between 1905 and 1922, would the Rand nurtured in, say, rural Alabama have been different from the Rand nurtured in St. Petersburg? Yet she insisted that events of her private life were "of no importance whatever. I have never had any private life in the usual sense of the word. My writing is my life."[1] As a philosopher would demand, "The *essential* Rand is the *thinking* Rand."[2] However, can one adequately divorce thought from experience? Are we — in fact, is the world — not composed of the past? Is there other material at hand?

Ayn Rand (1905–1982) was able to remember "the day and the hour" at age nine when she determined to become a writer. It was a decision made while at school in St. Petersburg, Russia. She was the first of three daughters of Zinovy and Anna Rosenbaum, who had named her Alissa, or Alice.[3] Prior to her journeying west there were three distinct and highly impressionable periods that defined her youth: a privileged childhood in St. Petersburg, adolescence during the European and revolutionary war years of 1914–1920, and the Soviet Union's painful, diabolical impositions of 1917–1926.[4]

6

St. Petersburg, Petrograd, Leningrad, Chicago

Alissa was born 2 February 1905 and for the next ten years lived an easy life within a comfortable family. Being Jewish, although nonobservant, seems to have influenced matters less than their being entrepreneurial, middle class and thoroughly bourgeois. Her mother and father enjoyed being rather wealthy, loved entertaining, employed a Belgian governess who taught French and German, were generally aloof with their daughters, and took their familial entourage to the Crimea for two months each summer, lazing about on sun-whitened beaches.

Her father became a professional chemist, coming from a poor family and supporting himself through one of the universities that would allow but a few Jews. Pretty Anna was attracted to social life and enjoyed being a hostess to lawyers, doctors, other professionals, and literary people. She loved organizing the cook, maid, nurse, and governess in maintaining an urban apartment. Daughter Alissa Zinovievna enjoyed popular music and theater and at school proved to be bright.

While the Rosenbaums were abroad during the summer of 1914, first in Vienna followed by six weeks in Switzerland and time in Paris, the royal families of Europe began a new war. Rail lines were threatened, so from Paris the Rosenbaums hurried to London, where passage was arranged to a Russian port on one of three vessels to sail that week. The Rosenbaums' ship arrived safely; the other two struck mines.

Russia was tragically unprepared for war; military losses were staggering and debilitating hardships fell upon all. To instill a sense of Slavic nationalism St. Petersburg was renamed Petrograd and Russian literature was promoted. Alissa remembered that urban society soon began to disintegrate. People were starving. There was inflation, looting and, in the melee, violent anti-czarist activity. Finally in February 1917 anti-czarists were murdered on city streets. In reaction the revolutionaries struck and succeeded: Within weeks the czar abdicated. The young lawyer Alexander Kerensky became prime minister that July.

All events Alissa observed or heard about as the personal encounters of others were "almost like fiction taking place in reality. That was why I became so interested." Perhaps she had "romanticized it a great deal," raising Kerensky to hero status because "he was fighting for freedom." She emphasized a favorite theme: "I took it literally — by which *I* meant individualism: it's *man*," she emphasized, "who must be free."

The rather passive first phase of the Russian revolt rapidly collapsed. In October the Bolshevik irregulars swarmed through Petrograd; the city became theirs, soon followed by Russia, and then places south — Ukraine, Crimea, Armenia — and east to the North Pacific. The boundaries of the new military Russian Empire became defined. Alissa later insisted it was during those revolutionary months of 1917–1920 that she came to understand politics as "a *moral* issue,"[1] yet impersonal.

For emphasis she recalled that a red seal was stamped on her father's drug store; pharmacists had been nationalized, and he was cast aside. Alissa "felt" his look and remembered well his reaction "of helpless, murderous frustration and indignation," she has said. "It was a horrible silent spectacle of brutality and injustice. I thought *that's* the principle of communism."[2] News of White Army victories in the Crimea urged them south.

While in Petrograd and Crimean preparatory schools (gymnasia) Alissa prospered intellectually, taking Russian and French literature (Hugo was a favorite) and philosophy; enjoyed especially the logic of mathematics (she was adept enough to become a tutor); and studied American history, an unusual high school subject. She also read Mediterranean classics, independently wrote screen scenarios and short stories, and became an atheist. Always near poverty, though, her family lived a difficult life.

When the Red Army again took control of the Crimea, the Rosenbaums reluctantly returned to Bolshevik Petrograd. They froze in winter, roasted in summer, used acorns for coffee and lard to cook in; breakfast was millet, lunch millet, and dinner lentils and dried fish. Crime was rampant in the city, and illness was everywhere, compounded by outbursts of plague. The Communist Party harassed people, and informers were easily enlisted with payment in food or preference. Fear had become formalized. In a retrospective summary Rand observed that the life of people of intelligence and ambition were claimed as the mob's property. "It was the demand for the sacrifice of the best among men, and for the enshrinement of the commonplace, that I saw as the unspeakable evil of communism."[3]

In 1921 she entered Petrograd University: education was a Rosenbaum imperative. Under the Soviets all education was free, which was especially necessary at university level because no one had the money to enroll if it was not. The university, she has said, "lacked heat and light. Reports of death by starvation, disease, and suicide proliferated. Students and professors met ... in cold classrooms, dormitories, and auditoriums illuminated by flickering candles."[4]

She majored in history (where Marxism was a "serious presence") and philosophy (even more present); she remembered especially Professor N.O. Lossky, a German specialist. And of course historical materialism was required by all.

Between periods of "wild experimentation and extreme anarchy" there was factional fighting between the anticommunists, in green caps, and the communists, in red kerchiefs and military leather jackets. Terror was ever present, opposition to the Reds was repressed, and some of her student friends and teachers just disappeared. Alissa's hatred of communism, now undiluted, was embedded and remained.

During the university years 1921–24 her father suffered deep depressions and could not work. So her mother taught languages in various high schools, and Alissa

found a job as a tour guide at the local Peter and Paul Fortress. With these tiny incomes the family of five managed in a three-room apartment in newly renamed Leningrad. ("It was St. Petersburg; then war made it Petrograd; then revolution made it Leningrad."[5] Now it is again St. Petersburg.) When in 1924 Alissa received a Leningrad University degree in social pedagogy she was age 19.

These are Alissa's recollections; their context, induction, and bias are clear.

Early in 1925 there arrived at the Rosenbaum house a letter from Sarah Lipski, the married daughter of Harry Portnoy, who had emigrated to America in 1889 with financial assistance from Mrs. Portnoy's niece Anna Rosenbaum. When Alissa exclaimed "*I have to* go *to America*,"[6] her mother relented and wrote to Sarah, but to be optimistic was difficult. In preparation for the possibility of a new adventure, Alissa first enrolled in courses in screen writing and performance in the recently opened State Institute for Cinematography. When movies became cheap Alissa attended almost every night; she saw pictures and voices of "the world outside." American silents created a dynamic, but was it improbable?, a vicarious world?[7] In a real sense movies and America had become synonymous. She also took English language lessons privately from a family friend. But these educational efforts lasted only a few months.

Sarah Lipski's response was to enclose papers for Alissa to complete, together with a statement confirming the Portnoys would act as sponsor and also pay Alissa's passage. With little sadness, in January 1926 she said goodbye to her family and boyfriend and set off to Riga, Latvia, where the United States maintained consular offices (before it recognized the Soviet government) and obtained a visitor's visa. Then she went on to Berlin and Paris before departing France on 10 February.

While on Atlantic seas she decided that in the new world she would be a new person with a new name. She disembarked as Ayn Rosenbaum, borrowing the name of a Finnish writer whom she had apparently never read.[8] Perhaps it was Aina, a single-name pseudonym for Anna Olsson, who was fairly well known, but a Swede. Anyway, the ship approached New York City in a dense February 1926 fog that obscured the Statue of Liberty; this was a great disappointment to her. After wandering New York streets she was off to Chicago and the Portnoys. The plan was to write some scenarios for silent movies and, with these in hand, settle in Los Angeles and sell them. Simple.

Ayn was welcomed by Aunt Anna, but they soon fell out, so Ayn moved in with another Portnoy daughter, Minna Goldberg and family, all devout Jews. However, the 21-year-old Ayn acted spoiled, was selfish, thoughtless, and self-absorbed; "very ambitious" was another word used by Minna. Ayn never talked about home or family, only about what she would do and be. And she decided to change her name once again, fearing, perhaps, prejudices induced by the name Rosenbaum or the fate of relatives in Russia that might result from her innocent actions in America.[9] While pecking at a typewriter she decided on Ayn Rand rather than Ayn Remington.

Sadly, as she had lost touch with family in Russia (who had been denied passports), Rand distanced herself from her family in Chicago. The Portnoys and Goldbergs maintained an extended family and deep involvement with their synagogue.

But as biographer Barbara Branden has said, Rand "did not understand their values, ... they were not, as she understood it, 'intellectual values.'" She found it "difficult to remain close to them" in spite of the fact she believed the Portnoys had "saved" her life. Rand was indifferent to the phenomenon of family. "It's not *chosen* values," Rand emphasized, "one is simply born into a family. Therefore it's of no real significance."[10] It is not surprising that after only a few months in the windy city, in midsummer 1926 she sped off to Hollywood; the undertaking was not speculative.

While in Chicago Rand had attended movies, absorbed the medium and improved her English. She had gone to a small neighborhood theater owned by Aunt Sarah (who each evening played the piano and sang) and her husband. From a friendly movie distributor Sarah had obtained for Rand a letter of introduction to a woman employed in the publicity department of Cecil B. DeMille's production company. It was an introduction fourth removed, yet it worked.

Perhaps Rand had paid attention to newspaper advertisements now and then taken out nationwide by the Hollywood Chamber of Commerce that warned:

> Don't Try to Break into Movies in Hollywood
> Until You Have Obtained *Full, Frank and Dependable Information*
> It May Save Disappointments.[11]

The obsessed went anyway and Rand was obsessed. The reason for her obsession is unclear because neither she nor her biographers have said why there was such a compulsion to write screenplays. Had she at such an early age decided to be a public philosopher like Hugo, Walt Whitman or Tolstoy (whose writing she disliked)? Did a new philosophy require a new medium? Was screen writing a new, burgeoning propagandistic medium with a universal audience? No. It seems to this observer that initially she was determined to be involved with movies, for reasons unknown, principally as a screen writer. Only much later when opportunities arose, with time more flexible, were broader goals contemplated and precise decisions made. Regardless, she loved movies, hated Soviet Russia, and saw opportunities in freedom-loving, capitalistic America. Screen writing was an entree.

With four completed movie scenarios and 100 borrowed dollars, Rand traveled by bus to Los Angeles and obtained a room (ten dollars a week included two daily meals) at newly constructed facilities of the YWCA-managed Hollywood Studio Club for women. Begun in 1916 the club had new premises that had opened in May 1926, only a few weeks before Rand's arrival. It was the first Hollywood home for thousands of women seeking fame. Rand remained a resident for three years and supported the club well into the 1930s.

7

Hollywood

Cinema, moving or motion pictures, films, or just plain movies were in their infancy around 1900, driven by the promise of big financial returns in a burgeoning business, and were created in messy workshops whose owners fought each other for staff, production rights and audience numbers. The decade of the 1920s was one of—and this is the correct word—fantastic growth, so much so that late in the decade the making of movies was one of the top ten American industries in dollar turnover. It produced 95 percent of the world's movies and employed at least 15,000 people, mostly in New York City and Los Angeles.

In many ways the Los Angeles area's agricultural, industrial and commercial development and concomitant population explosion from about 1900 through the 1920s was similar to that of Wright's stomping ground of Chicago from the 1870s to World War I. Between 1920 and 1930, 1.5 million people settled in southern California. The peak rate of 100,000 a year occurred between 1920 and 1924. Social historian Kevin Starr puts the situation like this. The diverting of mountain rivers

> made imperial Los Angeles possible; but it was real estate development and a phantasmagoria of attendant activities—buying, subdividing, building, selling, and finance—which with the decade of the 1920s propelled greater Los Angeles past the million mark,... the fifth largest city in the United States. An oil boom fueled this emergent economy, together with a tourist industry energized by Hollywood.... A City of Dreams, its boosters called it.[1]

In 1920 Hollywood (excluding Los Angeles) was a city of 36,000 people; by 1929 it had 260,000.

Ayn Rand probably knew that DeMille was not one of the movie industry's founding fathers, but he was close. From a family committed to live theater, he was involved as a playwright and in stage production and promotion. In 1913 Jesse L. Lasky, Samuel Goldwyn and DeMille formed the Jesse L. Lasky Feature Play Company. Merging with other producers in 1918 the company became Paramount Pictures. Earlier, in 1912, the nucleus of Feature Play had set up a studio in Hollywood as part of the Famous Players–Lasky Film Company whose headquarters were in New York City, the industry's financial center. There were, of course, a few others involved with movie making in the Los Angeles area before 1912. William Selig, for instance, was engaged in productions for a few months in 1907.

Looking for uniform exterior light, the major film studios set up production centers in Jacksonville, Florida. Before 1914 they included Lubin, Selig, Thanhauser, Vitagraph, Essanay, Eagle, Gaumot (from France), and Biograph. Looking for less wind and rain but uniform light, cheap labor, and better concessions from local government, the movie makers' westward migration began seriously around 1916. Selig returned; D.W. Griffith set up the Biograph Company's western studios, then followed the New York Motion Picture Company, Kalem, I.M.P., Rex, Power, Bison and others, all to Los Angeles. So Famous Players–Lasky and their succession in Hollywood with Goldwyn and DeMille (together with Adolph Zukor and Frank J. Garbutt) was significant.[2]

The DeMille legend is based on substantial contributions to the art of filmmaking. Believing movies should offer more than silly or light entertainment and, again like his contemporary D.W. Griffith, that movies might influence a nation's cultural attitudes, he created films about substantive — if often emotional — subjects. He began with the epic *The Ten Commandments* for Paramount, released in 1923. DeMille soon left Paramount in 1924 to establish his own company, DeMille Pictures Corporation, and produced *The King of Kings* that year, only to close his company in 1927. He joined newly formed Metro-Goldwyn-Mayer as an independent producer the following year. For Rand, therefore, the twice-removed friend of Sarah Lipski had fortuitously proved a most valuable connection.

Rand met DeMille, got the odd job as an extra, and after a few months was offered a full-time position at 25 dollars a week as a junior screen writer preparing outlines of silent movie treatments. Of course she continued to write independently, but DeMille always rejected her film scenarios as unrealistic, improbable, the characters "not human enough." (These were judgments and charges often made about her novels, including *The Fountainhead*.) One was in 1928, a treatment and scenario for DeMille of Dudley Murphy's short story titled "The Skyscraper." The hero, architect (please note) Howard (please note) Kane, saves (please note) a skyscraper from a fire.[3]

While working as an extra she met and — three years later in 1929 — married another acting extra, the quiet, reserved Frank O'Connor. In a rocky relationship the childless O'Connors remained married, parted only by death, he in 1979, she in 1982. In 1931 Rand became a naturalized citizen.

During her 14 or so months with DeMille, Rand would have worked on such films as *The Volga Boatman* (1926), with William Boyd (later to achieve fame as Hopalong Cassidy), Elinor Friar, Theodore Kosloff and Julia Faye. Or perhaps Rand was involved with the production of the disappointing *The Godless Girl* released in 1929. She also continued to work as an extra, as did husband O'Connor, including parts in *King of Kings*. Soon after marriage she began with RKO Pictures, eventually working up to head of wardrobe. In 1932 she became a freelance reader evaluating and synopsizing manuscripts, principally for Universal Pictures, MGM (and DeMille), and Paramount.[4] Clearly, Rand had a heady and thoroughly professional introduction to the movie industry, holding various jobs in and about Los Angeles from 1926 to 1932.

During this period she wrote an original talkie screenplay titled "Red Pawn,"

about life in oppression, a Soviet prison, love and hate. It was purchased by Universal in 1932 for $700, and she was paid a further $800 to do the treatment and screenplay. Then it was traded to Paramount, where preliminary planning included tempting the immigrant director Joseph von Sternberg and his protégée Marlene Dietrich with the script. Turned down by von Sternberg and suffering other defeats, "Red Pawn" was put on a shelf, where it remains.[5]

Her first successful, independent artistic work was a play, *Penthouse Legend*. The factual evidence of the "heroine's guilt or innocence" is so evenly balanced in the play that a verdict "had to be determined by the moral philosophy of the jurors," by their own values, Rand has said, and in consideration of "the diametrically opposite characters of the woman on trial and the major witness against her." The play's popularity was no doubt due to a stunt devised by Rand of selecting from the audience new jurors at each performance. Sitting on stage they witnessed the play and near its end presented their verdict to the audience. One of two endings followed: always good for a blush and giggle.

Penthouse was first performed at the Hollywood Playhouse in October 1934 as *Woman on Trial*. With Doris Nolan and Walter Pidgeon in leading roles it opened on Broadway the autumn of 1935 with yet a third title, *The Night of January 16th*, to good reviews. On opening night the boxer Jack Dempsey was put on stage as one juror. The play ran for seven months in 1937, and then two road companies toured the United States, as did another in Britain. Without Rand's participation a bowdlerized version was prepared in 1945 for the amateur theater market. A revival Off Broadway in 1957 was ravaged by critics and closed after three long weeks.

The years as a freelance reader for the major studios, that is after 1932, were some of her most creative and productive. She wrote not only "Red Pawn," *January 16th*, and *Ideal* (in 1934) but also her first novel, *We the Living*, which Macmillan in London eventually released in 1936.[6] In Rand's words it is about the evils of dictatorship, about "Man against the State," about "the sanctity of human life," that is, sanctity not in the "mystical sense but in the sense of 'supreme value.'" It is about a young girl who is sentenced to imprisonment in Siberia knowing she will never return and about the question of how any man "could be so lacking in self-esteem as to grant to others the right to dispose of *his* life." The plot is simple; the research was first-hand. In recollection Rand found that the question was answerable: abrogation of individual will — of the "sacred treasure" of life — to the State.[7]

Like most of her literary efforts of the 1930s, published or not, *We the Living* is rabidly anticommunist and (less obviously) antifascist. Also, the first third of the book contains much background, environment and development that is autobiographical.[8] A slow starter in sales, by 1985 the book in all editions had sold about 2 million copies, mainly in the United States.

During that intensely creative period Rand began working on a manuscript for a novel that became *The Fountainhead*. In notes of December 1935 for what was then a book proposal titled "Second-Hand Lives," she wrote with emphasis, "The first purpose of this book is *a defense of egoism in its real meaning*." The dualism was to be the individual versus the collective. She also asserted, for what it is worth, that the idea was conceived while living in Hollywood, by observing a selfish girl whose

goal was to have one more of everything than others about her. She made no decisions but simply reacted. Reductively, Rand then isolated the two antagonists; as paraphrased by Barbara Branden, they are

> The man of self-sufficient ego, of first-hand, independent judgment — and the spiritual parasite, the dependent who rejects the responsibility of judging. The man whose convictions, values and purposes are the product of his own mind — and the parasite who is molded and directed by other men, merely responding to propositions and acts of others. The man who lives for his own sake — and the collectivist of the spirit who places others ... above self. The creator — and the second-hander.[9]

In the finished novel the duality is in Howard Roark — and Peter Keating: Toohey is the agent provocateur.

In an apartment above East 74th Street in New York City, while continuing to outline the book, in December 1937 Rand approached a redoubtable hero, one who became her real-life model, the creator Frank Lloyd Wright.

Part III

Wright and Rand

"On one level, Ayn Rand was a ridiculous person, with her neo–Fascist ideas. But the heroism of *The Fountainhead* has never left me — the feeling that architecture represents a heroic gesture."

— Stanley Tigerman, 1993

"On the substantive questions of personal belief, in their admiration for individualism and enterprise…, in their contempt for the state, for mass culture, and for compromise," Rand's Roark and Wright the architect were in "uncanny agreement."

— Andrew Saint, 1983

"[P]eople think that the most important issue of my philosophy is individualism versus collectivism, or egoism versus altruism, but they are derivatives, not the starting point. The most important issue, the most fundamental, is reason versus mysticism…."

—Ayn Rand, 1966

8

New York City

Around 1934 Frank and Ayn O'Connor moved to an apartment high above Manhattan Island, certain that he would obtain theater work and she could more easily freelance. Then in 1937, among other activities, Ayn talked New Yorker Ely Jacques Kahn into giving her a job in his architectural office. She believed that practical experience in the profession was a necessary part of research for *The Fountainhead*. This trivial office experience as a typist was kept secret from fellow employees probably because she received no wages. She also had no contact with clients or contractors, and anyway, the job lasted only a couple of months.[1] If she learned practical aspects of the profession or observed the design process or procedures in the drafting room or on-site construction, there has been no admission, and they are not obvious in her research notes or in the novel.

A New York City man thoroughly, Kahn received a bachelor of arts followed by a bachelor of architecture (in 1907) from Columbia University and, as was socially appropriate, continued studies at the École des Beaux-Arts in Paris. An independent architectural practice begun in the city in 1917 lasted until 1966. During the 1930s he taught at Columbia. His architectural designs were conservatively traditional in the beginning, but when Art Deco arrived he took on the style and some of his buildings survive. As well, he organized for the Metropolitan Museum of Art three exhibitions in 1929, 1934 and 1940 on the decorative arts, and another for the Chicago Centenary Fair of 1934 in the industrial arts section.[2] Kahn was a member of the large Jewish community in a city full of immigrants and in the 1930s an increasing number of émigrés. Much of his work was housing, not for the needy but tall apartment buildings for the well-to-do.

From her reading and interviews with a few people including professionals and from gossip in Kahn's office, Rand obtained some factual detail and probably many anecdotes. Historian Andrew Saint and Rand's notes identify some: architectural education in the 1920s, social events of the 1930s, descriptions that suggest an actual building or a Wright design, parallels with a few of Wright's architectural ideas such as Broadacre City, and so forth.[3] She conducted research 1936–38 and some of her notes are edited and published in the *Journal of Ayn Rand*.

Rand has confessed to having no interest in buildings other than skyscrapers and, prior to writing about them, to being ignorant of the art and technology of architecture.[4] Of course she experienced and appreciated architecture as a layperson

might, read some architectural magazines and used the vast resources of the New York Public Library, where reading lists on aesthetics and architecture were made available. Itemized were Wright's 1932 *An Autobiography* (avidly read) and the English edition of Le Corbusier's *Towards a New Architecture* (an "interesting" book, Rand said). Prior to the 1930s most Europeans, including Russians, were awestruck by the American skyscrapers, hardly believing them real; Rand was no exception even into the 1930s. In any event she proved to be a fairly competent researcher on the subject of architecture but never quite understood its aesthetic principles, its demanding technology, the design process, or the complexity of construction on site.[5]

But what of the people of her imagination who would inhabit the novel? Rand has retrospectively discussed the sources of the main characters in *The Fountainhead*. The newspaper mogul Gail Wynand, who sought power "by appealing to mob taste" and was politically ambitious, she based on three obvious personalities: William Randolph Hearst (the movie by and with Orson Welles, *Citizen Kane*, was released in 1939), Henry Luce and Joseph Pulitzer. (Please read appendix B.) Dominique was one of literature's typical spoiled rich women — cold, scornfully austere, teasing — who pitied Roark's asceticism and married an elder but very rich Wynand. She otherwise toyed sexually with attractive men like Roark. Her charms were "exacerbated by some sociospiritual dysfunction," one commentator has said, and became "something swaggering, musculinoidal, and potentially destructive." Rand did not define the Dominique character by comparison to real people.

Conversely, Peter Keating was a "conventional" and "soulless" architect who succumbed to paternalistic tastes and blackmail. Some observers believe Keating was modeled on Chicago architect Raymond Hood, but that seems unlikely. From her notes it becomes obvious that Rand preferred to characterize New York architect Thomas Hastings; the "perfect picture of everything that stands against Roark" was her comment.[6]

Ellsworth Toohey was given special attention by Rand. His "spiritual sources" were many but derived mainly from Harold Laski, an ever-prominent English political scientist and Marxian socialist. Laski taught in Canadian and American universities from 1917 to 1920. In England he lectured as a specialist on comparisons and history of, and faults with, American and English politics. A prolific writer, during the 1930s he was one of the bright and popular darlings of the left on both sides of the North Atlantic. On watching a Laski lecture at the New School of Social Research in New York City, Rand found "the soul" of Toohey. Rand was taken by Laski's mannerisms, his "pseudo-intellectual snideness" and an inappropriate sarcasm (his "only weapon"). She thought of him as a drawing-room scholar and a "cheap little" comrade. Apparently she made a drawing of Laski (round face, black-rimmed glasses, bushy black moustache) as a reminder.

Other sources for Toohey were three: the "busybody," "collectivist" (Rand's words), and newspaper columnist Heywood Broun; the architectural critic for *The New Yorker* and cultural historian Lewis Mumford; and Clifton Fadiman, the left's "archliterateur" who was then book editor of *The New Yorker*.[7] In the novel Toohey was the architectural critic on Wynand's paper who also tried "to unionize its staff and sneak his way to power by simultaneously collectivizing the paper," as reviewer Raymond Durgnat has put it.[8]

Mumford, who was at one time committed to socialism and was kind toward the Soviet system, and Fadiman are odd sources, too formally aloof and intellectual, perhaps. To admit to basing one's evil dualist on Broun, however, was bold indeed. But then the admission came after Broun's death in 1939. He was a reporter and columnist with four New York City papers successively between 1911 and his death. He championed the unemployed, was against religious prejudice, was for unionism and socialist causes, and ran for U.S. Congress on the Socialist ticket (in 1930), only to be defeated by a nine-to-one margin. He was a mountain of a man who "without pretense, and seemingly without effort," biographer Whitney Mundt has said, Broun "managed in a brief lifetime of only fifty-one years to accumulate more friends and acquire more readers than any journalist has a right to expect."[9]

Rand's elder architect, Henry Cameron, Roark's confidant and mentor, echoes almost literally aspects of the life and character of Chicago architect Louis H. Sullivan, who had died in 1924. She knew something of his close relationship with Wright, at least as Wright had put it. Even Rand's own notes support the analogy: Cameron was a "great and tragic figure" who at 70 retained an "air" of former powers and a "ferocious bitterness."[10] Also like Sullivan, Cameron would succumb to alcohol, despair and self-imposed isolation. Both used society's acceptance of fashionable taste (including architectural beaux-arts classicism) and general lack of intellectual rigor as external forces that helped induce an internal, personal decline. Rand knew Sullivan's life-story as contained in *The Autobiography of an Idea* (1924). It was a "good" autobiography, she has said, not about events but properly about values, ideas, and convictions.[11]

It would be safe to say that Roark's idealized and concretized character and physical appearance were developed not out of specific prototypes but in Rand's mind as writing proceeded. On one occasion after *The Fountainhead* had been published she revealed that the only similarities between Roark and Wright were their approach to "principles" and the fact that they were innovative men who fought for a modern American architecture. Their personalities were not similar, let alone their philosophical convictions or the "events in their lives."[12] Her disclaimer fails on two counts. Their professional characters are obviously similar as discussions herein will attest. Further and likewise, the conviction to principle Rand gave Roark are close to Wright's, the latter's by far the more elastic and realistic, though less dogmatic or intensely pursued. With minor exceptions their professional biographies are dissimilar, so too their private lives. The counts of similarity suggest the men were entities sui generis.

Yet, Wright's role during that period of Rand's investigations might seem problematical but only on first reading.

After leaving Kahn's office Rand made contact with Wright. On 12 December 1937 she composed a letter of introduction and a request for an interview. She described her undertaking, advising that the book was not about architecture or a historical treatise but a novel about a fictional architect. She did not want his help or collaboration or to put any additional work upon him but to hold talks at his Wisconsin winter quarters. She then introduced her previous literary work and then the new book's outline. All this was to convince him of her serious mission. The novel

would concern an architect who holds tightly to philosophic convictions regardless of the opinions or actions of society. She said that Wright was the one man on this earth she "must" talk to. She was convinced that her hero's "spirit" was Wright's spirit, but not his life or career or work; perhaps not even his "artistic ideals."

The story of the erect, tall, red-headed Roark (Wright was 5' 7") was to be about human integrity. She told Wright he was the only one of this century who had lived a life dedicated to integrity. At their proposed meeting she wanted to be inspired by his presence, by his miraculous life because her hero was a miracle. Her theme might be explained by Wright's own words, and she quoted him:

> The natural man, the natural way is no longer the desirable way. Man power itself is becoming vicarious. Culture itself a vicarious atonement; academic education in its stead, destroying native powers. Remittances have taken the place of earnings. Criticism takes the place of creation. Life is more and more vicarious matter of subsisting existence — no subsistence existing as organic. Therefore life is no longer really living.[13]

The person who wrote those words would "understand" her thesis, it was in a shared language. She believed her book would be a "monument" to Wright. She closed by again asking if she might visit at his Wisconsin home.[14]

Wright did not reply. It is doubtful that he was embarrassed by such high praise, for adulation was a necessary ingredient of his personality. Rand knew it needed nurturing; his writings and autobiography revealed that. No, he did not reply because he thought that, as others had been, Rand was out for publicity or out to "use him."[15] According to Wright archivist Bruce Pfeiffer, however Wright's initial neglect of Rand was not intentional; rather, the architect was otherwise occupied in looking for a site to build an Arizona home.[16] Wright's silence was disconcerting, but Rand was not discouraged, not yet.

The Manhattan chapter of the National Real Estate Board asked Wright to give a talk at their mid–September 1938 dinner. This coincided with an exhibition of his work at the Architectural League's rooms. Photographs and drawings used in the January 1938 issue of *Architectural Forum*, which had been devoted to Wright, formed the core of the show. Designer George Nelson, assistant to editor Harold Myers of *Forum*, patiently organized the show while Wright provided some supplemental material.[17] It was Rand's intention to attend the dinner, meet Wright and arrange a future interview. To this end Mrs. Alfred Knopf, vice president of Knopf publishers, wrote to Wright explaining that Rand was writing a novel about architecture and wanted to meet the architect at the dinner.[18] Ely Kahn agreed to escort her.

After Wright's after-dinner talk Kahn made introductions. Rand did not remind Wright of her previous letter but spoke of the novel and requested an interview at some later date. But he seemed "disinterested" in her entreaties and "vague" about future plans, effectively putting her off. Still undeterred, she now believed the only course was to send him some of her writings.[19] At the dinner Wright had apparently said he would be in New York City in a few weeks and they might meet then.[20]

By November 1938 she had completed three chapters of the book and sent to Wright typescript copies of them together with a copy of *We the Living*. In the cover

letter she mentioned trying "desperately" for the past year to make contact and reiterated that the new novel was the story of a great architect who defies tradition. Now came a significant twist to her petition. She feared that when her book was published readers would connect Wright to her hero, although that was not her intention. It was a disclaimer and ploy to grab his attention, yes, but a worrying suggestion that a truth might be suspected. For that reason she was anxious to discuss the book with him before publication. As well, she did not want him in the future to disapprove of her comments because, she opined, the book would come very "close" to him.

After reading the draft of her three chapters she thought Wright should be able to decide if she was a writer worthy of his attention, pleading to let her know a specific time for an interview. Otherwise if Wright did not approve of her literary capabilities or of the proposed novel, she would proceed without his blessing.[21] In about a week came a reply:

> Dear Ayn Rand: No man name[d] "Roarke" with "flaming red hair" could be a genius that could lick the contracting confraternity ... and he is not very convincing. Will try to some-time see you in New York and say *why* [he emphasized] if you want me to do so.[22]

On receipt Rand fired back a telegram again asking to visit Taliesin, saying in part,

> THIS BOOK MEANS MORE TO ME THAN A TOUR DE FORCE SEEKING AS I AM TO INTERPRET THROUGH THE MEDIUM OF FICTION THE SIGNIFICANCE AND BEAUTY OF MODERN ARCHITECTURE. PLEASE DON'T HESITATE TO BE AS BRUTAL AS YOU LIKE IN EXPRESSING YOUR WISH IN REGARD TO MY TRIP AND I WOULD APPRECIATE IT IF YOU'D WIRE ME COLLECT.[23]

Wright's secretary, Eugene Masselink, immediately replied that Wright was again enroute to the "Arizona desert."[24]

Rand was "wounded" (Barbara Branden's word) by Wright's short, negative letter, referring to it as an "antagonistic" note. "I never could forgive him," Rand later lamented to Branden, "because he hurt me through his virtues; he could hurt me only because I admired him."[25] But consider this. Surely at some time during their conversations, Wright, Nelson and Kahn (and other New York architects) would have mentioned Rand. After all, from 1935 on, Wright was in Manhattan on many occasions, preparing an exhibition or a special issue of *Forum*, and so on. Was Wright's hesitation a result of private talks between friendly architects? Regardless, Rand's attempts to interview Wright ceased.

The Hero

Why an architect as the hero? In the acknowledgments section of *The Fountainhead* Rand offers "profound" gratitude to all architects who assisted her, more grandly to the "great profession" of architecture and to its "heroes" who have expressed "man's genius." There is, however, nothing in her background to suggest she would write a novel about architects and their art. The obvious exception was the movie treatment in 1928 of "The Skyscraper." This had provided an opportunity

to conduct some research on tall buildings. Perhaps she referred to W.A. Starrett's *Skyscrapers and the Men Who Build Them* (1928) as she was to do in 1936 and 1937. In any event the treatment was the practical seed that flowered 15 years later.

To the reckoning of biographer Barbara Branden and her husband (at the time), the psychologist Nathaniel Blumenthal, later Branden, there were two other, more fundamental reasons. First, Rand wanted to show "the essence of a creative man's attitude toward work." But all people are creative in some manner and degree. Work is an ethic that most people support if in a variety of guises, and all people have an attitude to work. It's a natural reaction or position toward labor and toil: There was nothing in *Fountainhead* about that.

But why architecture? The Brandens' amplification suggests that architecture was "an excellent vehicle" for Rand's purpose because it was simultaneously an art, a science, a business. But that is only partly correct. Architecture is an art form that applies a variety of technologies drawn mainly from engineering disciplines for obvious reasons and necessarily uses business techniques in its practice. Science is not involved except as it may be applied (by others) to technologies. But why architecture or engineering or business should be "excellent" in discovering that essence was not explained.

The second reason given by the Brandens is more personal. Rand had seen pictures—moving and printed—of American skyscrapers while a Leningrad student. The Brandens thought she wanted to pay tribute to those symbols of man's achievements.[26] This is an interesting if suspect thought obviously made after the fact—and trivial.

A more persuasive argument is this. In one way or another, actively or passively and from early childhood, Rand was attracted both as participant and spectator to the arts, in particular popular art forms such as movies, musical reviews, light theater, literature, less poetry. Art, the abstraction—or abstract investigation—of human actions, principles, and aspirations, is less practical day to day than most forms of human activity. A work of art is something without existence before being created. In that sense it is a most private endeavor. But of all art forms architecture is the most socially penetrating, applicable, and serving. Both architecture's private qualities and serving requirements made it especially attractive to Rand. Art is also a subjective human endeavor, difficult to define, at times rational in its means but at all times nonrational in act or product or assessment. Of all arts, architecture can be—must be—the most pragmatic, yet it retains a subjective quality. Attempts to measure that quality are fraught with emotional judgments and mental complications.

In general, only a professional could confront the various higher levels of society that were necessary, in her scheme, for a dramatized dialectic that would enable her emerging philosophy. It is difficult to imagine another profession of similar productive activity that would allow all of these various interactions and yet be intrinsically subjective. There is an important bonus: the potential of a creator to destroy the creation once realized (see appendices A and B). It seems that in modern times, artists, and possibly only artists, have a right to eliminate their own creations.

In the case of Rand's hero, Roark, such a willful—apparently nonrational—act

was the total destruction of buildings that, under pressure and out of weakness, had been constructed not to his design or liking. (Would anyone be outraged if a painter shredded a finished canvas, or a poet or writer burned a manuscript, or a sculptor melted her bronze?) Society brought Roark to account in a public court where his defense was a declaration of artistic and individual integrity, an integrity lost in rash moments and regained with dynamite. Thereby, individual will was made triumphant over collective taste and demagoguery and personal weakness. If observers were wise then ipso facto that triumph could free all humanity.

And a further consideration. Architecture is symbolic of the worlds of art and profession met and entwined. Rand's father worked to become a professional and to be part of that class in St. Petersburg. He was then publicly deprived of economic and productive wherewithal and stripped of all symbols of personal effort, pride, and dignity, and of society's recognition. The individual person had been absorbed by the collective state. To all this, teenage Rand was an intimate witness.

The success of *The Fountainhead* (perhaps 3 million copies sold by 1988), a long, labored and difficult book, attests to the popular attractiveness of Rand's theme, not to the quality of the assertive and tiring prose. Her understanding of art, architects, architecture, and professionalism was seen diversely by professionals. Here are some responses that might be typical of thousands. Architect William Gray Purcell, a close friend of Wright's writing from Pasadena in late 1945, said with emphases:

> She out Wrights Wright in stating *his* case and she says just what he would say.
> She even absorbs what he did, to his benefactors and to all the able men who helped him to become what he is—the best of him.
> Her logic is devilish in its cleverness.
> This writing is antichrist with a vengeance and as brilliant and ingenious as the devil can be.[27]

Architect and educator Ellis Lawrence wrote from Portland, Oregon, also in late 1945, that

> It [*The Fountainhead*] is an indictment of the ... architecture profession in New York, and smells to heaven in spots. Louis Sullivan (Cameron in the book) and his disciple Roark redeem the story.... I never detested a book more but always I was drawn back to it like a magnet pulls.[28]

Writing from New Haven, architect and Yale University architectural historian Vincent Scully recalled, "I read it as I was getting out of the service in 1946. I would read 10 pages and want to throw it against the wall."

In Fayetteville, Arkansas, architect E. Fay Jones remembered that he was in his "second or third year as an architecture student."

> There weren't that many novels about architecture at the time, so of course I read it. I also knew it was about Frank Lloyd Wright, and he was a hero of mine. I enjoyed the book, but I remember having reservations about some of the philosophical attitudes.

Kevin Roche, an architect now living in Connecticut, read it in 1948: "I was in Washington, D.C., trying to get a job. I thought it was ridiculous, the whole thing. It's just a misrepresentation of what the profession is all about. Rand used the book as a vehicle to support her own crypto–Fascist views."

New York architect Richard Meier was about 16 when he read it and had "just decided to be an architect":

> I found the novel not only riveting, but exciting — a very important book for someone young....
> I read it at face value as a novel that depicted the kind of democratic spirit that existed at the moment: ...that, somehow, the architect has an influence.... There was a sense that quality and idealism and striving for excellence were important in the world and that single voices could make a difference.

"That book caused me to become an architect," said Chicagoan Stanley Tigerman:

> It was tremendously influential in my life and remains so.... On one level, Ayn Rand was a ridiculous person, with her neo–Fascist ideas. But the heroism of *The Fountainhead* has never left me — the feeling that architecture represents an heroic gesture.... Rand was not writing about Modern architecture[,] ... She was writing about going against inertia.[29]

And so on. Those crypto–Fascist and neo–Fascist ideas, we must note, were very attractive to conservative, right-wing economists, politicians, and voters.

Accepting Jean-Paul Sartre's proposition that "individuals [must] have complete freedom to choose their own direction," architect, educator and historian Mark Gelernter added that individuals

> must [also] accept complete responsibility for their choices. Ayn Rand expressed this priority of the individual in her novel, *The Fountainhead* [1943]. Her architect protagonist ... definitely refuses to compromise his Modernist principles to the point of ruining his career.[30]

Architectural historian Mary N. Woods "never" finished that book "about art, freedom, and architecture." And she

> never got through the film, adapted from the novel, without squirming, yawning, and giggling. I found Howard Roark, Rand's architect-protagonist, neither sympathetic nor charismatic.... What I found memorable were the setting and supporting characters.... The mise-en-scène was always more vivid and intriguing than Roark, his designs, or Rand's philosophy.[31]

Architect and historian Dana Cuff thinks the public at large seemed to be

> under the impression that architects, in their artist-like studios, worked in relative isolation, making drawings of buildings. [Such a view] captures neither the range of activities nor the people involved. Where did this innocent vision come from? Chiefly, perhaps, from Howard Roark, hero of Ayn Rand's novel.[32]

A big perhaps.

Historian Merrill Schleier believes, with one-eyed objectivity and naivete, or humor, that "The key to interpreting Rand's mixture of [ill-defined] ideologies is sexuality.... Roark's body conquers [Dominique] Francon's, just as his buildings conquer space and his creativity conquers the forces of mediocrity and collectivism."[33]

One of the more perceptive views was that of University of Washington architectural historian Meredith Clausen. Attesting to the

> growing power of the mass media to shape social values and to the American craving for cultural heroes, *The Fountainhead* ... served as inspiration for a whole generation of young architects.... [The profession became] infatuated by the ideal of artistic self-expression ... [perpetuating] the public image of the genius-architect working in divinely sanctioned solitude.[34]

It is clear that Rand did not instigate this era of self-gratification as often implied; for other purposes she recorded it and then glorified it.

With the exception of John Walker, however, all architects, reviewers, and historians failed to appreciate a critical anomaly. As Rand's alter ego Roark said, he did not consult or collaborate or cooperate or work with councils or other collectives; his first duty was to himself. Further, Roark would only respond to a male client with a powerful ego equal to his own: Nietzschean Superman. Yet, architecture is both a social art and social *process* requiring the collaboration of many people and bodies of people: clients, engineers and other consultants; councils and building codes; construction companies and outfitters; and on and on; and finally the users, all testing three senses rather than only the abstract written word. The book emphasized the clash of the "hero-architect" and the social crafts. Architecture is a consensual social phenomenon, *not* a private enterprise.

Did Rand discover this when making the movie? Roark destroyed a housing project because his designs were not carried out exactly. One wonders if Rand ever contemplated destroying the takes when her instructions for the movie were not carried out exactly. Movie-making, like architecture, is a collaborative venture. Writing a novel is a very private, insular process.

As to other opinions, author and critic August Derleth correctly described Rand's "writing manner" as "offensively pedestrian, pockmarked with short, clipped staccato sentences." But he found the book "authentic enough" (did he mean believable?) and the theme pursued "without deviation and with good characterization and enough action to satisfy."[35] He was, of course, analyzing the book as a novel, not as a philosophic thesis. Nathaniel Branden referred to *The Fountainhead*'s "stylized writing," her "particular way of seeing and recreating reality," to her—and this is important—to her "*stylized universe.*"[36] Others have referred to her characterizations not as stylized but inflexible and rigid, a problem recognized since the late 1920s and in the 1948 movie script. We shall return to the idea of stylization where more appropriate.

Reviewer Lorine Pruette found Rand's characters to be "amazingly literate." They spoke "with her voice, expressing in dynamic fashion the counterpoint of her argument." It was the "only novel of ideas written by an American woman." (What

of Harriet Beecher Stowe's *Uncle Tom's Cabin* or Charlotte Perkins Gilman's (Stowe's niece) *Herland* among others?) Ellsworth Toohey was, to Pruette, a modern devil who corrupted Peter Keating. Roark was the tough guy who worked "cheerfully in the quarries" when not allowed "to build in his own way." And Pruette isolated three sentences in Roark's defense (to charges of blowing up a public housing project) that in the reviewers' mind summed up the hero's and Rand's view:

> Man cannot survive except through his mind. But the mind is an attribute of the individual. There is no such thing as a collective brain.[37]

It is no surprise that Pruette's naive review was Rand's favorite.

The fact that public (i.e., government-sponsored) housing was dynamited and that the Wynand building was a corporate-free enterprise venture has been seen by some people as the defeat of New Deal politics and a victory of laissez-faire economics. Wright's frustrated dislike of Roosevelt's administration centered on what he perceived as its interference in the fundamental exercise of American democracy as defined by the framers of the Constitution. His position was well known; it was similar to Rand's, if less obstinate. When one reads the novel, Rand has said, one sees it as an "indictment" of New Deal politics.[38] While the government's laissez-faire nexus is more or less clear in the book, it is heavily veiled in the movie.

Nora Sayre thought the book detailed the lumbering progress of an architectural genius that "mystics and liberals conspire to ruin" but who "succeeds in rebuilding slabs of New York," and here Sayre's sentence ended with a blunder, "in his image." Rand "grafts old-fashioned laissez-faire capitalism," said Sayre, "onto a fresh branch of paranoia: Miss Rand's conviction that America is being destroyed by altruism and mysticism."

In contradiction to earlier comments, Rand has said:

> Because of *The Fountainhead*, people think that the most important issue of my philosophy is individualism versus collectivism, or egoism versus altruism, but these are derivatives, not the starting point. The most important issue, the most fundamental, is reason versus mysticism — the premise that knowledge is based on logic and the evidence of the senses versus claims to some sort of nonsensory, nonrational knowledge.[39]

Pruette and Sayre represent extremes. But then Pruette was a follower and Sayre was writing (after Congressional hearings on un–American activities in which Rand had participated, and after Rand had established her objectivist movement) for *New Statesman*, a magazine then only slightly right of the far left.[40]

To attract academia and the cognoscenti, a number of Rand's followers suggested she write a nonfiction book to clarify her philosophy. This was rejected in favor of another fictional piece, *Atlas Shrugged*, released in 1957. It is not a philosophic treatise but "a philosophic novel, expressing all of the author's key ideas," the objectivists' bible.[41] It is also well beyond the time frame of this study.

No value will be gained by comparing the architect in Henrik Ibsen's play *The Masterbuilder* (1892) with that in William Dean Howells' novel *The Rise of Silas*

Lapham (1885) or with Peter Ibbetson or with Rand's Roark, or even less with Peter Greenaway's Sourley Kracklite in the British-Italian film *The Belly of an Architect*, of 1987. Each was written in its own place and time and for purposes personal or social or artistic. However, except for Ibbetson and Kracklite, there are obvious shared concerns: one, the loss of certainty; another, the imperative of an individual's intellectual freedom.

Philosopher Mary Ellen Waithe sees the main themes in Rand's works as threefold: "happiness is the moral purpose of human life, productivity its highest activity, and reason its sole absolute."[42] Perhaps. Together with liberty, happiness is an explicit condition set out in the United States Constitution. No doubt Ibsen would have agreed with its moral necessity. Wright was in constant search of that Jeffersonian happiness. His life was dedicated to meaningful productivity and in it he was content. But, aware of its value, he found difficulty in applying or explaining reason, or at least logic. By comparison, however, although hidden by assertions, Rand's unexceptional life approached prosaism.

9

Roark and Wright

Ayn Rand's futuristic novelette *Anthem*, originally teasingly titled "Ego," was first published in England in 1936 but not released in the United States until 1946, when abridged for Pamphleteers Press. It is a stark portrayal of authoritarianism under a dictatorial world council. The personal pronoun "I" is banished, and all people "must be alike" and strive for equality. Words cut in marble over the grand entry to the council's palace are spoken aloud by the egalitarian masses whenever tested by temptation:

> We are one in all and all in one.
> There are no men but only the great WE,
> One, indivisible and forever.

A man is introduced in the novel as "our name is Equality 7-2521." One day he sees the female Liberty-5300 and yearns for her outside the Time of Mating in nature's spring. Through love, Equality 7-2521 discovers self, will, ego, and the full implications of the word "I." [Did the female Liberty-5300 make similar discoveries?] *Anthem* has been fairly described as a "dystopia set after a devastating war; individualism has been eliminated," the "protagonist discovers himself and escapes to the forest with"—of course—"a beautiful woman."[1] Does she not escape with, of course, a handsome man? Rand's fictional writings are invariably male-centric.

The idea for the novel was borrowed, so too the literary form and method. During the years 1919 and 1920 the prominent, Petrograd anti–Bolshevik writer Yevgenii Zamyatin wrote a novelette titled *We*. It projected a future communistic soviet society where people were numbered and private and daily life regimented by a "mighty unipersonal organism" that called itself One State. Surely Rand knew Zamyatin and attended his literature classes in Petrogad. *We* circulated in 1920 and 1923 in manuscript form, not to be published until translated into English in 1924, and often thereafter.

The ascetic, dehumanizing anti-collectivist theme and method of portrayal by Zamyatin (and then by Rand) had a mighty influence upon the English author George Orwell. He first read *We* in French in 1928 and immediately announced an interest in writing "that kind of book," as he put it. Parallels with Zamyatin and Rand in his *Nineteen Eighty-Four* (of 1949) are obvious, including fascistic slogans such as "Freedom Is Slavery" and "Ignorance Is Strength."[2]

During the early 1930s Rand wrote another novelette, in some ways similar to *Fountainhead*, that in 1934 she converted to a play titled *Ideal*. On a Rand revival wave it premiered in Los Angeles 55 years later, on 13 October 1989, as an Equity Waiver production directed by Michael Paxton and to modest reviews.[3] Another mystery play written by Rand in the 1930s, "Think Twice," could not be sold.

Rand also adapted the novel *We the Living* as a play and retitled it *The Unconquered*. Some of New York City's favorite theater luminaries were involved in bringing it to an opening night in February 1940. Rand admitted to a crush on leading man Dean Jagger. But he, producer George Abbott and all others involved could not save its closure after only five dismal nights on Broadway.

Ayn and Frank also took time in 1939 to voluntarily work for the election of U.S. presidential candidate Wendell Wilkie. Rand was disturbed by Roosevelt's New Deal leftist policies that, in her view, eroded the fundamental freedoms inherent in the establishment of the American republic. She (as had Wright) feared they were leading the country closer to socialism and too close to communism. She could not understand why Roosevelt's opponents so ineffectively defended capitalism and free enterprise. Wilkie presented himself to Rand as a crusading intellectual, uncompromising in defense of what she interpreted as America's treasured beliefs.[4] When Wilkie lost the election, the O'Connors were nearly broke, so in the New York winter of 1940–41 Rand returned to Paramount, again as a reader.

Paramount picked up the option on *Night of January 16th* and appointed Sol C. Siegel to produce a motion picture. But Rand was not allowed to participate. Three screen writers of varied background were involved. One was Delmer Daves, who began as an actor in the 1920s and then became an actor and writer with *So This Is College* (MGM, 1929). He went on to write mainly B films but also the engaging A production *Farmer's Daughter* (Paramount, 1940). He became a successful director; one film was *Pride of the Marines* (Warner Brothers, 1945) with John Wayne. Another writer, Eve Greene, had begun a sporadic screenwriting career with *Prosperity* (MGM, 1932), and just before *January 16th* she had written *Moonlight in Hawaii* (Universal, 1941). The third writer was Robert Pirosh, whose credits around this time included *The Quarterback* (Paramount, 1940) and the Marx brothers' movie *A Day at the Races* (MGM, 1937). Like Daves, he also became a director of B movies such as *Go for Broke!* (MGM, 1951), yet in 1949 he won an Academy Award for MGM's A film *Battle Ground*. In a typical defensive outburst Rand peevishly claimed that the Daves/Greene/Pirosh screenplay contained only a single line of her original dialogue.[5] In other words, if it failed, it wasn't her fault.

William Clemens, who was selected to direct *January 16th*, began as an editor of B films like *Ghost Valley* (RKO, 1932) but soon was assigned to direct B mysteries in 1936 and 1937, some of the Nancy Drew series (1938–39), and in 1943–44 three of the *Falcon* movies. In 1940 he directed the mystery *Calling Philo Vance* and in 1941 (a very productive year) *Knockout* and *She Couldn't Say No*, each for Warner Brothers. For the movie of Rand's *Fountainhead* the art director's job was to be of special importance. But for *January 16th*, just another run-of-the-film movie, two studio men were selected: Haldane Douglas and Hans J. Dreier. *Mr. Moto's Gamble* (Fox, 1938, with Peter Lorre) began Douglas's art-directing career, which later included the dramatic A

film *For Whom the Bell Tolls* (1943). Another of the important German emigrants to Hollywood, Dreier eventually obtained a long list of credits—hundreds—that began in 1928 and lasted to 1951 as a studio designer with Paramount. During 1941 alone he was their art director or co–art director on no fewer that 20 films, among them *Road to Singapore* with Bob Hope and Bing Crosby. Drier eventually won three Academy Awards. Some of the set designs for *January 16th* were rather modern.

The *New York Times* review of *January 16th* mentions some "pre-production casting difficulties" before the producer settled on Robert Preston (to play the amateur sleuth), Ellen Drew (secretary and a murder suspect), and Rod Cameron (the district attorney), who were just beginning their acting careers; and Nils Asther (Drew's boss), who was in the twilight of his. The irrepressible Cecil Kellaway played a drunk.

With such a talented production team (the co- or assistant producer was Joseph Sistram, who was just beginning his career),[6] a first-class production would be assumed. But when the 80-minute film of *January 16th* was released in December 1941 it attracted little attention. The *Times* reviewer found it to be a "thriller of better than average quality," a "minor but gratifying offer." But that reviewer ("A.W.") was pleased with nearly all films. *Variety* ignored the movie. A recent and brief postmortem found the film "dull, insipid," with a plot solvable "in the first five minutes."[7] Again in a passing-off defense, Rand said that the movie was "cheap, trashy and vulgar" and little else about it.[8] Still, there must have been some satisfaction that a literary work of hers was finally made into a movie, if only a B film.

Rand's novel *We the Living* sold rather well in Europe, especially in England and as translated in Italy and Denmark. Moreover, it was pirated in Italy without Rand's knowledge and made into a movie titled *Noi Vivi*.[9] Released by Angelike Films in 1942 (not a good year in Italy), it was directed by Goffredo Allesandrini and starred Alida Valli, Rossano Brazzi (just beginning their careers), and the reliable Fosco Giachette. Banned by Fascists in Italy and Nazis in Germany, *Noi Vivi* remained obscure until the late 1980s, when there were a few showings prompted by followers of objectivism. (Those followers had also encouraged a production of *Ideal* in 1989.)

All of these literary, promotional, cinematic, and theatrical efforts were effectively—and generally professionally unsuccessful if personally useful—detours en route to Rand's first major endeavor, *The Fountainhead*. She had written a few chapters, some as early as 1938, as we've learned. Her agent had placed these with a number of publishers but by 1940 gave up; so too did Rand, but not before the New York office of Macmillan (who had published *We the Living* in London) showed interest, as did Cassell in London; eventually they pulled out. It seems that Rand (perhaps foolishly) insisted on a guarantee to publish before she would submit a complete manuscript and also not before Knopf agreed to publish with an advance on royalties; that was in 1938.[10] She was unable to meet their deadline, so the contract amicably lapsed. By 1941 the book apparently had been rejected by 12 publishers.

Then, as with Sarah Lipski in 1926, a friend of a friend intervened and suggested the manuscript be sent to yet another friend at Bobbs-Merrill. Sample chapters and the concept of the book were accepted, and, just before the bombing of Pearl Harbor on 7 December 1941, a contract was signed. The complete manuscript was due 1

January 1943. With almost two-thirds yet to be written, Rand quit Paramount. When the final manuscript was presented to Bobbs-Merrill, her advance on royalties had run out, so she went back to reading for Paramount.

The Fountainhead was released in May of 1943, and Rand immediately sent a copy to Wright. In a responding acknowledgment Wright told her, rather carefully, that "so far as I have unconsciously contributed anything to your material you are welcome." Her reply of May 1944 was unrestrained, saying his letter closed a circle that began and ended with him. Of course he contributed and he knew it:

> I have taken the principle you represent, but not the form, and I have translated it into the form of another person. I was careful not to touch on anything personal to you as a man. I took only the essence of what constitutes a great individualist and a great artist.

Her architect hero Roark represented a conception of man of which Wright might not approve, she went on, but she wanted him to accept her literary effort as a tribute to him. He was, after all, the "figure" of her man-god. She closed with unusual tenderness: "Gratefully — and always reverently."[11]

To privately or publicly give even the impression that Wright was Roark's exemplar would be to confess that she had not created the ideal personification of a new philosophy, rather that he — the man as god — already existed, and she fictionally merely retold his story. Yet it was an implication too easily deduced from the book and movie.

Other than the association with Wright, Rand's clearest explanation of the book was contained in one of her defenses of the movie against severe criticism. In order not to challenge negative comments about the movie, she attacked as a budding philosopher must:

The philosophy of "The Fountainhead," she said, is as follows:

> Man has an inalienable right to his own convictions and to his own work, the right to exist for his own sake, neither sacrificing himself to others nor sacrificing others to himself, neither forcing his ideas upon others nor submitting to force, violence or breach of contract on their part; the only proper form of relationship between men is free exchange and voluntary choice. To whom can this philosophy be dangerous? Only to the advocates of man's enslavement, the Collectivists, such as the Communists, Fascists, and all their lesser variations.... Their spokesman in "The Fountainhead" is Ellsworth Toohey.

The statement that her egocentric (she would have liked that adjective) architect would not force "his ideas upon others" is quite contrary to her man's final destructive action against the community. Her defense continued in a bias of Nieztschean rhetoric:

> Man cannot survive except through his mind. He comes on earth unarmed. His brain is his only weapon. But the mind is an attribute of the individual. There is no such thing as a collective brain.... The reasoning mind cannot work under any form of compulsion. It cannot be subordinated to the needs, opinions or wishes of others. It is not an object of sacrifice.[12]

The reviewer for *The New Yorker* put the resolution of the proposition's fictive dilemma this way:

> the dynamiter argues so fluently about the right of the artist to satisfy himself, no matter what the community thinks, that a warmhearted jury lets him off.[13]

Anthony Vidler extracted from *The Fountainhead* novel a singular example that highlights the "out of touch" sociological and psychological poverty inherent in the Howard Roark personification of Rand's thesis. When mentor Henry Cameron asks if Roark "ever look[s] at the people on the street?" the reply is "But I never notice the people in the streets." Vidler correctly describes this as "a sublime indifference and disdain for streets and people alike."[14] We can add that it exemplifies Roark's estrangement from society. There is no feeling or affection, only alienation. Therefore it follows that Roark comfortably treats Dominique as no more than a sexual thing and that he easily finds his professional colleagues inferior.

After reading "every word of *The Fountainhead*" Wright wrote Rand and said, with emphasis, that the thesis was "*the* great one" (he does not clarify what it is) and that her "grasp of the architecture ins and outs of a degenerate profession" (what a sad comment) astonished him. The "novel is Novel. Unusual material in unusual hands and, I hope, to an unusual end."[15] (After giving it further thought he would change his mind, as we shall note in a moment.) In a 1946 letter to Edna Koretsky he mentioned that Rand had told him that Roark was "modeled" on himself."[16] Wright's secretary Eugene Masselink once said that the "subject" (of the book?) and Rand's "principles" about architecture were taken from Wright, but any "semblance" ended there.[17]

Then in September 1944 Wright asked son Lloyd, because of his contacts in Hollywood, if he had "heard" anything about "the Fountain Head," no doubt referring to a proposed movie. Wright said he felt "a little guilt of snobbishness where that affair" with Rand was concerned, and "[I'm] not accustomed" to the "feeling either. Don't like it."[18] However this was meant, he was clearly uneasy with his aloof treatment of Rand, with the implications of associating with her, and with the practical and philosophic content of her book.

Wright's public utterances were less kind. At a radio symposium in May 1949 he was asked to offer an opinion of the book. "Well, that's very simple and as easily disposed of," he said at the beginning of a strangely garbled reply:

> I'm sure of this, because I haven't seen this movie which is forthcoming. Miss Ayn Rand had apparently played house with the idea which I have just expressed to you [that truth is hypnotic and] ... of the individual, per se, as such. She has absolutely mistaken and abused the privilege which she took to herself and is going to get people very madly mixed up if they are already in the gutter. But I don't think it is going to hurt anybody who isn't in the gutter already. So I don't think you or I need worry much about [it]. I suspect it's a hideous deformation from any standpoint of a great philosophy.[19]

On another occasion in 1949 he suggested that if the book's "thesis" was about the "right of an artist to his work," Rand "bungled it." And Wright charged her with

putting a "treacherous slant" on his philosophy. "She asked me to endorse the book, but I refused."[20] There is no evidence of an expressed request for endorsement—approval of the screenplay, yes, but not of the book's content. One of Wright's more succinct interpretations of Rand's "thesis" was the "inalienable right of the individual to the integrity of his idea."[21] (Later on, mysticism was the evil enemy.) The mind and therefore artistic creativity are attributes of the "individual," not of a collective. Yet Wright always acknowledged humanity's social interdependence; Roark did not.

Rand learned from Gerald Loeb that the book was at Wright's bedside table and that he had suggested his employees read it.[22] Indeed there was much in the book to engage and hold his and his followers' attention, one way or another.

Architect Andrew Saint's summary evaluation is at least partly correct. While differing on some issues, "on the substantive questions of personal belief, in their admiration for individualism and enterprise as the pristine American virtues, in their contempt for the state [statism], for mass culture, and for compromise and in the propensity for hero-worship," author and architect were in "uncanny agreement."[23] But we've learned it was canny. And what of the difference between mass culture and social interdependence?

Of course most of the *au fait* reading and moviegoing public were convinced that the character of Roark was Wright (or Wroark was Right). Wright received unsolicited letters from people so convinced and from others who noted that Rand's architectural ideas came from Wright.[24] No evidence beyond the novel and Wright's life (often luridly and unfairly revealed by the press) was needed to satisfy even other architects. Three remote yet tidy examples should reinforce those educated or intuitive perceptions. The first is found in appendix E; the other two are post–1949.

The Fountainhead had been translated and published in 1959 in Amsterdam with the intriguing title *De Eeuwige Bron* ("The Eternal Spring"). It was also the year of Wright's death, a fact met with sincere sadness in Holland, especially by architects and artists who matured between 1910 and 1935.[25] Dutch architect Willem Dudok, a pioneer of modernism in the 1920s who acknowledged theoretical sustenance from Wright's ideas and aesthetic principles, believed Wright "the exuberant, the romantic, looked for beauty of expression and demanded of his work that it moved the emotions. He knew no boundaries." Dudok expressed the popular view that Rand's *Fountainhead* was a novel that Wright's "artistry inspired."

Then in January 1960 the Rotterdam literary critic W. Wagener offered a few lines many might share, North American or European. Wagener's review of *De Eeuwige Bron*[26] was headlined:

<center>Frank Lloyd Wright's
spirit remains in a
lifelike novel</center>

But does it?

10

Rand's Neutra House

Wright and Rand did not meet again until near the end of the Second World War. By this time her career had been firmly established and his reestablished. But a continuing wartime austerity prevailed. Rand could write in support of the war effort, but Wright could only wait because he could not obtain government contracts. Hollywood's major industry brought them together, at Rand's insistence, for what eventually became a slightly more substantial relationship than those fleeting, defensive, unsatisfactory moments in 1938.

While Wright's architectural practice was more or less in limbo awaiting postwar reconstruction, Rand's literary and movie work gained momentum. She was of course a slightly known professional in Hollywood as a result of employment in and out of studios in the 1920s and 1930s. With *The Fountainhead*'s success (within six months 18,000 copies had been sold) in October 1943 her agent, Alan C. Collins, negotiated with Warner Brothers the sum of $50,000 for movie rights.[1] The fee Rand received was perhaps average and can be compared with figures paid to more established authors in the 1930s. For instance, Erskine Caldwell received $200,000 from Fox plus certain royalty provisions for *Tobacco Road*, and Edna Ferber $175,000 for *Saratoga Trunk*.[2] Somewhat different from normal practice, on 3 November 1943 Rand also obtained the promise of a contract to write the preliminary screenplay adaption of *Fountainhead*.[3] She was counting on Warner's approving the first script and then hiring her to write the final screenplay.

While preparing the adaption Rand was required by Warner to be available on a moment's notice at their Hollywood office. Leaving a New York apartment, she and husband Frank arrived in Los Angeles in early December 1943. A four-page outline was presented on 13 December 1943 (appendix A). Her contract to write the initial adaption was not agreed upon until 17 February 1944.[4] She was assisted thereafter by a staunch supporter and the studio's selected producer for the *Fountainhead* film, Henry Blanke. (When the German director Ernst Lubitsch was brought to the U.S. in 1923 he insisted his chief assistant, Blanke, accompany him.) Rand's completed preliminary adaption, presented on 20 June 1944, was an unwieldy 300 typewritten pages in length.[5] (When her final screenplay was completed in 1948 it was 56 pages.) The following day she wrote Jack Warner a note of thanks for his support and for being allowed to prepare an adaption that would ensure preservation of the book's "theme and spirit."[6]

While working with Blanke and Warner, in early 1944 Rand met Hal B. Wallis, whose career as a producer was well known; it began with *Scarlet Dawn* for Warner Brothers in 1932. Around the time of their meeting his credits included such memorable Warner films as *Yankee Doodle Dandy* (1942) and *Watch on the Rhine* (1943), as well as *The Maltese Falcon* (1941), *Casablanca* (1942), and *Passage to Marseilles* (1944); the last three starred Humphrey Bogart. After one of many quarrels with Jack Warner, in 1942 Wallis and lawyer Joseph Hazen formed their own company, initially known as Enterprise. Effectively they became an independent producer but with a "link up" to Paramount.[7]

Rand wanted to work again as a screenwriter and yet be free to privately pursue a literary career. Both Warner and Wallis had offered a long term contract but Jack Warner refused to allow Rand a part time arrangement. Wallis agreed to a deal where Rand was required full time for one-half of a year and would otherwise be independent for the remaining six months. For this service Rand's annual Warner wage was nearly $35,000,[8] a salary higher than the average for screenwriters but short of the big money a few received. For instance, Ben Hecht, Anita Loos, and Robert Ryskin in the late 1930s were in the $87,000 to $180,000 bracket.[9] On the other hand, Rand's pay was for only six months' work.

She began work immediately on transforming for the screen an "obscure novel" by Chris Massie, *Pity My Simplicity*. Little is known of Massie except that another novel of his, *Corridor of Mirrors*, became the basis of a film made in Britain, released in 1948. Rand adapted *Pity* for Wallis, and it became the movie *Love Letters* when released by Paramount in 1945. Joseph Cotten starred with Jennifer Jones, who was selected because Wallis felt she had "the nervousness, the fey quality, the sense of abstraction the role demanded."[10] The movie needed William Dieterle's "guiding directorial hand" on what was described as an "overly sentimental script." Art directors were the experienced Hans Dreier (again) and Roland Anderson, with modest sets by Ray Mayer.

In the same year, 1945, Rand was cowriter of the Paramount screenplay *You Came Along* with the story's originator, the experienced film writer Robert Smith. His first screenplay was as assistant on *Hurricane Horsemen* (Columbia, 1931), and others followed such as *Call Out the Marines* and *The Mayor of 44th Street*, both for RKO in 1942. Robert Cummings and Lizabeth Scott were the stars of *You Came Along* under John Farrow's direction. Two seasoned art directors were involved: studio man Dreier plus Hal Pereira. Therefore Rand had worked — but not necessarily collaborated — with a few of Hollywood's better directors, art directors, and set designers.

At Wallis' request, Rand put in many months on an original movie script about the physicist Dr. J. Robert Oppenheimer and his leading role in developing the atomic bomb in the 1940s. Before the script was complete Wallis sold the rights to MGM. It remains unproduced (a fate that irritated Rand), perhaps because of Oppenheimer's opposition in the 1950s to the H-bomb and his communist tendencies. Her last screenplay for Wallis was titled *House of Mist* and it too became shelf-bound.[11]

Between book royalties and contracts with Warners and Wallis, by 1944 Rand was financially secure and no doubt sensed that she was on a threshold to even greater

success. So she bought a house. At one time she thought of purchasing the rather neglected Wright-designed Storer house of 1923–24. After consulting Wright's son Lloyd she decided it was too costly to repair.[12] So, the O'Connors paid $24,000 for an "ultra-modern" house and 13 acres of land near Chatsworth, 20 miles from Hollywood in what was then a semirural San Fernando Valley. They called it a ranch or an estate. It had been designed in 1934 by architect Richard Neutra for movie director Josef von Sternberg, both Austrian emigrants.

Vienna-born Josef von Sternberg arrived in America while a preschool child and began in the movie industry in New York in 1911. He joined the U.S. Army Signal Corps where he made training films during 1917–18. On returning to civilian life he continued filmmaking and by the mid–1920s was under contract to MGM. While in Berlin for a brief professional engagement he "discovered" Marlene Dietrich. On his urging she moved to America in 1931 to work in Hollywood with him. Some of his films were *Der blaue Engel* (and the English version *The Blue Angel*), 1930, *Shanghai Express* (Paramount, 1932, a movie that "impressed" Rand[13]), and *Crime and Punishment* (Columbia, 1935). "New York Cinderella" (1939) was based on a story by Charles MacArthur but Sternberg left the production before its release by MGM in 1940 as *I Take This Woman*. Between 1926 and 1956 he had been credited with only 25 films; the last, *Anathan* (1952), was for Japanese producers in their country. Movie producer and historian Herbert Luft remembered Sternberg as "one of the last individualists who shaped the screen in their own image," whatever that meant. By the 1940s Sternberg was a bit of a cult figure.[14]

Richard Neutra studied architecture with the Austrian theorist and teacher Otto Wagner in Vienna; then in 1921 and 1923 he worked in Berlin with the modernist Erich Mendelsohn. Neutra was enthused by what he read of Sullivan and Wright and learned much about them and America from Mendelsohn. At the time the German master's architectural schemes showed marked influences of European expressionism knitted to Wright's theory, and often to his architectural style. In October 1923 Neutra and wife emigrated to America.

After employment with other architects, he worked for a few months with Wright in 1924 and 1925. Thoroughly impressed, the Neutras named their newly born son Frank. In Wright's office Neutra assisted with the design of an automobile-accessed observatory planned (but not realized) for the top of a hill in Maryland called Sugerloaf Mountain. In 1925 the ambitious young Austrian was attracted to California by a friend and fellow countryman, Rudolph Schindler, who had emigrated to Chicago in 1915 and also had worked with Wright during 1918–1922 in the Windy City and Los Angeles.

When he established an independent practice in Los Angeles, Neutra's architecture was equally influenced by Wright and the newly advancing central European aesthetic of steel-and-glass boxes. But Neutra used technologies and construction techniques that were much advanced over European ones. By the mid–1930s he had earned a national and international reputation as an innovative modernist.[15]

Neutra declared to Europeans his appreciation and knowledge of American technology in his 1927 book *Wie Baut America?* ("How Does America Build?") published in Stuttgart, Germany. He presented not only construction techniques for tall buildings

but concrete slip form and block systems by Walter Burley Griffin (then in Australia), Irving Gill, Wright, and Schindler. Neutra's studies led him to believe there was a new architecture being created in America vitally responsive to a structural rationalism more pragmatic than that found in an overly-traditionalized Europe.[16]

The four story Lovell House, built from 1927 to 1929 on a steep hillside in Los Angeles, epitomizes Neutra's architectural design talents. The horizontality of an exterior composed of glass and stucco spandrels over steel-posted open spaces underneath, and an open two-story space, had been tentatively explored first by Schindler in 1925–26 with the cumbersome, monolithic, all-concrete Lovell family beach house. (Both have been widely published since the 1930s.) By contrast, Neutra used a slender steel skeleton. The importance of the two Lovell houses in the history of American architecture can be measured by the inaugural exhibition of the Buell Center for Study of American Architecture at Columbia University in 1983. Only 50 buildings, city views, and rural places on the entire West Coast were selected: the two Lovell houses and buildings by Wright were among them.[17] Neutra's Lovell house remains a tour de force as did his house for von Sternberg, until 1971 when it was demolished, the moat ripped out, the land left dry and vacant.

The von Sternberg house is unique, not only within Neutra's oeuvre but twentieth century architecture generally. This attribute is revealed by the steel walls that reached out into the landscape and the sweeping curve that embraced a large patio of Belgium marble. These vertical planes extended the house such that it appeared much larger than actuality. Figure 10.1 is of the house's rear and shows a portion of the long moat. It was an idea Neutra used often in later works.

Figure 10.1. Richard Neutra, architect, von Sternberg house, Northridge, California, 1935, photograph ca. 1935. House razed in 1971. Luckhaus Studio, courtesy of Thomas Hines.

Figure 10.2. Richard Neutra, architect, von Sternberg house, Northridge, California, 1935, from interior to patio with a seated Ayn Rand ca. 1949. Photograph © Julius Shulman.

The house also incorporated recent technical innovations. There were steel framed sliding glass doors and windows (Figure 10.2), where amid her husband's cut flowers Rand looks out to the walled patio. There were ribbed steel sheets shaped as channels and arranged vertically for most of the exterior walls (on Neutra's Beard house [also 1934–35] the channels acted as hot and cold air plenums), and for all the exterior fencing. There was reflective aluminum paint, a sprinkler system to cool the patio wall, Polaroid glass to control glare, a cooling copper-lined roof pool, a semi-circular reflecting moat with tropical fish and water lilies, and a master bathroom exotically fashioned with four walls of mirrors for the egocentric.

The client requested a long garage for one imported Rolls Royce, and no locks on the bathrooms. ("There is always somebody in the bathroom," said von Sternberg, "threatening to commit suicide and blackmailing you, unless you can get in freely.")[18] Typical of most Neutra houses of the period, on the interior he employed Wright's idea of a relatively uninterrupted or open floor plan, logical internal arrangements, and a free three-dimensionality about the living, dining and gallery spaces.

Thus, Rand was taking over a house built in 1935 with film and architectural

connections of great interest and possessed of artistic and sentimental value. It was appropriate that someone who professed to be championing modern architecture should do so not only with printed words but in her personal life. The purchase of the Neutra house was such a commitment; the first and last by Rand as it turned out.

The house was also an appropriate selection for a new top-selling author and screenwriter. It was designed for a famous film director and infamous personality who had famous neighbors. Nearby were actor Janet Gaynor — then married to Adrian, the dress and costume designer — and fellow writer and playwright Morris Ryskind. A sometime collaborator with George S. Kaufman (*Animal Crackers*, 1928, was one joint project), the gifted Ryskind was never accepted at the Algonquin Roundtable gabfests as was Kaufman (but more on that later).

Almost immediately on taking occupancy, husband Frank proceeded to plant rows of Australian eucalyptus trees and acres of flowers for the commercial market.

11

Wright's Rand House

By the mid–1940s Wright's granddaughter Anne Baxter had become a Hollywood movie star. Her career had begun in 1940 with a part in Fox's *The Great Profile* after which she acted in a number of mostly forgettable films directed to the war effort. Wright thought his granddaughter "a nice girl," but the studio was "wasting a good actress to make a, well, a fairly nice glamour girl."[1] In 1946 she received an Academy Award for a major role in *The Razor's Edge*, also for Fox. That year she married actor John Hodiak and they occasionally visited Wright in Spring Green or Scottsdale. When in Los Angeles Wright dropped in from time to time, as letters in the Wright Archive for 1947–1951 reveal. During the 1920s Wright had designed some shelters for the Oak Park Playground Association, one he called "The Ann Baxter," Ann sans "e." None were built.

In a letter of November 1944 to daughter Iovanna, Wright talked about a trip to Los Angeles made the previous April when he visited son Lloyd, daughter Catherine Baxter and her daughter Anne. He also saw Anne and Tallulah Bankhead rehearsing a Viennese play, he said, "Very dressy and sexy and elaborate, directed by Pressinger, the Viennese director whom I met." They were working at Fox studios on a film based on an old play titled *The Czarina*, by Lajos Biro and Melchior Langyel. Little is known of Langyel but Biro was a Hungarian who became involved in films throughout Europe and Hollywood, and eventually in the 1930s worked with the inventive Alexander Korda (from Turkey) in England. Another Biro play, *Hotel Imperial*, was adapted for film at least three times, the last the witty yet tense *Five Graves to Cairo* (Paramount, 1943). Charles Brasett produced, Billy Wilder (from Vienna) directed, and together they wrote the new screenplay in which Franchot Tone (from the United States) and Anne Baxter played leads in the four-star film.

The Czarina was retitled *A Royal Scandal* and starred Bankhead as Catherine the Great, supported by Charles Coburn, Eva Gabor (from Hungary), Mischa Auer (from Russia), Vincent Price, and "poor, miscast" Baxter as a countess.[2] The film was directed by Otto Preminger (born in Vienna) and produced by Ernst Lubitsch (from Germany) who 20 years before had direct the same film in Berlin but under the title *Forbidden Paradise* (1924).[3]

It was at one of Lloyd's house parties in April 1944 that Rand and Wright again met. Part of the evening's talk went something like this. To those gathered Wright offered the opinion that Rand's hero, the red-headed Howard Roark, was too tall and needed a long mane of white hair.

"Oh, Father," said son Lloyd, "Miss Rand wasn't writing your biography!"
Wright chuckled. "That's true...." To Rand he said, "I don't think you can write about integrity. You're too young to have suffered."
"Oh yes. I have suffered," she replied. "Do you want to know what was the worst of it? It was your letter."
Wright "shook his head sadly."[4]

Perhaps it was more an impression than a clear recollection.

In Rand's confessional letter of May 1944, where she candidly admitted her book began and ended with Wright, there were some personal observations about his architecture, one of value. In essence she believed his houses were not for ordinary, casual living but inspirational means to discovering a significant and deeper life.[5] (Interviews with some of Wright's other clients reveal a similar sentiment.) Even Alexander Woollcott's experiences drew him to seriousness: "I see now more fully than ever before," he said to Wright, "what effect the right house can have ... [it] uplifts the heart and refreshes the spirit. Most houses confine their occupants ... [yours] can liberate the person who lives in it."[6]

In reaction to published criticism of *The Fountainhead*, in her May 1944 letter Rand expressed no concern over the teasing threats of the architectural profession to burn her as a witch. Regardless of professional reaction or artistic or commercial results, a movie was great personal publicity. Now, she asked if Wright would to design a house for the Rands, something to refresh their spirits?[7] No reply.

In June she sent Wright a copy of her final screen adaptation. In a covering letter she asked for his observations, whether he thought it was acceptable, and then put a surprising question: would he be willing to participate in the making of the motion picture?[8] A month later he offered the opinion that the adaptation did not "betray" Rand, but he would not participate in making the movie. However, he would design a house for her.[9] Now it was Rand's turn: no reply.

One year later, in August 1945, Wright sent Rand an inscribed copy of one of his books; which, is unknown. Three had been recently published: a revision of *An Autobiography* released in 1943; *In the Nature of Materials* released in 1942, mainly a visual presentation of his architecture since 1893; and *On Architecture*, an edited collection of writings released in 1941. If the gift was meant to jog Rand into again thinking about building a new house, it was successful. She responded by mentioning plans to vacation in New York that September. With husband Frank and financial consultant Gerald Loeb they would hunt for rural land north of New York City on which to build a Wright house of her own, as she put it.[10] To this end she visited Taliesin at Spring Green to discuss details but alas, on arrival in the last week of October 1945 he was again absent.[11]

Still, she held useful discussions with resident staff and could not ignore the Taliesin house that later she vividly recalled. She thought Taliesin magnificent, the buildings adapted to the site, all joined by courtyards, walkways or galleries. But all was neglected and in poor condition with broken glass windows, doors that didn't fit, and creaky floors. She was shocked to learn that the apprentices ("students") paid for the privilege of maintaining house, grounds, and farm. They had to clean, cook and serve tables, act as servants in a "feudal establishment as well as operate within an architectural office."[12]

As to a Rand house, the prospect proceeded no further than preliminary discussions, probably with Wright's second in command, William Wesley Peters, and floating the possibility of preparing plans *before* a site was selected. A second meeting took place at Taliesin West in February 1946 when Wright was actually present and while another client, Chauncey Griggs, was a guest.[13] Later, when unable to arrange another get-together, Rand wondered if Wright was "still willing" to design a house before a site was found?[14] Two weeks later, on 30 September 1946, he unhesitatingly forwarded to her a set of preliminary architectural plans for a "compact dwelling" (Figure 11.1). He claimed it was suitable for a writer who "loves" organic architecture and that it could be built anywhere.[15] Rand was billed three percent of the estimated $35,000 construction costs and paid immediately.

The proposed house had much in common with Wright's design of March 1930 for an apartment building on a sloping site above Los Angeles for Elizabeth Noble, an ardent follower of communist politics.[16] Apparently Harold McCormick (a former Wright client) and Miss Noble visited Wright in 1929 and shortly thereafter McCormick proposed to finance a building for Noble.[17] The Rand and Noble buildings were to have rather similar exteriors of glass and steel-framed doors and windows. Balconies were extensions of interior rooms, their railings solid and square faced. Both buildings sat on a solid base of concrete or stone. Within the base of the Noble proposal of 1930 was to have been parking and a boiler room. By the mid–1930s Noble and McCormick had given the project to another architect for another site.[18]

Noble's "Terrace Apartments"[19] were a startling design in Wright's oeuvre (Figure 11.2), one influenced by the European International Style. Some have suggested

Figure 11.1. Ayn Rand house, semirural New York state, project, 1947, perspective drawing; ©2003 the Wright Archive.

Figure 11.2. Elizabeth Noble and Harold McCormick apartment building, Lost Angeles, California, project, 1930, perspective drawing from *Trend* 1934; ©2003 the Wright Archive.

a comparison with Neutra's Lovell house, but only regarding the exterior appearances and the way glass, mullions and balconies were employed. The Noble, Lovell, and Rand floor plans were quite different. The Noble plan incorporated ten Murphy-bed bachelor apartments and one tiny office, all either side of a central spine and squeezed around a tortuous circulation system. One set of stairs was to wind through the office. The character of the Rand and Noble buildings were fussily elaborated in Wright's first scheme for Point View Residences (1953), an apartment building project for the Edgar J. Kaufmann Charitable Foundation and Trust on a site overlooking Pittsburgh, Pennsylvania. A second proposal of much greater complexity was for 15 storys on the same site.[20] For each of these four proposals horizontal stratification was the persistent external theme, as it was for the similar Kaufmann Fallingwater house at Bear Run, Pennsylvania.

The Rands were delighted with the proposed house design, a "sculpture in space" with a writer's study at the top surveying all before and below. She suggested a few changes and asked some questions. Uncertain if she and Frank wanted to build in a semi-rural area, in the winter of 1946–47 she again visited the Wrights and fellows at Taliesin West. Again her recollections were vivid and recalled to her friend Barbara Branden:

> [One] horrible thing was that the menu for his table, where his guests also ate, was different than the menu for his students. We sat on a raised platform high above the others, we ate fancy delicacies and they got fried eggs; it was a real caste system.

Wright was the "deity of the place, its spirit[,] and she [Olgivanna] was the practical manager."[21] (It was an observation others have made, including alumni fellows.)[22] The apprentices acted like "emotional, out-of-focus hero-worshippers" in an atmosphere of "awed obedience," she said. When Wright and Rand argued, the apprentices were against her "instantly; they bared their teeth that I was disagreeing with the master." Their private designs she — and others have — described as "badly imitative." Their behavior was a tragedy because Wright wanted what she wanted, "independent understanding; but he didn't know how to stimulate it." She added that although approaching his eightieth year, "by comparison with that retinue he was the youngest person there."[23]

There was a story around Taliesin still ripe in the 1950s that went like this. On a winter's visit to Taliesin, Rand was asked to wait in the living room where she stood before the fireplace. "Meanwhile, Wright called up Ed, the old Welsh stonemason who was more than 70, and told him that the fireplace had a loose stone that needed fixing. Old Ed went into the living room, and finding only Ayn Rand, asked her what exactly needed fixing."[24]

It was a reenactment of a scene in *The Fountainhead* where Roark, working in a stone quarry, was called by Dominique to fix her apartment's fireplace hearth, a ploy to inveigle a sexual response. Rand was not amused. But most people at Taliesin found her to be funny, full of vigor, bouncy, inquisitive, always "in charge," and a chain smoker (it led to her death from lung cancer). Wright rather liked her, at least until the 1950s; Olgivanna did not.[25]

Rand's observations of the Fellowship must be placed in the context of her own life. Branden and other sources support the opinion that she was less than compassionate, tended to be unforgiving of human frailty and error to a point of intolerance, was consumed by self, always strived to be the paragon she wrote about: without failing, always supremely correct. When speaking about Wright and his acolytes, Branden believed Rand was worried about her own entourage, describing "conflicting aspects of her own attitude: the emotional need and demand for total agreement always at war with the equal, simultaneous longing for an independent response."[26] As suggested, Wright's and Rand's personalities were sui generis, both promoting and enjoying a "cult of personality," Rand with a "truculent temperament."[27] Yet, even in the 1950s when talking with Wright in public circumstances (such as a restaurant), Rand addressed him as "master."[28] Wright made no attempt to alter her address.

In any event, during 1947 Rand and her Frank decided to remain in a cozy Manhattan apartment.

Part IV

Filmland, Wright and Rand

12

Preproduction 1944

It is doubtful that Rand knew how close she came to losing the job of writing the screenplay of *The Fountainhead* to another writer. She probably knew that MGM had offered $450,000 for the property and that Warner Brothers refused that eight-fold profit. Those affairs and the story of the first attempt to put together the movie make for interesting reading.

In mid–1944 film director Mervyn LeRoy created Arrowhead Productions. It was not to be competitive with the major studios but was an independent production and accounting team, a system often employed within or beside most studios. Most were no more than tax shelters. From 1928 to 1930 LeRoy had been with Warner and from 1938 through 1944 with MGM. His film credits as director include *Little Caesar* (Warner Brothers, 1931), the realistic and socially influential *I Am a Fugitive from a Chain Gang* (also Warner, 1932), *Random Harvest* (MGM, 1942), and as producer, *The Wizard of Oz* (1939). After 1944 he worked with MGM first as supervisor of production, then as producer; that was until mid–1953 when he returned to Warner. His next movie for the brothers was the delightful comedy *Mister Roberts* (1954).

An agreement between Arrowhead and Warner Brothers dated 31 August 1944[1] stipulated that Arrowhead would put *The Fountainhead* together for Warner, the first photoplay to be produced by Leroy's company.[2] LeRoy had read Rand's "monumental" novel, as he described it, and then persuaded Warner to let him produce it.[3] Then Warner formally promoted the movie to Arrowhead, allowing LeRoy to direct.[4] After all, LeRoy had been Harry Warner's son-in-law until a 1943 divorce.

In preparing the final screenplay Rand has acknowledged the assistance of only Blanke. Yet LeRoy has said he personally worked on an adaptation after Rand's preliminary 300-page script was submitted on 20 June 1944. Also, writer Thames Williams, who was just beginning in films and whose only credit became *Brimstone* (1949), apparently wrote a "major" script for *The Fountainhead*, submitted on 22 February 1945.[5] A Warner employee, Williams may have assisted LeRoy because the director did not claim to be a writer. After turning down MGM's offer, Warner and LeRoy began the indelicate, almost undignified task of casting.

When on 18 January 1945 it was announced in *Variety* that Warner would make *The Fountainhead*, campaigns by actors, agents, and fan clubs were well underway. Apparently Barbara Stanwyck "convinced" Jack Warner in late 1943 to buy the rights

so she could play Dominique. Stanwyck started in movies rather modestly, appearing as early as 1929 in *The Locked Door*. Other more substantial roles followed, including *Stella Dallas* (1937) and *Lady of Burlesque* (1943), each for United Artists, and Billy Wilder's thriller of 1944, *Double Indemnity*, costarring Fred MacMurray.[6] Rand often talked to her about the role and on one occasion, dressed as Dominique might, Stanwyck gave a party for Rand. Rand thought Stanwyck was not ideally suited for the role of Dominique, too short and square shouldered, not lithesome like Garbo, perhaps, or latently emotional like Jennifer Jones. Still, Rand supported Stanwyck and in January 1945 the actress was "induced" (as they say) to play the female lead.[7]

Little is known of the run for the part of Roark except the following. The Hollywood press understood that Warner Brothers had asked Paramount for the loan of Alan Ladd to work with costar Lauren Bacall, but this came to naught. While returning on leave from the Army, Captain Clark Gable read the book and then jumped off a train in Chicago to call his studio, MGM, demanding they buy the book for him. When he learned that rights had been purchased by Warner he demanded MGM do a better job of looking after his interests.[8] Perhaps that was when MGM offered to buy the rights. Rand probably would have been satisfied with Gable as Roark: clean shaven, popular, an erect posture, and good credits; *It Happened One Night* (Columbia, 1936) and *Gone with the Wind* (1939), among the more memorable.

The front runner was Humphrey Bogart, whose film debut was in *Devil with Women* (Fox, 1930), while his movies of the 1940s are legendary: *Casablanca*, *Sahara* (Columbia, 1943), and *To Have and Have Not* (Warner Brothers, 1944).[9] In January 1945 the persuasive Stanwyck again "encouraged" the studio who then felt "induced" to cast Bogart.[10] Rand was not pleased with him: a physical appearance too short and dark, and a history of too many snarling film roles, so opposite to her upright and erect Roark.

We know almost nothing of the search for supporting actors or if any were hired during 1944 or 1945. But fan clubs had become active, and one of the more organized promoted Rand Brooks for the role of Peter Keating.[11] A career in mostly B movies since 1938, Brooks was a willing worker; in 1940 and 1941 he acted in 11 films.

The hero of *The Fountainhead* was an architect, so the person to design the all-important pretend architecture and movie sets had to be selected with care. In June 1944, two days after submitting a preliminary adaptation, Rand sent a copy to Wright. The first reason, as we have noted, was to obtain his approval of the script, not of her novel or her philosophy. The second was to ask for his help in making the movie, specifically to act as an "architectural supervisor" (perhaps she meant consultant) and to design Roark's imaginary architecture. She then told him rather grandly that another of her missions was to inform the world about great architecture (presumably modern), to show it on screen. Only Wright could design Roark's buildings: would he join the "experiment?"[12]

The studio was well aware of Rand's desires as evidenced by her instructions within the screenplay, the studio's actions, and the production team's Research Record. During the first months of 1945 it was recorded that many publications by and about Wright were circulated within the studio and production hierarchy.[13] Most requests were made by Blanke who, according to Rand, was "determined" to obtain Wright's

services to "illustrate" Roark's architecture.[14] Her June letter, therefore, specified Wright's limited role and ambiguously offered the possibility of some form of consultancy.

Another form of inducement, or persuasion, provides a good measure of the breadth of national interest in Wright and indicates the loose social and professional interlacement of Rand, Wright and Hollywood. Moreover, it exemplifies yet again the compelling attraction of movies and their mighty power to influence and persuade.

13

Redding, New York City, Hollywood

In the 1940s Gerald Loeb was a successful stockbroker with E.F. Hutton in New York City. A mutual friend in the Time/Life organization, Howard Myers, editor of *Architectural Forum*, introduced Loeb to Wright by letter in November 1940.[1] On meeting, Loeb soon intimated a desire for Wright to design a building for him. Nothing came of it until 1943 when, after reading the second edition of Wright's autobiography and other things about the architect, Loeb renewed correspondence. Confiding a desire to be an architect but having given up for lack of money, he also confessed that when San Francisco architect Bernard Maybeck had designed a small house for him in California he had interfered and ruined the design before cancellation. That was before becoming involved in the financial world. Now age 43 and still a bachelor, he wanted a house and was willing to spend $50,000. Was Wright interested?[2] Wright replied that if he were employed, Loeb "might have some fun."[3]

With that response Loeb, short, stocky, cherubic, looking a little like the inventive engineer Buckminster Fuller,[4] began to float many ideas for postwar joint ventures. How about a Wright-designed summer colony on part of his estate at Redding, Connecticut (two hours by car from Manhattan)? or a "F.L.W." 24-hours-a-day gas—and every other kind of—station? a theater? a store? a hotel "owned partly" by Wright with the right "important" people involved (like the symphony conductor Leopold Stokowski)? Of course Wright was interested in this man.[5]

That was the beginning of a voluminous correspondence, about eight to one by Loeb, a compulsive letter writer.[6] At one point Wright said Loeb was pushing too hard.[7] On another occasion Loeb expressed a belief that the news of his new house would "explode" on the world scene, that it would put Redding—Loeb—"on the map" and "stir" controversy, comment, even desire.[8] He promoted the proposed Wright-designed house to friends at New York's Museum of Modern Art and the magazine *Architectural Forum* (to Myers and Nelson) and elsewhere in efforts to get it published. When Loeb finally visited Wright's home at Spring Green he was smitten.[9] And because Wright collected Japanese prints Loeb began to buy them, once paying $15 for 25 Hiroshige prints.[10] Loeb had boundless enthusiasm, as Bruce Pfeiffer has recalled.

Perhaps through George Nelson or Ely Kahn, Loeb met Rand and learned that

13. Redding, New York City, Hollywood 77

Figure 13.1. Gerald Loeb house, Redding, New York, 1945, project, floor plan; ©2003 the Wright Archive. As published in *Architectural Forum*, January 1948.

Warner had acquired *The Fountainhead*'s movie rights. In October 1943 he immediately wrote Jack Warner to encourage the studio to do its best for the novel and for architecture. Popular building and garden magazines were illustrating terrible "monstrosities," he said, and Warner had a chance "to mold" America.[11] Unenthusiastically, Warner replied that through *The Fountainhead* his studio was hoping "to mold" public taste and improve architecture.[12] And there Loeb's energies rested, momentarily.

In June 1944 and during that first visit to Spring Green, Loeb commissioned Wright to design a bachelor's house for a windy hill near Redding (Figure 13.1–2).[13] Preliminary plans were received in November 1944.[14] Wright has described them as "really very simple,... an open arbor resting on stone-spools arranged like a crown on the slopes of a hill — like a clambering melon vine. The rooms lie in it like melons and a certain part of the arbor is simple glassed-in between the spools for the living room. That is all."[15]

The proposal was unique yet derived from Wright's *oeuvre*. His exploration of circular elements had begun in a plan for Ralph Jester in 1938, and in the mid–1940s were applied now and then to a variety of building types. Relevant to Loeb's house was a proposed 1939 cottage for Ludd Spivey beside a canal near Fort Lauderdale, Florida, using ordinary concrete blocks (Figure 13.3). Spivey was president of Florida Southern College and in 1938 commissioned Wright to prepare a campus plan and a number of buildings. Loeb's house was to be an enlargement and elaboration of

Figure 13.2. Gerald Loeb house, Redding, New York, 1945, project, model, 1946 photograph, depicted individual unknown. Courtesy of the Wright Archive. Other views were published in *Architectural Forum*, June 1946.

the Jester and Spivey schemes. The floor plan knitted the geometry of the square (the "main house") with the rectangle (the overall site plan) with elements of the circle. To the house was added an arbor, ancillary buildings, stables, and a guest house. Unfortunately the square central space of the main house was disconcertingly disrupted by walls, not only disfiguring the geometry but the columnar character of the space.

Soon after the design was completed Loeb married: Mr. liked Wright's design, Mrs. did not.[16] Nonetheless Loeb obtained estimates of construction costs that ranged from $133,000 to $200,000, and he flooded Wright's mail box with changes.[17] Wright maintained the house would cost about $80,000, and then almost innocently proceeded to solicit Loeb for a donation of $10,000 to his Frank Lloyd Wright Foundation. He argued that it belonged to the "Nation as a cultural foundation." Tax exemption forms were enclosed.[18] Under Wisconsin laws, in 1940 Wright had created a foundation to enable solicitation of funds in support of the Taliesin Fellowship as a certified school. As an employee of the foundation Wright claimed to be personally penniless, despite being in total control.

Inspired by Wright's foundation, Loeb began the Sidney S. Loeb Memorial Foundation with $10,000 and then suggested various deals that might financially support Wright.[19] Indeed, Loeb was always ready to promote Wright. Jack Kapp had begun Decca Records in 1935. During the 1940s he and Loeb discussed *The Fountainhead* and Kapp thought of making a talking record of it. Loeb suggested Wright when Kapp spoke of a new house in Los Angeles: the suggestion went unheeded. At Loeb's insistence, in 1945 Florence Nightingale Graham (Elizabeth Arden), the cosmetics executive, asked Wright to prepare plans for a "Desert Spa," but it was not built.[20] And there was the movie.

In 1944 Loeb rather brazenly approached "Col." Jack Warner (the war yet won) to say he knew Wright very well and wondered who would design the *Fountainhead* film sets. Loeb, who had recently obtained the Taliesin Foundation investment portfolio for E.F. Hutton,[21] also talked peripherally about Warner's stock and bond investments, perhaps to influence Warner toward Hutton. Anyway, Warner replied that Bogart and Stanwyck would be "the stars," the director LeRoy; a set designer had not as yet been selected.[22]

A couple of weeks later Jack Warner received from Loeb photographs of Wright's drawings for the proposed Redding house. Loeb thought they might be used as sets for the movie. The plans and model were pictured, including an interior view as published in a 1946 *Architectural Forum*. As late as June 1948 Loeb's flurry of letters,

Figure 13.3. Ludd Spivey house, Fort Lauderdale, Florida, 1939, project, plan and elevation; ©2003 the Wright Archive.

and photographs of Wright's Loeb plans, were being studied at Warner.[23] Insistent that Wright should design the sets, Loeb pursued the Warner brothers and other studio principals in New York and Los Angeles.

In early May 1945 Loeb hosted a dinner for Ayn and Frank, and Olgivanna and her Frank. During the private affair Wright agreed "to do the set." According to Rand, Wright demanded that none of his designs for buildings, sets or models be altered; insisted that the book's theme and major events to be retained intact (Rand claimed she did not persuade him of this); and offered to send staff to install his works on the sets. Loeb wrote to Harry Warner of Wright's decision; Rand wrote to Blanke. The fee would be a donation by Warner Brothers of $250,000 to Wright's foundation.[24] (That was $25,000 less than the eventual star, Gary Cooper, received.)

Soon thereafter Loeb asked Wright to describe the movie sets, the time necessary to complete the designs, and costs. Therefore Wright's agreement was confirmed, but Loeb needed specifics so he could "work" on Jack Warner, Blanke and LeRoy. To encourage Wright, Loeb asked how many people would read his recent book, *When Democracy Builds* (1945): 2500? 5000? About 32 million, he said, would see a movie of *The Fountainhead*. "Secretly," Loeb said, Wright should "PAY" to design the sets, or at least do them free as a "fulfillment" as teacher to the world.[25] Wright's reaction was silence. About a month later Loeb asked if Wright had given further consideration to the movie so he could tell Warners "something."[26]

Wright's silence worried Loeb.[27] So on 6 December the financial wizard took the initiative by writing Harry and Jack Warner "exactly similar" letters. Among other comments he outlined Wright's verbal agreement to do the sets and proceeded to describe the success of the Fellowship, the nature of the Foundation, and Wright the man who enjoyed publicity greater than "any other living architect" and had been on the pages of *Time* and *Life* magazines. Moreover, his designs would be a constructive influence on the nation. Loeb reminded the Warner brothers that proceeds of movies during the war were given to American "G.I.'s" welfare. A donation to the Wright Foundation would help educate the young.[28]

Production of *The Fountainhead*, Jack Warner replied, had been cancelled. If in the future the studio did proceed it would be "an enterprise that will aid all those who are trying to do something better in the world architecturally wise and otherwise." Contributing $250,000 to Wright "we will have to weigh in the balance at the right time," a decision "much further along."[29] It was a garbled letter, but clearly, although the studio intended to retain motion picture rights, Wright was not in their plans; all was left indefinite.

As Jack Warner had implied, LeRoy was also to describe the film as a war casualty. A shooting schedule for March 1945 was "scratched" by the War Production Board.[30] It can be assumed that because it was not an obvious piece of propaganda the board preferred not to sanction materials for sets or silver for film negatives. But that decision must also have been influenced by Rand's literary works, so many of which were seen as patently anti–Russian. In 1944 and 1945 Allied unity against the Fascists and Nazis remained paramount, with no damaging utterance or negative innuendo tolerated. The fact of a Soviet controlled Russia was too confusing.

In spite of his wife's dissatisfaction, Loeb continued to pursue a dream home

by requesting documentation. A full set of construction drawings were prepared in 1945. A model nearly eight feet in length was used by Elizabeth Mock (who later was Wright's guest at Taliesin) in a show about modern postwar house prepared by New York's Museum of Modern Art in 1946. With the passing of three and a half years, in April 1949 it was obvious that Loeb was avoiding a decision, so Wright sarcastically attacked, saying Loeb would probably "settle down to make a little more money for 'the little woman' in a pig-pile pent-house in the big pig-sty: another machine passing away among the machinery of cipherdom, adding a cipher to the multitude of ciphers amounting to this digitary-complex called civilization." Was Loeb "above all this"? Did he desire "something better?"[31] A year later Loeb abandoned the project, saying only that personally it was a "great loss."[32] The two men remained friends, or mostly so.[33]

As for the movie that Rand, Blanke and Loeb so vigorously promoted, once it was cancelled Warner Brothers did not consider *The Fountainhead* an immediate postwar proposition. And that leads to some interesting information and useful speculation as to why it was revived in 1948.

14

Washington, D.C., Hollywood, Paranoia, and HUAC

The United States House of Representatives' Un-American Activities Committee, or HUAC, began investigative hearings into Hollywood leftist affairs in the spring of 1947. Ostensibly, its task was to discover Communist Party membership and by exposure diminish, weaken and isolate the political left. The hearings were one aspect of a controversial postwar and cold war chapter in American congressional, legal, social, labor, and cultural history that has been effectively studied elsewhere.[1] However, a knowledge of HUAC's influences on Jack Warner, Rand, Wright, and on their relationship to Hollywood and HUAC will aid our understanding of why *The Fountainhead* was taken off the shelf and put into production; why Wright may have been privately spurned by Jack Warner while appearing to appease Warner's studio staff; why Wright disparaged Rand and her movie; and other connections and ramifications including the official "listing" of Wright and consequent lost architectural commissions.

> In all my Congressional experience of thirty-two years, I know of no committee so broadly condemned because of its conduct by people in all stages of life, and from all parts of the nation.
> — Representative Adolph Sabath, Chairman,
> House Rules Committee

> The Un-American Committee program so closely parallels the program of the Klan that there is no distinguishable difference between them!
> — James Colescott, Imperial Wizard
> of the Ku Klux Klan[2]

> Between the launching of his [President Truman's] security program in March 1947 and December 1952, some 6.6 million [government employed] persons were investigated. Not a single case of espionage was uncovered, though about 500 persons were dismissed in dubious cases of "questionable loyalty." All of this was conducted with secret evidence, secret and often paid informers, and neither judge nor jury.
> — Douglas Miller and Marion Nowack[3]

Hollywood had nicely lampooned the USSR in movies like those from MGM: *Ninotchka* (1939) with Greta Garbo and Melvyn Douglas and *Comrade X* (1940) with Hedy Lamarr and Clark Gable. And there was *He Stayed for Breakfast* (1940) from Columbia, in which Melvyn Douglas played a Russian who eventually renounces communism and wins an attractive American girl, Loretta Young. The theme (with roles reversed) was used for *Comrade X*, *Ninotchka*, and later *The Iron Petticoat* (1956). In one sequence of *Ninotchka* an envoy from Moscow visiting New York is asked, "How are things in Russia?" His lifeless reply: "There have been many successful mass trials. There will be fewer but better Russians."

The HUAC 1947 hearings were part of ongoing investigations into the influence of communism within the movie industry's unions that had begun in 1939 with Congressman Martin Dies of Texas as chairman of the House's Special Committee on Un-American Activities. In an attempt to help stem the tide (their word) of Stalinist motivated activities that avowedly worked to supplant the American system of government, Congress passed the Smith Act in 1940. It thereby became a federal offense "to advocate violent overthrow of the government" or hold membership in a group so advocating. It was a controversial law that enabled Congress to instigate investigations of not only Nazi sympathizers (like the Brown Shirts) but those communistic. In 1945 the Special Committee became permanent.

However, it was during Dies' demagogic chairmanship that HUAC's philosophy and methods were determined. Dies wanted investigative power equal to that of the FBI and the Justice Department, and he wanted to personally replace J. Edgar Hoover as director of the FBI. Hoover got wind of Dies' pretensions and effected a successful campaign to discredit him. In November 1940 President Roosevelt's attorney general, Robert Jackson, publicly claimed that Dies and his committee were "interfering" with the FBI's work.[4] Dies approached Roosevelt hoping for a fair hearing and, perhaps, redress. A stenographer secretly transcribed the conversation, part of which went like this. In recent years communist candidates had picked up perhaps half a million votes nationwide, and Europe was at war. So:

> ROOSEVELT: "Now, I would not bar from patriotic defense efforts every one of those people...."
> DIES: "I would be suspicious of them."
> ROOSEVELT: "Oh, I would check them out—absolutely; but the mere fact that they voted for a communist when voting for a communist was legal doesn't automatically entitle us to say to the public 'Those people are disloyal.' They may be loyal."
> DIES: "But ... exposure does get the innocent ones out.... When they are apprised of the practical purposes of the organization, they get out, without any harm being done."
> ROOSEVELT: "...just so long as you don't hurt human lives, because it is awfully hard, as I say, for the word of acquittal to catch up with the charge which is not proved."
> DIES: "In other words, the greatest care should be taken to safeguard innocent people, provided they are willing to cooperate with you."[5]

And the uncooperative? Dies then put his private case against Hoover. Roosevelt "suggested" Dies meet with Jackson, head of the Department of Justice and Hoover's political boss, to sort out "misunderstandings." According to Hoover's biographer

Curt Gentry, a deal was struck. So as not to interfere with ongoing secret FBI investigations, the "committee agreed not to publicize information it might obtain until after it had been cleared by the Department of Justice. In return, the department agreed to furnish the committee with information on cases which it felt could not be successfully prosecuted"[6] — in plain words, cases in which there was insufficient evidence. Therefore, as the *Congressional Quarterly* has reiterated, the "purpose of the anti-subversion hearings was exposure."[7] To placate Hoover and Dies, Roosevelt and Jackson put in place "the machinery" that "would be used in coming years to smear thousands upon thousand of Americans."[8]

Hoover's campaign against Dies continued. However, faced with evidence of accepting "$2000 to sponsor legislation permitting a Jewish refugee to obtain entry to the United States from Cuba," Dies threw "himself on" Hoover's "mercy." No charges were issued, and further, although remaining active, Dies did not attended another public hearing of the committee after December 1941. Rather, he acted as a subcommittee of one.[9]

Exposure and Innuendo

Hollywood began around 1939 to make antifascist and pro–Allied — therefore by implication pro–Soviet — movies. For example, *Foreign Correspondent* of 1940 was antifascist and thoroughly cinematic, produced by Walter Wanger, directed by Alfred Hitchcock, and starring Joel McCrea, whom most believe remained an underrated actor. Pro-Soviet films included *Song of Russia* and *Mission to Moscow*, both of 1943. In *Song of Russia* an American musical conductor (Robert Taylor) falls in love with a peasant girl (Susan Peters) in what was generally felt to be a weak film. (Does it sound familiar?) Later and to the press, Taylor said he had been forced by "Washington" to participate in the production or have his pending Navy officer's commission withheld. Obviously the federal government was involved with the production.

Warner Brothers' *Mission to Moscow*, if objectively analyzed, was one of the great propaganda movies. Freely adapted from a book by the rather conceited Joseph E. Davies, American ambassador to the USSR from 1936 to 1938 and a pro–Stalinist, President Roosevelt had personally asked Jack Warner to make it.[10] One reviewer described the epic sweep, the "well-nigh irresistible propagandist verve" of the movie, which used newsreel and "actuality clips and a ferociously incisive editing style to bludgeon its audience into agreement." Semifictional episodes received "even more technical wizardry." The 1937 Moscow purge trials were "staged in a palace of Babylonian proportions. The scenes at the city's railway terminal," some say, were among the most splendid of their kind ever filmed, while a crane shot of a political rally was for the time "of almost incredible virtuosity."[11] The movie was directed by the Hungarian emigrant and Warner Brothers studio director Michael Curtiz. He was to direct other excellent movies for Warner Brothers such as *Mildred Pierce* (1945), *Casablanca* and *Yankee Doodle Dandy* (1942), *The Adventures of Robin Hood* (1938), and *Female* (1933).

But the congressional committee in 1947 was not interested in filmmaking excellence, or even filmmaking at all. *Mission to Moscow* became one target of the Repub-

lican-dominated HUAC, which also implicated the Roosevelt administration for its role in the movie's finance and manufacture, and they questioned its purpose. Congressional interest in Hollywood before the war was activated by the struggle of labor unions and guilds against studios and management. The strength and belligerence of the unions and guilds (including the Screen Writers' Guild) was, depending on the accuser, attributed to the unions and commercial mafia and the Communist Party of America.

As to the unions' influence, consider this: In 1934 the Al Capone organization under Frank Nitti rigged the elections of the International Alliance of Theatrical Stage Employees and Moving Picture Machine Operators. The Alliance's boss was Nitti's man Willie Bioff, a former pimp and labor organizer. In 1936 Bioff boldly informed the major studios that labor peace had a price of $2 million. RKO, Warner, MGM, Loew's, Twentieth-Century Fox and Paramount quickly paid. But a personal investigation by Fox's president Joseph M. Schenck eventually led to exposing the Chicago mobster's role. The extortionists were eventually convicted in December 1943.[12]

A Hollywood strike in 1946 brought the contestants into a bitter public and at times physical conflict. One reaction occurred in March 1947 when HUAC announced through its chairman, Representative John Rankin, its intention "to look into communist subversion of American movies."[13] HUAC and its new chairman, Representative J. Parnell Thomas, began preliminary or investigative hearings in Los Angeles in May 1947. But they nearly came to naught. Just one month before the inquiry was to begin, HUAC realized it had no data with which to expose intended witnesses. In the belief that HUAC's work "would further Mr. Hoover's premise that the best way to fight communists was to expose them,"[14] the secret accord reached by Attorney General Jackson, Dies, and Hoover was now put into practice: HUAC became a congressional arm of the FBI. Immediately forthcoming was a "blind memorandum" that summarized "Communist activities in Hollywood," an annotated list of those in filmland and in radio whom the FBI asserted were active in the Communist Party or one of its "fronts." Another list contained "profiles" of 32 people deemed "cooperative or friendly witnesses."[15]

One casualty, screen writer Dalton Trumbo, believed (as did many other observers) that HUAC "attacked" Hollywood for three reasons: first, "to destroy trade unions," second, "to paralyze anti-fascist [read communistic] political action," and third, "to remove progressive [read communist] content from films."[16] Apparently fascist political action of the political right was OK. But the game was much bigger.

Labor unions aside, Soviet-supported insurgences were occurring in selected areas throughout the world. In reaction there were investigations everywhere in Western society directed at those who were attempting to subvert normal political and cultural life. The Hollywood episodes were not isolated phenomena, only different in that they occurred in a strange, wondrously popular and very rich industry, one constantly subjected to everyone's prejudicial and emotional scrutiny. Filmland loved it and hated it.[17]

After its hearings in Los Angeles, HUAC held a more formal public question and answer affair in Washington, D.C., in October 1947, with the express purpose of exposing communist sympathizers. The hearings soon focused on certain members

of the Screen Writers' Guild who became known as the Hollywood Ten. (An eleventh was the ascetic and always elusive emigrant German, Bertold Brecht.) None were major players, rather they were selected for their vulnerability and publicity value, and only incidentally in the hope of exposing larger game. Other Hollywood industry people were invited or issued subpoenas; others volunteered. As playwright Arthur Miller put it, the public hearings were conducted by "cheap publicity hounds."[18] "Cheap" is a value judgment, but by their own admission publicity hounds they were. HUAC member Representative Richard M. Nixon explained: HUAC was "definitely" against "outlawing the Communist Party" but in 1947 the committee was, Nixon said, not committed to "suppression" (its meaning in this context unclear) but to "exposure."[19] He was restating a practicality instituted by Roosevelt, Hoover, and Dies: by whatever means necessary, weaken and isolate.

Rand's Opinions

Rand was invited as a cooperative witness, her public role brief. She was instructed to view two films, the Goldwyn/RKO *Best Years of Our Lives* (1946) and MGM's *Song of Russia*. She wanted to extend her testimony and speak about her perceptions of the "really serious propaganda" then occurring elsewhere in the industry.[20] She also wanted to read from the pamphlet *Screen Guide for Americans* that she had written for the right-wing Motion Picture Alliance for the Preservation of American Ideals. An abridged version of the *Guide* was published in the new conservative magazine *Plain Talk* only a few weeks after the hearings closed in November 1947. An introductory comment described Rand's essay as an "education course in coping with the techniques of Communist infiltration" and a "penetrating analysis of totalitarian propaganda." She asserted that the "avowed purpose of the Communists" was to "insert propaganda into movies." From there on the text mixed common sense freely with bias.[21]

The Alliance was formed in 1944 as an anticommunist forum and was instrumental in providing information to HUAC and fomenting the hearings. Its membership included producer Sam Wood, its first president, along with many vice presidents including anti–Semites that may or may not have favored Walt Disney and Norman Taurog. Other members were writer Morris Ryskind, director King Vidor, and actors John Wayne (who became president in 1950), Robert Taylor (then Barbara Stanwyck's husband), George Murphy, and Gary Cooper.[22] Wood, Taylor, and Cooper plus Adolphe Menjou, Ronald Reagan, and Rand were among HUAC's "friendly witnesses." So too were Harry Warner, perhaps the most strident movie producer and a close friend of Hoover, and Jack Warner, who had asserted that "communists injected 95 percent of the propaganda into films" through writers,[23] but did *not* provide evidence of that filmic propaganda; nor did anyone else. With few exceptions those labeled "unfriendlies" were screen writers.

The Warner brothers and Wood were willing to publicly list people they personally believed were "un–American" including those they had already fired. Louis B. Mayer of MGM was also willing and more outspokenly anti–Red than Warner or Wood. Producer Pandro S. Berman believed that in the postwar years a flinching

"Mayer wouldn't make a picture like *Born Yesterday* because it insulted Congress."[24] Mayer favored making the Communist Party illegal, a proposition one large step beyond President Truman's Loyalty Order of March 1947.[25]

There was, of course, some activity responding to the efforts of the Alliance and HUAC. A Committee for the First Amendment was formed in Hollywood. Some of its group of "non-communist supporters" attended en masse the Washington hearings and registered their opposition to HUAC's proceedings. They included luminaries John Huston, Paul Henreid, Lauren Bacall, Danny Kaye, Ira Gershwin, William Wyler, Jane Wyatt, Larry Adler, Paulette Goddard (one-time wife of Charlie Chaplin, later a serious philanthropist), Humphrey Bogart, and many more including Senator Claude Pepper, author Thomas Mann, screen and playwright George S. Kaufman, and hoofer Gene Kelly.[26]

It was in the Screen Actors Guild that Ronald Reagan got a practical foundation in politics, on becoming its president. He was at the same time leader of a right-of-center political group whose activities were almost wholly directed to exposing the left faction and thereby, to his mind, strengthening the Guild.[27] In this he was aided by the FBI for whom he was a "confidential informant" and had been since 1943.[28] To HUAC he voiced an abhorrence of communists and their "dishonest" tactics that were like "those of the fifth column." But he also argued against outlawing "any political party."[29] Gary Cooper disagreed, confessing he didn't know much about communism but he didn't like it "by golly" because it wasn't "on the level." As a cooperating witness Cooper cleverly gave HUAC a moral boost, good press, but no useful information.[30]

Believing that she was an émigrée of the Stalinists, Rand was the only anticommunist "expert" to appear. She did not speak about Hollywood individuals but of her experiences and a knowledge of political and philosophic issues. And she "expounded imaginatively" and in detail about propaganda she found in *Song of Russia*,[31] denouncing it as a "falsification of Russian life as she knew it."[32] She also wanted to attack the movie *Best Years* but was stopped by Chairman Thomas.[33] *Best Years* went on to win Academy Awards in 1947, including that for best picture.

Sadly, contempt charges brought by HUAC were overwhelmingly sustained by an ambivalent if not cowardly Congress. On one occasion Chairman Thomas said, with frightening arrogance and ignorance, "The rights you [a witness] have are the rights given you by this committee. We will determine what rights you have and what rights you have not before this committee.[34]

The right to invoke the Fifth Amendment without penalty was once again upheld by the U.S. Supreme Court in 1951. This was in response to lower courts sending people to jail for contempt of Congress, initially the Hollywood Ten: Ring Lardner, Jr., Edward Dmytryk, Dalton Trumbo, Alvah Bessie, Lester Cole, Herbert Biberman, John Howard Lawson, Albert Maltz, Samuel Ornitz, and Adrian Scott.[35] One way or another the persecution continued — a blacklist drawn initially numbering 212 — and it spread to other related professions. Hundreds of personal lives were traumatized and more than a dozen suicides resulted. The lists were vigorously enforced by some labor unions who wanted to maintain control over closed shops and the filmmaking industry, and by the major studios who wanted to reassert their supreme authority.

The HUAC exposure tactic also ensured that thereafter certain issues were avoided in Hollywood movies. Spoofs about politicians such as the 1947 satire from Universal *The Senator was Indiscreet* became taboo. In the same year, *Crossfire* was released by RKO. Based on a novel by Richard Brooks about closet homosexuals, *The Brick Foxhole*, the story was switched to an anti–Semitic theme and directed by Edward Dymtryk. This was followed by an adaption of Laura Z. Hobson's novel *Gentlemen's Agreement* by Twentieth Century-Fox with a similar theme; it was of inferior cinematic quality but more popular at the box office. Moss Hart's screenplay was nominate for an Academy Award in 1948. But "no more of that was wanted by Hollywood in the blacklist era." As president of the Motion Picture Association of America, Eric Johnston reportedly also said: "We'll have no more *Tobacco Road* [from Fox]. We'll have no more films that show the seamy side of American life. We'll have no pictures that deal with labor strikes. We'll have no more pictures that show the banker as a villain."[36] The villain Johnston referred to was probably the Scrooge Banker (Lionel Barrymore) in *It's a Wonderful Life* (1946), a Frank Capra movie for Liberty/RKO with James Stewart and a wholesome Donna Reed. It's a story about greed and capitalist demagoguery. The "riffraff" (as the banker called ordinary people) worked against selfish capitalism and for the collective good and won, of course. Its theme was similar (but with a different story) to that of *Meet John Doe* (Warner Bros., 1941) with Cooper and Stanwyck. The Scrooge here was a power-driven politician (Edward Arnold). Why did HUAC avoid mention of these movies? (See Capra's view, appendix D.)

But Johnston soon succumbed to studio and union demands for maintenance and extension of the blacklist.[37] What have been described as "crude and foolish pantomimes" flickered on the silver screen, including *The Iron Curtain* (1948), *The Red Menace* and *The Red Danube* (both 1949). By the 1950s McCarthyism spread an even darker shroud over America.[38] HUAC had seeded terror such that people betrayed each other.

Rand's interpreter Chris Sciabarra offered this summation:

> Rand's cooperation with the committee was a source of great personal consternation ... she believed that it was improper for a government agency to engage in the ideological exposure of communists. But she had hoped that the HUAC would offer her a public forum in which she could voice her opposition to the communist tyranny; in the end, she thought that she had probably made a mistake.
>
> [She later argued] that Congress had the right to ask questions of fact with regard to Communist Party membership since the organization was committed to criminality.
>
> ...[But] in a genuinely free society[,] "There would be no hearings."[39]

Rand has said that in the 1930s she "talked too much against the Soviets," implying she fostered biases in the Hollywood community that made it difficult for her literary agent and herself.[40] Yet in a lapse of logic and memory, and in retrospect, she believed that not the government but private citizens had a right to penalize those with whom they disagree.

Since Wright and Rand were holding discussions about her new house during 1946 and 1947 one can only wonder about their conversations. For the most part

Wright's letters to Rand were succinct, businesslike, without friendly talk. The only personal reflection about their relationship is found in Brendan Gill's chatty, gossipy biography of Wright. On one occasion when the two men were seated at the ground floor bar of New York's 21 Club, Gill recalled that

> a tiny figure whose head was topped by a dark velvet beret waved to us from a distant banquet. "Oh, God!" Wright exclaimed in dismay. "Ayn Rand!" ...
> Rand addressed Wright as "Master" and ... lectured us on her political views which Wright ... was by no means beyond sharing. He had always talked a great deal about democracy ... [never] did it [the word] imply respect for the masses....
> Wright and Rand were both consummately elitist....[41]

Gill was then a columnist on architectural matters for *The New Yorker*, who followed — but did not succeed — Louis Mumford.

Wright's Opinions

From the 1930s and through the early 1950s Wright tended to favor the Soviets' initial impulse but in this sense: their desire to reject the dictates of an aristocracy and its concomitant peasantry and repressive social servitude. He was therefore also against the British social and political systems, a comparative example he repeatedly applied. Politically progressive throughout his life, he came to dislike President Roosevelt's New Deal because of its tendency to promote a central authority dominated by a bureaucracy rather than a society counseled by artists and wise individuals acting in spiritual and moral concert.

Another example of how Wright expressed his position is in order. Wright and Lewis Mumford came to a mutual admiration as a result of Mumford's book *Sticks and Stones*, where he had placed Wright and Sullivan as founders of a new American architecture. But when in 1932 Mumford spoke of the European model of an international architectural style as tending "toward" communism, saying it was good, that American should take advantage of communism, and that individualism could only be expressed through "collective enterprise," Wright became incensed.

Obviously Mumford had not read Wright's public condemnation since 1929 of Le Corbusier and the political philosophy his art connoted. Wright told Mumford that the internationalists had found a "formula" that was sterile, that theory had replaced creativity, and so on. To Philip Johnson, co-organizer with Hitchcock of the Museum of Modern Art show where they attempted to identify what they called the International Style, Wright was equally angry. He believed that had used him as part of their "propaganda" for the socialist left; and he suggested he and Hitchcock get wives.

Yet, an emboldened Wright asked Mumford if he would "lead," if he would take charge of the Taliesin Fellowship. This was in January 1932: grateful but wary, Mumford had to say no.[42]

The Soviet government and Communist Party in Moscow invited Wright to give a talk in 1937 to an international meeting of architects who shared communist ideals. The invitation was not offered because of his political beliefs but his celebrity.[43]

Shortly after returning from Moscow a friend asked, "Frank, come now, what do you really make of Communism in Moscow?" Wright replied:

> The Russians have done remarkable things considering their start with such tremendous illiteracy. But the Revolution has been only partial; they've kept our idea of Money — the System that is destroying us and will destroy Communism too....
> She [Russia] has fallen for machine worship — it will turn and rend her as it well rend us.

"Then," said the friend, "you don't come home a convert to Communism?" Wright answered,

> "No,... No isms, private or international, for me. I believe in a capitalist system. I only wish I could see it tried some time."[44]

As did many others, he ignored Stalin's murderous control during the 1930s and failed to recognize that the Russia of the 1920s was not the USSR of the 1930s. During the thirties and forties he urged a greater understanding of Soviet Russia while counseling the Soviets not to throw away Russia's history and culture in the constricted pursuit of communism and atheism. Ingenuously, he said in 1948 that Soviet Russia "wants what we want but believes in a different way to get it." But in the 1950s his arguments were more sharply focused as a result of Senator McCarthy's fanaticism and Congress' impotence.[45] Wright applauded Connecticut Senator William Benton's unsuccessful attempt in 1951 to expel McCarthy from Congress.[46]

Americans witnessed the harassment and expulsion of the English actor Charlie Chaplin, whom the FBI had labeled a "premature anti-fascist." At the time TV interviewer Mike Wallace asked Wright's opinion of the affair. Part of the broadcasted 1957 interview went like this:

> WALLACE: You've heard of Chaplin's anti–Americanism?
> WRIGHT: What do you mean anti–Americanism?
> WALLACE: Well, ... he made his living here....
> WRIGHT: Is there anything more anti–American than McCarthyism?
> WALLACE: Let's talk about Chaplin. He refused to become a citizen.
> WRIGHT: Why did he go away? Was he abused or something?...
> WALLACE: What do you think of General Douglas MacArthur?

Et cetera.[47] Or in typical Wrightian phraseology to acolytes, staff, and guests at Taliesin in 1956: "If Russian were to be the whole world [Wright said] and if Russian ideas and Russian costume and Russian this and that,... do you think the world would be any better off? Not I. Nor do I think it would be any better off if it was all United Statesized either." He went on to preach that "national characteristics and quality was the basis for a rich human society. Now that's the democratic faith as against the communist faith."[48] In the 1930s his dislike was manifest in arguments about the effects of communism and collectivism on art and architecture. In the 1950s his emphasis was political, only slightly architectural; his reasoning garbled by idiosyncratic language yet drawn from the national, cultural, anarchic, and elitist veins of his experience and philosophy.[49]

It can be assumed that Wright was not impressed by what he regarded as Rand's extreme, confrontational, dogmatic political and social views, particularly as they appeared in 1946–1948. Thereafter he treated her book and movie with some contempt and, as noted, attempted to disassociate himself. His attitude can be understood more generally by referring to his participation in an exhibition of his architecture whose last venue became Hollywood.

In 1949 Arthur C. Kaufmann, then head of the Gimbel Brothers department stores headquartered in Philadelphia, apparently conceived but certainly organized and promoted a major exhibition of Wright's work that eventually traveled about central Europe. The idea was personally put by Kaufmann in May 1949 to officials of Florence, Italy, who enthusiastically approved; and so did the U.S. government and Wright. It was administered and organized for Kaufmann by the Philadelphia architect Oskar Stonorov.[50]

Called "60 Years of Living Architecture," the exhibition was put together in Gimbel's Philadelphia store for one month during January and February 1951; 300,000 people attended.[51] Up to the point of its departing U.S. shores, Kaufmann had financed all aspects of the show and performed some of the delicate diplomatic negotiations overseas. A pamphlet was available at various venues, prepared by Wright and published in four languages including Russian. It was also published in full color in the January 1951 issue of *Architectural Forum*.

Models, photographs, and drawings, in all 1000 items together with many of Wright's quotable quips, were included. The U.S. Office of Military Government and the U.S. State Department sponsored the show in and out of Germany and possibly other countries. When finally in place May 1951 it was at the sumptuous 15th century Palazzo Strozzi.[52] Its venues in 1951 included Milan and Munich; in 1952 Zurich, Paris, then Rotterdam; and finally Mexico City, where it opened in October 1952.[53]

The primary reason for mounting the exhibition in Europe was to present a countering stimulus to the "rising tide of Communism" in postwar Europe.[54] As Arthur Kaufmann said in 1949, it was "to help cement among the free nations ... the bonds of good will so much needed these days,"[55] and (in 1951) to "make available the message" of Wright's work that was conceived as an architecture "for democracy."[56] At the time post-fascist Italy had the largest communist party in the free world and it usually obtained one-third of the national vote; a weak link in an ideological chain of defense. A seemingly nonpolitical art exhibition of the work of one of America's outspoken supporters of individualism, a critic of collectivism, and a detractor of the architecture of the political left was surely calculated.[57] People in foreign affairs were more aware of Wright's position vis-à-vis patriotism and communism than was the FBI.

Wright's anticommunist utterances were more or less consistent. He loathed the notion of collectivism but applauded the changes in Russia as long overdue. He was vehement in opposition to American participation in the 1939–1945 war and advocated appeasement. After the war, when the Soviet Empire was conquering countries and instigating internal revolutions worldwide, he was still conciliatory. In 1948 he could preach against the fear of "Communism or any other 'ism.'" (He used a similar argument when opposing entering the wars against Germany in 1917 and 1939–1941.) And in 1950: the "Russians want peace just as much as we do."[58]

Of course he liked the publicity but Wright also supported the exhibition's purpose. In a letter to architectural historian Bruno Zevi (in Rome) about the Florence show, Wright believed there "must be great times ahead for us all if we can stem the present tide of the old materialistic mistakes being made new all over the earth."[59]

In a comment to the American architectural historian Henry-Russell Hitchcock, Wright worried that "Great Architecture may succumb" to a "philosophic degeneracy (collectivism fit for communism)."[60]

And again to Zevi, Wright thought that the exhibition would help counter the "shallow dictums and staring facades of any 'International Style,'"[61] the architectural style promoted by Europe's political left. To Hilla Rebay, then working for the Guggenheims on their New York modern art collection, Wright confided in 1949 that as soon as the Soviets "found out what I was all about she [Russia] has had no use whatever for me. I am an individualist—democratic in thought and action—opposed to her methods in every sense."[62]

In Munich he said Germany must "take her rightful leadership where she belonged—in the growing realm of Democratic Nations." In Paris he called for the "Cause of a free architecture" to "continue to grow." To Rotterdamers he said the Netherlands was a "truly independent" democracy, that "freedom" was democracy.[63]

In early 1951 he said that communism was "the antithesis of anarchy" and was for "child-like individuals"; that political parties and institutions were "for incomplete personalities who have not arrived at individuality."[64] Rand would have agreed.

And so his ideas of the 1930s about the importance of individual responsibility had matured, if that is the right word, to become more openly anarchic. As detailed in my book *Frank Lloyd Wright versus America: The 1930s*, Wright's lifestyle was a commitment to—and a proclamation of—the practical possibilities of that philosophy. The book also details his comments about and attitude to the USSR.

All these contexts support the simple view that at least on the subjects of communism and collectivism, Wright and Rand agreed, as they did on the protection of individualism. One noticeable difference was Rand's very limited personal application as compared to the total-living commitment by Wright.

After Mexico most of the exhibition material was assembled together with new stuff for two final showings. The site for the first was unique. Wright's radical spiral design for the Guggenheim Museum on the corner of Fifth Avenue and 89th Street, Manhattan, was at the time bogged down in wrangles relative to building codes, structure, and probably a mire of personal opinions about aesthetics and visual urban harmonies. On the flat, vacant ground where the museum would eventually rise, the Guggenheims allowed an exhibition using the display items from the European show.

There were two parts to the New York "60 Years" show: a complete one-story, two bedroom brick house,[65] and a pavilion with a 145 foot-long sloping roof (supported by scaffolding pipe) made of alternating bands of gray asbestos cement panels and sandblasted wire glass that allowed daylight or exterior electric night lights to bathe the interior displays. During the first three weeks some 2,000 people a day visited at 50 cents each.

"60 Years" then traveled to Los Angeles (sans the brick house) where it was mounted at the Olive Hill grounds of Aline Barnsdall's Hollyhock house in Hollywood.

Part of the exhibition was installed in a new, temporary Wright-designed Hollyhock-like pavilion.[66] Playwright Marc Connelly, by then a longtime Los Angeles resident, was personally involved in arrangements on Wright's behalf. When it opened in May 1954 it was Wright's last great moment in Southern California.

FBI Opinions

Of course Wright could not escape the eye of HUAC, the Department of Justice and its Federal Bureau of Investigation. His public comments ensured that. In November 1951 the Seattle office of the FBI was "advised" that Wright was to be in their city during March 1952 and would participate "in many prominent social activities." The office had learned from "several people" that Wright had "engaged" in pro-communist activities, or that was the "impression." The Seattle senior special agent therefore asked the Bureau to perform a file check on Wright. This was done in summary form in February 1952. Shortly thereafter he was "listed" as a communist sympathizer for having been affiliated with "communist front organizations," although not blacklisted. But the effect was the same. He could not obtain a federal government commission, and in fact lost some.

Why was he listed? What evidence was there? We have seen that since ca. 1930 Wright was against communism. He warned that if other countries adopted the communist form of socialism, it would soon destroy their folk traditions and national character. If America wanted to improve, it could do so not by war or a cold war but by restoration of its founding principles and, in addition, incorporating his concept of an organic life. These three ideas were presented into the 1950s in such a way as to rile and confuse. FBI files, which include particulars from other federal and state investigating agencies as well as a file of over 260 pages on Wright alone, contain information (one hesitates to say "details") such as that to follow.[67]

In 1909 he "deserted" his wife and family and "eloped" with his neighbor Mrs. Edwin Cheney and, the FBI memorandum states, they lived in Berlin, Germany, for over a year. True, but only as a crude outline. In fact upon leaving their spouses Cheney and Wright did travel to Germany but she lived in Leipzig and Berlin, he in Firenze, Italy, where she joined him in 1910. After their return to Wisconsin and while living with Wright (in sin, was left implied) she and two of her children were murdered in 1914.[68] None of these facts were mentioned in FBI files.

It was reported that in November 1915 Wright was charged with White Slave Trafficking under the Mann Act but prosecution was "declined." Actually this involved Wright's new mistress Miriam Noel, and the charge was initiated by an ex-housekeeper. Wright got lawyer Clarence Darrow to see the charge dismissed.[69] But having employed Darrow was yet another problem. The famous defender of John Scopes in the so-called Tennessee Monkey Trial was seen by the FBI as having helped "other radicals capitalize on evolution."[70] (How does one capitalize on evolution?) Darrow, a known socialist, had also been on the national board of the American Civil Liberties Union (ACLU, the main challengers in the Scopes trial) and was much disliked by Hoover.

The FBI received information that in 1918 Wright had openly admired German

efficiency (didn't everyone?), was "so anti–English that he was pro–German," and at one time apparently said, "Damn the United States. They are getting just what they are entitled to." It is not known if this single informer spoke of 1918 or in the 1930s, 1940s or 1950s. But "numerous prominent individuals" were of the opinion that Wright was not "un–American or disloyal."

In October 1926 Wright and his new mistress Olgivanna Hinzenberg, "a dancer" (from the Russian Caucuses), were arrested near Lake Minnetonka, Minnesota. Again charges of violating the Mann Act were laid but "no further prospective action was taken."[71]

Claims of improper associations referred back to 1937. Wright had an article published in *The Midwest*, "The Man Who Succeeded."[72] A principal editor of the magazine was reported as a "functionary" of the American Communist Party. Another contributor to *Midwest* wrote also for *New Masses*, a popular periodical obviously devoted to communism. Wright also had material published in *New Masses* including "Life and Architecture in the USSR" in October 1937. It was about his trip to Moscow and contained juicy opinions about Russia.

Also noted by the FBI: in 1937 the *Daily Worker* reported that Wright was a "sponsor of a rally" that celebrated the twentieth anniversary of the Russian revolution. He was not a sponsor.

FBI files registered that during 1942 and 1943 Wright obtained films from "Artkino" Pictures, a firm operated by the USSR's New York Consulate (that was not mentioned by the FBI) that exclusively distributed Soviet films. Actually Wright had been using Amkino (as it was then known) since about 1935. Some people in Madison (neighbors?) were upset by the Soviet movies; perhaps they informed.[73]

In 1943 there was a sedition investigation prompted by Federal Judge Patrick T. Stone in Madison. From the bench he urged the FBI to investigate Wright for "obstructing the war." Stone alleged that Wright advised his young people "to escape military service by representing themselves as conscientious objectors."[74] In March 1941 "twenty-six members of the Fellowship [and some employees] submitted a petition to a local draft board and subsequently claimed to be conscientious objectors."[75] Wright's response to Stone was within the FBI files. The judge was "using the bench," Wright correctly observed, "to sound off his prejudice against another man on mere hearsay." Wright further stated that the judge was "another one of the things that is the matter with America. I think for the safety of this nation such men as yourself [the judge] should be deprived of any administrative authority what ever.[76] ...I know you only as you disgrace your judgeship...."[77]

Wright's uncle, the Reverend Jenkin Lloyd Jones, was an internationally known activist against war and in 1917 associated in the cause with the likes of Jane Addams, Henry Ford, and their colleagues. (Jones had been an artilleryman in the Civil War.) Wright too opposed American entry in 1917, 1939–1940, and the Korean War.[78] He was a conscientious objector not on religious but philosophical grounds. Addams was a religious welfare advocate and somewhat of a socialist. She was a founder of Chicago's settlement house, Hull-House (in which Wright participated), in the 1890s. For her continuing activities internationally, in 1931 she shared the Nobel Peace Prize with Nicholas Butler. The FBI identified her as a "zealous and consistent supporter

of radical and revolutionary movements."[79] Correct, but not in the sense implied: she was committed to social reform and in that sense a successful reform revolutionary from 1890 onward. Over the next seven decades almost all of the Hull-House programs were assumed by the people through their elected state and federal governments.

Judge Stone's intemperate comments were made on the occasion of a trial before his bench of Marcus Weston, son of a Wright carpenter and a cook. Weston was charged with draft evasion. His pleas of conscientious objection ignored, Weston was sentenced to three years in prison. During his incarceration Wright made unsuccessful pleas to have the young man released to his custody. After six months Weston was paroled to work in a hospital. In retrospect Weston said that Wright "saw the war hysteria, and thought it a big mistake. But as far as telling apprentices what we should do, that was absolute nonsense." People "came to Wright" with "similar feelings and felt the same way that he did."[80] In fact, most of those people did not agree with conscientious objection,[81] in spite of Wright's words about "sharing a common interest and faith."[82]

Wright's antiwar utterances and dislike of Roosevelt's New Deal came to the attention of the like-minded America First Committee and therefore the FBI.[83] What they may not have known was that Wright had written a brief note to Charles Lindbergh praising the pilot.[84] Lindbergh had accepted a decoration from Hermann Goering, believed the Luftwaffe invincible, feted Nazi leaders, promoted the isolationistic America First, and believed that those pushing America into defense of a "doomed" Britain were Jews and Roosevelt.[85] Part of Wright's letter to the Lone Eagle was repeated in Wright's revised 1943 autobiography: "square American," fly "straight"; everywhere is "equivocation and cowardice" but "you [Lindbergh] not only think right but you dare to speak straight." Yet Wright was unable to mention Lindbergh's name, just "a flyer," the "American Eagle."[86] Did Wright also recognize Lindbergh's fascist inclinations?

In October 1941 Wright was a speaker at the Russian War Relief Rally. In June 1943 an open letter by Wright to the "Mayor of Stalingrad," concerning the National Council of American-Soviet Friendship, appeared in *Soviet Russia Today* in June 1943.

In October 1944 Wright gave a talk to the California Labor School in San Francisco, an FBI-nominated communist front, Wright was to later learn.

In 1949 Wright's name "appeared on a list of supporters" of another communist front organization, the Cultural and Scientific Conference for World Peace, held in New York City.

In 1950 Wright was one of 17 "prominent individuals" who signed an appeal to parole eight of the "Hollywood Ten."

He also was found to be associated with the World Peace Appeal, another FBI suspect organization, and in 1950 he signed the Stockholm world appeal to outlaw atomic weapons.

On 5 April 1951 the New York *Journal American* named Wright as "affiliated with no less than five and maybe ten" unmentioned communist front organizations. How many?

On the odd occasion from 1951 to 1953 Wright was mentioned more or less favorably in the Communist Party's newspapers *Daily Worker* and *Daily Peoples World*.

Counterattack, an anticommunist newsheet, reported in 1953 that Wright had "aped Moscow's line" in a broadcast interview,[87] probably one that had been conducted by Jinx Falkenburg in April 1952.[88]

In 1957 the Bureau prepared a summary of its files, partly outlined immediately above, on Wright. On that occasion two statements effectively summarized the FBI's fuzzy-minded attitude: "Bufiles [sic] reflect that Wright has a background of promiscuity, [and he] has a long history of affiliation with communist-type groups and activities."[89]

Relevant to the discoveries just outlined, some comments seem in order. To begin, the advice of Victor Navasky, editor of *Nation*, to historian Curt Gentry in 1976 needs recall: it is a mistake to assume "that FBI memorandums provide answers rather than clues."[90] And further, Wright was not formally investigated by the FBI or the Department of Justice. Because he had been a controversial public figure, as information came to hand it was filed. On three or perhaps four occasions, the FBI was asked to study some specific situation, or an informant (usually casual) raised matters needing attention. On examining their files the FBI could not make a case.

It is patent that Wright was always on the periphery of organizations and events, not an active member or formal participant. Most FBI file checks or memoranda are laced by negative interpretations of negative information. The informers' comments reek of paranoid suspicion and innuendo. The Bureau's comments are prejudicial, one-eyed, biased, inhibited by closed instructions, never positive or favorable. It is as if Wright was assumed bent, undesirable or guilty. But hearsay is not evidence. Moreover, Wright's publicly uttered dislike of communism and intense love of country are *never* mentioned in the FBI files.

The worst one can say about Wright is that he was a man with a nonconforming philosophy, one incidentally politically left of center, with a hatred of war; an easy target. His pacifism was misconstrued as pro–German, pro–Japanese, pro–Soviet, and by a wicked twist of inference as anti–American. Because he was not verbally clear and seldom direct (let alone eloquent) he made a detractor's job simple. Indeed, his prose could dissemble, the mix demonstrable even beyond previous examples.

During the "tide" of anticommunism, 1948–1953, Wright publicly countered with advice. State-sponsored anticommunism, he opined, should be rejected because it used fear as a control devise. (And so said Rand.) There was nothing "to fear from Communism or any other 'ism' on Earth," he said. And further: "If you can scare the people you can huddle them where you will. Scare them a little more and they will shoot each other. Scare them enough and they will even go out and shoot themselves." His beliefs in pacifism, good manners, unilateralism, honesty, and plain trust were awkwardly expressed in words. To many they exposed a naiveté. To others they were blushingly frank. To the FBI he was an annoying crank. But was he dangerous?

In the early 1950s Wright became an early critic of both HUAC and the junior senator from his home state. HUAC "is not only mischievous but un–American itself," he said. "When a McCarthy can exist in our country ... our political system

cries out for revision." In Wright's view McCarthy was a "political pervert," the "chief demagogue," a "blatant" coward. There were few people so outspoken and not until 1954 was the senator censured. In spite of this, it can be said that McCarthy had become the scapegoat for the collective cowardice of Congress.

Anyway, the Red-hunters managed to get Wright "listed." When challenged, the FBI said the contents of its files reflected "unfavorably" on the aged architect. We've learned why. Wright's exasperated reply: "I am what I am. If you don't like it, you can lump it." It was his final and most eloquent defence.[91]

Lost Commissions

As a result of the political, congressional, bureaucratic and judicial machinations of 1941–42 Wright lost as least two federal government architectural commissions: a war housing project and a nearby defense plant for Pittsfield, Massachusetts, 1942–43. It was the powerful majority leader in the House, Congressman John W. McCormick of Massachusetts, who complained to bureaucrats in Washington that Wright was not a resident of his state. But many other architects throughout the nation obtained federal commissions outside their home states.[92] What was the role of the Department of Justice or its FBI? Or the bureaucrats? Rexford Tugwell, director of the New Deal Resettlement Administration, once said to Wright, "Why are you such a controversial item? We would like to employ you but we can't dare."[93]

As historian Zenia Kotval put the general situation, "there was a hint of retribution toward Wright":

> Given his public antipathy toward the American Institute of Architects, his egotistical responses to federal officials, the isolationist [antiwar] and pro–Japanese sympathies that he did not disguise, and the frequently unfamiliar nature of his designs, it is not surprising that there could be ... negative sentiment.[94]

Did Wright lose the commission for *The Fountainhead* movie art in 1948 because of Jack and Harry Warner's close association with Hoover and HUAC?

A U.S. post office for Spring Green, Wisconsin (1956), a boxy little building, got no further than preliminary drawings. Another post office for San Rafael, California (1957), was built; it was his only successful federal commission. Its plan was composed of segments of a circle built of concrete blocks under a flat roof. There were no other federal projects between 1942 and 1957, and none after.

There were a series of designs in 1957 for an island in the Tigris River beside Baghdad, a commission of the Iraqi king. Included were to be an art gallery, casino, opera house, museum, and university, together with a master city plan for Baghdad. The Counter Intelligence Agency (CIA), FBI, or others in the Department of Justice or Department of State might have worried about Wright's activities with a pro–Western government in such an economically and diplomatically sensitive area, but Wright lost the commissions in 1958 as a result of an Iraqi military coup.[95]

It is doubtful if other commissions of the immediate post–1945 period were affected by the festering anticommunism; but one can't be certain one way or another. Those unfulfilled were the mammoth Pittsburgh Point Park Civic Center (1947) and

the related Twin Suspension Bridges (both for the Kaufmann family and apparently rejected by the city); a San Francisco bridge (1949); and in the 1950s the Los Angeles Municipal Art Gallery (1954), soon to be discussed, and an Arizona State Capitol building for Phoenix.

At the instigation of Lloyd Clark, a reporter for the *Phoenix Gazette*, Wright prepared preliminary plans that were presented at a press conference in 1957. It was a vain attempt to foil the construction of a tall skyscraper in the desert.[96] There was, therefore, no need for the federal authorities to inform the municipal authorities of Wright's supposed indiscretions. But had the project gone much further there might well have been FBI activity, as machinations surrounding two other commissions firmly imply.

The Madison city Monona Terrace Civic Center, the second and third versions of 1953–56, was lost through intervention. It took only a year of "right-wing 'Wrightophobe's'" harassment before a questionable state law was passed in 1957 that stopped construction of Wright's design.[97] Wisconsin's great liberal tradition had succumbed. Behind-the-scenes activity by federal and state authorities of one kind or another can be easily assumed. In fact it was probably as a result of this commission that the FBI was asked (by whom, one wonders) to conduct a file check in 1957.

In spite of similar shenanigans Wright did obtain a local government job, again 1957: the Marin County Civic Center in San Rafael. Hours before signing the architectural contract the County's Board of Supervisors were presented with a document purporting that Wright had given "active and extensive support" to communist enterprises. The document was offered to the board by one of Senator McCarthy's former but influential staff, a convert or "ex–Red" by the name of J.B. Matthews (see Appendix F).[98] The board would not be intimidated, stood firm, and voted four to one to hire Wright. The resulting rather ill-conceived architectural stage-set product (1957–1972) was less by Wright and more by San Francisco architect and former Wright employee Aaron Green.[99]

It can be fairly and legitimately asked where the American Civil Liberties Union was during those fearful years. The ACLU had been neutralized by Hoover through personal relations with attorney Morris Ernst who was general counsel of the ACLU. Ernst was a "staunch anti-communist. Apparently he'd battled communist attempts to take over both the Newspaper Guild and the Lawyers' Guild." He also fervently championed Hoover. Ernst acted as an informal informant for the Bureau by reporting to Hoover about private, personal, and privileged conversations within — and documents of — the ACLU. He persuaded the ACLU to remain neutral (if not silent) during many spy cases; those of Julius and Ethel Rosenberg, and of Alger Hiss and Whitaker Chambers, were two.

Ernst and the ACLU never seriously questioned, criticized, or closely examined the FBI's role in the Smith Act roundups, the spy cases, the Hollywood blacklisting, the federal loyalty actions, the HUAC Red-hunts, and so on. From its beginning the FBI considered the ACLU a "communist front." Quite possibly on Hoover's urging, Ernst purged the ACLU of people identified sotto voce by Congressman Dies and the FBI.[100]

In the 1920s Wright had a distant link with the ACLU as a result of personal and

professional relations with Clarence Darrow, and earlier and more closely with Nobel Peace laureate Jane Addams, then both on the national board of the ACLU, and probably other members. Although not a member, Wright may have supported the ACLU in ways as yet unknown.

It was in the frustratingly tense atmosphere of national fear and mind-bending paranoia of the 1947–48 Hollywood HUAC hearings that the Warner brothers decided it was a good idea to produce a film about high-minded individual freedoms as expressed in *The Fountainhead*, authored by a staunch anticommunist, and to release it for American consumption. It was only four years earlier that Rand had been seen as too anti–Russian.

15

The Movie Revived

During a trip to Los Angeles in October 1947 Gerald Loeb visited Jack Warner, who confirmed that shooting for *The Fountainhead* was to begin in May 1948. Warner then asked Loeb "to help," implying he assist in obtaining Wright's services. Loeb informed Wright of this and further that Blanke and he would visit Taliesin West early in the following year in the hope of persuading the aging architect "to do the settings."[1] Then in January 1948 Loeb alerted Wright that King Vidor, contracted to direct the film, would join Loeb and Blanke on their visit in April. Again Loeb was insistent that if 32 million people were to see a film about architecture, it must pay tribute to Wright.[2] Parallel with discussions with Wright it was time again to select other production personnel and the principal actors. This took place in early 1948, the twentieth anniversary year of talking pictures. In his twenty-fifth year with Warner, Blanke again became a producer.

In other forums Rand's philosophic position was well known. She revised her 1930s anticommunist book *Anthem* for its first publication in the United States in 1946 (just when HUAC's hearings in Hollywood were announced); it was then reprinted in 1953 during the height of Senator McCarthy's rantings. Having concluded testimony in support of HUAC, Rand was the obvious choice to reduce and refine her 300 page preliminary screenplay. A contract was drawn that ran from 24 March to 26 June 1948 and she received $15,000. (Her final screenplay is dated 20 June 1948.)[3] During April she was assisted by Harriet Frank Jr. whose career was just underway with an unrealized script of "A really important person" (1947). She served as screenwriter for Warner Brothers' *The Silver River* (1948) with Errol Flynn, then as cowriter for Fox's *The Long, Hot Summer* (1958) and Paramount's *Hud* (1972) and *The Cowboys* (1967), among others.[4]

But what of Wright? Had he agreed in 1944 to Rand's and Blanke's proposition to execute some designs? Had Jack Warner left the door open, or at least ajar, for him to participate? It turns out that in early 1948 the studio had sent someone (Wright thought an art director, whose name he forgot) with instructions to negotiate, beyond — or in the light of — Rand's own efforts in 1945. The architect's account of the encounter is typical bluster and hyperbole. He would design the sets for the regular designer's fee of ten percent. The persuader asked if this was of the $400,000 budget for the sets? No; "of the cost of the movie, $4,000,000" (a wild guess). Convinced the demand "amounted to a refusal," Wright imagined the negotiator was "glad" because he "wanted to design the sets himself."[5]

The rumor on sound stages was similar to Wright's account. Apparently Edward Carrere was sent to lay the foundation of understanding about Wright's "services." Carrere reported to Vidor that Wright quite rightly insisted "upon the last word concerning his work for the picture and the nature of its presentation." This conformed with Rand's and Loeb's opinions. A staunch supporter of Wright, on receiving this report Vidor did an "about face" and "promptly" urged the appointment of Carrere as art director.[6]

Mexico City born and educated in Los Angeles, Carrere started with RKO around 1932 before transferring to Warner Brothers art department in 1944. *Fountainhead* was among the first of his assignments as art director, although studio publicity noted he was supervised by Bert Tuttle, head of the studio's art department.[7] But Carrere went on to art direction for James Cagney's last gangster film *White Heat* (1949), and Carrere was nominated for an Oscar for *Dial M for Murder* (1954) and *Camelot* (1967) for which he won an Oscar, and other films.

William Kuehl was assigned as set designer. He had previously worked on Warner Brothers films such as the Bogart and Bacall film *Dark Passage* (1947), then *John Loves Mary* (1949) with Ronald Reagan, Jack Carson, and Patricia Neal, and later UA's *The Court-Martial of Billy Mitchel* (1955, with Gary Cooper); in all, 12 movies through the 1970s. In 1948 Warner's research department provided Kuehl and others another selection of books by and about Wright together with publications about architectural ornament, the city, housing, and architectural history.[8]

The possibility of working with Wright, however, was eliminated. In May 1948 Wright wrote "directly" to "Dear Henry Blanke" saying that Rand's book was about sex and "individuality"; architecture was a secondary or "background" theme for sexual rape; he respected Rand's thesis and thought the movie might "open the eyes of the fox [sic] populi." But glamorizing it through hero-worship and a "sex-coated pill" was inappropriate; and Dominique was a "bitch." Nevertheless he thought Rand's comments about architecture stood "firm and the total result remarkable." Based on past performances, however, Wright believed that Hollywood could not seriously present a theme that supported basic freedoms and individualism. In spite of Loeb's promotions, Blanke's apparent sincerity, and Rand's "begging" and "prayers," Wright was categorical: he would "not participate in the making of the film." Period.[9]

Loeb had been convinced that he had convinced Jack Warner to give the Taliesin Foundation not the $250,000 requested but about $100,000 for the architect's services. Loeb blamed the architect for blowing his opportunities.[10] In any event, all contact between Warner Brothers and Wright ceased, probably to the relief of Jack Warner who worried constantly that Wright would find reasons to sue.

At first glance one's thoughts about Wright's possible roles might be something like this: If he had taken the job there would have been enormous publicity and much curiosity about his designs; the money was needed; it would not have been a difficult undertaking but rather an interesting interlude to a slow architectural practice during lean years.

But Wright's letter to Blanke that May 1948 was principled and practical. Firstly, he did enjoy Rand's portrayal of architecture in the novel. But he disliked Roark the person and Rand's presentation of those professionals around Roark. Wright believed

the thesis of individual integrity and freedom was an essential cause, but not as fictively formulated by Rand. He was, therefore, not pleased with major portions of the novel.

Secondly, he was not going to participate in a venture where his architecture and set designs were to play second fiddle to a fictional architect of questionable virtue, whose ascetic posturing excluded social responsibility. He was not going to be seen as subordinate to another architect, real or imagined. Thirdly, if the Warner Brothers studio wanted to make a movie about him and his architecture, fine, but not one where he is immorally disguised but his designs are real. Fourthly, based on a reasonable knowledge of Hollywood studios he was certain that he would not have control over his designs, that his name might very well be attached to works not wholly his creation. He was not a team man. And what else? Wright's integrity could not be bought.

But there is a problem with these interpretations. Production of the movie was well underway by that May! The letter was not preemptive. With his various Hollywood contacts and Loeb's close association with Rand and infatuation for Wright, the architect must have known what was occurring at Warner. Rather, it seems he wanted to place on record his rejection and thereby counter the fact he had been ignored. Warner's studio had selected their artistic staff well before April to meet a shooting schedule to begin in a few weeks.

While negotiations with Wright were active, casting of *The Fountainhead* proceeded amid the usual rumors. Apparently Blanke tried to get his friend Greta Garbo for the role of Dominique, and apparently King Vidor, assigned to direct the film, had, "as a friend," advised Greta Garbo against accepting the part.[11] Such a heaven-sent opportunity of a significant professional coup and ultimate popular acclaim for Vidor could not have been so easily dismissed. Yet Vidor and *The Fountainhead* are not mentioned in Garbo biographies.[12] Further, the only time Garbo seriously considered a return to celluloid was in the 1940s. For instance, in December 1942 she agreed to star as a resistance fighter in *The Girl from Leningrad*, one of those pro–Russian jobs, but the film was not made. Garbo often changed her mind after agreeing to a role. On one occasion shortly after the war she was approached to do the lead in RKO's *I Remember Mama*, but decided "no mamas." *Mama* was eventually shot in 1947 with Irene Dunne.

While others may have been interested in her return, Garbo was not. Those others were interested in Garbo as a public relations product, not in the quality of the actress' work. Professional views of her are best summed up by movie historian John Baxter: "Nothing so much became her career as the leaving of it."[13]

Vidor claims to have refused to consider Barbara Stanwyck as Dominique because "she had no sex appeal." Stanwyck had become friends with Rand, who confirmed that the star had persuaded Warner to buy the rights so she could play the leading female role. When they cast another woman, and Rand fought for Stanwyck, she managed to leave the studio in a huff.[14] And we note that Bogart was not cast. While Rand, Warner, and Stanwyck (and husband Taylor) were more or less on the same side of the HUAC-generated controversy, Bogart had publicly challenged the very existence of Congress' committee. When the possibility of casting independently

minded Bette Davis as Dominique was in the offering, a "violently opposed" Rand threatened to remove her name from the screenplay. Apparently other actresses seriously considered were the English emigrant—the "noble and courageous"—Ida Lupino; Veronica Lake, in Rand's view the "funniest" proposal; the newly acclaimed box office attraction Jennifer Jones; the erect and calm Gene Tierney; and may be others including Eleanor Parker.

However, a newcomer to Hollywood and the Warner Brothers stable was selected, Patricia Neal. She had recently received rave reviews for her Broadway debut performance in Lillian Hellman's play *Another Part of the Forest* and had received Tony, Donaldson, and Drama Critics awards for best featured actress during the Broadway season just past.

Her debut movie role was in *John Loves Mary* opposite Ronald Reagan and Jack Carson and released in 1949. Two more films were released that year: *The Hasty Heart* (based on the Broadway play by John Patrick in which Neal had had the lead), again with Reagan, and *It's a Great Feeling* in a cameo appearance together with Cooper, Joan Crawford, Reagan, Vidor, Edward G. Robinson, Danny Kaye, and others. The following year she played opposite John Garfield in *Breaking Point* (1950). From 1949 through 1951 she appeared in nine films for Warners.[15] All but *Hasty Heart* were unmemorable and Warners dropped their contract option.

Picked up by Twentieth Century Fox, Neal's first film was *The Day the Earth Stood Still*, in which she shared the lead with Englishman Michael Rennie. Science fiction critic Peter Nicholls has described it as "one of the first Hollywood sf movies produced during the sf boom of the 1950s, [and] one of the most intelligent."[16] Thirteen years later in 1963 Neal won an Oscar and British Academy awards for *Hud*, costarring Paul Newman and the inimitable Melvyn Douglas, and directed by Martin Ritt.[17]

Douglas was considered by Warner for the Gail Wynand role. Apparently because of his political views and a moustache,[18] he was rejected by Rand. Raymond Massey accepted the part. He had starred in Robert E. Sherwood's Broadway play *Abe Lincoln in Illinois* and the 1949 film version by RKO, but earlier appeared in MGM's *Possessed* (1947) with Joan Crawford.[19] Blanke wanted Clifton Webb for the part of Toohey (see appendixes A–C), but Jack Warner believed the public would not accept Webb as a villain. Webb's not-too-private abnormal lifestyle was probably a negative factor. (His role in *Laura* may also have affected his image.) Instead, the British theater actor Robert Douglas, recently signed by Warner, was selected. His credits included a supporting role in Errol Flynn's *The Adventures of Don Juan* and as a star in *Homicide* (both 1949). Two castings valuable to the film were Kent Smith as Roark's friend, the weakling Peter Keating, and Henry Hull as the elder architect, Cameron.

The hierarchy's choice for the role of architect Roark was Gary Cooper (Figure 15.1), who had signed a contract with Warner in October 1947, just a week before going to Washington for HUAC. Prior to 1945 he attained success as the idealistic hero in films such as Paramount's *The General Died at Dawn* and Columbia's *Mr. Deeds Goes to Town* (both 1936). Graham Greene described Cooper's performance in *Deeds* as "subtle and pliable" and "something of which other directors have only dreamed."[20] Cooper was universally liked in Hollywood, "admired and trusted."

Figure 15.1. Gary Cooper, Ayn Rand and Patricia Neal, 1948. From USC Warner; © Warner Bros. and AOL Time Warner.

Just three years after *The Fountainhead* he would make Carl Foreman's *High Noon* (1951), Cooper's finest film and to some people the "greatest Western ever made."[21]

The lanky actor from Montana (via England) had starred in the successful yet rather controversial film, Paramount's *For Whom the Bell Tolls*, released in 1943. Ernest Hemingway's passionate novel was written in support of the Loyalists, against Franco's fascists, and about communist-led guerrillas. However, with Adolph Zukor's production and the bent of Sam Wood's direction the film not only ignored the communist Loyalists but the contributions of non-communist Loyalists, the Republicans. The cause for which Cooper and the young Ingrid Bergman were fighting was obscured, almost perverted. The movie ended up as a "tale of tragic romance, not of tragic war."[22] *The Fountainhead* became Cooper's fifty-seventh starring role, his first for Warner under the new contract; it followed other films such as the excellent *Sergeant York* (1941) and feeble *Saratoga Trunk* (1945, but a 1943 production), both for Warner.

Perhaps those casting Cooper recalled his 1935 role as an architect in Paramount's *Peter Ibbetson*. Supported by Ann Harding playing his lover, and Ida Lupino, the movie is "about dreams and beauty and love." An American architect travels to

Paris, receives a commission, refuses to alter his design, has a sexual affair with the client's wife, kills the client, goes to prison and there dreams of his lover; she dreams of him and they meet in each other's dreams. The few published reviews confirm Cooper was "just not believable."[23]

Before the principal roles for *The Fountainhead* were cast, King Vidor was assigned to direct and Cooper approved; unfortunately, as it turned out. Fortunately, Robert Burks became director of photography. He was involved with special effects from 1932 (when he began as a "lighting cameraman") to 1948. As a cinematographer his credits at Warner Brothers included *To the Victor* (1948) and *Kiss in the Dark* (1949). But his best work was with Alfred Hitchcock: *Dial M for Murder* (1954, another Warner film), Paramount's *Trouble with Harry* (1955) and *Vertigo* (1958), and MGM's *North by Northwest* (1959).

That there was some collusive attention by Warners, the FBI and HUAC and/or its supporters can be reasonably assumed. And no doubt other movies of the time were subjected to some form of intervention. Now and then, as with *The Fountainhead*, it was disguised in terms of morality or the national interest. Certainly no movie was more vetted than Warner Brothers' *FBI Story*, based on Don Whitehead's novel of 1956 and starring Jimmy Stewart and Vera Miles. LeRoy was picked as producer and director after Hoover determined from a Bureau "fat File" that there was "enough on LeRoy to control him."[24] LeRoy believed in the film: it was "a beautiful story."[25] One wonders why LeRoy was not involved with Rand's movie back in 1948.

Warner Brothers' studio budget for *The Fountainhead* was $2,511,000. From that Cooper received $275,000, one-ninth of the budget; Massey $65,000, Neal $25,000, and Vidor $150,000. Cooper's fee can be compared to James Stewart's of $300,000 taken from a $1.5 million budget for Alfred Hitchcock's experimental film *Rope*, released in 1948 by Transatlantic/Warner Brothers. Shooting of *The Fountainhead* began on Thursday, 30 June 1948, with sound and photographic tests on stage two. The daily production and progress reports indicate that shooting was completed on Friday, 8 August 1948, one day ahead of schedule. (Therefore Cooper received $6425/day.) 123,880 feet of soundtrack negative were exposed. Of that 41 percent were "O.K. takes."[26] When editing by Blanke, retakes, and music dubbing were complete it was previewed in a Hollywood Park suburban theater in June 1949 and then premiered for public consumption in 114 minutes at Warner's Theater, Hollywood, July 1949. Rand expressed "complete" satisfaction with the movie.[27]

Opinion

A survey has shown that with but few exceptions, standard — or even slightly irrelevant — histories or surveys of movies seldom remembered *The Fountainhead*. People involved in making the film were also shy when writing autobiographically, including Jack Warner. LeRoy gives it about four lines. Raymond Massey forgot the novel and all concerned with the movie including fellow actors when he wrote an otherwise detailed autobiography. Until recently most biographies of Vidor only

reluctantly list the movie. Almost all contemporary professional reviews (or postmortems) were brief, uncomplimentary, or severely critical.

In books and articles by or about Neal and Cooper the film is usually listed, sometimes with short comments, usually for its catalytic effect on their three-year sexual affair. According to Neal, after viewing the movie premiere, and as she was escorted by Kirk Douglas about the brightly lit theater lobby, the silence was humiliating; "everyone just turned their heads." Her evaluation is the shortest on record: "*The Fountainhead* was a bomb."[28] Cooper's was the second shortest: "Boy, did I louse that one up." The viewing public made known their opinion by poor attendance.

Also and as might be guessed, it was not an effective propaganda vehicle to counter socialist, communist, or other pinkish tendencies in American society. In a letter to Wright, Gerald Loeb mentioned seeing an advanced showing in April and enjoying seeing the building blown up "in all its glory." However, the "theme" was "put over" too vigorously.[29]

Of the professional reviews *Cue* magazine proclaimed that

> It is a hysterical mixture of frenzy and fraud — of spasmodic sincerity and sinister cynicism — of flashes of literary power and shoddy, bombastic nonsense. Some of the picture's scenes are memorable, many are laughable ... [this film] turns into a Sunday supplement story fit for the tabloids and the trash basket.

Hollywood Reporter was succinct: "By no stretch of the imagination is [the movie] orthodox entertainment. Its characters are downright weird and there is no feeling of self-identification." Similarly, after its premiere Edwin Schallert in the *Los Angeles Times* wrote, "Above everything else it will NOT be a film to catch the interest of what is known as the average movie audience." The cumulative efforts of the production team, said *The New Yorker*, "have resulted in the most asinine and inept movie that has come out of Hollywood in years."[30]

Simply, despite its popularity among some people, the book was improbable (although theoretically plausible) while the movie failed to make it fictively credible. But it and the movie seemed to persuade sections of the political right who guaranteed a rise in Rand's fame.

Professional and critical opinion points to four reasons for the film's failure with moviegoers generally: miscasting of lead players, inadequate direction, a lecturing script insensitive to the cinematic medium, and incoherent visual images (these will be soon studied herein). Praise was given to individual performances by Hull, Smith and Douglas while Massey, Ray Collins, and Jerome Cowan performed to directorial requirements. Max Steiner's music (when mentioned) was judged competent and Burks' cinematography received the highest praise of all those involved.

There was only one positive critique of Cooper's acting: with his limited ability he brought a "studied sincerity" to the role. Most reviewers and biographers believe he was miscast, some that he was much too old for the part. Perhaps their criticism was meant to put the blame on those who cast him. On the other hand, his approval of the script (and director) was part of his Warner contract, so he must have read the script before accepting the part. Yet, during production he worried. Through

his lawyer, I.H. Prinzmetal (who had advised Cooper not to be involved with the film) it was put to Warner Brothers that Cooper's personal movie audience was not an intellectual group. If they saw him displaying "selfishness" and making long speeches (yes), "it might damage his career."[31] One of Cooper's biographers, Homer Dickens, said that the actor "didn't seem to understand, or care" about the role. In a turnabout and after the fact, King Vidor said Cooper was not "right," not "well cast." Vidor preferred Bogart, an actor he assessed as "a more arrogant type of man." Another critic believed Cooper's "faltering delivery" emphasized "his bent for the monosyllabic."[32]

Much as Warner may have wished to make a star of the gaunt and lean Neal, it did not occur under their guidance and administration. Criticized as appearing rather naive when interpreting Dominique, she was unable to unconditionally "give herself to the role." A somewhat affected method of acting and body movement did not help in a dramatic role on film where the slightest body or speech effect, where the "excesses of melodrama," are so easily observed.[33] She received more directorial assistance as a nurse in *Hasty Heart*.

The Fountainhead's screenplay was devoted almost exclusively to human interactions that, critics have noted, were activated by tediously labored lines executed in a succession of "turgid scenes." Each short and stiffly posed scene had one apparent purpose: to enable Rand's lecturing script.

In a vigorous manner Rand pointed out to Blanke that the people in her novel and screenplay were designed as unusual and peculiar. They were stylized and heroic. Blanke must not allow a humanization of their natures. They must not be conventionalized or seen as vulgar or common or average. To do so would weaken and dilute their idealism. Maintenance of her stylized characters, she insisted, would ensure viewer acceptance. Vidor and Blanke obviously agreed with Rand's analysis that approached an instruction.[34] But the moviegoer was unimpressed.

Vidor believed the resolution to Roark's dilemma "preposterous." During production he asked Jack Warner "if, when the picture was completed anyone changed or edited some part of the film and I retaliated by destroying that part of the film, would he [Warner] forgive me." Warner replied he "would not but that a court judge might."[35] In the end neither director or writer provided the "leavening of honest make-believe to aid in swaying the audience in [the film's] favor."[36]

At that period of his career Vidor did not always select scripts because of passion or for an intellectual test or purpose, as some biographers have surmised. The studio assigned *The Fountainhead* to him because he had agreed to a contract to do three unspecified films for Warner with their man Blanke as producer.[37] Perhaps a lack of influence in making the movie is one reason why Vidor was uninformative (he devoted one throwaway sentence to it in his autobiography), or negative. Recent comments, therefore, about Vidor's cinematic philosophy as it might be revealed in *The Fountainhead* and other contemporary films must be treated with caution. The film was only slightly Vidor's creation, more a product of his frustrated neglect.[38]

When asked for the most "indispensable requirement for a good picture — the star, the director, the producer, or what?" Samuel Goldwyn replied, "the author ... A great picture has to start with a great story," he said. "Just as water can't rise higher

than its source, so a picture can't rise higher than its story. The bigger the stars, the director and the producer, the harder they fall on a bad story. Not even Clark Gable and Myrna Loy, as excellent as they are, can save a bad story or script."[39]

Rand managed to obtain Jack Warner's support and on many occasions she was on the set, "usually to protect her screenplay," Neal remembered. Blanke, whom Rand enjoyed and Vidor found a "charming fellow," nonetheless could be obstinate and in this case apparently restrained his director. It was Vidor's opinion that Blanke believed "women writers were infallible" and that Rand "could do no wrong. Not even Cooper could tamper with her dialogue."[40] One critic was surprised that the "combined power of Cooper, Vidor and Warner couldn't prevail to at least modify Ayn Rand's comic-strip dialogue."[41] We've seen that that option was not available.

Another critic, Charles Silver, said Warner was "indulgent," Vidor "tolerant" and Rand "proud" of a script that was "horrendous in its soft-minded polemics, blatant absurdities and tasteless excesses."[42]

Although she and Vidor worked on the screenplay before shooting began, Rand struggled rather successfully to maintain control of the script, perhaps remembering what happened to films of her earlier writing, in particular *We the Living* and *January 16th*, or her two screenplays for Wallis. Blanke was probably under orders not to allow Rand's theme to be watered down, an order with which, it seems, he agreed. Vidor's association with Blanke was "not happy,"[43] but in postmortem did he complain too much?[44]

The movie further suffered from what critic Robin Wood correctly described as an awkward duality inherent in the screenplay. The first half presented "the Neal character as central to its thematic network, with the relationship between power and sexuality a leading issue." In the second half the "power struggles" became "increasingly centered on men and money, and the woman withdraws into the background," no longer relevant to the plot.[45] John Walker correctly points out that in Rand's fictional writings women "show no desire or aptitude for creation, only an ability to serve powerful men."[46]

One of Cooper's biographers, Stuart Kaminsky, referred to Rand's dialogue as devoid of "realism," saying that the movie, including its sets, was "one of the most antinaturalistic films imaginable." Reviewers and commentators have failed to note that in Rand's book, as in the film script, people were rigidly set in personality and philosophy and their dialogue stylized to fit. Therefore actors' "speeches" tended to be "monologues on human behavior."[47] Rand's "Romantic Realism," as she called her literary effort, presented a conventional story and that is one basis of how the movie was—and should be—judged.

Rand has recounted a rather humorous incident that nonetheless highlights pressures on studios and preoccupations of the industry in the late 1940s. Hollywood's more-or-less self-censoring agency, the Motion Picture Association of America, or what was then called the Eric Johnston Office (its predecessor, the old Hays Office, had started in 1922), sent two representatives, one a Catholic priest, to discuss a script problem with Rand. It was not about the so-called rape scene or ethics or morality, but rather about Roark's courtroom speech at the conclusion of his trial. It was, they argued, too "materialistic," easily likened to Soviet materialism; strange,

since it was a monologue devoted to principle, to high moral integrity and American Protestant individualism.[48] Rand won the point.

While in production Rand thought the movie looked "very good"; she was "very pleased."[49] It was only after the film was released that she expressed negative reactions. Then she was disappointed, at brief moments furiously so. But in matters unrelated to the film she was not unhappy. Sales of the book jumped, her celebrity rose, she quit the film industry (well, nearly), and she soon left Los Angeles, again and finally. Her new public role was to be a guru of sorts.

What of the pictorial and scenic images of architectural modernism that were so fundamental to the entire enterprise? They proved to be a mixed lot that were patently misconstrued during production and after the movie's release, and brimming with social and political symbolism. However, to understand them and the opportunities available to Rand and to Warner Brothers people involved with creating cinematic art work, it is of value to look closely at Wright's architecture for the greater Los Angeles area just prior to early 1948, when production of *The Fountainhead* began. It is also important to understand Wright's personal relations with Hollywood people as they may have affected his perceptions or those of the Warner brothers, Vidor, Blanke, Carrere, Rand, the FBI, or the moviegoing public.

16

Hollywood Clients

Wright's interest in and relations with southwestern America were parallel with society's romantic enchantment with the people and places on the high desert plateaus of Arizona and New Mexico, and in the 1920s with Spanish California and Mexico, colonial and pre–Columbian. His reasons were much as theirs: contrast, complement, climate, landscape, color, exotic indigenous societies (at least to Eurocentric Americans), and escape. He was following a fashion. By the early 1920s Santa Fe was becoming a New England outpost. Later in the twenties Chandler/Phoenix, Albuquerque, and Tucson became tourist centers, Los Angeles home and workplace. Their vogue was directly related to attractive promotions by the Southern Pacific and the Atchison, Topeka and Santa Fe railroads, to Harvey restaurants and so-called trading posts, Boulder Dam, Indian culture, the opening of Mexico, and so forth; ventures that received exceptional popular attention.

Many visitors to the high plateaus were in some way attached to the artists, and were described as gadflies and aesthetes on a search for respite with "primitive" and seemingly unfettered cultures and for experiences of geographically unique and culturally "meaningful" places. But of course their psychological baggage and social dependency traveled with them.

One of the more prominent among early migrants, and not necessarily an atypical example, was the "heiress" Mabel Dodge. She had married the painter Maurice Sterne, a Latvian who settled in New York City in 1889. Around 1921 they settled in Taos. She tired of Sterne, they divorced, he married a dancer from Isadora Duncan's troupe and fled to Rome, Italy; she married Tony Luhan, a Taos Pueblo Indian. Immediately she began to gather about her an entourage of northern people, hangers-on and artists mainly, who were attracted by her "mindless ecstasy" and the offer of free room and board.[1] Mabel Luhan was "known for her literary and artistic salons" in New York and Taos that attracted "interesting and creative personages from all over."[2]

Among long-term visitors to her Santa Fe adobe abode were the painters Thomas Hart Benton, Georgia O'Keeffe, John Marin and photographer Ansel Adams. They and others were Luhan's link to Alfred Stieglitz and the stable of artists and photographers he supported with shows in his 291 Gallery in New York City. Stieglitz began 291 in 1906 as a venue devoted to modern French art as selected by himself and occasionally by author Gertrude Stein (in Paris) and photographer Edward Steichen.

Stieglitz was one of the first to exhibit and sell the work of American modern painters. There were the three mentioned above, plus Stuart Davis, Arthur Dove, Max Weber, and Marsden Hartley.[3] Stieglitz promoted the 1913 New York Armory Show, a part of which later traveled to Chicago and Los Angeles. However, between 1908 and 1911 at 291 he had exhibited Parisian modernists like Matisse, Toulouse-Lautrec, Rousseau, Picasso, Cézanne, and the sculptor of lumps, Rodin.

Wright was attracted to Stieglitz's group of radical individualists, as they personified a lifestyle and philosophic attitude he favored, if one confused by its many-centeredness. Nonetheless it "was a sincere revolt against the confines of outworn traditions and social injustice,"[4] and drew intellectual and social sustenance from the Paris avant-garde ambience, from Walt Whitman and Sigmund Freud. If drawing from other sources than did Wright (although Whitman was a shared inspiration) their rebellion against the conventional was similar to Wright's. In a letter of 1932 Wright had sought the support of Stieglitz (who was elsewhere described as one of Wright's "old comrades" and had opened a new gallery in 1925), O'Keeffe (who had married Stieglitz), Benton, and Steichen from his Fellowship's artistic and educational program.

Among others with whom he curried favor were the Mexican artists José Orozco and Diego Rivera, whom Wright also invited to support his Fellowship. Painter and sculptor Lucienne Bloch, daughter of the American composer Ernst Bloch, studied and worked for ten years in Paris. On her return Wright invited her in the mid–1930s to teach sculpture to the Fellowship. En route to take up the job at Taliesin she met Rivera in New York City. To Wright's chagrin Rivera hired her as an assistant fresco painter. The connection between Wright and the Mexican communists is otherwise unclear.[5] None of these New York or Mexican artists offered financial support let alone verbal.

In 1942 O'Keeffe received an honorary degree from the University of Wisconsin and on that occasion visited Wright at nearby Spring Green. She was quite impressed by the experience and a gift of one of his books.[6] After Stieglitz's death she presented Wright in 1947 with her painting *Pelvis with Shadows and the Moon*, saying in part that it was "only a small gesture of appreciation" for something she felt about him.[7]

In contrast to the freezing winters and sweltering, mildewed late summers in the upper Mississippi Valley, between 1929 and 1936 Wright was drawn now and then to the dry and sunny Phoenix area (but not Santa Fe). When for health reasons his doctor advised settling in a dry climate, in March 1937, after a trip to Palo Alto and Hollywood, Wright selected extensive acreage on a mountain range pediment outside Scottsdale, Arizona.[8] There he began to build a new home and studio, Taliesin West, or as first named, Taliesin of the Desert. But there were interruptions that proved invigorating and rewarding.

Wright was invited to prepare the January 1938 issue of *Architectural Forum*. He edited and designed each page. It was a unique publication that presented his old, new and unpublished work. Included were three-page foldouts, special type, paper, and color. Walt Whitman was often quoted. Reaction to the issue was formidable, not only by readers with letters to the editor (hundreds were received, though only

24 were printed), but by reviews in other magazines. This included the communist-centered *New Masses*, where reviewer Jay Peterson summarized: "So, at seventy, nature's architect is still young enough to throw away the old society and move toward the new. He consciously builds for it." In the same issue of *New Masses*, Wright's former Los Angeles client Elizabeth Noble wrote a criticism of a proposed federal arts bill.[9]

(Around this time publications about Wright had begun to proliferate. He was written up in *Coronet* twice in 1937, also in *Town and Country* in 1937; then the January *Forum* was released, and he was pictured on the cover of the 17 January 1938 issue of *Time* [with a related article]. Rand must have been certain of the correctness of including Wright in her thoughts about a fountainhead.)

Then in March 1938 Wright was invited to assume the Sir George Watson Chair of the Sulgrave Manor Board. The Manor, northwest of London, was one ancestral home of President George Washington, and was purchased by the board to serve as a memorial of friendship between England and America. The chair is a series of lectures (usually six) on a subject of the holder's choice. Because of commitments to the new European war, only four lectures were given in 1939 to packed houses at a new Royal Institute of British Architects (RIBA) theater. That same year they were published and given wide distribution.[10] Also in 1939 while in London, Wright was asked by the *News-Chronicle* newspaper to write about expectations for rebuilding of the great city after the war. On return he lectured to federal architects in Washington, D.C. Then *Life* magazine requested a house design that was published in September 1938, and it highlighted his Johnson Wax administration building on the cover with a full article in the 8 May 1939 issue. *Forum*, *Time* and *Life* were all in Time/Life stable.

In 1940 the RIBA found itself at a disadvantage when determining its next Royal Gold Medalist. Because of the war, many of those who might have been considered were in one way or another deemed unsuitable. Wright's 1939 visit was easily remembered, so with little significant opposition and to much acclaim he received the 1941 medal.[11] He was not awarded the AIA (American Institute of Architects) Gold Medal until 1949, aged 82.[12]

Also in 1940 the Boston Institute of Modern Art held a major exhibition of Wright's work and he gave two associated lectures. Later in the year he was the subject of a widely reviewed major exhibition at the Museum of Modern Art in New York. He also gave an address at the opening of a new architecture building at the University of Southern California. These and many other activities were widely published in diverse professional and social magazines. It was all a cornucopia of information for the inquisitive Rand, and later for people at Warner Brothers.

These few examples of personal and professional recognition in Europe and America illustrate that although he was generally ignored in the early 1930s, at decade's end he had reconstituted a career by the cumulative effect of essays, lectures, exhibitions, books, the Broadacre City proposal, the Taliesin Fellowship, awards, an autobiography, and finally architectural productivity that included clients associated with Hollywood.

1930s and 1940s

One theoretically interesting unbuilt project was a house for Ralph Jester, a Vermont emigrant. A friend of Wright's sister Maginel, Jester signed as a friend of Wright's Fellowship and then went to Hollywood in 1933 to "do some designing" for United Artists.[13] While in Los Angeles he lived briefly with the Elizabeth Noble family, Wright clients in 1930–32. By 1937 Jester was with Paramount and in 1938 with Selznick International, but in unknown capacities. He later designed costumes, perhaps beginning in 1955 in collaboration with four others for Cecil B. DeMille's *The Ten Commandments*, released by Paramount and nominated for best picture in 1956. Jester then did costumes for Paramount's silly costume farce *Omar Khyyam*, starring Cornell Wilde and Raymond Massey among a bevy of others. Then in 1958 and also for Paramount, Edith Head and Jester were nominated for best costumes for *The Buccaneer* (Paramount, with Yul Brynner and directed by Anthony Quinn). They lost to *Gigi's* designers, selected by MGM.

During 1937–38 Jester attempted unsuccessfully to obtain Wright's services for the preparation of architectural plans for a hotel and houses on a subdivision of Frank A. Vanderlip's Flying Triangle Ranch outside Santa Monica at Palos Verdes.[14] The Jester house, carelessly described by Wright as "a true abstraction," was apparently to be located at the ranch.[15] It was one of Wright's first applications of the circle to a building's plan; in this case he designed rooms shaped as drums with plywood walls. It preceded the much larger Loeb house. Construction estimates were much

Figure 16.1. Huntington Hartford house, Hollywood, California, 1947, project, floor plan; ©2003 the Wright Archive. A similar house plan by FLW for Paul Palmer for a site near Phoenix, Arizona, was published in *Architectural Forum*, January 1948.

114 PART IV. FILMLAND, WRIGHT AND RAND

Figure 16.2 and 16.2A. Huntington Hartford house, Hollywood, California, 1947, project, perspective drawing; ©2003 the Wright Archive.

too high (note the circular swimming pool) so the project was shelved. Jester and wife employed Wright's son Lloyd to design a house that was eventually built at another location in 1949.[16] Wright's Jester floor plan with swimming pool became, with enlargement, the equally theoretically rational Huntington Hartford house, a project of 1947 (Figures 16.1–2).

At the same time as Wright was drawing circles, he also worked with right angles to produce house designs for places elsewhere in the Los Angeles area. Six "typical" designs were completed in early 1938, each of a proposed 100 "all-steel" houses to be dramatically sited on the side of a high ridge, without the usual land terracing. The project envisaged the use of two-inch-deep channeled steel sheets appearing as ultrathin planes. The vertically jointed sheets expressed compressive support, those horizontal the dynamics of cantilever; all were viewed through large sheets of window glass.[17] Unfortunately the project was abandoned after a few months.

Finally in 1939 the George Sturges house was built to a Wright design under architect John Lautner's supervision (then being tutored by Lloyd Wright) in Brentwood Heights above Los Angeles (Figure 16.3). With its dramatic cantilever thrusting away from a sloping hillside the small house has attracted admiration since first published. Less theatrical, the Sidney Bazett house at Hillsborough (1938–1940) was constructed to a design based on the awkward geometry of the 1937 Hanna house in Palo Alto, but not on its plan.[18]

Figure 16.3. George Sturges house, Brentwood Heights, Los Angeles, California, 1939. Courtesy of the Wright Archive. A similar view was published in *Architectural Forum*, January 1948.

John Nesbitt, a Hollywood radio writer and film studio administrator, began with bit parts in *Kentucky* (Fox, 1938) and *The Sullivans* (1944), in which Anne Baxter starred. But these were incidental to his writing. In 1956 he was nominated for an Emmy award for the teleplay *Man with the Beard* and from 1956–58 he hosted a dramatic anthology television series called "Telephone Time."[19] In April 1949 he purchased the Wright-designed Ennis house (1924–25) and immediately asked the architect to provide ideas for major alterations to the interior. Fortunately for the integrity of the splendid original building, Nesbitt rejected the design. He had earlier asked Wright to design a new house to be built beside the sea at Cypress Point, Pebble Beach. The voluminous correspondence between client and architect over the next 18-or-so years suggests that Nesbitt became too involved with his architectural projects, worried about costs, and was uncertain about his relationship with MGM, one of his employers.[20] None of Nesbitt's schemes were realized.

Another person involved with Wright and Hollywood was the writer, producer, and director Arch Oboler, a friend of Nesbitt. Like Nesbitt, Oboler was involved in radio through the National Broadcasting Company (NBC), directing and writing plays for the show "Lights Out" and his own "Arch Oboler's Plays." In 1940 he began writing screenplays. The first was the anti–Nazi movie *Escape* for MGM, produced and directed by Mervyn LeRoy, and starring Norma Shearer and Robert Taylor. His initiation into directing movies was his own script for *Bewitched* (1945) for MGM. Based on one of his own radio plays, Phyillis Thaxter was the star of this "classy chiller." In 1942 he wrote, directed, and with Claude Rains (who starred), produced *Strange Holiday*, an interesting — if lecturing — political drama with a theme in opposition to fascism. Oboler eventually sold it to MGM, which released it in 1945, too late to be effective as wartime propaganda.

When stereoscopic films became technically feasible Oboler was quick to write, produce and direct the first-released 3-D movie, *Bwana Devil*, in December 1952. The process was developed and owned by Milton Gunzberg, who called it "Natural Vision 3 Dimension." It required two cameras and two synchronized projectors, and the audience wore special spectacles. It was a cheaper process than Cinerama,[21] introduced the same year with the involvement of Mike Todd, whom we will soon meet again.

In 1940 Oboler asked Wright to prepare house plans. "I suppose you'll want to build in that Beverly Hills!" Wright said; "Cardboard cracker boxes anointed with pink stucco."[22] The house, "Eaglefeather," was a dramatic and inventive monolith built in the side of a hill's crown with a dramatically long cantilever hovering over a precipice (Figure 16.4). Many developmental and construction drawings were prepared but it too was not built. The writer decided on a small house, a gatehouse, and construction began in 1940. This was followed by plans for a separate studio "retreat" begun in 1941.[23] Both were built over the years with many changes (and without Wright's supervision) on a site along Mulholland Drive overlooking Malibu.[24] Then in 1954 Oboler decided the gatehouse was to be the main house and asked Wright to revise and enlarge it. Unsupervised by Wright, construction began in 1954 and was discontinued in the 1960s. It was to be a stone building of three storys with, on the bottom level, a projection room.[25]

Figure 16.4. Arch Obler house, "Eaglefeather," Malibu, California, 1940, project, perspective drawing; ©2003 the Wright Archive. As published in *Architectural Forum*, January 1948.

In his capacity as a real estate developer, in August or September 1946 Huntington Hartford visited Taliesin West, liked it and asked Wright to design a Canyon Park hotel complex for a hilly site with a view overlooking Hollywood and beyond to Santa Monica Bay. It was to comprise a hotel, another Hartford house, and a resort club. Son Lloyd, who was going to assist his father, recorded the club's program as envisaged by Hartford: "a superlative relaxation center with riding stables, tennis courts, swimming pool, dining and full complement of club accommodations."[26] The proposed new house was a refinement of the Jester scheme.

Near the bottom of Hartford's hills and nestled in a ravine Wright placed the hotel, deeply cut into a hillside. At the hill's crest was to be the ritzy, exclusive club (Figure 16.5). Hartford was serious; he took the project to the planning commission almost immediately, but it was turned down, an appeal lost, the buildings not built.

The proposed club was such a dramatically different design from all that preceded or succeeded it that the source of its concept has been a mystery. A recently discovered letter from son Lloyd to his father in September 1947 provides an answer. In the canyons of the Colorado River cantilevered "Dish-like" shapes caused by erosion are found on ridge formations along the White, Glen, and Kanab Canyons and Monument Valley. Lloyd reminded his father of these shapes and then drew their profile. That seems to have inspired the amazing architectural response.

The architectural designs for Hartford were extraordinary, dazzling, round, horizontal, disc-shaped, triangular, vertical, dynamic; shockingly new. Wright was in his eighties when those visionary works were created. They were the *kind* of architecture the "genius" architect Howard Roark should have produced in Rand's mind and for the silver screen of our imagination.

Figure 13.5 and 13.5A. Country sports club for Huntington Hartford, Hollywood Hills, Los Angeles, California, 1947, project, perspective drawing; ©2003 the Wright Archive. Top as published in *Architectural Forum*, January 1948.

16. Hollywood Clients 119

The book *In the Nature of Materials* by Wright and Henry-Russell Hitchcock was released in 1943. It showed the architect's work up to that date including the California houses. In 1938 and 1948 the January issues of *Architectural Forum* were devoted to Wright's architecture.[27] Displayed were the Walker house for Carmel; Oboler's Eaglefeather, the Hartford resort club (on a two-sided three-page foldout); Taliesin West; the Johnson Wax administration building; an early proposal for the Guggenheim Museum for New York City; the Loeb, Pauson and Sturges houses; the Rogers Lacy Hotel (also on a two-sided three-page foldout), and other works including a dramatic concept for one of many projects for V.C. Morris, an extraordinary house near San Francisco of 1944–46 (Figure 16.6), for which a full set of working drawings had been prepared.

Perhaps prompted by common local knowledge that Warner Brothers was making a movie of *The Fountainhead*, in 1948 a young filmmaker, Erven Jourdan, made

Figure 16.6. V.C. Morris house, San Francisco, California, 1944–46, project, perspective drawing; ©2003 the Wright Archive. A similar view along with floor plans was published in *Architectural Forum*, January 1948.

what Lloyd Wright described as an "experimental" film about the "west coast work" of Wright Senior.[28] Little is known of Jourdan's other efforts except a movie released in 1960 that he produced, directed, and wrote titled *The Half Pint*, reviewed as a not-too-bad family comedy. Jourdan sought Lloyd's assistance, who transferred the request to father.[29] It seems that Kenneth MacGowan "of theater and movie fame," then director of the Institute of Modern Art in Beverly Hills, was one promoter, along with Gerald Loeb and architect William Gray Purcell, an old crony of Wright's in yesteryear Oak Park and Chicago then (1948) living in Pasadena.[30]

Wright Senior has not mentioned the movie but Lloyd described the color as "washed out," the photography poor, the editing "cut to a jazz tempo whirling into a maize"— or maze —"with weak comments by Purcell."[31] With MacGowan's connections the film probably came to producer Blanke's attention. Apparently a print (financed by Loeb) was given to New York's Museum of Modern Art, other prints were sold, and both Taliesin manors scheduled a showing, obviously with Wright's knowledge.[32]

When one considers Wright's southern California promotions, projects and buildings of the 1920s, Noble's apartments in 1930, the Sturges house of 1939, Hartford's club, the Morris house, or the many other lively, inventive projects of the 1940s, one sees that Wright presented for pubic consumption some diverse and adventuresome stuff. The designs were thoroughly new, a few appeared futuristic, none mainstream regardless of which stream one might consider, and therefore nearly all avant-garde. Collectively they were the inspiration for any movie art director or set designer whose brief was the creation of a new, bold, individuated, idealistic architecture. If the non–California works are included, then the source was even more plain.

Rand was wrong to insist that architectural designs for the movie must be in — or reflect — Wright's style. By 1948 he was discovering new vocabularies, not stylistic but wholly responsive to each new architectural adventure. There was no singular style. But, as we shall learn, the confused makers of *The Fountainhead* looked only to what Wright had created before 1938. They, like most architects and filmmakers, were trapped in a time warp of convention.

17

Hollywood Friends

Architectural commissions were not the only means of contact with Hollywood, the place, the industry and its people. As Wright was linked in popular perceptions to the New York village and Santa Fe artistic Bohemian communities, he was also associated more intimately with the infamous Round Table that in 1919 began gathering for lunch at the Algonquin Hotel in New York City's theater district. It became a forum for playwrights, performers, writers, and critics who excelled in humor, comedy, and ridicule. At one time or another and to around 1950 they had an intimate and highly successful association with the film industry. Some were friends of — others just friendly with — Wright. Some were welcome guests at his manors near Spring Green and outside Scottsdale, or he met them or sought them when on visits to Hollywood or Manhattan.[1]

Algonquin Circles

Alexander Woollcott, a wit, gossip, humorist, radio showman, theater critic, and essayist, organized the luncheons about a large round table in the hotel dining room. His demanding personality dominated the informal meetings such that he became the object of much comment. The restrained once-in-a-while member Helen Hayes once said, "The big wind was Alexander Woollcott … the self-styled arbiter of protocol. There was nothing in between. He believed he was the center of the universe and that, since he was the sun, everything and everybody revolved around him. They did. It was mass hypnosis, I suppose."[2] Woollcott went on to gain such national popularity that he played himself in the Mickey Rooney and Judy Garland film for MGM, *Babes on Broadway* (1941). Later his and George S. Kaufman's play *The Dark Tower* was turned into a poorly made film in 1943 by Warner Brothers.

Journalist and author Ben Hecht was another not amused by the amusers. "Fine actors, actresses, composers and writers were among" Woollcott's "coteries." But "fineness was a secondary matter…. Success was the only proof of artistry, or even intelligence. If you failed you were a fool and a second-rater."[3]

In April 1925 Alexander Woollcott visited Madison, Wisconsin, and by telephone managed an invitation to Wright's hibernacle. It was their first meeting and indicative of Woollcott's desire to find "his own causes" and stand up "for them, vocal and alone,"[4] much like Wright. At this time, we've learned, Wright was ostracized

socially and professionally. Woollcott openly praised Wright. A better known example was in 1930 when he concluded that if "I were suffered to apply the word 'genius' to only one living American I would have to save it up for Frank Lloyd Wright."[5] A mutually stimulating friendship developed and Wright observed Round Table shenanigans. Wright has said, "I have seen Aleck bubble with wit in his lair by the river and scintillate in his seat with the mutual admiration society at the Algonquin." At another time he said:

> a colorful cynic, a man of the world but a bitter smart Aleck. The man who came to breakfast is a true friend, an esthetic enthusiast, lover of fine things, one who well knows why he loves them — a man of rare discrimination as well as master of a wit seldom at its end. The kindest, most generous man I know is Aleck.[6]

This was written about the time Wright had, so it seems, asked Woollcott to become director of the Taliesin Fellowship: he declined. So had Lewis Mumford.

Wright once wrote a tale about "The Man Who Came to Breakfast."[7] Woollcott had played himself on stage in a drama about him written in 1940 by Moss Hart and Kaufman titled *The Man Who Came to Diner*. A woolly faced Monty Woolley played Woollcott's role in the film version for Warner Brothers.

In an amazing gesture, in 1937 Wright gave Woollcott a boxed set of Hiroshige's prints, *Fifty-three Stations of the Tokaido*, landscapes he described as "starting at dawn from the bridge in Yedo and ending up at Kyoto in the sunset." The cover sheet of the set was carefully lettered: "This Japanese classic complete in original state to Alexander Woollcott a token of affection from Frank Lloyd Wright Taliesin — August 1937." Wright concluded his cover letter of explanation to Woollcott saying that "Their [the prints'] significance has changed the Western art world for the better in the elimination of the insignificant so badly needed. Cherish them for that if nothing else."[8] Totally surprised and much embarrassed by the gift, Woollcott began a thank you note, "I don't know quite what to say, which is not a characteristic difficulty."[9]

Many of Woollcott's fellow table-sitters became successful in Hollywood. The affable Robert Benchley went on to appear in movies in the 1930s and 1940s. He "signed" his name in 1932 to support Wright's Fellowship venture. Wright had actively solicited at least 130 people to lend their names as some kind of ritual and moral aid to Wright by becoming a "friend" of the Fellowship. Woollcott also signed in 1932 and may have provided a loan. It is not known if any others provided financial assistance. Author, poet, tease, and *Vanity Fair* columnist Dorothy Parker sat at the Table. When asked she became a Fellowship friend. With political and economic views far to the political left, Parker moved to Hollywood in the mid–1930s to become a screen writer. Her better known credits include Selznick/UA's *A Star Is Born* (that of 1937 with Janet Gaynor) and Fox's *The Fan* (1949).

(Parker: "If all the girls at Smith and Bennington were laid end to end, I wouldn't be surprised."[10])

Marc Connelly, a Broadway director and writer from around 1910 and into the 1930s, was an intimate of the society at the Algonquin. He became Wright's friend and later in Los Angeles that of Wright's son Lloyd. Together with Kaufman, Parker,

and Woollcott, Connelly was included as an "Advisory editor" to *The New Yorker* after it began in 1925.[11] The magazine's founding editor Harold Ross was — not surprisingly — one of the Algonquin crowd. Connelly collaborated with Kaufman on six books, wrote scenarios for silent screen and, after moving to Hollywood in the thirties, followed them with screenplays. He collaborated on the 1937 film version of Rudyard Kipling's *Captains Courageous*, directed by Victor Fleming for MGM. His most important stage drama is considered *Green Pastures*, released as a film in 1936. Henry Blanke produced it for Warner Brothers while Connelly directed portions and collaborated on the screenplay with Sheridan Gibney. Of Connelly the balanced summation is: He "was a man of enormous popularity but little lasting influence."[12]

Ring Lardner visited Taliesin in the 1920s and 1930s before his death at age 46 in 1933. Lardner, like Heywood Broun, began as a sportswriter, and he too sat around the Table. Many of his stories were made into movies like Paramount's *Fast Company* (1929), an adaption of his and George M. Cohan's comedic play *Elmer the Great*. Then there was Lardner's short story of conceit and hate, *The Champion*, about a boxer. Carl Foreman adapted the story for Stanley Kramer's 1949 Screen Plays/UA production, which starred Kirk Douglas and Marilyn Maxwell.

(An acquaintance whose recently deceased brother had written a poem asked Lardner to recite it. After scanning the poem he asked: "Did your brother write this before or after he died?" On another occasion Lardner bumped into a classical actor with long wild hair and asked: "How do you look when I am sober?"[13])

Lardner's son Ring Jr. became an author and wrote screenplays. Among them, MGM's *Woman of the Year* won an Academy Award for best original screenplay in 1942, and *M*A*S*H* (1970) took another Oscar plus the Grand Prix at Cannes. In the 1950s he was among those unjustly stained as one of the FBI's and Department of Justice's Hollywood Ten.

The McArthurs began as Oak Park boys. Warren became a Wright client in 1892, 1900, 1905, and his son Alfred employed Wright in 1927 to work on the Arizona Biltmore hotel commission (1927–29). Alfred's brother Charles MacArthur (sic) was employed by an Oak Park newspaper before joining another in Chicago. He joined the Algonquin society on moving to New York City in 1926 to work for *The American*, another newspaper. Soon he decided to devote his full time to playwriting. Independently or in collaboration, often with the irrepressible Ben Hecht, his films became many, including *The Front Page* (based on a 1928 play written with Hecht, 1931 for UA, then 1974), *The Scoundrel* (1935, again with Hecht), *Gone with the Wind* (1939, among many uncredited writers), and *Wuthering Heights* (Goldwyn/UA, 1939).[14] Still an ingenue, Helen Hayes was introduced by Connelly, to the Algonquin table where she met MacArthur.[15] In 1932 MacArthur signed as a Friend of the Fellowship. He and Hayes maintained a marriage that began 1928 with Woollcott as best man. Their friendship with Wright apparently remained firm if sparely exercised.

(A certain New York critic known as a homosexual panned the Hecht/MacArthur play *Ladies and Gentlemen* of 1939 and its principal actress: "the trouble with Miss Hayes is that she has been seeing too much of Charlie MacArthur." The next day when friends wanted to know MacArthur's revenge, he said, "I've already taken care of him. I am sending him a poisoned choirboy."[16])

The Round Table players also included authors Edna Ferber and Donald Ogden Stewart, newspaper journalist Heywood Broun, actress Peggy Wood, and Connelly's sometime collaborator George S. Kaufman (credited with over 33 film scripts). The players' influence on the nation's funny bone and entertainment industry was significant. As theater critic Brooks Atkinson said, the clique "changed the nature of American comedy and very largely established the tastes of a new period in the arts and theater."[17] Yet one can imagine the tensions in that "mutual admiration society." Hayes observed "How intimidating they could be.... That divine circle could be so corrupting and so destructive. The smallest infraction could result in lacerating ridicule."[18] When Margaret Case Harriman wrote as the daughter of the Algonquin Hotel's owner, she described them as "The Vicious Circle." Gathering at the table petered out around 1930,[19] perhaps a result of talking films or the depression, or snickering exhaustion.

(Ferber, who liked wearing tailored suits, once ran into Noel Coward who remarked, "You look almost like a man." "So do you," she replied.[20])

Woollcott's egoistic ring included people attractive to Wright socially, but to be identified with them and the theater world was important to him professionally. Harold Clurman, Cheryl Crawford, and Lee Strasberg formed the Group Theatre in 1931. Still broke and looking for architectural commissions, in 1932 Wright invited the three to see a "new theater" he had designed "that would inspire and match the young company's ambitions." As Peter Hay has recorded, the directors were "struck dumb by Wright's passionate presentation," if not the ill-conceived theater. Clurman was the first to speak.

> "But Mr. Wright," he stammered, "where can we find a place for such a theater in New York City?"
> "Oh," the reply with withering scorn, "if you wish to remain in the rubbish, noise, and filth of New York, then you are not as advanced as I thought you were."[21]

For many years Wright maintained a suite at New York's Plaza Hotel.

More successful was Wright's association with Lloyd Lewis who, in the early 1920s in Chicago, wrote sports news and drama criticism for the *Daily News* and then became managing editor of the *Sun-Times*. A versatile man of letters, between 1929 and 1949 he wrote biographies of Lincoln, General Sherman, Oscar Wilde, and (his passion) U.S. Grant. Lewis' association with the MacArthurs and the Algonquin people was uniquely close. Marc Connelly dedicated his autobiography (of sorts) to "the memory of Lloyd Lewis"; others spoke fondly and highly of him. In the 1920s Lewis and Wright were members of the Tavern Club, where writers, journalists, playwrights and artists met in a Chicago sky-scraping top floor.

Lewis often visited Wright at Spring Green, and finally in 1929 he and his wife Kathryn asked the architect to design a house. The site was on the Des Plaine River at Libertyville. Among housewarming guests in 1941 were MacArthur, Hayes, Harpo Marx, Wright, Connelly, and Woollcott. (Along with others, Marx and Hayes were deemed by the Department of Justice to be "Red."[22]) Wright's 1949 eulogy of Lewis mentioned they were "dearest" friends "through the thick and thin of the better part of my lifetime and his."[23]

Those literary artists satisfied their creative impulses by employing a keen, sharp knowledge of America's soil, traditions, history, and experience. They were convinced that human qualities good and bad were inevitable. Yet pride, humor, and optimism were essential ingredients to survival, and therefore to their work. Sherwood Anderson's inspection of small-town America, notably his classic *Winesburg, Ohio* (1929), was eagerly embraced by Wright, who enjoyed Anderson's company. Anderson was close to Stieglitz, Mabel Luhan and some of her Taos gang like O'Keeffe (who Wright asked to teach at Taliesin but she demurred), and Theodore Dreiser, as well as Ferdinand Schevill. Schevill and his wife Clara were "devoted friends" of Anderson and Wright. Anderson was an ally of Ben Hecht and others of the Algonquin literati. In October 1930 Anderson circumspectly told the Schevills:

> I have been thinking a good deal about Wright....
> There is something pitiful there, something that should arouse our most tender feeling.
> We do have to take intuition in spite of the muddle of fact.
> I dare say Wright, when he is alone, does have humble hurt moments....
> My heart bled for Wright when Ferdinand took me to his exhibition.

The exhibition was held during September and October 1930 at the Art Institute of Chicago where Wright gave a talk not dissimilar to that he gave at Princeton University the same year. Displayed were recent unbuilt projects (many of uneven quality) or buildings long ago completed. Anderson said of Wright, "I'll write a story about him someday."[24] Too bad he did not.

Schevill was Wright's age and from 1892 to 1937 was professor of history at the University of Chicago. When Frank Lloyd Wright, Inc., was formed in 1928 to prevent bankruptcy, the Schevills invested along with former Wright clients Darwin Martin (of Buffalo), Mrs. Avery Coonley (of Chicago then Washington, D.C.), Harold McCormick (of Chicago and Lake Forest), sister Jane, ex-wife Catherine's new husband Ben Page, Wright's lawyer Philip La Follett, George Parker of Parker Pens, and Alexander Woollcott.[25] The Schevills also invested in an ill-fated publishing venture of Anderson's. "Poor, great Sherwood!" said Wright, "Ferdinand loved him more than he loved me, because Sherwood was so much more lovable."[26]

Anderson and Schevill signed as Fellowship friends in 1932. So too did Joseph Urban, a talented New York architect who had emigrated from Vienna and designed decorations and sets for stage and many movies beginning in 1918. Urban's devotion to the arts and crafts was attractive to Wright (at least initially), who liked him rather more than his architecture or designs. Urban did the scene designs for Jerome Kern and Oscar Hammerstein's musical *Show Boat*, which opened in New York 1928.

Along with Woollcott, Ferber was one of the Algonquin stalwarts.[27] Films of her novels are many and include *Cimarron* (RKO, 1931; MGM, 1964), *Saratoga Trunk*, *Giant* (Warner Brothers, 1956), and *Show Boat* (1929 and 1936 for Universal, 1951 for MGM). Ferber was an occasional yet honored house guest of Mabel Luhan in New Mexico.[28]

Robert E. Sherwood's pacifism and worries about sustaining traditional values while examining social inequities were similar to those expressed (if not activated)

by Wright prior to 1917. Many of Sherwood's books were made into films: *Abe Lincoln of Illinois* (RKO, 1940), *The Petrified Forest* (1936, 1945), and *Waterloo Bridge* (Universal, 1930; MGM, 1940; and 1955 as *Gaby*). Standing beside the Algonquin lunch table the two would have been a sight: Sherwood a lanky six-eight tall and short-cropped, Wright a thin five-seven and wavy-maned.

As a postscript we can mention that Edna St. Vincent Millay had a passion for life and the Bohemian activities in Greenwich Village. The poet, playwright, and author now and then visited Wright at home in Spring Green and willingly signed as a friend in 1932.

The Petitioners

A recognition of those inevitable human qualities of good and bad knitted to a sustaining optimism as integral to themes of many plays by Thornton Wilder (occasionally among the Algonquin crowd), and they were shared by Wright. Films of Wilder's works include *Our Town* (UA, 1940), *Hello Dolly* (Fox, 1964, based on his play *The Matchmaker*), and he wrote the film script *Shadow of a Doubt* (1942) for Alfred Hitchcock. In 1943 Wright prepared a petition that, when signed, was sent to President and Eleanor Roosevelt. It called upon the federal government to financially support further study of Wright's Broadacre City concept because, he said, it was "the basis for a true capitalistic society."[29] He solicited about 75 "well-known men and women" to sign, and many did so. Occasionally Wilder visited Taliesin and he signed. So to did Connelly, Sherwood, Stieglitz, Benton, O'Keeffe, and the art historian and Stieglitz follower Thomas Craven, who had written an article about Wright.

But not all the people Wright solicited had signed. When a list was published, seven signatures had "not yet" been obtained, but in fact there were other people had been asked but refused. Wright had asked Erich Mendelssohn, a German émigré architect, to ask the German émigré mathematician Albert Einstein if he would support the petition. Einstein replied that he did "not believe in the possibility of a decentralized production at least if it is based on private enterprise." Therefore he could "not support" Wright's plan as outlined.[30]

In letters forwarding the petition to potential supporters Wright spoke of his beliefs in the countering effectiveness of a proper democracy and in the idea that future wars could be prevented by institution of the economic theories and social philosophy supporting his Broadacre City. For example, when he wrote to another German emigré then at Harvard University, architect Walter Gropius, he thanked him for hosting a visit to Cambridge, Massachusetts, a few years before, and then included a short paragraph sent to all that concluded with, "I choose my own weapons and fight for Democracy and true capitalist system my way.[31] His war was without gun powder.

Connelly signed the petition (Wright called it a "creative citizenry's voice"), but his name was not recorded. Wright also asked Connelly for the addresses of a few Hollywood people: all-rounder Orson Welles, French director René Clair, designer Richard Day, director John Ford, writer Preston Sturges ("the bastard — never answers me"), and writer Dalton Trumbo.[32] Welles (who at the time of his fame with Mercury

Theater supported the artistic activities of *New Masses*, and with whom Wright dined sometime in 1941), Day and Ford did not respond. On a visit to Los Angeles in 1942 Sturges introduced Clair to Wright, who was known to Clair through Robert Mallet-Stevens, a Belgian Paris-centered architect and sometime film set designer. Clair had been in America for little more than a year thanks to Robert Sherwood, who had secured a visa for the Clair family. The Frenchman signed a contract with Universal Pictures in recognition of his legendary satiric and comedic films of the 1920s and early 1930s. But his later work in England and America was not well received. He returned to France in 1946.

In February 1942 Wright threatened to invite Clair, Sturges, Trumbo, Welles, and Ford for a weekend at his home but thought better of it: "too many rams at one time in any ram pasture is no fun," he said.[33] Clair did not sign the petition and did not visit Taliesin, nor did the others including Trumbo.

Wright tried without success to develop friendly relations with Trumbo. He had met the writer in February 1942 on the same trip when he met Clair. He later wrote Trumbo reminding him of a promise to visit Taliesin West, adding that there was a "definite spiritual relationship" existing between the two men "that might be cultivated."[34] It never was, not even when Trumbo was in strife with HUAC. But we've noted (and so did the FBI) that Wright did sign a petition in 1950 asking that Trumbo and seven others of the "Hollywood Ten" be released from jail. While Wright was somewhat reserved with Trumbo, like a teenager he gushed over Sturges.

As a "stranger" Wright visited Sturges on a Paramount sound stage during the shooting of *Palm Beach Story* in 1941. On meeting, Sturges placed Wright in actress Mary Astor's lap as penance, apparently, because "she muffed her lines." Then Sturges took the elder architect to lunch. Wright thought Sturges was "just gorgeous…. Just gorgeous," he repeated, and Wright was "flattered to have the greatest moving picture director of all time" be nice "to just an architect like me." And so forth ad nauseum.[35] There was good reason for Wright's enthusiasm, if not his inelegant effusiveness. Sturges was hailed as a "comic genius."[36] His most notable film, *Sullivan's Travels* (Paramount, 1941), described as a "brilliant and often devastating profile of Hollywood and the real world beyond the rosy perception of tinseltown, is Sturges' greatest film, although the inspired, gifted, and socially incisive Sturges would put many masterpieces on celluloid."[37] Sturges wrote *Travels* to stir "fellow comedy-directors" who had abandoned "fun in favor of the message," trying to be "too deep-ish"; preaching, he said.[38]

Travels had succeeded a number of comedies by Sturges such as *The Good Fairy* (Universal, 1935, with William Wyler as director) and *Easy Living* (Paramount, 1937). That was followed by the popular if less critically won *Palm Beach Story* (1942), which Wright described as "another Sturges wow!"[39] The *Sullivan's Travels* screenplay was written with Joel McCrea in mind. When Sturges first approached McCrea (at the studio canteen) he said,

> "I've written a script for you."
> "No one writes a script for me," said McCrea with a smile. "They write a script for Gary Cooper and, if they can't get him, they use me."[40]

McCrea's sensitive portrayal in *Travels* was equal to his role in *Foreign Correspondent* (UA, 1940). Wright had obtained a print of *Travels* and after viewing it he told Sturges "that the creative touch that is yours and endears you to me is rampant in the whole thing."[41]

One of the more interesting people in Hollywood was Walter Wanger who did sign Wright's 1943 petition. He knew Woollcott from the days of World War One and was familiar with all sorts in literary and theatrical fields.[42] He eventually became a producer with MGM during 1939–1944, and after the war moved in high administrative echelons with Paramount, then Columbia, then United Artists. Mary Pickford and Charlie Chaplin, virtually co-owners of UA, selected Wanger to anonymously supply films for distribution. Wanger was seen as a "gentleman of breeding, college educated, and given to making lofty statements about the social responsibilities of the filmmaker and his educational role in a democracy," as a man who had made "daring yet tasteful" films, "politically provocative," appealing yet cheap.[43] His production company began in July 1936; its output included *Stagecoach* (Fox, 1939) and *Foreign Correspondent*. After Wanger Productions folded he produced *Tom Jones* (Woodfall/Lopert, 1963, voted best film). But Wanger was sacked as producer for failing to control costs for *Cleopatra* (1962), losses that nearly forced the closure of Twentieth Century Fox.[44] He also served a jail sentence on conviction of shooting Joan Bennett's agent.[45]

After a meeting with Wanger in early 1941, Wright rather crassly used him as an agent, of sorts, to obtain movies. Wanger did not complain and they maintained a careful relationship. It was probably through Wanger that Wright eventually came to meet Clair, Trumbo, and Sturges.[46] Wright believed Wanger had a greater interest in "the men behind this thing we call the cinema" than in actors. He surmised this was so because he was an architect. When asked if he would fight for democracy Wright's way and sign the petition, Wanger eventually said yes.[47]

In seeking support for the petition Wright approached people he had never met, casual acquaintances, friends, clients, even families of his apprentices. The intention was to impress President Roosevelt with names of the "well-known," as Wright put it. The exercise failed.

Those Profound and Free

Harry Seckel neatly summed up Wright's reputation and image in 1938. By that year Wright had received honors from around the world and within America his practice was revived, yet "people either despise or idolize him," Seckel said; "One must peer through a cloud of adoration and aversion to see the real man and his architecture." (One suspects Wright enjoyed that observation.) Seckel continued:

> He is immaculate and dapper, and follows a style that is his very own ... he will sometimes appear in rough clothes, but even then his apparel suggests the deliberate effect of the costume.
> He has pride in himself that at times is rather childish, but it is of the kind that amuses rather than irritates....
> He shamelessly parades his rather miscellaneous erudition. Occasionally he enriches his conversation with a Japanese word.

> He adores adoration. Disciples are a necessary part of his existence. In short, he is an architectural Isadora Duncan. How much like Isadora the arresting personality, the enormous ego, the illogical, piquant, clairvoyant mind, the odd mannerisms! How similar the unconventional life, the silly publicity?
> Like Isadora he has a sense of showmanship. He makes the usual seem unusual.[48]

In England the architectural profession was similarly and elatedly confused. Journalist "Murus" wrote that Wright was an egoist and an idealist. If Murus were to throw a party the most desirable guests would be Gordon Craig, Ouspensky, Augustus John, and Wright, while his co-hostess would be Duncan — all "profound and free."[49]

The linking of these people suggests that the substance of Wright's architectural work had become less important than himself, the social man who conducted such an extraordinary life: the medium had become the message. The Murus and Seckel circles touched or paralleled the careers of Olgivanna and Frank.

Edward Gordon Craig, bastard son of actress Ellen Terry and architect Edward Godwin, was a British expatriate of sorts who resided mainly in Florence. A theater critic, historian, and notable set designer, he supported Soviet theater during its early, most creative years. Craig's idea to free theater space from the bondage of proscenium and wing as taken by Wright for projected theaters in 1902 and 1915, Aline Barnsdall's of 1919 for Los Angeles, and later projects.[50]

Duncan was an American expatriate dancer who rejected conventional ballet dress for flowing draperies and bare feet. She danced in Russia in 1905 and influenced Diaghilev, Fokine and Benois. She led an open unconventional life, bore Craig's children and introduced him to Constantine Stanislavski; from that developed a significant theatrical relationship. On learning of the 1917 Bolshevik revolution she was "filled with hopeful joy" and in 1921, on invitation from the Soviets ("[We] alone can understand you. Come to us"), she departed for "the ideal domain," Moscow.[51] Her attitude to free love was drawn in part from the philosophy of Ellen Key, an inspirational source shared by Wright and his former mistress, Mrs. Mamah Cheney, before her death in 1914. Duncan's life with Craig and then with playboy Paris Singer were well known, as were her personal tragedies. Two of her children died when her automobile rolled into the River Seine. She died in 1927 when a flowing scarf caught in the rear wheel of a sports car in which she was riding, strangling her.

Murus also mentioned Augustus Edwin John, a British portrait painter who spent some youthful years living with gypsies. In 1914 the Dutch architect Robert van't Hoff, then living in London, had designed a house for John. He also visited Wright in Wisconsin and suggested collaboration on a new house-museum on Long Island for a friend of John's, but the project got no further than words.[52] John was engaged in London's Bohemian scene where he met New Zealand expatriate author Katherine Mansfield.

The Russian journalist and author Petr Demianovich Ouspensky was a vocal apostle of the mystic Gurdjieff. It was in Gurdjieff's Institute for the Harmonious Development of Man that, ca. 1922, Ouspensky knew the woman who became the third Mrs. Wright, Olgivanna Hinzenberg. Ouspensky lectured far afield, visited the Wrights, and in London attracted Mansfield to eventually attended Gurdjieff's institute,

then located outside Paris. Olgivanna, who by then had become a Gurdjieff "instructor," and Mansfield became good friends.[53]

Preston Sturges was a bright connection between the Europeans and Americans, having lived in Europe for many years and, as a child and young man, having been a close friend of and often companion to Duncan, Craig, Singer (who also lived in Florida for a time), and John. Sturges died 1959 in an Algonquin Hotel room.[54]

From about 1910 to 1935 the arts and society-based European circle of followers and occultists was extensive. Wright was seen as one of America's more obvious associates, so to speak, to those fluctuating, popular and avid publicity-seeking associations. The Europeans were as selfishly devoted to an unreal and sham-aristocratic world as the Americans were pragmatic. Wright wandered rather naturally — perhaps giddy but directionless–in both realms while participating seldom, and then awkwardly.

The activity that united Wright's philosophy and its varied practices was the Fellowship. The spirituality of that philosophy and the manner of life in its practice — although not for the apprentices — was attractive to many, as was Wright's apparently quixotic and flash personality. Around 1940 during the frightening turmoil generated by Nazi Germany in Poland, Czechoslovakia, and elsewhere, Wright was engaged in rewriting his 1932 autobiography. Out of context and much as a reverie about the 1930s he inserted the following:

> Young people had come from all over the world ... to share its [Taliesin's] spirit; to learn I suppose what message the indigenous United States had for Europe. And, evenings, after good work done, the piano, violin and cello spoke there the religion of Bach, Beethoven and Handel. William Blake, Samuel Butler, Walt Whitman and Shelley often presided. Carl Sandburg, Edna [St Vincent] Millay and Ring Lardner, too, had something to say or sing. And life in the hills revived for the little cosmopolitan group eager to know this "America," for Taliesin was at work quietly Americanizing Europe while American architects Europeanized America.[55]

The impending war bothered him; the good old composers, painters, and poets thrilled him; like-minded friends sustained him; and the success of the central European and internationalist's architectural aesthetic continued to rankle; no: it made him damn mad.

For many of those like-minded creative artists in the letters, motion pictures were another medium to expose their talent and express their philosophy. For unknown but probably no peculiar reasons, from mid–1930 Wright was drawn to those who created movies. The word he used to express the joy of but one friendly and instructive talk with Wanger was "companionship." Wright only occasionally but sufficiently dropped a few of their names in revisions for his autobiography as released in 1943.

It can be understood, therefore, that Wright's relationships with the movie industry were many and diverse. Except for the odd occasion, initiating and maintaining those relationships was made by Wright. There is no evidence of the Hollywood industry or its people indicating other than the occasional professional interest.

This one-sidedness is confirmed by the fact that the New Mexico, Hollywood, and Algonquin cliques did not mention Wright in their autobiographies and, with very few exceptions, he is not mentioned in their letters. Neither did their biographers see fit to record Wright's involvement. Nonetheless, as current knowledge indicates his strong desire to be associated with those popular artists and celebrities. He happily assisted the public's perception of at least a social if not a committed philosophic affinity.

18

The Fountainhead's Visual Images

In recent practice a production designer is assigned to work collaboratively with the film's producer and director on all visual effects of a movie by coordinating all the designers. Around the time of producing *The Fountainhead*, the movie industry's art directors, set designers, cinematographers, and costume designers—the visual artists—had fairly independent roles, the whole determined more by the producer and director. It is the responsibility of the visual arts to create physical effects, the environments that support, clarify and enhance the objectives of the screen play.[1] Movies are, after all, a visual medium, only secondarily employing sound. A key element of *The Fountainhead* was the philosophic trials of an architect. While experientially architecture engages all the senses, for moving pictures it is only visual, and on screen is limited to two dimensions that must imply a third.

In the instruction at the beginning of her screenplay Rand wrote, "It is the style of Frank Lloyd Wright—and *only* [she emphasized] of Frank Lloyd Wright—that must be taken as a model for Roark's buildings. This is extremely important to us, since we must make the audience admire Roark's buildings." We will soon discuss the poverty, the suffocating trial of that instruction. For the moment we need to know that Rand discovered Roark's buildings were assigned to "a studio set designer ... who had been trained as an architect but had never built anything," meaning Carrere had not practiced as an architect. She also thought that he and Vidor apparently "got pictures of *horrible* modernistic buildings and copied them" (horrible was emphasized); the copies she judged as "embarrassingly bad."[2] She was consistent. During filming Rand told Gerald Loeb she did "not like" the designs.[3] But an architectural aficionado or critic she was not.

Talk on *The Fountainhead*'s sound stage was slightly different and went something like this. Once it was known that Warner Brothers was producing the film, the studio received "from Architects throughout the country" about "twenty letters" a day with suggested designs. And when Wright was known to have refused the job, the neophyte Carrere was given a rough time because "everyone" took a "hand designing the show." In the matter of design, the "performance" of Warner's upper administrative echelons was deemed "a complete travesty."[4] But what did Carrere and colleagues create for the film?

Architecture

The presentation of modern architecture, that is, architecture not based on traditional and historical precedents, has been an intimate if limited part of filmmaking since the 1920s. Its inclusion occurred almost at the moment it was being created, if not publicly accepted. Production design of imaginary buildings includes interior design (or less attractively put, "decoration") and furnishings, and they necessarily jointly evolved. This connection is illustrated by Joseph Urban's art and crafts — European, not English or American — interiors designed for the silent *Enchantment* (1921), acknowledged as the first use of modern architecture and interior design in American films. In the 1920s European filmmakers lead the way just as had European architects, but only *after* they absorbed and revitalized the style of Albert Kahn's industrial buildings and carefully weighed Wright's ideas and concomitant designs just after the turn of the century.[5] It was those buildings, exemplified by Kahn's utilitarian aesthetic, that European architects settled upon. Coincident with America's recognition of Continental modernism, Hollywood producers, directors, and visual artists responded. Therefore, the use of the European version of modern architecture in American movies began around 1930.[6]

Figure 18.1. Apartment interior for United Artists' *Palmy Days*, art director Richard Day, set director Willy Pogany, 1931, Edward Sutherland, director. From Albrecht (1986); courtesy of MGM Clip-Still; ©1931 Goldwyn Entertainment, all rights reserved.

Figure 18.2. Lobby for Metro-Goldwyn-Mayer's *Grand Hotel*, supervisory art director Cedric Gibbons, unit art director Alexander Tolubott, 1932, William A. Drake, director. From British Film Institute; © Warner Bros. and AOL Time Warner.

Architectural styles employed in films prior to about 1941 were many (Figures 18.1–5). They ranged from Arts and Crafts to American Art Deco in the 1930s (*Gentlemen of the Press*, 1929, and *Arrowsmith*, 1931); to the more complete if industrial — or Bauhaus—*Dodsworth* (1936); to rather Wrightian themes (*Moon Over Miami*, 1941, and *Lost Horizon*, 1937); to something akin to Russian constructivism (less so *The Black Cat*, 1934, than some Russian Soviet movies such as *Aelita*, 1924); to the European aesthetic from the 1920s onward (*L'Inhumaine*, 1924, *What a Widow!* 1930, *Black Cat* and the musical *Palmy Days*, 1931); to the curved streamlining mixed with Art Deco for *Grand Hotel* (1932); to a science fiction pulp-magazine futurism based on modernism as exemplified by Germany's *Metropolis* (1927) and later Britain's *Things to Come* (1936, with Cedric Hardwick and Raymond Massey), based on the H.G. Wells novel *The Shape of Things to Come*.[7]

As well, there was a southern California adaptation of a compromise of European modernism and Art Deco that reached a stylistic epitome in buildings for the Chicago World's Fair of 1934. In Hollywood this style was occasionally and successfully presented in films where the prolific Gibbons was art director: *The Easiest Way* (MGM, 1931), *Men Must Fight* (MGM, 1933) and (more Wrightian) *Big Business Girls*,

Figure 18.3. Interior in Samuel Goldwyn's *Arrowsmith* for United Artists, Richard Day, set director, 1931, John Ford, director. From the first arch and to the right is a perspective matte drawing. From British Film Institute; courtesy MGM Clip-Still, © Samuel Goldwyn Jr., all rights reserved.

and other films.[8] A new house at Santa Monica for Gibbons and his wife, the actor Delores del Rio, was designed in this style by Douglas Honnold in 1934–35.[9] It should be mentioned that some of the sets for Ayn Rand's *Night of January 16th* (1941) for Paramount are in a comfortable but less dramatic modern mode than Gibbons'.

Throughout its history in movies, modern architecture has been usually characterized as something urban and unadorned. Of course styles were now and then mixed together for one set, sometimes with historical themes, to form an eclectic hodgepodge.

The Fountainhead was far from unique in attempting to employ modern idioms. Films of the post–World War II era usually employed 1930s varieties of modernism, for example many scenes in Paramount's *The Big Clock* (1948) with art direction by Hans Drier, Roland Anderson and Albert Nozaki. Use of those varieties persisted well into the 1950s[10] and held true for *Fountainhead*. The Carrere, Tuttle, and Kuehl designs should be compared to those for such films such as *L'Inhumaine*, directed by Marcel L'Hubier, designed by Fernand Léger (whose sets looked much like his paintings, but

Figure 18.4. Production design by Richard Day and Wiard Ihnen of hotel exterior for Fox's *Moon Over Miami*, 1941, Walter Lang, director. From Albrecht (1986), ©1941 Twentieth Century Fox, all rights reserved.

Figure 18.5. An office interior for Fritz Lang's *Metropolis*, Universal Film, distributed by Studio Real, Otto Hunte, Erich Kettelbut, and Karl Vollbrecht, set designers, 1926. From Albrecht (1986); © Friedrich-Wilhelm-Murnau-Stiftung, distributor Transit Film. A similar set was designed for Samuel Goldwyn's *Dodsworth*, art director Richard Day, 1936, William Wyler, director.

Figure 18.6A. Interior of Wynand's office with elevational drawing by Roark of proposed "Wynand residence" on the easel to the left, photograph dated 9 August 1948.

three dimensional), Claude Autant-Lara, Alberto Cavalcanti (with severely plain sets), and the Belgian-French architect Robert Mallet-Stevens (with designs of odd proportions taken from the Dutch de Stijl). In the French film *Maldone* (1927), directed by Jean Grémillon, art director André Barsacq's club bar on an ocean liner is obviously derived from Le Corbusier's designs.[11] A similar derivation is found in Paul Nelson's suave sets for United Artist's movie for Gloria Swanson, *What a Widow!*

Visual designs for *The Fountainhead* should be also compared to some of the interior sets for Fritz Lang's *Metropolis*, or Stephen Goosson and Ralph Hammeras' huge camera-ready model of a future New York City (of 1980, dominated by suspension bridges and Gothic–Art Deco skyscrapers) prepared for *Just Imagine*, released 1930.[12] It was an American reply to the successful *Metropolis*. Other 1930s American productions to consider were *What a Widow!* (whose art director Paul Nelson had one interior set with two spiral stairs), a few sets in UA's *Palmy Days*, the bar room and grand lobby of MGM's *Grand Hotel* (the movie in which Greta Garbo said "I want to be alone"), and in 1941 the hotel in Fox's *Moon Over Miami*. Such a comparison adequately exposes the hesitant and timid designs for Rand's movie.

Some of Wright's mannerisms were interpreted as Rand had instructed, but mainly as small props: pictures on walls or a model or drawings. The manners are cloying: a low horizontality, long balconies often cantilevered, random natural stone, and sometimes an angularity of form (Figures 18:6 A (left), B, C (on the wall), D, E, F, and G). Some people have suggested that the elevational drawing of Wynand's proposed residence recalls Wright's Kaufmann house, Fallingwater. Note that the outline of a building in the photograph hung in a stick frame near Cooper's left shoulder (figure 18.6C, possibly a waterfront restaurant) faintly resembles Wright's house for Mrs. Clinton Walker (1948) built on a beach near Carmel, California. (Wright called it a cabin, an "aristocrat among the bourgeois.")[13] It also resembles son Lloyd's house designed for Harold Swann, Santa Barbara (1940). The shapes in the tall building in Figure 18.6D are of the same geometrical family as those in 18.6E.

Vidor, Carrere and maybe Tuttle, had "inspected" (Vidor's word) all of Wright's buildings in the Los Angeles area and had read "all that had been published" about the architect. And they knew about son Lloyd's work. We know Vidor, Loeb and Carrere planned to visit Wright in 1948, but at the last minute Jack Warner got wind of it and insisted on no contact with Wright because he was "afraid" that if the movie or sets or other designs were discussed with Wright, and if "a deal" was not thereafter made, the architect might sue, claiming the studio had "stolen some of his

Figure 18.6B. A proposed house, ink and charcoal pencil by Roark.

Figure 18.6C. Interior of Roark's old office (with drawings hung on the wall by Roark of proposed buildings) with Henry Hull and Gary Cooper.

ideas."[14] Of course Wright's designs were copyrighted. But while he said in the 1930s that patents should be eliminated, as one of his strangely argued economic strategies, he clung to his own design copyrights.[15] And in 1947 there was the dark shadow of the FBI with whom Warner collaborated. Wright had not as yet sent his May 1948 letter to Blanke ending "the whole matter," so perhaps—only perhaps—he heard of Warner's concerns.

Yet in spite of FBI warnings, why not make a deal? Why not use an existing Wright building? Before the 1960s Hollywood's producers were loath to shoot outside the greater Los Angeles area and only reluctantly outside the cocoon of a sound stage. Difficulties with lighting and controlling extraneous sounds were the usual problems. Yet negotiations for fees and rights would have been with the owner of the Wright-designed building, not Wright. As early as 1933, for the Warner Brothers movie *Female*, art director Jack Okey used the exterior of Wright's Ennis house (1924–25); that was after installation of a swimming pool. The house was also used as the locale for UA's "well made little creepy" *House on Haunted Hill* (1939) starring Vincent Price and Carol Ohmart under producer and director William Castle.

Then in 1980–81 designer Lawrence G. Paull used the interior of Ennis house in

Figure 18.6D. A proposed manufacturing building designed by Roark, ink and charcoal pencil.

scenes of an overcrowded future Los Angeles in Ridley Scott's classic, *Blade Runner* (Bounty Hunter, 1982) for Warner Brothers. Also on Paull's advice some of the final scenes were shot in the famous balconied iron-caged interior of the Bradbury Building, Los Angeles (1893), by architect George Wyman. For *Blade Runner*, therefore, the artist's imagination responded to the script with an integrated, dramatic, and thoroughly cinematic impact, yet used existing buildings.[16]

Or, Warner could have given full credit and paid Wright for the use of his drawings for unbuilt designs and hung them on walls and placed models here and there. Or would that have been to close to confirming Wright as Rand's paradigm? But would Wright then have devolved to Roark?

Or, since Wright was the inspiration, there were precedents to reflect upon. The hotel exterior in *Moon Over Miami*, for instance, presented a suave tropical interpretation of mixed Wrightian and European elements. There was art director Stephen Goosson's peaceful yet dramatic place called Shangri-La designed for Frank Capra's *Lost Horizon*, with stars Ronald Coleman and Jane Wyatt. Major parts of the set were based on Wright's designs, while not mimicking them: for example, the deep overhang of the roof, windows tight to the roof eave, corner windows, a noticeable horizontality, and symmetry, especially about the principal and side entries.[17] The vertical character of the entries on the exterior and the handling of the plain lower walls either side can be related to the theatrical design by Wright's son Lloyd for the John

Sowden house, Los Angeles (1926).[18] Many dominant features of the exterior of the lamasery were Wrightian, the interior less so. The plain, flat stucco surfaces and delicate ironwork were meant to contrast with the rugged, jagged mountainscape of Shangri-La.

Or, they could have used son Lloyd's buildings, or his drawings, or hired him as consultant. He had been active in local theater and was well known in the motion picture industry. In 1916 he was in charge of Paramount's design and drafting department. After an introduction to Aline Barnsdall's theater circle, in 1917 he married Elaine Hyman, an actress known professionally as Kira Markham. Lloyd designed the first stage shell for the Hollywood

Figure 18.6E. Model of a proposed office building designed by Roark.

Figure 18.6F. Interior, administrative board room to Enright's office with models of proposed apartment buildings by Roark, presumably those destroyed. A revamped set, photograph dated 11 September 1948.

Figure 18.6G. Model of a proposed automobile service station designed by Roark.

Bowl in 1924–25 and then the second in 1928, assisted by the Allied Architects cartel. His design solved difficult acoustical problems (including an echo) inherent in a shell shape.[19] In the late 1920s he designed at least two sets for Bowl productions (one for Gordon Craig in 1926) and sets for Charles Laughton's stage productions.

Lloyd was commissioned to provide house designs for clients of such diverse artistic fields: Ramon Navarro, Alfred Newman, Claudett Colbert, Harold Ruby, Charles Vidor, Nelson Eddy, David Loew, Jascha Heifetz, and the gifted and prolific movie art director Richard Day. Lloyd also prepared a suggested remodeling for Anne Baxter's house (she did not hire granddad) but it was not built.[20]

But all this is speculation. Warner Brothers was trapped. They had to avoid designs that might be seen as plagiarized from Wright yet meet the condition that Wright's architecture was the exemplar. What would Carrere and his colleagues have created without that terrible constraint? One can sympathize when Carrere's predicament is known.

As an in-house art director for Warner, Carrere was assigned *The Adventures of Don Juan* with Errol Flynn, and it was nominated for best color art direction. It was a period piece, as were his designs for *The Flame and The Arrow* (1950) and *Helen of Troy* (1955). And there was the wonderfully restrained, "threadbare," English seaside resort hotel for UA's *Separate Tables* (1958). His other films were less obviously concerned with architecture. Sets for these movies tell us little about what might have

occurred sans Rand's instruction and Jack Warner's support of it. However (and this is also interesting if not helpful), while a draftsman with Warner, Carrere wrote to Wright in February 1938. He had seen the special January issue of the *Architectural Forum* and wrote as an "ardent admirer" of Wright's "principles." Naively he then asked for copies of the construction drawings of a typical Wright house, a request correctly denied.[21]

Another group of modern designs, based somewhat on what was then called Danish modern (Figures 18.6H–K), were mainly of sets described above as bland. A third group had contrived shapes and directional variety with some suggesting winged flight. Fitting uneasily in the group, one high-rise building, Figure 18.6E, was more-or-less based on a couple of Wright's proposals for tall buildings, mainly the Rogers Lacy Hotel for Dallas, Texas (1946).[22] The Lacy tower as published in January 1948 was to rise above a large atrium. That concept predates its application in many hotels by other architects beginning in the 1970s. Some other vertical building compositions for the movie appear derived from fancy or fantasy (Figures 18.6D and 18.6F). The sound stage set of Enright's apartment fit this group of angularity (Figure 18.6P2), while also having an affinity with designs in Figures 18.6A (left) to F.

The last group of modern designs, Figures 18.6L–P3, were inspired by the Euro-

Figure 18.6H. Interior of Roark's new apartment, photograph dated 30 July 1948.

Figure 18.6I. Interior of Roark's new apartment with Patricia Neal and Gary Cooper.

Figure 18.6J. Interior of Enright's apartment, designed by Roark.

18. The Fountainhead's *Visual Images* 145

pean schools with their crisp stucco-and-glass cubes, steel trim, and floating spiral stairs. A perspective drawing, supposedly by Roark, that hung on a wall in one scene, was of a suburban store to be of steel frame construction. Some of the first and better examples of American architectural designs in European idioms were buildings located in the Los Angeles area, including Rand's own Neutra-designed house.

In Rand's novel, Enright was a self-made man but not independent of mind. In Roark he recognized a like spirit and hired him to create Enright's own apartment. The charcoal drawing of the exterior of it (Figure 18.6L) is located above the fireplace in the stills (Figures 18.6H–I). It is the basis of the matte drawing in Figure 18.6M (with painted foreground trees), and then redrawn and placed as part of the urban background outside Enright's apartment, Figure 18.6P3. Therefore Enright's apartment was in *Roark's* building on the right in 18.6L. The complex of modern buildings in figures 18.6L and M are in model form sitting on a table in 18.6P3.

The building in Figures 18.6N (here being altered by Toohey) and 18.6O is based on two predecessors. One, the United Nations Secretariat of 1947, designed under the influence of Le Corbusier who had been coopted to the design committee chaired by New York (and Rockefeller) architect Wallace K. Harrison. The other predecessor was the piloti used for Le Corbusier's Swiss student hostel, Paris, of 1930–32. Further,

Figure 18.6K. Reception area, Wynand's private office, photograph dated 11 August 1948.

Figure 18.6L. Apartment tower designed by Roark for Enright, matte drawing.

one of Roark's supposedly older designs in model form, seen in Figure 18.6E, is centrally placed in Roark's new outer office, Figure 18.6S. His supposedly ultra-new office looked much the same as his old apartment, Figure 18.6H.

For the viewer these many and varied architectural images flashing on the silver screen were a visual jumble, imprecisely mixed in time. This confusion was exacerbated by yet another, but separate, group of architectural images, rather more general in scope, that relied on historicism. These included not only the city buildings seen outside windows but also some eclectic elevational studies of proposed buildings favored by Roark's enemy Toohey (Figure 18.6Q a sample), some based on the widely published drawings for the 1922 Chicago Tribune competition. A copy of the book illustrating competition results had been requested by Carrere and Tuttle. Also in this group was the interior of publisher Wynand's city apartment. The dining room, Figure 18.6R, is an example of a revamped set and one of the few that approached voluptuous ostentation and contrasted with the uninteresting plainness of the modern sets.

All in all a visual jumble, an amazing and confusing collection of architectural types, was offered to movie viewers. And therein resides another quite serious problem.

Figure 18.6M. Apartment tower designed by Roark for Enright, matte drawing.

Misconstructions

The first four groups outlined above were at one time or another presented as works executed by Roark over a span of nearly 20 years. More or less chronologically in the film there were, for instance, his own office (Figure 18.6C), an apartment that he furnished in Danish modern (Figures 18.6H–I), then his Wrightian designs (Figures 18.6 A, B, and D) done *concurrently* with his Danish-style office, then his angular and odd-shaped designs (Figures 15.6D, E, and G, one a gas station) that were fashioned at the same time as buildings imitating the Europeans (Figures 18.6L, P3, and S, the tall buildings in the model) and at the same time as his *new*, rather Danish office.

The uninitiated viewer may not have been consciously aware of these styles, but the obvious visual differences would have registered as chaotic. That visual information explicitly states that Roark was equivocal and inconsistent. His own architecture varied and was theoretically incompatible from one type to another and within any single period of time. Therefore it follows that, horror of horrors, he lacked philosophic rigor. Since the movie was about philosophic rigor to an explosive extreme and about rigor in architectural theory to often-argued excessiveness, the equivocations and inconsistencies in visual information was a production error both in design and continuity.

Quite simply, the pictorial evidence did not support the hotly argued verbal

Figure 18.6N. Model of an office building (see 18.6O) designed by Roark (Gary Cooper, right) with Toohey (Robert Douglas) offering changes.

claims. Visual information, including that given by an actor as gesture, must be not of *equal* importance to textual and verbal: in moving pictures it is always *more* important. (By their films John Ford and Peter Greenaway express agreement.) The failure to apply this axiomatic fundamental was compounded in *The Fountainhead*.

As serious as this production design error may have been, there was an even more momentous problem, one related to Rand's philosophy as so emphatically stated verbally in plays, novels and the film's scripted text.

In the movie, central to the legal battles, philosophic wrangles, and artistic concerns, was the harsh, ascetic style in Roark's later designs, those that resembled "waffle irons or upended tombstones," like figure 15.6O. That style was initially developed and then promoted almost exclusively by the political left in Europe and in the USSR during the 1920s and early 1930s. It was they who advanced single-party socialism or communism, collectivism, and a neutered international aesthetic devoid of cultural traditions.[23] They promoted an architectural style that came to symbolize the very political and social philosophies that Rand (and Hoover, Warner, Cooper, HUAC et al.) so vehemently opposed. Moreover, one reason — perhaps the main reason — Rand was attracted to Wright was his oft and directly spoken opposition to the left-leaning President Roosevelt and to the architecture of the political left and its hegemonic influence in America as developed in the 1930s.

Figure 18.6O. Model of office building in 18.6N, designed by Roark.

To Rand European modernism was cold, box-like, boring, bare, too plain, lacking ornament, even inhuman.[24] Was Rand aware that her description and the house she bought (Neutra's design for von Sternberg), on its exterior, in its use of materials, in its massing and planar elements, was a fine example of the internationalists' Modern Movement that, when defined in 1932, was called the International Style?

Figure 18.6P1. Interior of Enright's apartment designed by Roark, photograph dated 17 August 1948.

Even the word "international" weighted interpretation to the far left of politics, around 1948 construed toward statism.

Had Rand and the consultant and studio artists been more fully aware of the history and theory of modern European architecture, of the reasons Wright had clearly enunciated in support of his architecture in the 1930s and 1940s, maybe such an error might have been avoided, but only maybe. Perhaps some studio people were aware. Perhaps the architectural symbol of political internationalism was an intentional victory, hoping the information would rest in the moviegoer's mind.

We've seen that Wright had created some adventuresome and experimental works, individualistic, almost futuristic, definitely not typical, only American. His life and words and architecture were symbols antithetical to the notion of an international collective will or a fascistic centralism. With words and deeds Wright argued and fought for what he believed were the essential elements of American culture and democracy.

While Rand's words were provocative, her mediums were not. They were conventional. Her novel was in a popular narrative literary form, almost trite. The movie was a typical melodrama, weirdly directed in collaboration with Rand. That said, it is not surprising that visual designs were also conventional.

Figure 18.6P2. Set designer's engineering drawing of the floor plan for Enright's apartment, dated 24 July 1948.

Figure 18.6P3. Interior of Enright's apartment.

The words of philosopher Susan Langer, arguing for the identification and perpetuation of the uniqueness of each cohesive society, are of value in this context. "Any miscarriage of the symbolic process is an abrogation of our human freedom," she said, adding that

> the most disastrous hindrance is disorientation, the failure or destruction of life-symbols and loss or repression of votive acts. A life that does not incorporate some degree of ritual, of gesture and attitude, has no mental anchorage. It is prosaic to the point of total indifference, purely casual, devoid of that structure of intellect and feeling which we call personality.[25]

Architecture is a ritual.

Architecture of Sets

Thirty-four outdoor and 36 indoor sets were used in making *The Fountainhead*. Of the outdoor sets almost all related to street scenes or scenes shot in a quarry (near Fresno, California) where Roark and Dominique first met. Most others sets were of building interiors constructed for a sound stage. A study of the construction—or engineering—drawings reveals that some sets were a revamp of previous Warner Brothers movies, revised for *The Fountainhead*. Before reuse they were mostly tra-

ditional interiors: a courtroom, an "interior of Luxurious Drawing Room" (and English revival piece), Keating's room (an Adamesque rococo), or Wynand's penthouse (Figure 18.6R). Therefore traditional interiors were available, as was a permanent New York City street scene between sound stages.

The studio artists who usually drew these designs and revamps were Ed Held, someone named Peck, and William Grau; all worked to Carrere and Kuehl designs. Kuehl had a nice sense of proportion and was especially good on plaster relief work, and furniture and set detail. Contemporary architectural models to be used as props were detailed by delineators Moll and Campbell. Modern interiors, including Cameron's garret office, were designed and made for the movie, identified as Warners Brothers Pictures number 707. Held did the drawings of some new Danish modern–type furniture in July 1948 and of Roark's new office interior. That office and the interior of his apartment were determined by the description set out in Rand's instructions, summed by these words: Roark "would never make attempts at homey comfort or prettyfying."[26]

The construction drawings of Enright's apartment (Figure 18.6P2) were by Held and Grau following one of Carrere and Keuhl's better designs. The dynamic spatial effect of the walls, glass, and spiral stair were superior to other sets that tended to be shot as closed corners or in tight and relatively flat spaces (Figures 18.6C, F, I, K, and S are typical). Roark's pretend design of Enright's apartment is very much an international style piece.

For the most part, the modern interiors were too simple and lacked not only texture and volume but personality. This is easily understood by looking at *The Adventures of Robin Hood* of 1939. The *design* of the flats of the castle interior were taken almost directly from Fairbanks' *Robin Hood* of 1922 where art director Wilfred Buckland built a castle outside of shadowed black curtaining lit mainly by sunlight kicked into the set by reflectors. Stark simplicity was a feature of internationalism's style while warm and textured simplicity characterized Danish modern. In *The Fountainhead* both became bleak, plain, and boring. Emptiness is not simplicity. One observer stated that the sets were inspired by the "tradition of German Expressionism" and this was an aspect of the film's supposed "anti-naturalism."[27] Well, as outlined above and as can be seen in the illustrations herein, the sets had nothing to do with 1920s Expressionism.

Lighting and camera work offered some of the more satisfying visual aspects. This is exemplified in a photographic still of Roark's old office, Figure 18.6C, a disappointing design, since it was supposed to be the personal office of a brilliant, hot shot, idiosyncratic, architectural genius. It was saved by light coming over Cameron's (Hull's) shoulder to illuminate and pattern the wall behind Roark (Cooper). The furniture chosen to represent Roark's selection of modernism for his own professional office looked not inexpensive but cheap. A lumpy 1920s chaise lounge is crammed in a corner. In recall Vidor mentioned only one technical aspect and that was the lighting, noting the soft light on one figure contrasted with the "harsh dramatic lighting" on another in the same shot (Figure 18.6I perhaps).[28]

The set for Roark's apartment, Figure 18.6H, was again bare, only suggesting a modern, rather postwar Danish. It is a useful exercise to compare Roark's (and

Figure 18.6Q. Toohey (Robert Douglas, standing) presenting to Wynand (Raymond Massey) proposals for a Wynand office building, ink and charcoal. Note the city office buildings rising beyond Wynand's modern window wall and compare *Metropolis* (1926) and *Dodsworth* (1936), among others.

Wynand's) apartment set to Day and Pogany's penthouse interior for UA's musical for Eddie Cantor, *Palmy Days*, Figure 18.7. Here the horizontal bands are straight from Wright's Los Angeles houses of the 1920s, including the glass corners of the Freeman house (1924–25). These Wrightian features were nicely blended with a European influence. In *Palmy Days* the three-dimensionality through the transparent wall to the space, bright light and forms of the gymnasium beyond, and then to the city roofscape, gave the set a described three-dimensionality. As well, the furniture fitted nicely with the architecture, while the use of steel and horizontal elements was only subtly Wrightian. The shot through the glass wall also helped relieve the effect of a closed corner while recognizing the limited peripheral vision of the camera lens.

Modern interior decorative elements for *The Fountainhead* such as furniture, desk and table props, wall hangings, lamps and the like were of the 1920s and 1930s (Figures 18.6A, H and S) and generally looked second-rate. The furniture approved for Roark's second office (Figure 18.6C) was, well, pathetic.[29] These prop and set problems were not a result of a meager design budget.

Reaction

The visual evidence presented in support of verbal situations, character development, and story events is indispensable to our judgment of a movie. The visual aspect is of two basic parts: the *moving* picture or cinematic exhibition presented in time, and the physical things being recorded. Those things are people and their body and facial movements and language, their clothing and makeup, and their physical environment, regardless of location or scale. Since Rand's movie was about an architect and his buildings, a viewer's reaction must include thoughts and speculations about the man's unique art and related artworks as visually displayed on screen.[30]

In 1949 the longtime movie reviewer for the *New York Times*, Bosley Crowther, referred to the architecture designed for *The Fountainhead* as "trash."[31] Most reviewers were less succinct or candid, but equally unimpressed. Few opinions surface in the 1980s and 1990s, but the brief opinion of film historian Raymond Durgnat in 1973 was that the architectural "substitutes" were uninspiring, their "international-style angularity ... most boring and inorganic." The interior scenes Durgnat found vacuous, edgy yet heavy.[32] As late as 1990 movie historian Beverly Heisner thought,

Figure 18.6R. Dining room of Wynand's old residence, a revamped set.

strangely, that the sets were "aggressively modern and so large that the actors seem to be lost in them."[33] Most people were — and are — not pleased with inhuman highrise glass-faced skyscrapers and non-cultural boxes. And surely the confusing spectrum of architectural styles affected the general audience.

But were our astute architectural theoreticians and historians concerned by the visual confusion or theoretical contradictions vis-à-vis collectivism (communism) and individualism (democracy)? No such concern has been uncovered. We now know Wright's response, but how did others in the professions react? Unhappily, only a couple of them have expressed views for public consumption, but they were unambiguous.

The first published comment about the film's architecture and set designs occurred two months *before* the movie was released. George Nelson, one of America's more inventive designers at mid-century, attended a preview and found *The Fountainhead* to be the "silliest travesty of modern architecture that has yet hit films." In support he identified the sketch meant for scene 129c, Figure 18.6B, that showed structurally ridiculous cantilevers. Further, he thought the perspective drawing of a factory, Figure 18.6D, pathetically recalled Wright's Johnson Wax building, perhaps because of the windowless exterior walls and sawed-off corners. In any event, the factory perspective had a mysteriously massive and contrived horizontal bulk unrelated to a tiny vertical tower. Off the tower protruded what Nelson call a swimmer's diving platform. And he found other disturbing difficulties with the artwork. (Rand had accused Nelson of intellectual indecency.)

It was Nelson's opinion that if the producers wanted Wright involved they would have pursued him. Unsuccessful, why did they not hire another architect, Nelson asked, one of many "who could have done a first-rate job?"[34] Nelson informed readers that the designs were not executed by Wright and that they had irrationalities not normal in real-life architecture. Rather, they were abnormal technically and aesthetically.

(The advice of independent art director William Cameron Menzies is valuable: "in many cases, authenticity is sacrificed, and architectural principles violated, all for the sake of the emotional responses." Rather, Menzies advised, "be as accurate and authentic as possible," make it "look real."[35] In a realistic situation it should appear coherent. Specifically, why make the Le Corbusier–like high rise building in Figure 18.6O [the "Security Bank of Manhattan"] and the house in Figure 18.6B appear structurally irrational? And why do the shapes of the skyscraper in Figure 18.6F or the factory in Figure 18.6D appear functionally or structurally questionable, look fake?)

Architect Nelson's criticisms were correct if not realistic. We should recall that he was a longtime friend of Ely Kahn and Wright, and knew about Rand; that he and Wright occasionally met in New York; and that Nelson was an associate editor of *Architectural Forum* when the entirety of the January 1938 issue devoted to Wright was produced. Moreover, Nelson did not like Rand's philosophy as advanced in *The Fountainhead* book, so he would have had some leftover hostility ready to vent on the film.[36]

There is, however, further sobering and fundamental criticism to level. It regards portraying an architect, even fictively, as a fanatic resorting to violence. It was a view put by Victor Gruen, one of California's respected and more active architects from

Figure 18.6S. Reception area designed by Roark for his new office, photograph dated 27 August 1948.

the 1940s to the 1960s. Gruen said Roark "went beyond the rules of the community"; that he was an "egotistical, crazy artist."[37] Moreover, Roark was "guilty of criminal neglect," and Gruen proposed legal charges—against whom?—for "damaging the reputation and the business of contemporary architects."[38] Gruen publicly expressed irritation but reassured society and his readers that Roark was not an average or normal person, quite the contrary. Other architects were similarly concerned.

Writer and architect Edward Gunts, for instance, believed *The Fountainhead* "left an indelible impression of the architect as an arrogant, selfish iconoclast who builds to satisfy his own ego rather than to serve clients.... And America's real practitioners have been trying to live it down ever since." New York architect Robert A.M. Stern recalled the movie: It's like the Bible. You almost feel as if you've read it, even if you've never opened it. I shudder to think that any architect would actually model his career on that of Howard Roark.[39]

Yet, these and similar public expressions of alarm were occasioned by the movie, the visual medium, not by the novel. Words are almost too abstract for the visually oriented artist. Effectively engaging only two human senses with or without a sense of reality, movies are a potent, emotionally driven and responding instrument.

A more celebrated reaction to the film resulted from a tactical error by Warner Brothers. It asked about 250 architects and students to preview *The Fountainhead* at a venue within the University of Southern California's School of Architecture. The invitees were a polite audience who occasionally tittered but remained quiet. Afterwards, Warner released a publicity blurb that said in part that "leading architects" had "hailed" the picture. It was brilliant, Warner said they said, "the greatest single approbation of their profession."[40] Well, architects thought the blurb was patently incorrect and made known their views. Through its editor, Ted Criley, the Southern California Chapter of the American Institute of Architects responded at length in its *Bulletin*. Rand's book, Criley said, was misleading ("Any resemblance between this Mutton-head [Roark] and a real Architect" was not evident), the movie's "art staff" perhaps unintentionally revealed a sense of humor, Roark's architecture was "phenomenally droll," etc.[41] Major portions of this pointed response were republished in local newspapers and nationally in the *Journal of the American Institute of Architects*.

Sympathy must be offered, however, to those involved with making the film, but only for the following reason. With the constant reminder and implication of "genius," how could Vidor, Cooper, or the designers satisfy such high-minded, unmeasurable demands? or meet Rand's, the audience's and the architectural profession's expectations? Moreover, and the nub of it all: who would have known if fictive works of genius had been created? Were predetermined — that is acceptable — examples required?

But there is no sympathy for the makers—and later the critics and reviewers—who refused to make comparative study of previous movies, as Donald Albrecht did and we've done herein, that presented wonderful architectural sets (*Metropolis*, *Things to Come*, the castle interior in either of the Robin Hoods, etc.), and those that had depicted aspects of architectural modernism such as *Palmy Days*, *Grand Hotel*, *Lost Horizon*, *What a Widow!*, *Moon Over Miami*, *The Big Clock* and so on.

In public responses to—or reviews of—the film, no one, including HUAC or the FBI, noticed the schism between the vaguely Wrightian — American — architecture at the beginning of the movie and the victory in architecture of the socialist left's internationalism at the end.

No one mentioned the failure of the visual artistic elements of the movie to support the philosophic passion and mental rigor so central to Rand's book and screenplay. Perhaps, and a cautious perhaps, Wright sensed the potential of these problems when, in May 1948 and too late, he wrote to Blanke calling off his participation.

Most architects, like most lawyers or actors or bus drivers or podiatrists, are just ordinary folks. For most people, threats to one's society, to well known and cherished cultural norms and symbols, are difficult to recognize, unless of an overtly caustic or physical character. So too unnatural dichotomies or philosophic failures in something as common as a Saturday night movie or an evening's video. After seeing the film in 1949 an architectural office in Los Angeles posted a sign at the front of its premises,[42]

> Dynamite for artistic
> integrity will be charged
> against the client.

19

Hollywood Clients, the 1950s

Ayn Rand was a relatively minor figure in Hollywood, openly political with strong biases, not wildly attractive to most fashionable cliques, often an outsider. The cinematic failure of *The Fountainhead* and niggling discomforts in Hollywood probably influenced Rand and husband Frank to move on. Their new home would be an apartment in a Manhattan tower. The granite, steel and concrete island became the working locus of her intellectual universe.

Before leaving Los Angeles, though, Rand was introduced to the real-life body of Howard Roark. The episode ran something like this. One hot summer day in 1952, architect Richard Neutra, his sister-in-law Regula Thorston, together with a building contractor named Fordyce "Red" Marsh, were inspecting a San Fernando Valley building site. Marsh had not seen the von Sternberg house so wondered if they might visit. Rand was then owner and resident and Neutra thought she would happily "receive them" unannounced. It was all cordiality until Rand "fixed up the tall, handsome, blue-eyed, red-headed Marsh. Then moving past Neutra, who was unaccustomed to such brush-offs, she put her hands on Marsh's broad shoulders and solemnly told him that he was Howard Roark, that he epitomized the image upon which she had based her book." Rand was "mesmerized" with the "reified superman" until "she realized that it was time for a radio speech by another of her heroes, Senator Robert Taft." Neutra, "offended by the double upstaging, decided that as a loyal Democrat he did not want to listen to [Republican] Taft, and left with [his] entourage before 'Roark' got to tour the house."[1]

Yet Hollywood was not quite through with the diminutive Russian emigrant. Producer Albert Ruddy proposed to buy the film rights to *Atlas Shrugged* in 1972, but the deal fell through because Rand again insisted on controlling production through the screenplay. In 1977 Jaffe Productions wanted to prepare a ten-hour miniseries of *Atlas* for NBC. A contract was signed and Rand agreed to the appointment of Stirling Silliphant to reduce her text accordingly. She assisted and Silliphant remembered Rand well: "I cared for her, and valued her," but she "did not reflect the kind of humanity and warmth I like in people." She was a "person who required you to play by *her* rules."[2] After months of work by the two writers NBC unaccountably canceled the project.

While Hollywood was through with Wright,[3] his architectural practice thrived. Beginning in 1951 he annually received more commissions than in any previous year.

Wright Foundation archivist Bruce Pfeiffer lists 42 active commissions in 1955. Of the approximately 1,151 commissions obtained during his career, a full 30 percent occurred between 1949 and 1959. (Did the movie of *The Fountainhead* precipitate the rush of clients?) And the Taliesin Fellowship prospered under Olgivanna's stern but caring rule.

After the 1945 armistices in Europe and Japan, Wright now and then received commissions from southern Californians. One in 1951 possessed a bit of deja vu. In 1946 Mr. and Mrs. Edgar Kaufmann, Senior, asked Neutra to design a house to be located near Palm Springs. Neutra knew of Wright's long association and friendship with the Kaufmann family, one that began in 1933. And we remember that Neutra worked for Wright in 1924–25. The house Neutra designed became a masterpiece of open planning and landscape design. Conceptually it was a personal homage to Wright.[4]

For unclear reasons, the Kaufmanns in 1951 asked Wright to prepared plans for yet another house near Palm Springs. It has been reported that Wright said Neutra's design had "no feeling for the terrain," that it did not "respect" the "special requirements" of the Kaufmanns.[5] It would be sad if he made those comments publicly. Anyway, Wright prepared a design opposite in character, space, form, and even spirit, to Neutra's and therefore to Wright's own precedents. The result, "Boulder House,"

Figure 19.1. Lilliane and E.J. Kaufmann house, Palm Springs, California, 1951, project, perspective drawing; ©2003 the Wright Archive.

was an experimental invention of curved, lozenged, bubbled, copper ribbed, and stoned contrivances awkwardly fused to on a hillside (Figure 19.1.)[6]

During the 1950s Wright used many geometrical forms in a frenzied nonrectangular exploration, perhaps as a reaction to the rectangular abstractions of Mies van der Rohe, then so popular and with many followers. But there was little or no conformity in program, time or genre. For example, Wright designed Aderton Court in 1951, a small retail building in Beverly Hills. As built it is a one-off, angular, sloping, pinched, ill-fitting and ill-proportioned building.[7] Another example was an art gallery to have been built on Olive Hill in the center of Los Angeles.

Olive Hill Campus

Around September 1944 Lloyd Wright and Dorothy Clune Murray inspected the uninhabited Barnsdall house, Hollyhock, on Olive Hill and found it in good condition.[8] Murray began to formulate ideas for new uses and plans for preservation. She formed the Olive Hill Foundation and requested the Los Angeles Park Department (who administered the property for the city) "to grant" a ten year lease. She wanted Wright to "rehabilitate" the house with Lloyd's assistance. Preliminary work took less than a year when in June 1945 the foundation made an offer that included a willingness to put up $20,000.[9]

Lloyd asked if father was interested in taking on the job: the reply, "you do the work — I'll stand by."[10] Murray then sought a ten year lease but the Park Board stalled and was, in Lloyd's words, "something more than obdurate." He believed some board members were willing to "let the damned thing rot to the ground" rather than assist, their actions a "political vendetta."[11]

When in 1922 Barnsdall was unable — mainly a result of indecision — to realize a dream for a theatrical colony on Olive Hill she attempted to donate the entirety of the property and its buildings to the city of Los Angeles, all together a $2 million gift (in 1923 dollars). It was refused three times but finally the top of the hill and Hollyhock were accepted, grudgingly.[12] During negotiations Barnsdall's extreme political views, radical social propositions, and singular asocial personality rankled city bosses and conservative art patrons. Most came to dislike the lady because she was different. One recent history records some of the irritants and half truths. Barnsdall was a "most liberated" personality, "she campaigned for freeing India from British rule," she "erected huge billboards above Hollywood Boulevard scandalizing the city fathers," she was a pacifist, socialist, and feminist, and "she hoped to establish a kind of commune for women in the arts and politics."[13] (No doubt the FBI has a fat file.)

The California Art Club leased the house ca. 1931 and the next year approached Barnsdall to allow a remodeling to suit their needs. Apparently the idea was Neutra's (a club member) who proposed to box in the "central court" (yes!) and "swing high trusses over."[14] Barnsdall said there would be no changes without Wright's approval.[15] In a few months the momentum was dissipated in befuddlement. Finally the Art Club relinquished its lease in 1940. (In 1945 Barnsdall was still irritated by all that had passed.)[16]

However, the Park Board's actions apparently were vendetta-like. Shortly after

Lloyd's and Murray's visits in 1944, Hollyhock house was vandalized, evidence suggesting it was governmentally sanctioned. Expertly crafted cabinetwork, doors, trim, light fixtures, as well as plumbing, toilets, sinks, and electrical wiring had been removed, ripped out or "torn apart."[17] Nonetheless Murray persisted while Wright procrastinated. Lloyd urged him to assist, especially in October 1946 (during the HUAC hearings) when Murray "stuck to her guns" by offering $100,000 for "reconstruction" of Olive Hill.[18] Wright told Lloyd to "Give Mrs. Murray a slap on the thigh for me—I think she is all right."[19] But otherwise the elder Wright dithered.[20]

After Aline Barnsdall's death in December 1946, the foundation was able to obtained a lease on Hollyhock. But Murray began to vacillate about whether to proceed or not; on again, off again, as Lloyd put it. By then the reassembled house was repaired and should "not be again wrecked," Lloyd hoped.[21] In late 1947, however, Murray "reversed herself completely, made her contractor her chief advisor—and advised" Lloyd to forget about his father's contribution, he was "thru," his "work done." Lloyd was soon out of it too.[22]

In 1954 Wright's temporary buildings that housed the "60 Years" exhibition opened on Olive Hill. In a turnaround, that year the Los Angeles Municipal Art Department commissioned Wright to prepare plans for an art museum on Olive Hill. When Aline's daughter Betty assumed management of Olive Hill, parts of the periphery of the campus were soon subdivided, so that an area almost two-thirds of the total was gone. Only the central area with the house and a corner lot was now available for the proposed building.

Wright's new gallery was to be uneasily juxtaposed to the now-famous single story house (Figure 19.2), but the concept was inventive and unique. Spiral ramps at each end of the multistoried main gallery reached balconies on the long sides that were to overlook a high-ceilinged, elongated, rather narrow central space on the interior and on the exterior, a 360-degree aerial view of Hollywood. It would have created a wonderful expanding space. However, the general concept of the building was for flat land, not the steep slopes of Olive Hill.[23] Fortunately the 1954 proposal was abandoned. Years later an art gallery was built just below Hollyhock but designed by other architects in a Gropius/Harvard model.[24]

John A. Gillin asked Wright to design a new house on land up a canyon in the Hollywood hills overlooking the distant Olive Hill campus. Wright had previously designed a house for Gillin that was built in Dallas, Texas (1950). It was a low-profiled, extensive structure placed on a gently rolling landscape. A similar type of house was proposed for the Hollywood hills, with a planning geometry based on a triangle. From a living room, two long wings would extend to form a large imprecise triangle that ignored the steep hill contours and therefore clumsily straddled the hilltop. It was not built.[25] Generally, such a result was and is common for an architectural practitioner. Most commissions do not reach construction stage. For Wright it was less than half: about 510 constructed of about 1,150 total commissions; fairly average.

In the 1950s Wright was a very popular personality yet intentionally isolated at Taliesin. The exhilarating moments and delightful people seemed to have gone ... one way or another. The society and artists of his day were of his day, like those at

Figure 19.2. Art gallery and Barnsdall park development, Los Angeles, California, 1954, project, aerial perspective drawing; ©2003 the Wright Archive.

the Cliff Dwellers or in Tokyo or at the Algonquin Table or those profound and free. It was a day that could be only a memory: sustaining for the mind only. He concentrated more and more on being a commodity, a counseling senior, a professional celebrity, and a patriarch of the family of working apprentices. From time to time he had peripheral contact with Hollywood, if not with the movie industry. There were two interesting exceptions instigated by movie people. One was for a private home in rural Connecticut, the other a movie house for car parking lots Anywhere suburbia.

Marilyn Monroe (and Arthur Miller)

A radio and New York theater playwright, Arthur Miller's association with Hollywood began with the production of his play *All My Sons* (released in 1948 by Universal) by producer Chester Erskine. Edward G. Robinson played a war profiteer and shared the screen with Burt Lancaster, among others. The next association was with Stanley Kramer who produced Miller's play *Death of a Salesman* for Columbia. Released in 1952, it was directed by Laslo Benedek. The lead part of Willy Lohman was not played by its stage creator Lee J. Cobb but by Fredric March.

Miller and film actress Marilyn Monroe met in Hollywood; a courtship ensued, Miller claiming Monroe to be the unresistable aggressor, and they married in 1956. With revelations of "Communist ties" and further FBI involvement, Miller had been refused a passport. So when they married press headlines appeared like this:

PINKO PLAYWRIGHT
WEDS SEX GODDESS

Delaying applications or denying passports was a common practice of intimidation by the Department of Justice. "Blacklisted Hollywood writers, directors, and actors hoping to find work abroad, such as Edward G. Robinson and Ring Lardner Jr., were denied a passport unless they first made their peace with HUAC ... (Robinson did, Lardner didn't)."[26] Neither did Miller. When called by HUAC the central issue, ostensibly, was to expose supposed members of the Communist Party of America. Miller refused to cooperate. Among other arguments, he questioned why a person had to become an informer before being allowed to practice his profession in America. The opinion of the fractious right of politics can be summed by Gary Cooper's "simple-minded" chauvinism: "A man like Arthur Miller, he's got a gripe against certain phases of American life. I think he's done a lot of bad. Ours is a pretty good country and I don't think we ought to run it down. Sure there are people like this fellow [Willy Loman], but you don't have to write plays about them."[27]

On HUAC's recommendation the U.S. House of Representatives cited Miller for contempt of Congress (ratified by the House 373 to 9, please note). A judge reluctantly set a fine of $500 and gave Miller a suspended 30-day jail sentence. Months later Miller easily won on appeal.[28]

In 1957 the Millers purchased a 300-acre farm on hilly semirural and wooded lands outside Roxbury, Connecticut, a place of gentleman farmers and country retreats. Monroe described the farm house as "a kind of salt box with kitchen extension."[29]

In anticipation of a marriage blessed with children, Monroe telephoned Wright. Alone, she went to his Manhattan apartment in the Plaza Hotel where she invited the 90-year-old architect to prepare plans for a new house that was to be a gift to husband Arthur. Mr. and Mrs. Wright and Mr. and Mrs. Miller visited the old Roxbury house ("don't put a nickel in it," said Wright) and look for a suitable site for a new house. Olgivanna recalled the first occasion the Millers together visited the Wrights at the hotel. Arthur was "dressed as always in his markedly democratic — to his mind — clothes: dark blue shirt, no necktie." Marilyn was "lovely looking, taller than I expected."[30]

Although not asked, the Millers mentioned their expectation to "live fairly simply," having no need for an overly impressive or "elaborate" house. As we shall learn, this request was ignored (Figure 19.3). A craftsman of words but not a visual artist or architect, the playwright set out his interpretation of Wright's design as follows:

> a circular living room with a dropped center surrounded by ov[o]id columns of fieldstone some five feet thick, and a domed ceiling, the diameter not less than sixty feet, looking out toward the view over a swimming pool seventy feet long with fieldstone sides that jutted forth from the incline of the hill. The pool's supporting walls at the far end would ... require, I judged, heavy construction in the order of the Maginot Line.... His pleasure-dreams of Marilyn allowed him to include in this monster of a structure only a single bedroom and small guest room, but he did provide a large "conference room" complete with a long board-room-type table flanked by a dozen highbacked chairs, the highest at the head, where he imagined she would sit like the reigning queen of a small country.

Figure 19.3. Mr. and Mrs. Arthur Miller house, near Roxbury, Connecticut, 1957, project, aerial perspective drawing; ©2003 the Wright Archive.

Miller concluded that the house might have been useful as a hideaway for corporate executives to plot illegal stock deals and illicit mergers.[31] (But why not union leaders or labor politicians plotting for more powers to facilitate corruption?) When offering those comments Miller was worried about litigation then pending with Wright's successors.

Anyway, the house's floor plan was based on a project in 1942 for Carl Wall in Plymouth, Michigan, for which Wright used a geometry of triangles. The Wall plan was reused in 1949 but with circles surmounting shallow domes, for the Robert Windfohr mansion in Fort Worth, Texas; it was not built. That plan reappeared in 1951 as a "tropical vacation house" for Mexican financier Raul Bailleres for a hill top above Acapulco.[32] It too was not built. All three circular plans had similar massing, construction materials, elevational characteristics, and recall the Kaufmanns' Boulder House and the Jester/Loeb paradigm.

Otherwise Miller's memory was only somewhat hazy. There was no conference room but a dining room that appeared a bit formal, and there were many bedrooms (including four servants' and two children's).[33] In reality the Millers had received a revision, if somewhat smaller, of the Forth Worth and Acapulco projects.[34] And it was overly impressive and quite elaborate.

The evolution of the design indicates, even to the unschooled, that by the late 1940s Wright had abandoned all thought of a proper regional architecture, his former philosophic rigor of no value. A house on a hot, dry Texas desert or beside windswept Mexican hillsides or on green, cold New England lands could have the same plan, appearance, and materials. This lapse, together with an educated overview of his work in the 1950s, leads to the conclusion that the theoretical demands he placed upon himself throughout the 1930s had been cast aside.[35]

Miller recalled that during visits Wright, ignoring requests for an unpretentious house, would change the subject or display large watercolor sketches prepared for the Shah of Iran or the "ruler of some oily sheikdom, with dozens of dreamy pink

towers and minarets and interconnecting roadways strung across the sky."[36] Miller was not impressed by the aged architect. So, the actress' house for her playwright husband proceeded no further.[37]

During 1962 Ayn Rand wrote a weekly column for the Los Angeles *Times*. On Monroe's death, probably by suicide, Rand wrote that the actress faced life with the "joyous self-flaunting of a child or a kitten who is happy to display its own attractiveness as the best gift it can offer the world."[38] Faint praise.

Mike Todd (and Elizabeth Taylor)

Mike Todd was always involved with theater. A gag writer for J.S.O. Olsen and H. Johnson, he went on to produce mainly skin shows during the 1930s, including Gypsy Rose Lee's autobiographical third-rate comedy *The Naked Genius*.[39] Todd's first hit as a Broadway producer was in 1939, *The Hot Mikado*, in which the Gilbert and Sullivan classic was transformed into a jazz version with an all black cast. The Mikado was played by Bill Bojangles Robinson, who one reviewer described as "the most articulate man of our time.... He is a titan, not of literature but with his feet, a superb master."[40]

In mid–1946 Todd visited Wright at home in Wisconsin, the reason for the impromptu meeting a mystery. Drama critic Lloyd Lewis was present and recalled that the Broadway producer

> was for the first and only time in his life stricken dumb, at the sight of Wright and his private theater at Taliesin, Wisconsin. The room has seats circling tier on tier and focusing down on a stage floor where the Taliesin Fellowship apprentices play chamber music, and where a picture-screen has on its left margin a red board so that the film soundtrack can zigzag there during the performance, like fireplace shadows.

Wearing a white suit, "flowing tie, and white flowing hair," Todd said, the architect introduced his wife's "Fellowship orchestra" in "that enchanted room." Of Wright an "overwhelmed" Todd said: "I first thought that it was Buffalo Bill, then Robert E. Lee, then Beethoven, and finally, George Washington, I didn't know who — only there is the greatest showman I ever saw."

Todd then asked his host if he would design a theater on Broadway, no two!—"a big one for the public and a little one for Mike." The answer was yes. But the exciting moment faded quickly to become lost.[41] The meeting, however, was not forgotten

When Todd married film actress Joan Blondell in 1947 Wright dropped a note with a strange closing: "And to you — valiant crusader down the Styx — our sincere wishes for your happiness. Affectionately."[42] The *extraordinaire* of their professions had met and modestly acknowledged each other's talents.

With filmmaker Merian C. Cooper and newsman and broadcaster Lowell Thomas, Todd was involved early on with developing Cinerama. The process was a refinement of an invention by ex–Paramount cameraman Fred Waller for a World War Two gunnery training device. When presented at local theaters, Cinerama required three projectors to mesh visually on a deeply concave screen. The first production opened at New York's Broadway Theater in 1952, *This is Cinerama*. It created

a sensation, much more so than Oboler's *Bwana Devil* when it opened two months earlier using Gunzberg's Natural Vision 3 Dimensional.

But in some manner Todd was forced out of the company. He immediately set out independently to improve Cinerama, to present the same breadth and apparent three-dimensionality but through only one projection lens. The resulting system used a special film process, a new projector, a large wide screen and stereophonic sound. He called it Todd A-O, an acknowledgement of the technical role of American Optical Company, which helped develop the process.[43] Audiences were introduced to Todd A-O in a movie of Richard Rogers and Oscar Hammerstein's musical *Oklahoma!* (1955). The movie, financed by Todd among others, was produced by Arthur Hornblow, Jr., and directed by Fred Zinnemann, with actors Gordon MacRae, Gloria Graham and Shirley Jones. The most delightful Todd A-O film was released in 1957, *Around the World in Eighty Days*.[44]

At the height of his career Todd married another actress, British expatriate Elizabeth Taylor. (Todd: "She's been on a milk-toast diet until me. But me, I'm red meat.")[45] Each was attempting a third marriage.[46] Shortly after their wedding Todd and Taylor traveled to Taliesin West to determine if Wright would participate in a theater venture. Former NBC president Sylvester "Pat" Weaver and "impresario" Todd had convinced industrialist Henry J. Kaiser to join in forming the corporation "Dome Enterprises." Its purpose was to construct similar theaters throughout the nation.[47] Todd A-O equipment would present Todd-produced motion pictures between "concerts and live theatrical productions," and other films.

A memorandum of understanding between "the gifted quartet of showmen"[48] was drafted on 6 December 1957. Kaiser had been licensed to construct Buckminster Fuller's geodesic domes: Kaiser called his version the Overhead Aluminum Dome. After agreeing to employ Kaiser's system "without modification," Wright was retained as architect.[49] The first theater was to be built in California at a location unspecified. Wright's fee was ten percent of construction costs. If future theaters were built to his plans—"fifteen or twenty" were mentioned—the fee was to be a flat royalty of $5,000 for each.

Four distinct architectural ideas were prepared. The first, Scheme A, was by Kaiser Engineers and dated November 1957. They suggested a very high hemispherical dome. There was therefore a great expanse of unusable air space above the seated audience (of 1,040) that anticipated acoustical problems. Entry, lobby, and backstage facilities and a covered open walk around the exterior were constructed of concrete. It all looks a very amateurish 1950ish thing. Perhaps that is why Todd sought architectural assistance.

Prints of the Kaiser drawings were given to Wright, who hastily sketched on them some ideas for revisions. In normal application a Fuller dome, whether a near hemisphere or not, usually springs more or less from the ground. In January 1958 Wright suggested a much shallower dome (still a segment of a sphere), partially hidden behind high unadorned concrete walls and arches that conformed to a new, large lozenge-shaped plan seating 1,500 people. The exterior of this design, scheme B, was a spartan and dominating thing, a bulwark against the visual and aural world outside.[50]

Figure 19.4. Todd A-O cinema and theater for Mike Todd and Dome Enterprises, 1958, project, plan and elevation drawing of scheme B; ©2003 the Wright Archive.

For scheme B there were to be but 600 seats in a round plan and exterior shape, with a bulb on one end to house modest stage facilities. Curved precast concrete slabs butted end to end were round-topped and served as blank walls on which a dome was to rest (Figure 19.4). This obviously met the requirements for greater compaction, cheaper construction, and a prominent dome to please Kaiser. Scheme C was effectively a ballooning of scheme B, with seating increased to 1,550 and a high aluminum-framed dome dominating all.

During about four months of negotiations, telegrams and darting visits by Todd were insufficient. After revisions were ready for inspection, probably for scheme C, Wright tried to get Todd to settle down long enough to study them. Finally on 7 March 1958 Wright wired "Dear Mike":

> YOU ARE MISSING THE MICHAEL TODD UNIVERSAL THEATER.... YOU SHOULDN'T TAKE WHAT OTHERS TELL YOU BUT SEE FOR YOURSELF. LOVE TO ELIZABETH....[51]

In the absence of a response, this telegram followed:

> WHAT ABOUT THE THEATRE PROJECT? IS IT DEAD OR ARE WE JUST NOT SO SMART AS WE THOUGHT YOU WERE.[52]

Todd replied on 10 March that he would stop at Taliesin West on Friday next.[53] Two weeks later he piloted his leased aircraft, "The Lucky Liz," intending to fly to New York City to attend a party in his honor. Running a fever, Taylor decided to

remain in Los Angeles. During the night of 22 March the plane crashed in New Mexico. Todd, age 51, and his crony and biographer Art Cohn were killed. Lucky Liz.

Exactly one month later Pat Weaver telegraphed Wright that he, Kaiser, and Mike Todd, Jr., were recovering from the tragedy of Todd Senior's death, yet they still wanted to study "the dome plans."[54] "Deliberations went on for some time," says Wright archivist Bruce Pfeiffer, who was then active in Wright's architectural office. But enthusiasm for the project failed to engage all participants.[55] Apparently there were problems with a number of aspects of the proposal including the question of whether to include a fly loft.[56] The evidence indicates that Taylor did not participate in deliberations or project planning before or after Todd's death. She resumed rehearsing her role for the movie *Cat on a Hot Tin Roof*. Soon she and songster Eddie Fisher began a relationship.[57]

Todd and his Dome Enterprises colleagues were looking for an adaptable scheme, one that would seat 600 people for legitimate theater or expand to seat 1,500 for movies. Such a theater building is one of the more difficult architectural design problems because it must accommodate inflating and deflating functions and spaces, live or electronic performances with disparate acoustical needs, scenic and stage management problems, massive back stage and front of house requirements, and a wide variety of other often contradictory needs that must combine with reasonable aesthetic considerations.

No specific site was given. The investors' idea was to construct domed theaters on flat land adjacent to "major" shopping centers where there was "lots of parking, lots of shopping, and lots of opportunity for smart showmen."[58] Wright's drawings indicate that much was yet to be done. However, interest in the project "gradually faded," Pfeiffer has said; "Finally it was dropped altogether."[59]

When all the gossip, rumor, designs (artistic and social), scuttlebutt, movies, treachery, travels, writings, and even facts are known and then weighed, one can safely say that Hollywood and Wright had a sometimes intimate but always a loose, awkward, lingering, often disorderly, personal then casual, usually frustrating and unfulfilling relationship. To that comment the reaction in Hollywood would be, "So what's new?"

Part V

Fountainheads

20

Conclusion

This study has revealed a truth: Architecture is much more than ornamented structures or mere aesthetics. It is infused with diverse aspects such as technology, business, symbolism, construction expertise, bylaws, commerce, philosophy, materials science, art theories, intuition, artistic talent, ritual, tradition, and time. It is created by individuals with certain psychological and societal conditions, and for individuals or collective societal entities, private and public. It quite obviously reflects society's conservative or vulgar or commercial or radical or inventive or petty or political or ignorant or avant-garde quirks and strains. Through its intellectual content and experiential component it helps to tell us where we have been, are, or might go. Art has purposes and, of the nonliterary arts, architecture is the greatest identifier of them, the most expressive.

This book has also revealed that the study of architecture cannot be whole unless one knows the biography of its creators. If we study only the objects, we refuse content. Consistent throughout Wright's life was a belief in the Unitarian principles of individual freedom *and* reasonable ethical standards in the conduct of social interaction. It was a religious foundation set in mid-nineteenth century. But his architecture changed aesthetically over the decades because of certain internal and external changes in his life. Those aesthetic appearances evolved as artistic endeavors, but equally as responses to each new moment. They had nothing to do with the European notion of *Zeitgeist* but with American pragmatism.

Dissatisfied with what appeared to be a normal marriage, Wright abandoned wife and children to share a life of free will and intellectual nourishment with another woman who, similarly motivated, abandoned her husband and children. Their public act was to flee to Europe. Thereafter his architecture changed. Traumatized by that woman's gruesome death and ensuing psychological and social difficulties, he took advantage of a serendipitous invitation and fled to Tokyo. Perhaps strangely, his architecture in Japan reverted to previously acceptable, almost conventional themes. Soon rejected by Japan he resettled in the United States and, attracted to his son Lloyd, Wright came in contact with the people, places and buildings of Southwestern America. Thereafter his architecture was dramatically transformed.[1] And so on until death. The aesthetic changes in his architecture can be measured, although this is seldom done. But causes are within the man, not in the aesthetics. Architectural historians too often stumble over this fundamental.

The relativistic pluralism of today (2003 c.e.) is matched by architecture's freedom from the confines of formalism and styles. (Wright proved both the existence of the wherewithal and the viability of that potential in the 1930s.) The American exception is governmental architecture in Washington, D.C., and sometimes elsewhere, which continues a staid formality by using stale semi-modern modifications of Greco-Roman classicism. (It is not certain that Thomas Jefferson would be pleased by such artistic inhibition in our modern world.) And it exemplifies the ultraconservative restraint that can be imposed by statism, in this case secular, but elsewhere by religious states.

Like law and church, mainstream politics tends to be conservative because it tends to be satisfied with — and to defend — existing conditions. It loathes to question or anticipate and abhors change, for fear of unknowns. Now and then statism in the guise of politics escapes the psychological and verbal confines of the District of Columbia to invade the rest of America. Its collusive, systemic smear campaign against those who held — real or imagined — allegedly fascist, communist, or subversive views (as Muslims and selected foreign nationals experienced from 2001 onward), and the resulting diabolical and disruptive incursion into Hollywood and into Wright's private and professional life, are but examples. They affected not only his architecture and the practice of it, but his life.

The usual definition of *fountainhead* is "the source from which a stream flows," hence, the chief source of anything. The fountainhead of American politics, as with law, is in Mediterranean antiquity and English common law. The practical source of everyday American politics is by sufferance of the people in the contemporary state. Pragmatically, therefore, the state is a physical and philosophic fountainhead. But in sufferance the people must now and then demand to be informed or allowed to challenge questionable actions by appropriate — but not excessive — means. If they do not they will become victims of collective state avarice, cupidity, and covetousness, the effects of a society of secrets. So, their questions must be carefully answered by those given the power of governance.

Wright was an artist steeped in religion and transcendentalism obtained from his father and progressive uncle, the Reverend Dr. Jenkin Lloyd Jones, a respected, nationally recognized Unitarian minister who favored a nondenominational church. As I've discussed elsewhere, he was for many (not just his nephew) a fountainhead of honesty, clear thought, compassion, and a progressive, participatory and virtuous religion that shunned church. Through Uncle Jenkin (and his farmer brothers and teacher sisters), Wright learned to become idiosyncratically independent of mind and repulsed by institutional authority, church or state, and an *inhibiting*, resisting society. Moreover, he firmly believed in the redemptive power of art.

Wright used a freely exercised individualism and architectural genius to create the initial strain of a new architecture. Thereby he became the fountainhead in Europe and America of a new art for the twentieth century. In later life he used his celebrity to promote a unique alternative lifestyle found in the exercises of his Fellowship. His great atelier was meant to be the liberating example for America. But during his lifetime it was no more than a manorial guest house (heroes are not perfect). Nonetheless, Wright was seen as the personification of America's hallowed mainstay, "indi-

vidual liberty." His life and professional career up to 1940 was in maintenance of that position and was Rand's inspiration, the FBI's worry, and a Hollywood itch.

The emphasis of Rand's book was, as she said, "the individual's ego as the fountainhead of human progress." Only later did she identify it as "reason against mysticism." Her film outline identified the movie's theme as "man's integrity." Her thoughts about the centrality of egoism were mightily reinforced by reading about Wright, digesting his words and those of his observers, and comparing his buildings with those of the mainstream. Her book, she said significantly enough, began and had to end with him. But after 1949 and the peculiar and outspoken reaction to her movie, its script and its visual presentation, Rand moved on. Her thoughts expanded beyond the proclamation of egoism and selfishness to an evolving concept that became the philosophy of Objectivism. Academics are uncertain of its validity but, in the face of pragmatics, are helpless to ignore it. Wright's life, art and philosophy were absorbed as one stage in — perhaps a foundation of — Rand's maturation. It is not clear that she would have succeeded without his intervention.

Hollywood represents the fullest exploitation of capitalism by an industry enabled by free enterprise. Obsessively working to manufacture its success, Hollywood was and is full of self-possessed egos, few substantial in the Randian sense, most boldly sham. Yet they shine before lights powered by the cult of personality. Hollywood is the practical fountainhead of make-believe and propagandistic persuasion; vision and sound, celluloid and celebrity its media. Hollywood is capitalism's most popular, excessive and potent symbol. Only now and then does the state attempt to patronize (in all of its meanings) or restrain it.

There is another true story that needs telling. It also is about freedom of speech, about right-wing totalitarianism in the guise of patriotism, about hate generated by ignorance, about the extremes and tragedy of state-induced paranoia.

It was 1953. Movie producer Paul Jerrico, then banned by Hollywood studios, and Herbert Biberman, who served a few months in prison for being no more than an uncooperative witness before HUAC, created a film company. Its purpose was to give work to blacklisted members of the film industry and present movies about the experiences of ordinary downtrodden people. Their first and only film was about a mineworkers' strike and how the mine company, federal agents, the Taft-Hartley Act, the press, and neighbors, all act to physically and emotionally beat poverty-ridden employees and their families. It was one of the first films to realistically and accurately portray racism and the struggle by and suppression of women, Jews, Chicanos, blacks, immigrants, workers.

Partly produced by — and most of the actors were members of — the International Union of Mine, Mill and Smelter Workers, Local 890, of Bayard, New Mexico, the cast had only five professional actors. One, Will Greer, who plays a local redneck sheriff (and later Grandpa in *The Waltons* on TV), had been blacklisted. The star, Mexican actor Rosaura Revueltas, was selected after Biberman's wife, Gale Sondergaard, refused the role, saying it must be played by a Hispanic actress.

Then troubles began. A New Mexico school teacher sent a letter to Walter Pidgeon, president of the Screen Actors Guild, warning that "Hollywood Reds" were making an "anti–American" movie. Pidgeon alerted HUAC and the FBI, therefore

the Department of Justice. There followed a frenzy of lies and hate orchestrated from on high. CIA operative Donald Jackson, for instance, publicly vowed to stop production of the "Communist-made film." Howard Hughes, then head of RKO, instigated attempts to stop film processing and distribution and nearly succeeded. Vigilante groups (organized by whom?) picketed the shooting site, fought with the crew, set fire to buildings, and threatened murder, while some local businesses refused to serve the crew.

Finally, not the local but the New Mexico State Police protected the company. Then the talented Revueltas was deported by the Justice Department for a minor passport violation. Soon she was blacklisted in Mexico never again to work in the industry. The frightening episodes during the making of the movie paralleled the equally serious trials portrayed in the movie itself. And the smearing continued. Some newspapers refused to carry ads and theaters were threatened with pickets.

In spite of those ugly troubles, in March 1954 *Salt of the Earth* debuted at 13 theaters nationwide. "Critical reaction was surprisingly good" and the supposed "anti–American message" was of course "nonexistent." The film was well received outside the U.S., in France, China, West Germany, Canada, and the USSR. Beginning in the 1960s it made a successful return with exhibitions throughout America and Canada.

Salt of the Earth's "portrait of the dignity of men and women unifying for a cause ... remains without comparison." It is consistently praised as one of few five-star movies. "While history has passed judgment on the people who tried to stop this important work, [it] continues to walk hand-in-hand with real American ideals."[2] Since ca. 1948, with each new decade the state comes closer and closer to zealously protecting itself, to a totalitarian position. Sadly, that reactive course conforms to the history of all cultures.

While many people believe otherwise, therefore, the Federal Bureau of Investigation by definition is not a fountainhead nor is its parent the Department of Justice. The Constitution is America's practical political fountainhead. The FBI is on a line described by and descending from the elected government through the Attorney General. It is an institutionalized preserver and maintainer of the state it serves. Its secrecy, although at times necessary in some limited *prescribed* manner, does not always safeguard the sovereignty of the American people, a sovereignty proclaimed by a constitution. Yet, an apparently impotent U.S. Congress allows it an awful, unfettered license.

Outside normal police activities, the FBI acts to maintain the status quo and preserve the narrowness of tradition as if it were a holy grail. In an arrogant and often ignorant mood, Congress will now and then sanction incursions into private affairs in the belief that those affairs deleteriously influence affairs of state and the national "interest." Usually the White House and Department of Justice are its agents. Their argument is that the only way to know something is or is not an influence is by discovery. But in that pursuit the acceptance of hearsay is demagoguery. And the simpleminded weapon of exposure is slanderous. Both are puerile and the last resort of the defeated, the cowardly unsure or the blinkered arrogant.

One of our subjects epitomized statism, one capitalism, two individualism and

individual freedom. Three acted with free exercise, two of those achieved through unrestrained individual liberty, one through free enterprise. The other one, a poser, was and is about clandestine sanctions by state bosses wielding fear or power in the shape of conservation and preservation, or contriving a public mandate. To conserve the principles (the root stock) is one thing; to preserve the past (the fruit) by traditionalism is the wrong thing.

With the knowledge contained in these chapters, we note that all of our subjects steadfastly faced one another and on most occasions were independently resolute, but in the main they acted conceitedly as if correct. On rare occasions they worked in concert although remaining bound tightly by personal principle in the name of good.

Recently, broadcast and cable or satellite television, together with effective employees' rights, have induced slightly less myopia and corporate greed in the dream factories producing motion pictures and television. They also have caused some commercial but little philosophic, let alone artistic, independence. Yet, new corporate mergers threaten to unilaterally, or by collusion, constrain and bias art and information. They beget private sector bosses, in the guise of benefactors who shun social responsibility. Nearly all corporations adhere to the ultraconservative belief in the holiness of a totally unregulated laissez-faire system. This was Rand's view. This means no representation for employees or consumers, no overview by citizens. So, in reality the market only regulates itself for itself. Society is merely an ignorant — in the sense of uninformed — consumer. Plutocracy becomes inevitable. This was Wright's view.

We have witnessed over recent decades that the serving institutions — the Department of Justice's attorney general and FBI, and the people's national Congress — have not satisfactorily reframed their purposes or made attempts to alter their methods in spite of the guiding principles offered by the Constitution, people's publicly exclaimed dismay and disbelief, case law, Supreme Court security, the *X-Files* or *Law and Order*, and common sense for the common weal. We now see that the "Stasi," the state system of surveillance, intimidation and disclosure, is easily reconstituted with a consequent diminution, even abandonment of enshrined rights and freedoms. The U.S. attorney general is nearly a czar, perhaps, certainly a political rationalizer. It is disheartening to hear the old right-wing, constraining, and suppressing rhetoric from new faces served by new political factotums.

Our two passionate individuals, Frank Lincoln Wright and Alissa Rosenbaum, have been succeeded by a multitude of artists and architects and writers and philosophers who are possessed of equal ardor, and unashamedly face similar tests fashioned by similar people. Freedom is not free.

Appendix A: Film Outline

The outline to follow was quite possibly prepared by Ayn Rand shortly after the motion picture rights to *The Fountainhead* were purchased by Warner Brothers. It is quoted with permission of Warner Brothers and AOL Time Warner.

"The Fountainhead" by Ayn Rand

(December 13, 1943)

General Theme: Man's integrity.

Plot Theme: Howard Roark, an architect, as man of genius, originality and complete spiritual independence, holds the truth of his convictions above all things in life. He fights against society for his creative freedom, he refuses to compromise in any way, he builds only as he believes, he will not submit to conventions, traditions, popular taste, money or fame. Dominique Francon, the woman he loves, thinks that his fight is hopeless. Afraid that society will hurt and corrupt him, she tries to block his career in order to save him from certain disaster. When the disaster comes and he faces public disgrace, she decides to take her revenge on the man responsible for it, Gail Wynand, a powerful, corrupt newspaper publisher. She marries Wynand, determined to break him. But Roark rises slowly, in spite of every obstacle. When he finally meets Wynand in person Dominique is terrified to see that the two men love and understand each other. Roark's integrity reaches Wynand's better self, Roark is the ideal which Wynand has betrayed in his ambition for power. Without intending it, Roark achieves his own revenge—by becoming Wynand's best friend. Dominique finds herself suffering in a strange triangle—jealous of her husband's devotion to the man she loves. When Roark's life and career are threatened in a final test, when be becomes the victim of public fury and has to stand trial, alone, hated, opposed and denounced by all—Wynand makes the supreme effort toward his own redemption. He stands by Roark and defends him. Wynand loses, defeated and broken by the corrupt machine he himself had created. But Roark wins without his help—wins by the power of his own truth. Roark is acquitted—and Dominique comes to him, free to find happiness with him, realizing that the battle is never hopeless, that nothing can defeat man's integrity.

Key Points

Part One: Roark—Cameron. Keating—Francon. Roark in Snyte's office—the Heller house—Roark's first commission.[1] Keating's rise with Francon and his attempted romance with Dominique. The Cosmo—Slotnick competition. Roark's refusal of his last chance at a commission. Roark's departure for quarry. Celebration of Keating as partner.

Part Two: The quarry—the meeting of Roark and Dominique. Their romance. Roark gets commission for Enright house and leaves. Keating's success and friendship with Toohey. The

party where Roark and Dominique meet again. The fight of Dominique and Toohey against Roark's career. The commission for the Stoddard Temple. Roark — Mallory. The Stoddard trial. Dominique leaves Roark. The reconstruction of the Stoddard Temple.

Part Three: Gail Wynand and the Banner. First meeting of Wynand's proposal. The meeting of Roark — Dominique in small town. The wedding of Dominique and Wynand.

Part Four: Roark's rise — Modanock Valley.[2] First meeting of Roark — Wynand. The dinner at Wynand's home — Roark, Wynand, Dominique. Keating's downgrade. The pact — Roark — Keating. The friendship of Roark — Wynand, Dominique's jealousy, the building of the Wynand house. Keating and his collaborators ruining Cortlandt. The explosion. The public fury against Roark. Keating — Toohey. Wynand's crusade for Roark. Wynand's surrender. Dominique — Roark love scene. Roark's trial. Last scene — Wynand — Toohey — the end of The Banner. Last scene — Wynand — Roark. The Wynand Building — Dominique — Roark.

("Then there was only the ocean and the sky and the figure of Howard Roark."[3])

Appendix B: Book Synopsis

In the late 1920s and through the 1930s, when each studio was making 50 to 150 movies a year, story departments in Hollywood and New York searched for and recommended literary material. In the 1940s the majors were releasing about half that number. Studio story editors had a small staff of people called "readers," and Rand was a reader during the last days of the silents and off and on into the 1940s.

A reader's job was to read novels, plays, and "originals," to make synopses of no set length, to venture opinions on a story's potential as a film, and to perhaps suggest changes. As a story analyst the reader had to work fast because the same material was usually under consideration by a number of studios. A synopsis for Mervyn LeRoy required it convey "the story in condensed form and also the style of the author and of the story itself. The story shouldn't lose anything by being synopsized." (Appendix A is not a synopsis.) When Dore Schary was the head of MGM he wrote that often a "reader's synopsis, particularly of a long novel, is better than the original for our purposes; crisper, the story line cleaner, and the characters standing out in sharper relief."

The story material covered by readers during any *one* year at only one major studio during the 1930s and early 1940s was staggering; around 10,000 literary items. In 1940 there were 375 writers under contract to studios; in 1950 there were 147, and 48 in 1960.[1]

It is not known who wrote the synopsis below but the literary style is not Rand's. The fact that actors are named suggests it was revised during production or post-production. It is quoted with permission of Warner Brothers and AOL Time Warner.

Synopsis of The Fountainhead

Dismissed from architectural school because of his unconventional modernistic theories on design and construction, Howard Roark (GARY COOPER) sets out to prove the world will beat a path to his door — and his ideas.

At first he goes to work for architect Henry Cameron (HENRY HULL) whose ideas, much like Roark's, have brought him steadily diminishing clientele.

The years drag by and Roark gradually takes over the office from Cameron, who has taken to drink. Then comes the night when Cameron, drunk and staggering, meets a newsboy for the all-powerful metropolitan newspaper, *The Banner*. Cameron spends his last funds to buy all the boy's copies, tears them up and strews them in contempt along the street.

Roark finds him on the verge of death, takes him to his squalid office. There Cameron points to pictures of the four

buildings Roark has designed — his total work of years — and urges him to forget his radical architectural ideas if he wants to gain financial success.

Cameron tells him that Gail Wynand (RAYMOND MASSEY) publisher of *The Banner* and "the most powerful man living" has gained his position by giving the people "what they ask for, the common, the vulgar, the trite."

Cameron dies in an ambulance as Roark tells him he intends to fight for his ideals even if his fate is the same as that of his old friend.

Returning to his dank office to carry out Cameron's last request, the burning of his drawings and papers, Roark has a visitor. He is Peter Keating (KENT SMITH) who, as a college chum, had urged Roark to follow the conventional pattern if he expected any success.

Keating tells him he has just been made a partner by Guy Francon, the country's leading architect. He again implores Roark to forget his radical forms of design. Although he is in debt, without a client and with even his watch in hock, Roark tells Keating he intends to stand alone — until he wins.

Roark's spirits are momentarily lifted when the Board of Directors of the Security Bank of Manhattan, in which Publisher Wynand holds a controlling interest, tells him they have accepted his plans for a new building.

They are dashed when he is told there must be a "slight compromise," one which Roark cannot meet without a sacrifice of his rigid integrity. He turns down the offer and goes to work in a granite quarry in Connecticut, owned by architect Francon.

Behind the machinations which cost Roark the bank job is Ellsworth M. Toohey, scheming but powerful architectural columnist of *The Banner*. Toohey urges Wynand to name Keating for the job, but he refuses until he consults Guy Francon's daughter, Dominique (PATRICIA NEAL), who is engaged to Keating and conducts another architectural column on *The Banner*.

This meeting reveals Wynand's love for Dominique and her contempt for her employer. The same night at dinner Wynand tells Keating he can have the bank contract if he'll break his engagement to Dominique. Keating is shocked but accepts.

Dominique tells Wynand she became engaged to Keating because he is "the most safely unimportant person I could find, and I knew I'd never be in love." She then leaves to spend some time at her father's place in Connecticut.

Roark and Dominique feel an irresistible attraction for each other when she visits her father's quarry, but they do not speak. At a second meeting, she berates him for staring at her.

She has him sent to her home to advise repairs on a marble fireplace she deliberately breaks. Later, he sends another man to finish the repairs and angered she strikes him across the face with a stick when she meets him in the woods.

That night he comes to her home and makes violent love to her. When he returns home he finds a letter from wealthy Roger Enright who wants him to design an apartment house. Roark goes to New York and Dominique, who does not even know his name, is upset by his departure.

At Toohey's instigation, Alvah Scarret, editor of *The Banner*, launches a smear campaign at the Enright Building. Dominique quits the paper when Wynand refuses to call of the campaign although he admits he is personally impressed with Roark's great talent.

The Banner's campaign raises a pubic tumult, but the building is completed and Enright gives a party in honor of the event. There Roark and Dominique come face to face again. She tells him of her admiration for his work, but tells him abruptly that she'll not easily be brought into submission.

However, that night she goes to his apartment and in another violent emotional scene they confess their love for each other.

Dominique offers to marry him if he'll give up his attempt to fight for his convictions and Roark refuses. He tells her that she must learn not to be afraid and that he'll wait for her.

After a final embrace, Dominique goes to Wynand on his yacht and tells him she'll marry him. From an office

building across the street Roark grimly watches them leave on their honeymoon.

After his years of struggle success finally begins to come to Roark in full measure. The climax is capped when Wynand calls him to his office and commissions him to do a country house for himself and Dominique. Despite the smear campaign which *The Banner* had conducted against him, Wynand tells Roark of his great personal admiration for his work.

Dominique is amazed when Wynand tells her he has engaged Roark. She chides him, tells him that Roark has won his fight. Wynand becomes angry, again threatens to break Roark. However, when Roark stands up to him later, again refuses to compromise on his work, Wynand backs down and invites him to dinner with himself and Dominique.

That evening she accuses them both of admitting defeat, but Roark says no, that he and Wynand now understand each other.

Meanwhile, Keating has been going steadily downward in reputation. He finally appeals to columnist Toohey to help him get the contract to design Cortland Homes, a model development of low-rent housing. Toohey tells him he is incapable.

Desperate, Keating goes to Roark and pleads with him to do a design which he can submit in his own name. Roark finally agrees because he knows it is the only chance he'll have at the project. But there is one stipulation. Roark's demand is that his plan will be followed without a single change. Keating gratefully agrees.

At Wynand's invitation, Roark goes on a long cruise on the Wynand yacht, his first vacation. As they sail from New York harbor the publishers tells Roark he plans to have him design the Wynand Building, to be the tallest in the city.

While Roark is away, Keating is unable to prevent changes in Roark's design and when Roark returns he finds the first of the six apartment buildings in the development completed.

Keating explains to him he did everything possible to keep the design intact and offers to give Roark the money he had received and to confess that Roark actually had drawn the plans. Roark declines and says he'll decide himself what to do.

Dominique comes to him, tells him she can't conquer her urge to be with him and says she plans to leave Wynand. She guesses his plans to blow up the Cortland building when he asks her to be outside the project at ll:30 p.m. the following Monday night. She asks if he wants to test her courage, but he doesn't answer the question.

Dominique is there, apparently a casual passerby, when the building is blasted apart. Roark is arrested.

Columnist Toohey works to inflame the public against Roark, but Wynand, to Dominique's delight, defends him in *The Banner*. Roark visits Dominique and again they pledge their love.

For once, Wynand finds the city against him. Bricks are hurled through the windows of the newspaper office. Circulation drops. He fires Toohey and the city staff quits in protest. Dominique goes back to work to help get out the paper, but circulation continues to drop.

The condition becomes so bad that board of directors of *The Banner* forces Wynand to reversed himself and denounce Roark. Wynand is horrified by his own action and refuses to see Roark, but Dominique goes to him again.

Roark goes on trial and wins speedy acquittal in a statement to the jury in which he declares what he believes to be a man's rights to his own ideas and ideals.

Enright, who had given Roark his big chance years before, buys the Cortland development and places Roark in full charge to carry out his plans.

Overcome with remorse, Wynand closes *The Banner*, commissions Roark to design and build the Wynand Building, to be the tallest in New York, then commits suicide. The story ends with the Wynand Building, under construction, towering into the sky and Dominique ascending in a work elevator to the top to meet Roark, as his wife.

Appendix C: Film Credits

The Fountainhead

A Warner Bros. Picture. 114 minutes, black & white. Released 21 June 1949.

Production

Producer, Henry Blanke; director, King Vidor; screenplay, Ayn Rand; photographer, Robert Burks; music, Max Steiner; editor, David Weisbart; art director, Edward Carrere; set designer, William Kuehl; costumes, Milo Anderson; special effects, William McGann, Edwing DuPar, H.F. Koenekamp and John Holden; makeup, Perc Westmore and John Wallace.

Cast

Gary Cooper (Howard Roark), Patricia Neal (Dominique), Raymond Massey (Gail Wynand), Kent Smith (Peter Keating), Robert Douglas (Ellsworth Toohey), Henry Hull (Henry Cameron), Ray Collins (Enright), Moroni Olsen (Chairman), Jerome Cowan (Alvah Scarret), Paul Harvey, Thuston Hall (Businessmen), Harry Woods (Superintendent), Paul Stanton (The Dean), Bob Alden (Newsboy), Tristram Coffin (Secretary), Roy Gordon (Vice President), Isabel Withers (Secretary), Almira Sessions (Housekeeper), Tito Vuolo and William Haade (Workers), Gail Bonney (Woman), Dorothy Christy (Society Woman), Harlan Warde (Young Man), Jonathan Hale (Guy Francon), Frank Wilcox (Gordon Prescott), Douglas Kennedy (Reporter), Pierre Watkin and Selmer Jackson (Officials, John Doucette (Gus Webb), John Alvin (Young Intellectual), Geraldine Wall (Woman), Fred Kelsey (Old Watchman), Paul Newland and George Sherwood (Policemen), Lois Austing (Woman Guest), Josephine Collins (Foreman), Ann Doran and Ruthelma Stevens (Secretaries), Creighton Hale (Clerk), Philo McCullough (Bailiff).

Appendix D: Frank Capra's Bleeding-Heart Liberals

Frank Capra was one of the most respected and successful of Hollywood's directors. He was also one of the more articulate, who zestfully applied the industry's colloquial language. Capra's summation, written around 1970, of "Communist or Fascist" reactive events in mid–1940s Hollywood is succinct and typical of his language. He prefaced it with a comment that his movie *State of the Union* was a political satire, "rather brutal at times."[1] Most people will laugh at "political lampoonery" but if they are on "either end" of the political spectrum, "they lose their sense of humor." They "never laugh. They can't."

The extract is taken from Frank Capra, *The Name Above the Title: An Autobiography* (London: W.H. Allen [Howard and Wyndham], 1972; New York: Random House/Vintage, 1985) 390–391, and quoted below with permission of Random House.

> The year 1947 was a time of vicious intra-industry political war; returned service veterans and others were trying to root out the entrenched reds. Bitter arguments, loud shouting matches, even blows filled the air. Whose bitch was witch? became a grizzly game.
>
> In a tense, emotional, big-money industry, governed by super-egos with super-thyroids, an industry whose history could be the plot of a Marx Brothers' farce, one might have expected that industry's politics to follow suit in kookiness. It did. In spades. It seemed that two thirds of the picture people registered as breast-beating Democrats, but voted as coupon-clipping Republicans.
>
> Only the Big Brother twins (one left-handed, the other right-handed) were grimly, deadly serious about Hollywood's politics. And for strong reasons. Hollywood had become not only a world center for entertainment and "news"; it was also the home of the world's richest Easy Marks. Since every day was Christmas Day for some lucky ones, these emotional suckers would contribute to anything and everything charitable—including some not easy-to-spot Big Brother Enterprises. Then, of course, what better propaganda than a party-line speech here and there by some popular movie hero to a listening audience of hundreds of millions?
>
> In films—as in radio and press—Stalinites were more numerous, and certainly more popular, than Hitlerites. First of all the reds were our allies in fighting Hitler's Fascists. Second, Hitler's human barbecue ovens made even some of our own Kook Kluck Klackers pale under their hoods. But despite the presence of war-created popularity of reds in Hollywood, red propaganda in films had been minuscule in importance or dividends.

Another Hollywood political ana: Big Brother "Lefty" early glaumed on to the words "liberal" and Democracy" and "progressive" as slogans for his snake-oil; these words being normally in Big Brother "Right's" lexicon of shibboleths. "Right" had to be content with such less glamorous words (since the war) as "patriotism" and "conservatism" and — a word they wish they could eat — "reactionary." But still, Hollywood "gave out" as liberals, yet voted as conservatives. An example: In our filthy-rich residential section of Brentwood, a group of "bleeding-heart" liberal home-owners would regularly solicit for progressive movements. But one day they came to our house asking us to sign a community contract that pledged us all not to sell our homes to Negroes! Some liberals. My wife threw them out on the progressive ears.

Appendix E:
Mrs. Walsh's Extracts

"Naturally, being a vain and successful man, you are not loathe to a little adulation, so that you will be very pleased to add me to your monumental list of admirers."

And so began Mrs. Orinda B. Walsh's letter to Wright on a New England winter's evening in 1946.[1] She affirmed the "persistent rumors" that Rand's Roark was "patterned" after the real-life, vain and successful architect by quoting sections of *The Fountainhead* novel that supported her contention that Roark's architectural ideas "coincide" with Wright's. Some of her selections are quoted below. There has been no attempt to locate the extracts within the novel or determine if they are correct; precision is not essential. Walsh was right; it all reads much like Wright under the influence of Sullivan, and better than he could write.

> Nothing can be reasonable or beautiful unless it's made by one central idea. A building is alive, like a man... .
> The house had been designed by the cliff on which it stood. The house was broken into many levels following the ledges of the rock, rising as it rose, in gradual masses, in planes flowing together up into one consummate harmony. The walls, of the same granite as the rock, continued its vertical lines upward, the wide projecting terraces of concrete, silver as the sea, followed the line of the waves, of the straight horizon....
> Look at it, every piece of it is there because the house needs it... . The rooms in which you'll live made the shape. The relation of masses was determined by the distribution of space within. The ornament was determined by the method of construction, an emphasis of the principle that makes it stand. You can see each stress, each support that meets it... .
> He did not grasp it as a building, at first glance, but as rising mass of rock crystal. There was the same severe, mathematical order holding together a free fantastic growth, straight lines and clean angles, space slashed with a knife, yet in harmony of formation as delicate as the work of a jeweller, an incredible variety of shapes, each separate unit unrepeated, but leading inevitably to the next one and to the whole, so that future inhabitants were to have, not a square cage out of a square pile of cages, but each a single house held to the other houses like a single crystal to the side of a rock.

Appendix F: Red Charge, Marin County, 1957

The following newspaper article concerned the Marin County Civic Center Government Building, San Rafael, California, constructed 1960–63, F.L. Wright architect, Herb Greene Associate.

Red Charge Stirs Wright to a Boil.

by Francis B. O'Gara[1]

Frank Lloyd Wright, a rugged individualist personally as well as architectural, rebelled yesterday when accused of hewing his political philosophy along Communist lines. He walked out of a meeting of the Marin County Board of Supervisors, while the charges were being read, protesting that he is a loyal American who detests Communism.

The colorful 88 [90] years old dean of American architects also delivered a few lines that were just as frank as his professional expressions, if not as original.

"UTTER INSULT."

"I am what I am," he told the supervisors. "If you don't like it, you can lump it. To hell with it all."

He waved his cane angrily as he paused in his exit and upped with a tag line:

"This is an absolute and utter insult and I will not be subject to it."

It developed, however, that although Wright was walking out on the meeting, he was not walking out on his contract with the board. The contract guarantees him 10 percent of the construction cost for designing and planning the projected $8,000,000 Marin County civic center north of San Rafael.

SIGNS CONTRACT

Two hours after his stormy exit from the courthouses, Wright had cooled sufficiently to sign the official contracts retaining him for the civic center project. But first, he lunched at the Meadow Club in Fairfax with several county officials and played the piano for their entertainment.

While Wright fumed outside the supervisors' courthouse chambers, board members fumed inside.

A one hour recess was called, pending an opinion from County Counsel Lee Jordan on whether, as a matter of law, County Clerk George Jones should finish reading the charges. The charges were contained in a letter from Bryson Reinhardt. [...]

During the recess board members—except Supervisor William Fusselman—and other county officials joined the mercurial Wright for his first inspection of the hilly, 130 acre civic center site.

The spry old man explored the terrain with the eagerness of a child at a picnic.

He ducked between the strands of one barbed wire fence and climbed over another one, jumped across several ditches and fought his way through knee high grass and thistles.

Finally, he rendered his appraisal.

"Splendid," he said. "It's as beautiful as California can have."

Two 15 year old Santa Venetia girls, Linda Martinez and Carole Baas, asked Wright to pose for snapshots. He agreed amiably.

"Are you going to knock down all these hills?," one girl inquired.

"Not a single hill," said the master architect, now beaming with enthusiasm.

Some one asked if he planned to make further site inspections before getting to work on the plans. Wright evidently considered that something of an insult too.

"I don't have to drink a tub of dye to know what the color is," he replied.

LETTER FOR SALE

The supervisors had meanwhile returned to their San Rafael chamber for Jordan's opinion. Jordan ruled that no law required them to have Reinhardt's letter read publicly.

Supervisor Fusselman moved that it be read aloud in its entirety but his motion didn't even get a second.

The document was made a public record, however, and board attaches said copies would be available for $3 each.

When County Clerk Jones started reading it into the record earlier, he had finished only two paragraphs when Wright made his exit speech. The letter began:

"Frank Lloyd Wright, America's best known architect, now in his 89th year, has a record of active and intensive support of Communist views and enterprises. He believes the popular notion that youth alone is beguiled by the appeals of radicalism and subversion.

"Wright expounded the Communist line on television. In the Daily Worker on October 20, 1953, on page 7, Frank Lloyd Wright was featured under the line 'How a Celebrated Architect Shocked Jinx on Ike [Eisenhower].' This authorative journalistic mouth piece of the Communist conspiracy had good reasons to gloat over Wright's performance on the television program (WNBT, Channel 4) of Jinx Falkenberg on October 16, 1953."

It was then that Wright reached his boiling point and departed.[2]

Supervisor Vera Schultz defended the noted architect, observing that the board does not inquire into the religious or political belief of any county employee and adding:

"It is most inappropriate that we should subject a man of Mr. Wright's caliber to the reading of unfounded and unsubstantiated charges."

"PLOT" CHARGED

Mrs. Schultz charged the whole thing was a carefully laid plot against Wright. She said Jones failed to show up at a special Wednesday night meeting of the supervisors, when Wright was to have signed the contracts.

No copies of the documents were to be found in Jones' office, she said, adding that she believed Wright's enemies hoped to prevent him from signing until after the Communist charges were read.

As it happened, Board Chairman Walter Castro happened to find a carbon copy of the contract in his pocket. Mrs. Schultz said Wright signed this, and affixed his signature to official contracts after the uproar at yesterdays meeting.

Reinhardt claimed privately that his letter was based on documented information from J.B. Matthews, former chief investigator for the House Un-American Activities Committee and former staff director of the Senate Investigations Subcommittee.[3]

Reinhardt said he started investigating Wright because he questioned the 10 percent fee on the civic center project.

Wright, also privately, defied anyone to prove he is or ever has been a Communist sympathizer.

"I challenge anyone to prove one act or one association of a character that could be subversive," said Wright. "If the kind of belief I have is subversive, then I am the greatest subversive in America."

Chapter Notes

See References, following, for published sources and abbreviations.

Epigraph on page vi: Frank Lloyd Wright, 1896, as quoted in *Architectural Forum*, January 1930, 2; epigraph on page ix: Ayn Rand, 1937, *see also* in Sciabarra (1995), 111.

Chapter 1

1. Principal biographical sources are Twombly (1979); Smith (1992); Langmead and Johnson (2000); Secrest (1992); Alofsin (1993); Wright (1932); Wright (1943); Wright (1946); Sergeant (1976); Johnson (1990); Donald Leslie Johnson, "Notes on Frank Lloyd Wright's Paternal Family," *Frank Lloyd Wright Newsletter* 3 (2, 1980), 5–7; Gill (1987).

Chapter 2

1. The role of educators and religionists in the development of Frank Lloyd Wright's thought prior to 1919 is part of this author's extended research.
2. See e.g. Brooks (1972); McCarter (1991), passim. The influence of Frank Lloyd Wright's uncle, Rev. Jenkin Lloyd Jones, and the theory of "pure design" is part of this author's research. Frank Lloyd Wright's architecture pre-ca. 1919 has been usually called the Prairie School, but this does not account for his cubic stylizations, among other problems. Since all references to a school are to Frank Lloyd Wright's architecture as source and precedent, the Wright School is the correct descriptive title. This is analyzed and documented in this author's continuing research.
3. Langmead and Johnson (2000), chapters 2–3.
4. First published internationally in the London magazine *Studio* as early as May 1915; see especially Kruty (1998), throughout.
5. Wendingen (1925) is a book compilation of a series of articles that appeared in *Wendingen* (Amsterdam) during 1925; and see H.P. Berlage, "Frank Lloyd Wright," *Wendingen* 4 (11), English translation, ibid. 7 (6, 1925); H. de Fries, ed., *Frank Lloyd Wright: Aus dem Lebenswerke eines Architekten* (Berlin: Pollak, 1926); Henry-Russell Hitchcock, introduction, *Frank Lloyd Wright* (Cahiers d'Art: Paris, 1928); and especially Langmead and Johnson (2000), chapters 4–7.
6. Gill (1987), 300; but see Twombly (1979), 191–192; Wright (1943), 291–294.
7. Wright (1943), 503.
8. L. Wright worked for landscape architect brothers F.L. and Charles Olmsted in Boston (1911) and San Diego (1911–14), Frank Lloyd Wright to Taylor Wiley (Woolley's nickname was "Wiley Woolley"), 31 August 1911, Woolley Collection. Biographical information from Weintraub (1998); Gebhard and Von Breton (1971); Gebhard (1971), chapter 3; Wright (1946); 129–133.
9. The chronology of Hollyhock is often incorrectly published. From Chicago Barnsdall visited Los Angeles in 1915. There she leased a house beginning in 1916; she bought Olive Hill in 1919. Frank Lloyd Wright prepared plans for a Chicago "little theatre" in 1915, then a Los Angeles theater, then the commission was canceled in 1917. In 1916 he surveyed Olive Hill and made preliminary plans; the final scheme was settled upon in 1919, the construction drawings are dated 1919–22, the house completed 1922; see Smith (1992), passim.
10. Cf. De Long (1996), passim; Sweeney (1994).

Chapter 3

1. Dimitri Tselos, "Exotic influences in the architecture of Frank Lloyd Wright," *Magazine of Art* 47 (April 1953), more or less began the fiction that was rejected by Frank Lloyd Wright, but see also Vincent Scully, Jr., *Frank Lloyd Wright* (New York: George Braziller, 1960), 24–25, idem, *American Architecture and Urbanism* (New York: Praeger, 1969), 156–160, where he asserts that Hollyhock "is the plaster model of a Usumacinta temple" and Wright's A.D. German warehouse (1915) "is the Temple of the Two Lintels"; see also Neil Levine, "Hollyhock House and the Romance of Southern California," *Art in America* 71

(September 1983), 159. Alofsin (1993) forcefully argues that Wright's decorative and architectural sources are many. My own research will clarify arguments pro and con and then show the inspiration was Southwest American Indian architecture and that of Irving Gill.

2. Wright (1932), 227.

3. As quoted in Kathryn Smith, "Frank Lloyd Wright, Hollyhock House, and Olive Hill, 1914–1924," *Journal of the Society of Architectural Historians*, 38 (March 1979), 27n; Torrence (1982), 146 and 163, based in part on "Frank Lloyd Wright's Hollyhock House," circular (Los Angeles Municipal Art Department, n.d. but ca. 1953); see also Frank Lloyd Wright, "In the cause of architecture: The third dimension," *Wendingen* 4 (1925), 59; Wright (1932), here and there 226–240, and letter to and from L. Wright and Frank Lloyd Wright, 2 April 1932 to June 1932, Wright Archive and L. Wright papers; and Pfeiffer (1954), n.p.

4. Wright (1946), 131–135. Frank Lloyd Wright knew Gill from Adler's office, Frank Lloyd Wright to L. Wright, 1 June 1932, copy Wright Archive. For background see Harold Kirker, *California's Architectural Frontier ... Nineteenth Century* (New York, 1960, reissued 1970); David Gebhard and Robert Winter, *A Guide to Architecture in Los Angeles and Southern California* (Salt Lake City: Peregrine Smith, 1977).

Frank Lloyd Wright's design for a "Cinema for San Diego" has been dated 1905 but the car in one perspective is of ca. 1915. Architecturally the building's appearance is of a type he began designing only on return from Europe, or after 1911. A new perspective was executed for the 1924 *Wendingen* issue where the car is a Bugatti-type roadster ca. 1923 and the facade dolled up with balloons, bright colors, etc. See also Pfeiffer (87–59), plate 33 with 1912 perspective; Pfeiffer (02–06), plates 323–324, with 1924 perspective; Alofsin (1993), 290–291.

5. Frank Lloyd Wright to L. Wright, 1 June 1932, Gill to L. Wright, 26 May 1932; copies Wright Archive.

6. L. Wright to Alice Robinson (at *Fortune* magazine), 14 May 1932, copy Wright Archive. Gill's architecture was obviously a forerunner of that settled upon by the central European followers of Le Corbusier in the 1920s.

7. Reyner Banham, *Los Angeles: The Architecture of Four Ecologies* (London: Allen and Unwin, 1971), 179–181. The two houses were remodeled during the 1920s.

During 1919 and for Frank Lloyd Wright, Schindler produced almost the entire design for a river-front park and buildings for Wenatchee, Washington; see Donald Leslie Johnson, "Wenatchee and Frank Lloyd Wright: 1919," *Arcade* (Seattle) 9 (December 1989), 18–23. Frank Lloyd Wright was absent in Japan or at sea for at least 70 percent of the period 1917–22.

8. Smith (1992), passim. Barnsdall's first attempt to donate Olive Hill campus to the city of Los Angeles was in 1923.

9. Jeff Trunbull and Peter Y. Navaretti, eds., *The Griffins in Australia and India* (Melbourne: University of Melbourne Press, 2000), 151ff; Miles Lewis, "Wright, Griffin & Natco," typescript (paper to SAHANZ Conference, 1933, rev. 1994, Melbourne). The source of and design for the Frank Lloyd Wright textile block houses is a part of this author's continuing research.

10. Wright (1932), 233.

11. Wright (1932), 240.

12. L. Wright to Alice Robinson, 14 May 1932; and Frank Lloyd Wright to L. Wright, 1 June 1933, copies L. Wright papers and Wright Archive.

13. Sweeney (1994), passim; Pfeiffer (14–23). Edward R. Ford, *The Details of Modern Architecture* (Cambridge, Mass.: MIT Press, 1990), 322–327, for redrawn construction details.

The Storer house has been carefully restored by Joel Silver, a Hollywood producer of puerile police movies devoted to the tradition of violence in American society. Silver kindly allowed Robert Sweeney, Jock de Swart, and me to study the Storer house in 1985.

See later discussions herein as well as Pfeiffer (14–23), passim; Charles Lockwood, "Frank Lloyd Wright in Los Angeles," *Portfolio* 2 (February 1980), 74–79; for plans and pictures see Sweeney (1994); Jim Tice, "LA Block Houses, 1921–24," *Architectural Design* 51 (8–9, 1981), passim; and for photographs see Fusco (1986); and Pilar Viladas, "Wright in Hollywood," *House and Garden* (February 1990), 78–87. On Wright's proposal for Lowes see Wendingen (1925), 55–59, the drawings by son John.

14. Wright (1932), 227, 234, 252.

15. Johnson (1990), 90–92.

16. Johnson (1990), 23–25; Margerie Green, "A National Register Evaluation of Camp Ocotillo and Pima Ranch," Archaeological Consulting Service, Tempe, 1983.

17. Wright (1932), 306, 308; and see Johnson (1990) for a critical discussion of Frank Lloyd Wright's work in the late 1920s and 1930s.

Chapter 4

1. This chapter based on Johnson (1990).

2. Wright (1932); Wright (1943). A suspect third edition appeared in 1977, 18 years after Frank Lloyd Wright's death.

3. Frank Lloyd Wright, "Of the I sing," *Shelter* 2 (April 1932), 10. The engineer R. Buckminster Fuller was a promoter and editor of *Shelter* and probably invited Frank Lloyd Wright's contribution.

4. Ibid., 11.

5. In 1934 Thomas Craven wrote "a denunciation of modernism as a capitulation to foreign art," paraphrased by Brown (1955), 56, and based on Craven's *Modern Art* (New York, 1934) in which there is a chapter devoted to Frank Lloyd Wright. Craven was not the first to attack the extraordinary influence of European art (but not its architecture) that began with Steiglitz's gallery in 1909, followed by the Armory Show in 1913. Art historian Craven signed as a supporter of Frank Lloyd Wright's Fellowship in 1932 and the 1943 Broadacre City petition.

6. Johnson (1988); Johnson (1990), chapter 8.

7. Johnson (1990), chapter 8.

8. Johnson (1990), chapter 2 for details.

9. See especially Jonathan Lipman, *Frank Lloyd Wright and the Johnson Wax Buildings* (New York: Rizzoli, 1986).

10. Cf. Franze Schulze, *Mies van der Rohe: A Critical Biography* (Chicago: University of Chicago Press, 1985).
11. Documented in Langmead and Johnson (2000), chapters 5–10.
12. Statement, December 1933, as quoted in Wright (1982), 206–207.
13. Johnson (1990), chapters 11–16.

Chapter 5

1. Ayn Rand, "To readers of *The Fountainhead*," as quoted in Sciabarra (1995), 66.
2. As nicely put by Sciabarra (1995), 66.
3. Branden and Branden (1962), 87; Gladstein (1984), 7.
4. Biographical details based on Branden and Branden (1962), and Branden (1986), which is based on more extensive research and intensive interviews including tape recordings.

Chapter 6

1. Branden (1986), 19, Rand's emphasis.
2. As quoted in Branden (1986), 21.
3. As quoted in Branden (1986), 22, see also Rand (1984). On schooling, university education, and Marxist reforms see Sciabarra (1995), chapter 3. See also Gladstein (1984), chapter 1.
4. Sciabarra (1995), 77.
5. Rand (1936), 226.
6. As quoted in Branden (1986), 56. On George Nelson's recollections of Howard Myers and the *Forum* ca. 1938, see "Making Bridges," Edgar Tafel, *About Wright: An Album of Recollections...* (New York: John Wiley, 1993), 225–227; Abercrombie (1995), passim.
7. As quoted in Branden (1986), 57.
8. Branden (1986), 63, contradicted on 71.
9. Rand occasionally corresponded with her mother, father and sisters in Leningrad but ca. 1939 lost contact, assuming they were killed in the Nazi-Soviet battle for the city. In 1973 her sister Nora, the sole family survivor, visited Rand (Alissa) in New York City. Their few weeks together were apparently filled with anger and animosity: Nora pro Soviet, Alissa otherwise.
10. Branden's paraphrase in Branden (1986), 72, see also 176.
11. Torrence (1982), 88.

Chapter 7

1. Kevin Starr, *Material Dreams: Southern California Through the 1920s* (New York: Oxford University Press, 1990), 68–69, cf. Palmer (1937), 256–261, Rosten (1941), for statistical data especially of the 1930s.
2. Essoe and Lee (1970), 244f; Palmer (1937), 190–194; Rosten (1941), chapter 16; and Bordwell (1985), appendix B. Apparently the Nestor Film Co. was first to set up a studio in Los Angeles in 1909.
3. Rand (1997), 6–15; Branden and Branden (1962), 175; Schleier (2003), 312.
4. *Contemporary Authors*, vol. 105, 654. The only reference to Frank O'Connor is as a bit player in *Ride, Tenderfoot, Ride* (1940), a typical Gene Autry movie.
5. Cf. Branden (1986); Leonard Peikoff in Rand (1984). Talkie = talk (ing) (mov)ie.
6. Originally entitled "Air Tight, A Novel of Red Russia;" Rand (1997), chapter 2.
7. As quoted in Branden and Branden (1962), 182–183.
8. Rand introduction to Rand (1934), the 1939 edition; Rand (1997), chapter 2; Branden (1989), 247; Jenny A. Heyl, "Ayn Rand 1905–1982," in Waithe (1995), 216; see also Peikoff in Rand (1984), 193–194. For outlines and brief critical analyses of Rand's literary output to ca. 1950 see Sciabarra (1995), 96–111; and *Contemporary Authors*, vol. 105.
9. As paraphrased in Branden (1986), 133; different in Branden and Branden (1962), 194.

Chapter 8

1. *Contemporary Authors*, vol. 105, 13–16; Branden and Branden (1962), 16; not in Branden (1986), 140.
2. Macmillan (1982); Rand (1997), 143; Ely Jacques Kahan, *Ely Jacques Kahn* (New York, 1931), and idem, *Design in Art and Industry* (New York, 1935); Cervin Robinson and Rosemarie Haag Bletter, *Skyscraper Style: Art Deco New York* (New York: Oxford University Press, 1975), 60f.
3. Saint (1983), 7–18. For a detailed analysis of Frank Lloyd Wright's architectural works of the 1930s see Johnson (1990).
4. Branden (1986), 140.
5. Branden (1986), 140, stated it was a biography, but there was only Wright (1932); Schleier (2003), 314–316.
6. Rand (1997), 134; Durgnat and Simon (1988), 32; Schleier (2003), 321, 327n6.
7. Branden (1986), 138–146.
8. Durgnat (1988), 31.
9. Whitney R. Mundt, DLB no. 29.
10. Titled "Screenplay by Ayn Rand," it is actually a synopsis, typescript, 13 December 1943, story file WB Archives. See also Saint (1983), 12; Twombly (1986), and Hugh Morrison, *Louis Sullivan* (New York: W.W. Norton, 1935, reprint 1962).
11. Rand (1959), introduction.
12. As quoted in Branden (1986), 140; Branden and Branden (1962), 197.
13. Frank Lloyd Wright's words have not been located but probably not earlier than the 1930s, and may or may not be correctly quoted.
14. Rand to Frank Lloyd Wright, 12 December 1937, Wright Archive; Rand (1995), 109. The letter was written from East 74th Street, New York, and partly quoted in *Treasures* (1985), plate 39 description.
15. Branden (1986), 190.
16. Widely illustrated but see Pfeiffer (37–41), plates 62–78; Johnson (1990), chapter 2. Construction

began in 1938 and Frank Lloyd Wright called it Taliesin West.

17. G. Nelson to Frank Lloyd Wright, 19 April 1938, Wright Archive; Twombly (1979), 290f. On Nelson and his significant role in creating the popular and revolutionary modernism of the 1950s and 1960s see Abercrombie (1995).

18. Mrs. A. Knopf to Frank Lloyd Wright, 12 September 1938, Wright Archive.

19. Branden (1986), 189.

20. Johnson (1990), chapter 4. Frank Lloyd Wright had been invited to the Sir George Watson Chair of the Sulgrave Manor Board to give a series of lectures in London in 1938. At the last minute he postpone his obligation. The Board not pleased but acquiesced. The new date was April 1939.

21. Rand to Frank Lloyd Wright, 7 November 1938, Wright Archive, partly and inaccurately quoted in *Treasures* (1985), plate 39 description; and Rand (1995), 110–111.

22. Frank Lloyd Wright to Rand, 13(?) November, partly and inaccurately quoted in *Treasures* (1985), plate 39 description, an "e" on Roarke; Rand (1995), 110. See also Park and March (2002), 470–479.

23. Telegram, Rand to Frank Lloyd Wright, 21(?) November 1938, Wright Archive; Rand (1995), 111.

24. Telegram, Masselink to Rand, 21 November 1938, copy Wright Archive.

25. As quoted in Branden (1986), 189.

26. Branden and Branden (1962), 168, 195–196; not in Branden (1986).

27. Purcell to E. Lawrence, late 1945, University of Oregon, Knight Library, Archives.

28. E. Lawrence to Purcell, 5 September 1945, ibid.

29. Scully, Jones, Roche, Tigerman quoted in Gunts (1993), 37. For a Freudian and architectural interpretation see Vidler (2000), 99–110.

30. Mark Gelernter, *Sources of Architectural Form* (Manchester: Manchester University Press, 1995), 259.

31. Mary N. Woods, *From Craft to Profession* (Berkeley: University of California Press, 1999), 1.

32. Dana Cuff, *Architecture: The Story of Practice* (Cambridge, Mass.: MIT Press, 1991), 1.

33. Schleier (2003), 317.

34. Meredith Clausen, *Pietro Belluschi: Modern American Architect* (Cambridge, Mass.: MIT Press, 1994), 204, 407.

35. *Twentieth Century Authors*, Ayn Rand entry.

36. Branden (1995), 14, his emphasis.

37. Lorine Pruette, "The Battle Against Evil," *New York Times Book Review*, 16 May 1943, 7, 18; but see Flew (1984); Rand to Pruette, 25 March 1946 in Rand (1995), 267.

38. Rand to Dewitt Emery, 17 May 1943, as quoted in Schleier (2003), 310.

39. As quoted in Branden (1995), 45.

40. Nora Sayer, "The Cult of Ayn Rand," *New Statesman*, 11 March 1966, 332. As late as 1997 essayist Robert Rosenblatt referred to Rand's book as a "half-batty novel," in "The Admiration of Others," *Modern Maturity* (January 1997), 22. Academic reviews very seldom come to the public's attention.

41. "Key ideas," Branden (1995), 80. On Rand's activities post–*Fountainhead* see Sciabarra (1995), passim; Branden (1995), throughout; Baker (1987).

42. Waithe (1995), xxiii.

Chapter 9

1. *Science Fiction* (1979), dystopia entry; text from *Anthem*, Rand (1969), 18–19.

2. Yevgenii Zamyatin, *We*, translated by Bernard Gilbert Guerney (New York: Dutton, 1952); D.J. Taylor, *Orwell* (London: Chatto & Windus, 2003), 342, other predecessors to 1984 are found p. 375–6, and Orwell's *Animal Farm* was published in 1944; Sciabarra (1995), 39–40, 39 1note 38.

3. *Impact* (Ayn Rand Institute newsletter), December 1989; see also Rand (1984). Together with other national attention the play was a result of a revival of Objectivism gained through the activities of the Ayn Rand Institute, founded in 1985 and then based at Marina del Ray where Paxton (aka Palumbo) had been employed.

4. Branden and Branden (1962), 199; different in Branden (1986), 161.

5. Branden (1986), 124n.

6. Sol Siegel produced mainly B movies such as some of Paramount's *Henry Aldrich* series of the 1940s and their *Glamor Boy* and *West Point Widow* in 1941. Sistram went on to produce only nine movies including *Wake Island* (1942) and the unforgettable A film noir, *Double Indemnity* (1944), both for Paramount.

7. Nash and Ross (1986), 2150. The film was aka *Night of Jan. 16th*.

8. Branden (1986), 124n.

9. "Ayn Rand background information," probably by Rand, typescript, File F-85, WB Archives; Rand to Jack Warner, 14 February 1948, Rand (1995), 385; and Branden (1986), 127; Branden (1995), 120–122. *Noi Vivi* was not reviewed or may not have been released in the U.S.

10. Rand to Frank Lloyd Wright, 12 December 1937, Wright Archive; Rand (1995), 112.

11. Rand (then in Hollywood) to Frank Lloyd Wright, 14 May 1944, Wright Archive; Rand (1995), 113.

12. Rand (1949), 4x.

13. *New Yorker* (1949), n.p.

14. Vidler (2000), 58–61.

15. His emphasis, as quoted in Saint (1983), 14; Rand (1995), 11; Branden (1986), 190.

16. Frank Lloyd Wright to E. Koretsky, 24 January 1946, copy Wright Archive.

17. Masselink to W.R. Peden, 2 December 1949, copy Wright Archive.

18. Frank Lloyd Wright to L. Wright, 11 September 1944, copy Wright Archive.

19. As quoted in Meehan (1986), 207, and the comments were before release of the film.

20. Mosby (1949), press clipping; Flew (1984), 192.

21. Telegram, Frank Lloyd Wright to C. Whitney (owner of a publishing house that included *Interiors* magazine), ca. 1 January 1949, Wright Archive.

22. Rand to Loeb, 5 August 1944, Rand (1995), 161.

23. As put by Saint (1983), 14.

24. Cf. Korestky to Frank Lloyd Wright, 10 January 1946; Orinda B. Walsh to Frank Lloyd Wright, 15 December 1946; and Masselink to Peden, 2 December 1949, Wright Archive.

25. Nicely discussed in Langmead and Johnson (2000), throughout.

26. Brought to my attention by Donald Langmead. See W.M. Dudok, "Upon the death of Frank Lloyd Wright," *Bouwkunding Weekblad* 77 (7 November 1959), 333; and W. Wagener, "Frank Lloyd Wright's spirit remains in a lifelike novel," *Rotterdams Newsblad*, 30 January 1960; cf. Langmead and Johnson (2000), chapter 14.

Chapter 10

1. J. Warner to Loeb, 1943, copy WB Archives, the date is more likely October than November as stated in Branden (1986), 205–206.
2. Rosten (1941), 317.
3. Story file, WB Archives; Branden and Branden (1962), 206; Branden (1986), 184.
4. Story file, WB Archives.
5. File-85, WB Archives.
6. Rand to J. Warner, 21 June 1944, File F-85, WB Archives.
7. Wallis and Higham (1980), chapter 10. Other "outside" or independent producers included Cosmopolitan Productions (William Randolph Hearst, 1937), Cagney Productions (1943), and Liberty Films (Frank Capra, William Wyler, George Stevens, Samuel Brisken, 1945). On Liberty see Jeanine Basinger, ed., *The It's a Wonderful Life Book* (New York: Knopf, 1986), 3–7.
8. Rand to Archibald Ogden, 19 July 1944, Rand (1995), 148–149; Branden (1986), 191; Branden and Branden (1962), 214.
9. Rosten (1941), 321–323.
10. Wallis and Higham (1980), 124.
11. "Ayn Rand background information," probably by Rand, WB Archives; Nash and Ross (1986), 1753–1754.
12. Herbert G. Luft, "Josef von Sternberg, Impressions and Remembrances," *Films in Review* 32 (January 1981), 14; *International* (1984–87); *MacMillan Film* (1982); and other standard references.
13. Isabella Gournay, "France's love affair with Richard Neutra and 'snubbing' of Frank Lloyd Wright: a study in cultural biases," typescript, 1991, copy kindly sent to this author.
14. See Pauline Schindler, review in Los Angeles City Club Bulletin, as quoted in Hines (1982), 65–66.
15. De Long (1986); Hines (1982); Drexler and Hines (1982); and Gebhard (1971).
16. "A steel house with a suave finish," *House and Garden* (August 1949), 54–57; Hines (1982), 54–57; Richard Guy Wilson, Dianne H. Pilgrim, and Dickran Tashjian, *The Machine Age* (New York: Brooklyn Museum/Abrams, 1986), 197; Drexler and Hines (1982). The folded steel plate forming channels was a recent development; see Roger W. Sherman, "New materials and methods...," *Architectural Forum* 58 (March 1933), 231–233, and "Products and Practice," *Architectural Forum* 59 (July 1933), 88.
17. J. von Sternberg, *Fun in a Chinese laundry* (London, 1965), 263.

Chapter 11

1. Meehan (1984), 278. On the loss and retrieval of the Baxter/Hodiak/Wright heirlooms of daughter Katrina Hodiak, see Debby Abe, "Star's child say heirlooms...," *Morning News Tribune* (Tacoma), 1 June 1991, p.1, A8, and "Tracking auctioned heirlooms," *Post-Intelligencer* (Seattle), 7 June 1991, p. B1, B5. Katrina lives in Gig Harbor, Washington. With thanks to Tom Rickard in Lakewood.
In 1983 Baxter narrated a television documentary titled *The Architecture of Frank Lloyd Wright*. It is a fair survey and one of the "Films on Art" series of the New York Metropolitan Museum of Art and Getty Trust, Santa Monica.
2. "Poor, miscast" was the opinion of John T. Mcmanus, 1945, in Hochman (1974), 365.
3. *Variety*'s Miniature Review on 21 March 1945 summed up their larger review as follows: *Scandal* was a "strong Lubitsch farce comedy; big box office." The *New York Times*' review of 13 April 1945, however, found the movie an "oddly dull, and generally witless show," suggesting "Lubitsch should blush." Critic John McManus thought the movie was "more noxious than naughty," Hochman (1974), 365.
4. Altered here from a description in Branden (1986), 189–190; confirmed in G. Loeb to Frank Lloyd Wright, 27 April 1944, Wright Archive; and Frank Lloyd Wright to Iovanna Wright, 15 November 1944, in Wright (1982), 107. Cf. anecdotal comments in Anne Baxter, *Intermission: A True Tale* (London: 1977), 19–21, 33–36.
5. Rand to Frank Lloyd Wright, 14 May 1944, Wright Archive; Rand (1995), 113.
6. Woollcott to Frank Lloyd Wright, 15 April 1941, as quoted in Wright (1943), 499.
7. Rand to Frank Lloyd Wright, 14 May 1944, Wright Archive; Rand (1995), 114.
8. Rand to Frank Lloyd Wright, 22 June 1944, Wright Archive.
9. Frank Lloyd Wright to Rand, 8 July 1944, copy Wright Archive.
10. Rand to Frank Lloyd Wright, 20 August 1945, and G. Loeb to Frank Lloyd Wright, 29 October 1945, Wright Archive; Rand (1995), 115.
11. G. Loeb to Frank Lloyd Wright, 2 November 1945: and Rand to Frank Lloyd Wright, 30 November 1945, Wright Archive; Rand (1995), 115–116.
12. As quoted in or paraphrased by Branden (1986), 190; see Rand to Mimi Sutton, 2 December 1945, Rand (1995), 241; compare with Secrest (1993), 494–498.
13. Fred Albert, "When you're Wright you're Right," *The Herald* (Everett), 29 May 1983, based on interviews with Griggs, with thanks to Tom Rickard. See also telegrams Griggs to Frank Lloyd Wright, 23 and 27 February 1946; Frank Lloyd Wright to Griggs, 26 February 1946, Wright Archive. On Griggs comments about Rand, Frank Lloyd Wright and his house, Donald Leslie Johnson, "A Frank Lloyd Wright House in Lakewood," *Columbia* (Washington State Historical Society, Tacoma) 10 (winter 1996–97), 39–44.
14. *Treasures*, description to plate 39; Rand to Frank Lloyd Wright, 10 September 1946, Rand (1995), 116.
15. Frank Lloyd Wright to Rand, 30 September 1946, copy Wright Archive.

16. Plans were sent to Noble (the daughter) on 11 March 1930, not 1929 (Frank Lloyd Wright to E. Noble, 11 March 1930, copy Wright Archive) and receipt was acknowledged by Noble's mother. Cf. Johnson (1990), chapter 5, on Noble's relations with Frank Lloyd Wright and the pro–Soviet press in the 1930s.
17. Frank Lloyd Wright to L. Wright, 29 October 1929, Wright Archive.
18. Telegram, Frank Lloyd Wright to L. Wright, 17 April 1930; Frank Lloyd Wright to L. Wright, n.d., 1930, Lloyd Wright papers; and L. Wright to Frank Lloyd Wright, late 1930, Wright Archive.
19. Frank Lloyd Wright to L. Wright, ca. January 1930, Wright Archive.
20. Richard L. Cleary, *Merchant Prince and Master Builder: Edgar J. Kaufmann and Frank Lloyd Wright* (Pittsburgh/Seattle: Kaufmann Foundation/University of Washington Press, 1999), 65–66, 166–173; *Treasures*, plate 55a–b; and Pfeiffer (51–59), 59–62.
21. As quoted in Branden (1986), 190–191.
22. Langmead and Johnson (2000), chapters 10–12, on H.T. Wijdeveld's influential role, indeed so critical that the fellowship concept was much more his than Frank Lloyd Wright's; Secrest (1993), 398–420, 507–512; Johnson (1990), chapter 4; Henning (1992), passim.
23. As quoted in Branden (1986), 190–191.
24. Donald Hoppen, "A Journey with Frank Lloyd Wright into Architecture," *U.I.A. International Architect* 6 (1984), 58.
25. Interview with Bruce Pfeiffer, 1985, Frank Lloyd Wright Foundation Archivist, referring to information passed on to him.
26. Branden (1986), 191.
27. Sciabarra (1995), 4, 12, 272–273, 403n63.
28. A personal recollection of Gill (1987), 491.

Chapter 12

1. Arrowhead to WB, 31 August 1944, Arrowhead file 2852, WB Archives.
2. Arrowhead to WB, 15 February 1945 and 30 January 1945, Arrowhead file 2825, WB Archives.
3. LeRoy and Kleiner (1974), 153. On the relevant historical period of studio production systems see Bordwell (1985), 325–329, 330–332; and Balio (1976), on typical internal politics.
4. J. Warner to Ray Obringer, 29 January 1945, Arrowhead file 2825, WB Archives. On LeRoy see e.g. *International* (1984–1987); Hochman ((1974); Ted Sennett, *Warner Bros Presents* ... (New Rochelle: Arlington House, 1971); LeRoy and Kleiner (1974); and *World Film Directors*.
5. File F-85, but script not located; and LeRoy/Kleiner (1974), 153.
6. Marjorie Rosen, *Popcorn Venus: Women, Movies and the American Dream* (London: Owen, 1973), 184, 233–239; and, for example, Nash and Ross (1986).
7. AFI (1999), 812; Arrowhead to WB, 15 January 1945, Arrowhead file 2825, WB Archives.
8. Confirmed in Gable to Rand as recorded in Branden (1986), 196. Not mentioned in standard biography by George Carpose, Jr., *Clark Gable* (New York, 1961), 106–109; AFI (1999), 812.
9. In 1934 director Arthur Hopkins was casting the outlaw Duke Manatee in Robert Sherwood's play *The Petrified Forest*. To Hopkins' mind Bogart had been "an antiquated juvenile who had spent most of his stage life in white pants, swinging a tennis racket." But there was that "dry, tired voice ... So I engaged him"; Hay (1989), 95.
10. Arrowhead to WB, 15 January 1945, Arrowhead file 2825, WB Archives; Di Orio (1983), 141.
Both Stanwyck and Bogart had been under contract to Warner for many years. In 1947 they finally played together in *The Two Mrs. Carrolls*, and most agree it was Bogart's worst film. And the rest of the cast?
11. File F-85. WB Archives, almost all letters are of early 1945.
12. Rand to Frank Lloyd Wright, 22 June 1944, Wright Archive; Rand (1995), 114.
13. Research Record, File F-85, WB Archives.
14. Branden (1986), 208.

Chapter 13

1. Loeb to Frank Lloyd Wright, 7 January 1941, 20 February 1941, 15 September 1941, Wright Archive.
2. Loeb to Frank Lloyd Wright, 6 September 1943, Wright Archive.
3. Loeb to Frank Lloyd Wright, 20 September 1945, Wright Archive.
4. *Treasures*, plate 30 description.
5. Loeb to Frank Lloyd Wright, 28 November 1943, Wright Archive.
6. Much to Frank Lloyd Wright's amusement and impatience, the bulk of correspondence over the next two years was about Loeb's proposed house. A number of Loeb's letters ran into many pages, some over five and all single spaced. Some of Loeb's architectural naiveté can be read in letter to editor, *Architectural Forum* 93 (August 1950), 24, 28.
7. Frank Lloyd Wright to Loeb, 28 August 1944, copy Wright Archive.
8. Loeb to Frank Lloyd Wright, 32 (sic) 1944, Wright Archive.
9. Loeb to Frank Lloyd Wright, 9 June 1944, Wright Archive.
10. Various letters, Loeb to Frank Lloyd Wright, April–July 1944, Wright Archive.
11. Loeb to J. Warner, 22 October 1943, F-85, WB Archives.
12. J. Warner to Loeb, 29 October 1943, F-85, WB Archives.
13. Loeb to Frank Lloyd Wright, 22 April 1944, and relevant correspondence June 1944, Wright Archive.
14. Frank Lloyd Wright to Loeb, 18 November 1944, copy Wright Archive.
15. Frank Lloyd Wright to Hilda Rebay, 20 August 1946, Bruce Brooks Pfeiffer, comp. *Frank Lloyd Wright: The Guggenheim Correspondence* (Fresno/Carbondale: California State University Press/Southern Illinois University Press), 88.
16. Loeb to Frank Lloyd Wright, 12 August 1944, Wright Archive. Also, Loeb heard stories that the roof and walls of Frank Lloyd Wright's Pauson house leaked; while dining, water dripped on Herbert Johnson's head; one client went broke supposedly as the

result of building a Frank Lloyd Wright house; and so forth, all of which amused Loeb.

17. Loeb to Frank Lloyd Wright, 16 December 1944, Wright Archive.

18. Frank Lloyd Wright to Loeb, 3 December 1944, copy Wright Archive.

19. Letters December 1944 through December 1945, Frank Lloyd Wright Archives.

20. Loeb to Frank Lloyd Wright, 22 January 1951, 2 and 5 June 1945, Frank Lloyd Wright Archive.

21. Loeb to J. Warner, 15 January 1945, WB Archive.

22. J. Warner to Loeb, 24 January 1945, copy WB Archive.

23. Memo, Blanke to Steve Trilling, 14 June 1948, Warner Collection, WB Archives; "House in Connecticut," *Architectural Forum* 84 (June 1946), 83–88, cover.

24. Loeb to Harry Warner, 6 December 1945, copy sent to Frank Lloyd Wright, not in WB Archive; Rand to Blanke, ca. October 1945, handwritten note in Ayn Rand Institute, as described in Schleier (2003), 321.

25. Loeb to Frank Lloyd Wright, 18 May 1945, Wright Archive.

26. Loeb to Frank Lloyd Wright, 15 June 1945, Wright Archive.

27. Loeb to Frank Lloyd Wright, 9 November 1945, Wright Archive.

28. Loeb to H. Warner, 6 December 1945.

29. J. Warner to Loeb, 18 December 1945, copy sent to Frank Lloyd Wright, not in WB Archives or Jack Warner Collection.

30. LeRoy and Kleiner (1974), 153.

31. Frank Lloyd Wright to Loeb, 25 April 1949, copy Wright Archive.

32. Meehan (1984), 17, a comment of 1956. See also *Treasures*, plate 30; "A stockbroker meets F.L.W.," *Architectural Forum* 93 (August 1950), 24; *Architectural Forum* (1946); and Pfeiffer (42–50), plates 99–101. However, the Jester/Loeb plan reappeared in at least six houses between 1952 and 1959, none built, and it was modified for the Pfeiffer house.

33. Apparently Loeb did not pay the architect's fee in full and at one point Frank Lloyd Wright said Loeb "stinks," telegram, Frank Lloyd Wright to A. Kaufmann, 8 June 1951, copy Frank Lloyd Wright Archives.

Chapter 14

1. This chapter elaborates a paper presented in July 1992 to the International Conference of the Australia and New Zealand American Studies Association. California's legislature had its own Red-hunting committee in the 1940s and 1950s. Relevant to this study see Schwartz (1982); Kahn (1949); Bentley (1971); Maltby (1981); Gentry (1991) passim; Bentley (1972); Schumach (1964); Balio (1976). Also of good value on Dies, HUAC and Hollywood is Neal Gabler, *An Empire of Their Own: How the Jews invented Hollywood* (New York: Crown, 1988), 288ff. A good short summary of HUAC's effect is Zinn (1998), the chapter titled "A people's war?"

2. Sabbath epigraph, brought to HUAC's attention by actress Margaret Sullivan, in Kahn (1949), 221. Colescott epigraph, brought to HUAC's attention by actress Evelyn Keyes, in Kahn (1949), 224.

3. Epigraph, historians Millar and Nowack quoted in Zinn (1998), 165.

4. Gentry (1991), 240.

5. As quoted in Gentry (1991), 241.

6. Gentry (1991), 241.

7. Congress, 247.

8. Gentry (1991), 241–242.

9. Congress, 247.

10. Maltby (1981), 89, 96.

11. Higham and Greenberg (1968), 101–103. On Curtiz see *World Film Directors* and on his files, Hochman (1974).

12. Gentry (1991), 334–335.

13. As put by Gentry (1991), 353.

14. As quoted in Gentry (1991), 353.

15. Ibid. loc. cit.

16. As quoted in Schwartz (1982), 286.

17. See e.g. Reagan and Hubler (1965), chapters 9–12; and Schwartz (1982), passim.

18. Bentley (1971), 948.

19. As put in Bentley (1971), 270.

20. Branden (1986), 201.

21. Rand (1947), 37–42, reprint Rand (1997), 355–366.

22. It is alleged that Wood inserted a clause in his will "making his daughter eligible for inheritance only upon signing of an anti–Communist oath," Pohl (1978), 323.

23. Schwartz (1982), 254.

24. Chase (1975), 4.

25. It was Executive Order No. 9835 together with the 1940 Smith Act that enabled Congress' investigations.

When enlisting in the U.S. Navy in 1948 I was not required to sign the "Oath" but was required to do so when accepting federal education grants under the GI Bill in the 1950s. See also Gentry (1991), 335–336.

26. Schwartz (1982), 277; Branden (1986), 199ff; and Kahn (1949), chapter 17.

27. Cf. Reagan and Hubler (1965), chapters 9–12.

28. Gentry (1991), 354.

29. Bentley (1971), 146–147; and Schwartz (1982), 268.

30. Kahn (1949), 55–59; Bentley (1971), 152–153; Schwartz (1982), 268; Meyers (1998), 207–213; and Kaminisky (1980), 146–154.

31. Maltby (1947), 90; Kahn (1949), 33; and in detail Bentley (1971), 111–119.

32. *New York Times*, 21 October 1947, 1; Rand (1997), 371–381.

33. Rand (1997), 367–370, 381; Branden (1986), 201.

34. Congress, 250.

35. Brief biographies in Dalton Trumbo, *The Time of the Toad: A Study of Inquisition in America ...* (New York: Harper and Row, 1972); Kahn (1949). Some writers managed to continue by working overseas or under pseudonyms, see for example Trumbo entry in *International*.

36. As quoted in Schumach (1964), 139.

37. Trumbo (1972), 192; Schwartz (1982), 286, 288; Schumach (1964) is good on the aftermath of 1947, 120–140.

38. Bentley (1971), 189–194; Schumach (1964), 121; Gentry (1991), 353; Eric Bentley, *Are You Now or Have You Ever Been: The Investigation of Show Business ...*

1947–1958 (New York: Harper and Row, 1972), 15–16. Parnell Thomas was sentenced for stealing taxpayer's money ("payroll padding"), and before a grand jury it was his turn to invoke the Fifth Amendment. He, Ring Lardner Jr., and Lester Cole met in the Danville, Connecticut, federal prison yard. Later, President Truman pardoned Thomas.

39. Sciabarra (1995), 95, 399n72, as interpreted from Branden (1986); see also letters in Rand (1995) and journal notes in Rand (1997), 381–386.

40. John Kobler, "The curious cult of Ayn Rand," *Saturday Evening Post* 11 (November 1961), 100.

41. As recalled by Gill (1987), 490–492.

42. Frank Lloyd Wright to Mumford, and Frank Lloyd Wright to Philip Johnson, both 19 January 1932; Frank Lloyd Wright, "To the neuter"; Mumford to Frank Lloyd Wright, 6 February 1932; Bruce Brooks Pfeiffer and Robert Wojtowicz, eds., *Frank Lloyd Wright and Lewis Mumford: Thirty Years of Correspondence* (New York: Princeton Architectural Press, 2001).

43. Donald Leslie Johnson, "Frank Lloyd Wright in Moscow: June 1937," *Journal of the Society of Architectural Historians* 46 (March 1987), 65–79; Johnson (1990), chapters 13–18.

44. Wright (1943), 560.

45. The ultra-conservative turn of Congress in post-war America is exemplified by their investigation into the Bureau of Indian Affairs and Indian communities because of their tradition of communalism, see David Hurst Thomas, *Skull Wars* (New York: Basic Books, 2000), 194–197. On McCarthy vs Hoover see Gentry (1991), 377–383, 428–437.

It is not known if Frank Lloyd Wright and Rand talked of their shared belief of opposition to American involvement in the 1939–45 war, see Branden (1986), 161.

46. Twombly (1979), 370–371.

47. Condensed from Meehan (1984), 301, reprint Pfeiffer (1989), 86–87.

48. Meehan (1984), 162–163.

49. See especially Frank Lloyd Wright, "Frank Lloyd Wright speaks up," *House Beautiful* 93 (July 1953), 86–88, 90, introduced by editor Elizabeth Gordon who said Frank Lloyd Wright "speaks up forth-rightly against the sterility and the totalitarian threat of the 'International Style.'" Frank Lloyd Wright therein called it the style of communism and collectivism. Other examples in Meehan (1986), 82–82, 189, 207, 298, 301–303.

50. Frank Lloyd Wright to Stonorov, 9 November 1949, Stonorov papers. Kaufmann was also approached by Clare Boothe Luce; see Maristella Casciato, "Wright in Italy," and Bruno Zevi, "Wright in Italy, a recollection," in Anthony Alofsin, ed., *Frank Lloyd Wright: Europe and Beyond* (Berkeley: University of California Press, 1999), 84–88, 237n42, and 70–74.

The late Edgar Kaufmann Junior had paid to be an apprentice with Frank Lloyd Wright ca. 1933. His father shared financing the exhibit of Frank Lloyd Wright's Broadacre City 1934–35 in New York City. Kaufmann Senior then commissioned the beautiful Fallingwater country house (1935–39). Junior went on to become an art historian and also propagandize Frank Lloyd Wright's philosophy and architecture, sometimes at Frank Lloyd Wright's request.

51. Wright (1984), 177; Frank Lloyd Wright/Arthur Kaufmann letters, and Frank Lloyd Wright/Stonorov letters, May 1949 to July 1949, Wright Archive.

German émigré architect Erich Mendelsohn described Frank Lloyd Wright at the beginning of 1951 as "looking like a rosebud, slim and trim, healthy ... and apparently determined to live forever in his self-made world, in his fame and glamour...," Mendelsohn to H.T. Wijdeveld (in Holland), 18 February 1951, Wijdeveld Archives, Amsterdam, brought to my attention by Donald Langmead. Cf. Langmead and Johnson (2000), passim.

52. Arthur Vogel to A. Kaufmann, 17 September 1949; George Allen to A. Kaufmann, 21 July 1949; Fabiani to A. Kaufmann, 22 September 1590, copies Wright Archive.

53. Frank Lloyd Wright to W. Moser (in Austria), 28 January 1952, Frank Lloyd Wright (1984); Langmead and Johnson (2000), chapter 12; Keith Eggener, "Towards an Organic Architecture in Mexico," in Alofsin (1996), 177. Frank Lloyd Wright promoted venues in London, Stockholm, Helsinki, Bombay, Havana, and somewhere in Brazil, but without success. The Mexico showing was sponsored by some of Frank Lloyd Wright's state-side friends (unnamed) and the Colegio Nacional de Arquitectura, Wright to Carlos Lazo, 30 August 1952, Wright (1984).

54. Wright (1984), 174, and 174–178, where Frank Lloyd Wright suggests Mrs. Clare Luce was involved, but she was not appointed Ambassador to Italy until February 1953; see Stephen Shadegg, *Clare Boothe Luce* (New York, 1970), and Alden Hatch, *Clare Boothe Luce: Ambassador Extraordinary* (London, 1956).

55. "Description of the exhibition...," Wright (1984), 184.

56. A. Kaufmann to Frank Lloyd Wright, 7 July 1951, Wright Archive.

57. The Communist Party mayor of Florence may have understood the exhibition's purpose for he placed many obstacles before Kaufmann and Stonorov, delaying matters for nearly a year. Frank Lloyd Wright described this as a "mis-up." See Frank Lloyd Wright to A. Kaufmann, 15(?) July 1951, copy Wright Archive; Pfeiffer (1989), 148–149, for some of Frank Lloyd Wright's daughter's recollections of Italy.

58. As quoted in Twombly (1979), 370–371, and see 291–296.

59. Frank Lloyd Wright to Zevi, 19 September 1951, Wright (1984).

60. Frank Lloyd Wright to Hitchcock, 18 February 1952, Wright (1984).

61. Frank Lloyd Wright to Zevi, February 1951, copy Wright Archive; and particularly Johnson (1990), themes 2 and 6.

62. Frank Lloyd Wright to Rebay, 28 February 1949, Wright (1986), 120.

63. Wright (1984), 194–196.

64. Wright (1987), 90–91. See also Meehan (1984), 162–163.

65. The house plan was a duplicate of Frank Lloyd Wright's house for Davidson's Farm Tracts of 1931–32, and it was the basis for his Usonian houses from 1935 onward; see Johnson (1990), chapter 5.

Some of Frank Lloyd Wright's apprentices helped build the facilities under supervision of former apprentice David Henken. Although designed to be

demountable, both structures must be considered separate legitimate products within Frank Lloyd Wright's oeuvre. The November 1955 issue of *House Beautiful* was devoted to the exhibition house.

66. *Sixty Years of Living Architecture*, catalog (Art Commission of Los Angeles, 1954); see also Pfeiffer (51–59), plates 207–209.

67. Much of the information in this chapter is based on that obtained through Freedom of Information procedures. The FBI was formed in 1908 as the investigative division of the Department of Justice. Its wider role (including counterespionage) did not begin until 1934.

68. Twombly (1979), chapter 5; Gill (1987), chapter 12–13.

69. Twombly (1979), chapter 7; Gill (1987), chapter 14. Noel was addicted to morphine, the major reason for Frank Lloyd Wright to seek a divorce.

70. Gentry (1991), 141.

71. Twombly (1979), 185–192; of less value Gill (1987), 290–299.

72. Not in Sweeney (1978).

73. Johnson (199), 211; Henning (1992), 270–272, and on movies 321–322.

74. Intelligence Division report, Sixth Service Command, Chicago, 12–19 December 1942, annex 3, p. 3, G-2; Twombly (1979), 295–296; various letters Wright (1982), 144–149; newspaper clipping in file check, 9 September 1957, 1–2, FBI Bureau File 25-133757, declassified from "secret."

75. File check, 9 September 1957, FBI.

76. Memo, Cunningham to Ladd, 21 December 1942, and newspaper clipping, File check, 9 September 1951, FBI.

77. Wright (1982), 154.
After defecting to the U.S. in 1967, in 1970 Joseph Stalin's daughter Svetlana married William Wesley Peters, Frank Lloyd Wright's right hand man for many years. They lived on Frank Lloyd Wright's manorial land only to divorce in 1975. She returned to the USSR in 1983, then returned to the U.S. in 1986.

78. Johnson (1990), 319; Meehan (1984), 281, 285.

79. Gentry (1991) 141.

80. As quoted in Sowers (1990), B9; and for some relevant letters Frank Lloyd Wright to Weston, Wright (1982), 150–155.

81. Johnson (1990), 319.

82. Frank Lloyd Wright's open letter to Judge Stone is reprinted in Wright (1982), 150–155.

83. L. Wright to Frank Lloyd Wright, 30 June 1941, Wright Archive; cf. Johnson (1990), chapters 26, 28.

84. Johnson (1990), 343.

85. Gentry (1991), 226–227.

86. Wright (1943), 500–501; Johnson (1990), 343.

87. Most of these paragraphs are based on an Office of Naval Intelligence Report of 2 November 1953 (p. 3–4), which recounts some of HUAC's records, and on a series of file checks and summaries (including that of September 1957) in FBI, some identified in previous notes, most declassified from "secret," all supported by information in Frank Lloyd Wright's personal FBI subject file.

88. Meehan (1984), 273–290.

89. File check, 9 September 1957, 1–2, FBI.

90. Gentry (1991), 806.

91. These paragraphs based on FBI documents. See also Twombly (1979), 370–372, 375, and Wright (1943), 544–560, about the USSR and written after 1938. Consult Johnson (1990) for relevant and related episodes in 1930s (including Frank Lloyd Wright's trip to Moscow) and early 1940s; and cf, Sowers (1990), B9.

92. Johnson (1990), 322–338, illustrated; Kotval (2003), 25–46, with additional illustrations.

93. As quoted in Kotval (2003), 37.

94. Kotval (2003), 37.

95. The coup was not that of Saddam Hussein, who came to power about 20 years later as leader of a socialist party, as had Mussolini, Hitler and Stalin.

96. The buildings under discussion are in Pfeiffer (42–50, 51–59); and Zimmerman and Dunham (1994).

97. Twombly (1979), 326–327, 373–375; often illustrated.

98. Bently (1971), 727; Twombly (1979), 229–231, 375; and of less value Gill (1987), 481.

99. Often illustrated but see Zimmerman and Dunham (1994).

100. Gentry (1991), 234–235.

Chapter 15

1. Loeb to Frank Lloyd Wright, 26 October 1947, Wright Archive.
On 19 February 1947 Arrowhead and Warner agreed to abandon production of *The Fountainhead*. LeRoy, who had supported Warner and Mayer during the "Red Scare," was thereby no longer involved.

2. Loeb to Frank Lloyd Wright, ca. January 1948, Wright Archive.

3. On the date of the final screenplay see WB publicity photo 707-PUB-A95, File F-85, WB Archives.

4. *Film Dope* (London) no. 17 (April 1979).

5. Branden (1986), 209; Aline Mosby, "Frank Lloyd Wright Pans Stars' Homes: 'Vulgar Hollywoodiana,'" *Hollywood Citizen*, Press clipping WB Archives.

6. Story by one of the film's production staff as relayed to Lloyd Wright who recounted it in a letter to his father, 2 August 1948, Wright Archive. Lloyd also said people on the set found "Rand's lines for the picture ... unbelievably corny." Another story has it that Frank Lloyd Wright wanted final word on the script, Branden (1986), 209.

7. Heisner (1990), 151, 326. AFI (1999), 811, states Carrere was joint art director with John Holden.

8. File F-85, WB Archives.

9. Frank Lloyd Wright to Blanke, 24 May 1948, copy Wright Archive, not in WB Archives.

10. Loeb to Frank Lloyd Wright, 22 January 1948, Wright Archive.

11. Rand to Loeb, 23 April 1944, Rand (1995), 132; Branden (1986), 186, 207.

12. Vidor and *The Fountainhead* are not mentioned in Garbo biographies; Fritiof Bilquist, *Garbo: A Biography* (New York: Harper & Row, 1960), is good on Garbo but see also Zierold (1969), 121–132; John Bainbridge, *Garbo* (Garden City: Doubleday, 1955), chapter 27; and Alexander Walker, *Garbo Portrait* (London: Weidenfeld and Nicolson, 1980), 164–167.
Near the end of her film career Dunne soon began another with the United Nations.

13. Nash and Ross (1986), 252.
14. Di Orio (1983), 141; Rand to A. Ogden, 10 July 1948, Rand (1995), 403.
15. Perhaps the record for number of movie appearances in a single year is 22 in 1930 by Glenda Farrell for Warner, Zinman (1973), 442.
16. *Science Fiction*, "The Day the Earth Stood Still" entry.
17. Nash and Ross (1986); Kaplan (1985); Neal (1988), 273, 354; and Michael Buckely, "Patricia Neal," *Films in Review* 34 (April 1983), 203–220 plus filmography. The next Cooper-Neal movie, *Bright Leaf*, was also a loser.
Neal married author Roald Dahl and one of their children died from complications of measles. While in a stroller another child was hit by a car and suffered permanent brain damage. At age 39 Neal suffered a stroke while three months pregnant. Barry Farrell was commissioned by *Life* magazine to write about her recovery and Dahl's patient role. Farrell developed the article into the book *Pat and Roald*. In 1981 Robert Andersons' screenplay adaptation of the book appeared as the television film *The Patricia Neal Story*. Neal thought Jackson's "performance was masterful." After a 30-year marriage Dahl and Neal divorced.
18. Schwartz (1982), 243.
19. Gary Cooper has said that Robert E. Sherwood wrote the play *Abe Lincoln* for Cooper. Claiming a lack of talent, Cooper declined the role; Kaminsky (1980), 161.
20. Graham Greene, *Graham Greene on Film*, ed. by John Russel Taylor (New York: Simon and Schuster, 1972), 97.
21. Meyers (1998), 252; the movie was produced independently by Stanley Kramer, written by Carl Foreman, directed by Fred Zinnemann, and released by Columbia. In Moscow *Pravda* blasted it as "a glorification of the individual."
22. Pohl (1978), 324.
23. Quite correctly judged a poor film by Meyers (1998), 362.
24. Gentry (1991), 447.
25. Gentry (1991), 445–447, 708.
26. Various schedules, Jack Warner Collection and File F-85, WB Archives.
27. Rand to Allan Collins, 8 January 1949, Rand (1995), 419. Rand referred to a studio preview of 6 January 1949.
28. Neal (1988), 115–116; Raymond Massey, *A Hundred Different Lives* (New York, 1979), who was on the New York stage for most of 1947–49.
29. Loeb to Frank Lloyd Wright, 18 April 1949, Wright Archive.
30. "Architecture and love in mixup," *Cue*, 9 July 1949, 2; "'Fountainhead' faithful to controversial book," *Hollywood Reporter*, 23 June 1949, 4; Edwin Schallert, "'Fountainhead' provokes keen interest at premiere," *Los Angeles Times*, 24 June 1949, press clipping, WB Archives; *New Yorker* (1949), n.p.
31. Branden (1986), 211, and comments, 211–213; Bawden (1976), for a fair evaluation.
32. Critical comments recorded in Homer Dickens, *The Films of Gary Cooper* (New York: Citadel, 1980), 216–217; Kaminsky (1980), 155; Meyers (1998), 220–222. On the three-year Cooper-Neal relationship see Meyers (1998), passim; see also John Updike, *In the Beauty of the Lilies* (London: Hamish Hamilton, 1996), 318–320; Neal (1988), 94ff; and Douglas Fairbanks, Jr., *The Salad Days* (New York, 1988), passim.
33. Robin Woods in Nash and Ross (1986), 464; and most other reviewers and critics.
34. Rand to Blanke, 6 December 1945, Rand (1995), 242–246.
35. Vidor (1972), 231–232, an often mentioned comment. Selznick's head of distribution, Neil Agnew, conceived the idea of launching the movie by simultaneous showings throughout the U.S. It is best to remember Vidor for the pioneering days and his pre-1945 films.
36. "Borg," *Variety*, 24 June 1949. See also as examples, Boseley Crowther, *New York Times Film Reviews*, July 1949; Arce (1979); Durgnat and Simmon (1988), 253–269 (plus filmography); Vidor (1972); Julia Johnson in *Magill's American Film Guide*, Frank Magill, ed., vol. 2 (Englewood, Cliffs: Salem Press, 1981–83).
37. Kevin McGann, "Ayn Rand in the Stockyard of the Spirit," in Peary and Shatzkin (1978), 311; Durgnat and Simon (1988), 31, and re. *Beyond the Forest*, 35.
38. Durgnat (1973), 29–35; *World Film Directors*, 1134–1135; Durgnat and Simon (1988), passim.
39. As quoted in Rosten (1941), 316–317.
40. Neal (1988), 98–99; Higham and Greenberg (1969), 241.
41. Durgnat (1973), 31.
42. As quoted in Meyers (1998), 221.
43. Herbert G. Luft, "King Vidor," *Films in Review* 33 (December 1982), 587–612; and Hochman (1974).
44. Vidor's very next film for Warner and with Blanke, *Beyond the Forest*, was also released in 1949, starring Bette Davis who hated it; critics shared her opinion.
45. Robin Wood in Nash and Ross (1986), 464.
46. Walker (1993), 98.
47. Kaminsky (1980), 156–157; among others.
48. Branden (1986), 211; cf. Schwartz (1982).
49. Loeb to Frank Lloyd Wright, 28 September 1948, Wright Archive.

Chapter 16

1. Larkin (1949), 363; cf. 386–387.
2. Tricia Hurst, "Heiress brings lavish lifestyle to Taos," *New Mexico* 67 (November 19890, 30. The heiress in this instance was Millicent Rogers, whose adobe home is now a museum.
3. Cf. Daniel M. Mendelwitz, *A History of American Art* (New York, 1971); Peter Hassrick, *The Way West* (New York: Abrams, 1977); 222f; Jan Garden Castro, *The Art and Life of Georgia O'Keeffe* (New York: Crown, 1985).
4. Opinion of Brown (1955), 8; compare with Frank Lloyd Wright to Harry Guggenheim, 21 January 1956. See also Mackinley Helm, *John Marin* (New York, 1970), 20–66; Larkin (1949), 326–327, 354–360, 386.
5. Sergeant (1976), Appendix E; Steichen as Frank Lloyd Wright's "old comrade," Gill (1987), 415; Linda Banks Downs, *Diego Rivera: The Detroit Industry Murals* (New York, 1999), 50–53, 63; on Frank Lloyd Wright and the Mexicans see Keith Eggener,

"Towards an organic architecture in Mexico," Alofsin (1999), 166–183.

6. O'Keeffe to Frank Lloyd Wright, May 1942, in Cowart and Hamilton (1987), 287; Frank Lloyd Wright to Harry Guggenheim, 21 January 1956, *Frank Lloyd Wright: The Guggenheim Correspondence*, Bruce Brooks Pfeiffer, comp., (Fresno/Carbondale: California State University Press/Southern Illinois University Press, 1986).

7. As quoted in Cowart and Hamilton (1987), 287. Shortly after her 1942 visit, Wright sought O'Keeffe's signature on his 1943 Broadacre City petition to Mrs. Eleanor Roosevelt: the artist agreed.

8. Hanna and Wright correspondence in Paul R. Hanna and Jean S. Hanna, *Frank Lloyd Wright's Hanna House* (Cambridge, Mass.: MIT Press, 1981), 58–59.

9. Jay Peterson, "Nature's Architect," *New Masses* 26 (8 February 1938), 30; Elizabeth Noble, "The Federal Arts Bill," ibid. 17–18. See also "Frank Lloyd Wright," *Architect's World* 1 (February, 1938), 6–7; letters, *Architectural Forum* 68 (February 1938), 42, 86, 68 (March 1938), 22,36, 68 (April 1938), 39.

10. For details Johnson (1990), chapter 24. Frank Lloyd Wright eagerly accepted the chair but because of illness and pressing work, he persuaded a reluctant committee to a postponement to 1939. The series of talks were rather casual, off-the-cuff affairs that, as remarks made in the press revealed, both irritated and joyed audiences. The lectures were afterwards published as *An Organic Architecture* (1939).

11. Johnson (1990), chapters 22–24 for details.

12. The most persuasive argument offered by members of the medal committee to approach Frank Lloyd Wright was that it was inconceivable that the American Institute of Architects had not honored America's best-known architect, one celebrated in many countries but not his own, Johnson (1990), chapter 24.

13. Jester to Frank Lloyd Wright, ca. August 1933, Wright Archive.

14. Jester to Frank Lloyd Wright, 19 May 1937, 24 May 1937, and 19 August 1938, Wright Archive.

15. The Jester design was started around July 1938, Frank Lloyd Wright to Jester, 6 August 1938, copy Wright Archive.

16. Weintraub (1998), 160–161.

17. E. Masselink to L. Wright, 23 May 1938, confirms approximate date; Johnson (1990), 71–72; Hines (1982), 120–127; Hitchcock (1942), 94; Drexler and Hines (1982), 56; Wright (1955), 178–181; Arthur Drexler, *The Drawings of Frank Lloyd Wright* (New York: Horizon, 1962) plates 141–144.

18. L. Wright to Frank Lloyd Wright, 4 May 1939; and Frank Lloyd Wright to L. Wright, 8 August 1939, Wright Archive. Gebhard and Zimmerman (1988), 48–51, for illustrations, not the text; also Zimmerman and Dunham (1994). The Sturges house was copied apparently at the client's request as late as 1952 for the Swan house project in Detroit. Brendan Gill and Derry Moore, *The Dream Came True: Great Houses in Los Angeles* (New York: Lippincott & Crowell, 1980), illustrate houses by Frank Lloyd Wright, L. Wright, and Frank Lloyd Wright's former employees and followers. The brief text has a negative tone, is imprecise and at times incorrect.

19. Nash and Ross (1986); Kaplan (1985), specific entries.

20. Some minor changes and additions (including a swimming pool) were supervised by L. Wright and John Lautner.
Letters in the Wright Archive began 15 April 1940 and continued through 1958, sporadically in later years. See also L. Wright to Frank Lloyd Wright, 21 May 1940. Cf. Wright (1986), 212–226; Wendingen (1925). On Carmel house see Pfeiffer (37–41), plates 396–406; on Ennis proposal see Pfeiffer (37–41), plates 407–409. On Ennis see Gill (1987), 279–281, for a depressing account.

21. After the release of *Bwana Devil* (a pretty bad movie), Gunzberg signed a five-picture deal with Warner Brothers mid–December 1952, Lambert (1990), 30, 34–35; Cohn (1959), passim.

22. For recollections see Oboler (1958), 49–54. On Oboler/Frank Lloyd Wright letters and on Oboler and Nesbitt houses see L. Wright/Frank Lloyd Wright letters of 1940, LW Papers and Wright Archive; cf. Enser (1971). Among many other clients and buildings not discussed by Gill (1987) is Oboler.
Of the movie *Five* (1951), which Oboler produced, directed and wrote, one reviewer was moved to say it was "not so much a drama as a sermon [that] preaches against prejudices and insanities that may lead to atomic war," John Brosnan in *Science Fiction*, 223.

23. L. Wright to Frank Lloyd Wright, 22 January 1941, and ca. 1 February 1941; and Frank Lloyd Wright to L. Wright, 22 January 1941, Wright Archive.

24. Construction drawings sighted at Wright Archive; Pfeiffer (37–41), 97–97, plates 379–390; illustrated Zimmerman and Dunham (1994), 76–80. There are occasional references to Oboler in the Nesbitt/Frank Lloyd Wright letters of the late 1940s, Wright Archive. After much of the construction was complete, on a visit Frank Lloyd Wright instructed his apprentices (Oboler called them a "flying squad") to destroy unsightly and "badly built" changes to the original design. They then spent 30 days free of charge building much of the guest/studio house, Frank Lloyd Wright to L. Wright, 21 October 1946, copy Wright Archive; Gordon Chadwick, "The challenge of being a Taliesin Fellow," in Terry B. Morton, ed. *The Pope-Leigh[e]y House* (Washington: National Heritage Foundation, 1969), 73–74. See also Frank Lloyd Wright/L. Wright letters relevant to the Hartford projects 1946 to 1948, LW Papers.

25. Sergeant (1976), 174n; Oboler (1958), 53–54; Wright (1959), 115; Pfeiffer (51–59), 148.

26. L. Wright to Frank Lloyd Wright, 18 October 1946, Wright Archive. Wright titled the project variously as Country Club, Cottage Hotel, Play Resort, Country Club and Resort, among other names. The proper title is Canyon Park Hotel, with a Hartford residence, and with a club or Canyon Park Club.
Hartford approached L. Wright, Frank Lloyd Wright agreed L. Wright would be supervising architect but in March 1949 the job became Lloyd's when Frank Lloyd Wright realized it had no future. Frank Lloyd Wright was ill and told his son that the Hartford project might be his "swan song"; Frank Lloyd Wright to L. Wright, 21 October 1946, copy Wright Archive.

27. Frank Lloyd Wright oversaw the 1938 magazine cover; Eugene Masselink designed the 1948 cover and much of the interior. With the success of the 1938 issue,

as early as 1941 *Forum* editor Harold Myers anticipated a new Wright issue.

On the modern architecture in Southern California being created by others 1948–1960 see Esther McCoy's fine book *The Second Generation* (New York, 1984); Neil Jackson, "Metal-Frame Houses of the Modern Movement in Los Angeles, Part 2: The Style that Nearly…," *Architectural History* 33 (1990), 167–187.

28. L. Wright to Jourdan, 11 March 1948, copy Wright Archive; L. Wright to Frank Lloyd Wright, 2 August 1948, copy LW Papers, note comments on Rand, p. 2.

29. Lloyd insisted his father comment, approve, and edit the film before release (comment, yes, but edit another artist's creation?); L. Wright to Jourdan, 11 March 1948, and 28 July 1948, and L. Wright to Frank Lloyd Wright, 12 August 1948, copies Wright Archive.

30. L. Wright to Frank Lloyd Wright, 2 August 1948; and Loeb to L. Wright, 3 August 1948, copies Wright Archive.

31. L. Wright to Frank Lloyd Wright, 2 August 1948.

32. L. Wright to Frank Lloyd Wright, 29 September 1948, Wright Archive.

Chapter 17

1. Hay (1989), 311, 119; Meredith (1977), 84. I've found only one picture of the circle, a drawing by the master Al Hirschfeld. It can be found on pages 230–231 in *The World of Hirschfeld* (New York: Abrams, n.d.).

2. Hayes (1968), 148–149. On Woollcott see e.g. DLB 29; and Woollcott (1946), introduction.

3. Gaines (1977), 30.

4. Wolcott Gibbs as quoted in Herbert Muschamp, *Man About Town: Frank Lloyd Wright in New York City* (Cambridge, Mass.: MIT Press, 1983), 41. See also Secrest (1992), 373–374, 476–477.

5. Alexander Woollcott, "Profiles: The Prodigal Father," *New Yorker* 6 (19 July 1930), reprint in Brooks (1981), 9–11.

6. Wright (1943), 352, 488; not in Wright (1932); cf. Harriman (1951).

7. Wright (1943), 486–489. Cf. Woollcott to Sibyl Colefax, 18 March 1940, in Woollcott (1946), 188–190. The men continued visitations until Woollcott's death in 1943.

8. As quoted in Meech (2001), 247–249. Four years later Woollcott gave the boxed portfolio to a good friend, Dr. Gustav Eckstein, Jr.; Woollcott to Eckstein, 23 November 1936, in Woollcott (1946), 153–154. Eckstein was professor of physiology at the University of Cincinnati, a student of Japanese culture and biographer of the scientist Noguchi. See Wilder (1985), 29–30, where the set is entitled "Thirty-six Views of Mount Fujiyama."

9. Woollcott to Frank Lloyd Wright, 15 September 1937, in Woollcott (1946), 155–156; Meech (2001), 248–249.

10. Meredith (1977), 84.

11. Brendan Gill, *Here at the New Yorker* (New York: Random House, 1975), 86–87.

12. Ward W. Briggs, Jr. in DLB.

13. Hay (1989), 29.

14. Twombly (1979), 192; Gill (1987), 131; Secrest (1992), 332, 476; Sergeant (1976), appendix F; *International* (1987), vol. 4; *Contemporary Authors*; and Ben Hecht, *The Improbable Life and Times of Charles MacArthur* (New York, 1957).

15. Harriman (1951), 211; Hayes (1968), 141f; DLB 7. Actor Ruth Gordon was introduced to the Table by Woollcott.

16. Hay (1989), 192.

17. As quoted in G.S. Kaufman entry, *Contemporary Authors*, vol. 108. See also entries in Enser (1971); *Twentieth Century Authors*; DLB 7, 9, 28, 86; James Mason Brown, *Worlds of Robert E. Sherwood … 1896–1939* (London: Hamis Hamilton, 1965); and Johnson (1990), chapter 4, 19.

18. Hayes (1968), 19.

19. Gaines (1977), 226–228.

20. Hay (1989), 310; cf. Whitney R. Mundt, DLB 29.

21. Hay (1989), 45. For drawings of the theater see Wright (1955), 181–184, and compare with theater in Lewis (1949), 33–34, an article written at Frank Lloyd Wright's request.

22. Many theater people had been tainted as "Red" by HUAC and the FBI including Hayes and Harpo Marx, or as "respectable" including Shirley Temple, Greer Garson and Ginger Rogers; Gentry (1991), 309f. After an extended visit to Russia in the late 1930s Edna Ferber was categorical: "I've seen it over there. Communism is slavery," Ferber (1939).

23. Letters and description, Wright (1986), 197–211; cf. Lewis (1949), 32; Secrest (1992), 472–477; Wright (1984), 169–170; Meehan (1984), 269–270; Wright (1943), 486–487, 496–499, 560; Gill (1987), 407–410.

24. As quoted in Howard Mumford Jones, ed., *Letters of Sherwood Anderson* (Boston, 1953), 223–224. On Anderson, Wright (1943), 503–504. On Schevill, Gill (1987), 296–297.

25. Wright (1943), 503; Gill (1987), 299–301; Meech (2001), 203.

26. Wright (1943), 504.

27. Ferber (1939), 294f.

28. Ferber (1939), 386–389.

29. Sergeant (1976), where appendix F contains the petition and those Frank Lloyd Wright claimed supported it; Wright (1943), 439.

30. Einstein to Mendelsohn, March 1943, translation by Mendelsohn, Wright Archive. It is doubtful if Einstein signed the 1932 petition in support of the Fellowship.

31. Frank Lloyd Wright to Gropius, 6 February 1943, copy Wright Archive.

32. Frank Lloyd Wright to Connelly, 17 March 1943, and reply Connelly to Frank Lloyd Wright, 21 April 1943, Wright Archive.

33. Frank Lloyd Wright to Clair, 23 February 1942, copy Wright Archive; and Clair entries in *International* (1984), Bawden (1976); and *World Film Directors*. See also "New Masses Concert: Orson Welles will present each number," *New Masses* 26 (8 February 1938), 30.

34. Frank Lloyd Wright to Trumbo, 23 February 1942, copy Wright Archive.

35. Frank Lloyd Wright to Sturges, 30 June 1945, and 17 July 1945, copies Wright Archive.

36. Quotation only from Eric Smoodin in *International*; cf. *World Film Directors*.

37. Nash and Ross (1986); cf. Bawden (1976).

38. Sturges (1990), 295.
39. Frank Lloyd Wright to Sturges, 30 June 1945.
40. Nash/Ross (1986).
41. Frank Lloyd Wright to Sturges, 23 February 1942, copy Wright Archive.
42. Woollcott to Julie Taber, 10 December 1917, to Alice Truax, Spring 1918, and to Beatrice Kaufman, 28 January 1940, in Woollcott (1946).
43. Balio (1976), 138.
44. Walker (1990), 215f.
45. Bawden (1976); *International*, vol. 4.
46. Frank Lloyd Wright to Wanger, 10 April 1941, and 29 December 1941, copies Wright Archive.
47. Wanger to Frank Lloyd Wright, 12 February 1943, and 26 February 1943, Wright Archive.
48. Harry Seckel, "Frank Lloyd Wright," *North American Review* 246 (autumn 1938), 61–63; Johnson (1990), 233–234.
49. "Murus," "Frank and Free," *Builder* 156 (May, 1939), 890, written while Frank Lloyd Wright was in London; Johnson (1990), 260–262.
50. Smith (1992), chapter 3.
51. Isadora Duncan, *My Life* (London; V.Gollancz, 1928), 371f; see also Francis Steegmuller, ed, "'Your Isadora': The Love Story of Isadora Duncan and Gordon Craig (New York: Random House, 1974).
52. Cf. Langmead and Johnson (2000), chapter 4.
53. Johnson (1990), chapters 4, 25.
54. Sturges (1990), 24f.
55. Wright (1943), 260.

Chapter 18

1. Cf. Marner (1974); Chase (1975), chapter 5; and Lindsay Anderson, comp. and ed., *Making a Film: The Story of "Secret People"* (London: Allen and Unwin, 1952), passim, as typical of the period; and Heisner (1997), introduction, for the roles of today's "production designer" and yesterday's "art director."
2. Paraphrased in Branden (1986), 208–209.
3. As quoted by Loeb to Frank Lloyd Wright, 28 September 1948, Wright Archive.
4. As put by L. Wright to Frank Lloyd Wright, 28 September 1948, Wright Archive, where the story from people on set was relayed to L. Wright who passed it on. None of the "twenty letters" a day have been found in archives.
5. Cf. Langmead and Johnson (2000), especially chapter 2.
6. See Albrecht (1986); Mandelbaum and Myers (1985); Heisner (1990) and Barsacq (1970).
7. Cf. David Kyle, *A Pictorial History of Science Fiction* (New York: Hamlin, 1976); Albrecht (1986). Designs for *Aelita*, based on a play by Alexei Tolstoy, show marked influences of the German Bauhaus school, especially in the costumes.
8. Albrecht (1986), figures 94–98, 121.
9. "Portfolio," *Architect and Engineer* (San Francisco) 123 (November 1935), 43–47
10. For instance see filmography by D. Albrecht and Ronald S. Magliozzi in Albrecht (1986), 179–189; Heisner (1990); Neumann (1996); and less usefully Mandelbaum and Myers (1989), passim.
11. Perspective drawing by Barsacq for the ocean liner interior set (Albrecht [1986], 145) was very close to the final set as constructed, Barsacq (1970), no plate number.
12. Often illustrated but see Heisner (1990), figure 123. The film for Fox was a box office failure but the special effects were very good and the model of New York City cost $250,000.
13. Wright (1986), 266; building construction was supervised by Aaron Green. Studio, bedroom, fence and gate were added in 1956 to Frank Lloyd Wright's design.
14. Higham and Greenberg (1969), 240; and Highham and Greenberg (1968), 48.
15. Johnson (1990), chapters 5, 13, 19.
16. "Blade Runner 2020 Foresight," *Cinefex* 9 (July 1982), the issue brought to my attention by Adam Johnson. Paull took an architecture degree from the University of Arizona where this author was then teaching design.
17. On how the valley and lamasery were filmed see illustration in Heisner (1990), 264. However, the lamasery had no relation to Frank Lloyd Wright's Tokyo Imperial Hotel (1916–22).
18. See Langmead and Johnson (2000), chapters 2–12. Goosson's designs were also reminiscent of Dutch and English modernism of around 1930: the English were influenced by the Dutch and they by Frank Lloyd Wright, especially the doyen of Dutch modernism Willem Dudok, a man revered in Britain.
19. L. Wright to Frank Lloyd Wright, ca. November 1929, Wright Archive. L. Wright divorced Hyman in 1925 to marry Helen Taggart, and their son Eric became an architect. L. Wright invented a color motion picture process in 1930, in the wake of the few color scenes in Vitaphone/Warner Bros' *The Jazz Singer* (1929).
20. Gebhard and Von Breton (1975), 22f; and cf. "The New Decoration in America," *Studio* (London) 478 (January 1933), 23; and Paul Goldberger, "Reorienting a Classic," *Architectural Digest*, March 1987, 108–115.
21. Carrere to Frank Lloyd Wright, 11 February 1938, Wright Archive.
22. Also illustrated in Pfeiffer (33–59), 134–137; and Pfeiffer (42–50), 144–151; *Architectural Forum* (1948).
23. Detailed in Johnson (1990), chapters 11–15, 24.
24. Rand to Loeb, 23 April 1944, Rand (1995), 1933.
25. As quoted in Art Petersen, "Architecture and the Tradition of Symbolism in Northwest Art: The View from Cold Mountain," *Column 5* (Seattle), 1988, 16, taken from S. Langer, *Philosophy in a New Key*. Rand's regressive ideas about aesthetics were developed after writing *The Fountainhead*; see Peikoff (1991), 414–435.
26. Rand (1997), 239.
27. Kaminsky (1980), 156.
28. Vidor (1972), description to his figure 15.
29. On props see e.g. Marner (1974), 46–50.
30. Cf. Marner (1974); Chase (1975).
31. *New York Times Film Reviews*, vol. 4, 1949, 2345, "Brog.," *Variety*, 24 June 1949, found the architecture "interesting," saying that it and the photography, sound, and "technical assists" help "cloak the plot," what ever that meant.
32. Durgnat (1988), 34.
33. Heisner (1990), 151; Neumann (1996), lists some reviews.
34. George Nelson, "Mr. Roark goes to Holly-

wood," *Interiors* 45 (April 1949), 106–107. Nelson's obituary, *Interior Design,* April 1986, 203; Rand's comment to Loeb, 23 April 1944, Rand (1995), 132.

35. As quote in Heisner (1990), 4–5.

36. Loeb to Frank Lloyd Wright, 3 May 1949, paragraph 2, Wright Archive.

37. Mosby (1949), WB Archives. Gruen was described as a store designer.

38. As quoted in *Architectural Forum* (1949), 13–14.

39. Gunts and Stern in Gunts (1993), 37.

40. As reported in *Journal of the American Institute of Architects* 12 (July 1949), 27–28, 31.

41. Ibid. A more complete typescript copy is in WB Archives.

42. As reported in *Architectural Forum* 90 (June 1949), 14.

Chapter 19

1. Based on interview with R. Thorston, Hines (1982), 252–253. At cocktail parties Neutra would proclaim that Rand "used me," he would say, "as the model for Howard Roark's sexuality," as quoted in Hines (1982), 138.

2. As quoted in Branden (1986), 390.

3. Frank Lloyd Wright sent a copy of his autobiography to Lloyd's friend, the actor and producer Charles Laughton, Masselink to L. Wright, 17 December 1952, LW Papers; cf. Finis Farr, *Frank Lloyd Wright* (London: Jonathan Cape.), 206.

4. Cf. Drexler and Hines (1982), passim.

5. Pfeiffer (51–59), 20, description, plates 38–40.

6. For contrast Frank Lloyd Wright place a dreaded box-shaped house in the perspective drawing of the proposed "Boulder House" for Kaufmanns.

7. For photographs (not text) see Zimmerman and Dunham (1994), and Gebhard and Zimmerman (1988).

8. L. Wright to Murray, 29 September 1945, copy Wright Archive.

9. In 1945 Dorothy Clune Murray of Los Angeles asked if Aline Barnsdall would sell her house Hollyhock. The reply was yes, for $2 million and the right "to sit in her wreck of a house on the side of the hill and raise hell generally," as quoted in L. Wright to Frank Lloyd Wright, ca. May 1945, Wright Archive. Actually, as a result of her gift, the City of Los Angeles owned the land on which the house sat and called it Barnsdall Park. But she had a right of veto in all matters relevant to the house.

10. Frank Lloyd Wright to L. Wright, 14 June 1945, copy; L. Wright to Frank Lloyd Wright, 5 June 1945; and L. Wright to Murray, 29 September 1945; Wright Archive or LW Papers.

11. L. Wright to Frank Lloyd Wright, 18 August 1945, Wright Archive.

12. Barnsdall's last effort to donate another area of the Hill was in 1931 and L. Wright was involved marginally, Karasick (1982), 12f. Her daughter Betty attended Frank Lloyd Wright's Fellowship in the 1930s.

13. Karasick (1982), 51.

14. L. Wright to Frank Lloyd Wright, ca. July 1932, Wright Archive.

15. Lloyd was to act as the go-between. He prepared some plans that Wright rejected and he then prepared his own that Lloyd modified, Frank Lloyd Wright to L. Wright, 14 July 1932, copy; and L. Wright to Frank Lloyd Wright, ca. August 1932, Wright Archive.

16. L. Wright to Frank Lloyd Wright, 25 March 1946, Wright Archive. Murray visited Frank Lloyd Wright in Scottsdale, Frank Lloyd Wright to L. Wright, 11 April 1945, LW Papers.

17. L. Wright to Murray, 29 September 1945.

18. L. Wright to Frank Lloyd Wright, 18 October 1946, Wright Archive, copy LW Papers.

19. Frank Lloyd Wright to L. Wright, 21 October 1946, copy Wright Archive.

20. Murray was a rather demanding person, committed to Hollyhock, but at the time no doubt sensitive to people's reactions, for she confessed to Lloyd that she and husband had separated "because of the Olive Hill project," L. Wright to Frank Lloyd Wright, 5 May 1947, Wright Archive.

21. L. Wright to Frank Lloyd Wright, ca. May (not September) 1947, Wright Archive.

22. L. Wright to Frank Lloyd Wright, ca. May (not November) 1947, Wright Archive. L. Wright quit Murray in May 1947, LW to Frank Lloyd Wright, 4 June 1947, copy LW Papers.

23. Drawings Wright Archive; Pfeiffer (51–59), 146–147, plates 287–288; and *Treasures,* plate 65 description, gives the date 1957 for the art gallery proposal. Two stories of parking under the gallery and its plaza were incorporated into a minor revision requested by Kenneth Ross, then Director of the Municipal Art Department, cf. *Treasures, loc. cit.*, and especially LW to Frank Lloyd Wright, 19 January 1959, 2 pp., copy LW Papers.

24. Smith (1992), 195–202.

25. Storrer (1993), 358–359, photographs and plan.

26. Gentry (1991), 410. Scientist and Nobel laureate Linus Pauling had his application delayed for over one year.

27. As quoted in Meyers (1998), 213.

28. Miller (1987), 317f and 358f; Summers (1985), 210–213; Benjamin Nelson, *Arthur Miller: Portrait of a Playright* (London: Owen, 1970), passim; Jeffrey Helterman in DLB 7; and Bentley (1971), 792–825.

29. Summers (1985), 326.

30. In Mrs. Wright's "autobiographical papers" she wrote Monroe was "a good actress" and Miller "an intelligent man," adding that she "enjoyed, or rather was shaken up by his plays— they are not plays to enjoy," as quoted in Pfeiffer (1989), 118–119. On one occasion Miller said Wright "reminded him" of W.C. Fields; Gill (1987), 475. When Broadway man David Merrick was introduced to Arthur and Marilyn he said, "I just couldn't stop staring at Arthur Miller," Hay (1989), 105. Author Curt Gentry described Monroe as "surprisingly plain in the flesh, much too substantial in the derriere, she nevertheless glowed in photographs and in the movies," Gentry (1991), 493.

31. Miller (1987), 468; Miller to Edgar Tafel, 7 March 1986, in Edgar Tafel, *About Wright: An Album of Recollections...* (New York: John Wiley, 1993), 68, 82–83.

32. Pfeiffer (33–59), 198; and Pfeiffer (51–59), 48–49.

33. Pfeiffer (51–59), 298–299. The house can be usefully compared to Wright's design of 1954 for a restaurant for Deganan Donohoe Inc., to have been sited at Yosemite National Park, *Treasures*, plate 57; Pfeiffer (51–59) plates 311–312; "Frank Lloyd Wright on Restaurant Architecture," *Food and Service Magazine* 20 (November 1958), 17–21, 32.

34. Wright Archive and see Pfeiffer and Norland (1988), 26–27. Eight sheets of construction drawings were prepared.

35. The Taliesin Associate Architects, successors to Frank Lloyd Wright's architectural practice, also reused—or "synthesized"—the same plan and external appearance for a "golf park" on Maui Island, Hawaii, in 1990, "Maui Clubhouse...," *Progressive Architecture* 179 (January, 1991), 21.

36. Miller (1987), 469. Frank Lloyd Wright stated in September 1957 that the Millers had not "in so many words yet" asked for a house design, Meehan (1984), 302–303. Bruce Pfeiffer confirmed in 1996 there was no Miller correspondence of 1957–58 in the Frank Lloyd Wright Archive. Perhaps any letters were still with lawyers. A legal tussle over fees between Miller and the Wright Foundation and Taliesin Associated Architects followed Marilyn's death.

Gill (1987), 475, believed the house had "reached the point of being bid on by a contractor" but, typically, no confirming information or dates were given.

37. Helterman, DLB 7, 102; note 3 above. One quarter of Monroe's considerable estate was left to her psychiatrist, who bequeathed it to the Anna Freud Centre, a children's clinic in north London. The rest went to Monroe's acting coach, the late Lee Strasberg, whose widow—perhaps in need of money—claimed that the psychiatrist's share was invalid when she died in 1980. A judge in Manhattan saw reason, and the money went to help children.

38. As quoted in Branden (1986), 318.

39. Meredith (1977), 20–21.

40. Hay (1989), 163. When Bojangles read the review he said to Todd, "I ain't been so happy since I been colored."

41. Lewis (1949), 33. Cf. telegram, Frank Lloyd Wright to Todd, 12 September 1946, Wright Archive.

42. Frank Lloyd Wright to Todd, 19 December 1947, copy Wright Archive.

43. Cohn (1959), 324f. A corporation was formed in 1954.

44. The director, Michael Anderson, was relatively unknown. The production fit Todd's personality with 68,894 people photographed; the entire population of Chinchon, Spain (all 4,348), were used in the bullfight sequences; locals were shot in 13 countries; there were 112 natural and 140 special sets at 11 studios; there were 74,685 costumes; and it won an Oscar. Margaret Hinxman, *International Encyclopedia of Film* (London, 1972); Bawden (1976); Walker (1990), chapter 21; Cohn (1959), 374f.

45. As quoted in Walker (1990), 183.

46. Taylor's "star image" has "always overshadowed her capabilities as a performer," with two exceptions: *National Velvet* (MGM, 1944) and *Who's Afraid of Virginia Woolf* (Warner Bros, 1966); Fiona Valentine, *International*, 4.4; Walker (1990), 178–182; Bawden (1976), passim.

47. Twombly (1979), 364.

48. Press clipping, Wright Archive.

49. The memorandum was drawn to The Frank Lloyd Wright Foundation, sighted unsigned copy Wright Archive. Cf. "Wright to Design Dome Theatres for Mike Todd," *Architectural Forum* 108 (February 1958), 61.

50. Drawings Wright Archive; Pfeiffer (51–59), plates 722–723.

Apparently Kaiser had earlier talked to Frank Lloyd Wright about prefabricated houses, LW to Frank Lloyd Wright, 25 August 1944, copy LW Papers.

51. Telegram, Frank Lloyd Wright to Todd, copy Wright Archive, date 7 March 1958 added; partially quoted in *Treasures* (1985), plate 70 description. On the drawings the project was referred to as "Theater for Mike Todd" or similar words; the term "universal" not used.

52. Pfeiffer (51–59), 360.

53. Telegram, Todd to Frank Lloyd Wright, 10 March 1958, Wright Archive, partially quoted in *Treasures* (1985), plate 70 description.

54. Telegram, Frank Lloyd Wright to Todd, 22 April 1958, copy Wright Archive.

55. Telegrams to and from Frank Lloyd Wright and Weaver during April 1958, Wright Archive; Pfeiffer in *Treasures* (1985), plate 70 description. Archivist and architect Bruce Pfeiffer was active in Wright's architectural office at the time.

56. Pfeiffer (51–59), 361.

57. Walker (1990), 378.

58. Press clipping, Wright Archive.

59. Pfeiffer (51–59), 361. Frank Lloyd Wright's biographers, including Twombly (1979), Secrest (1993), Gill (1987), and Neil Levine, *The Architecture of Frank Lloyd Wright* (Princeton: Princeton University Press, 1996), have ignored the important Todd and Monroe-Miller (and related) projects, in fact most commissions of the 1950s.

After Todd's death and without the Todd A-O corporation, Kaiser and Cinerama collaborated on constructing at least one dome theater, not beside a shopping center but in the 6300 block of Sunset Boulevard, Hollywood. Architecturally a pretty naive affair, the seating, small balcony and screen are surrounded by a concrete wall surmounted by a huge dome. Butted against the exterior wall are concrete structures that contain ancillary functions. The building as constructed was probably an adaptation of the Kaiser Engineers proposal of 1957. "Regulars say the first rows of the low-slung balcony are best for getting Terminatered or thoroughly Dolbyized by invisible android assassins," see "Cinerama Dome," *Sunset* 128 (February 1992), 79, with color illustration.

Chapter 20

1. Wright's years in Los Angeles 1919–1924 and his professional relationship with architect Irving Gill are continuing areas of study by this author.

2. Nash and Ross (1986), 2715–2716, a good review and summary.

Appendix A

1. In the 1890s FLW designed and had built a house for a Heller family.
2. The Monadnock Building, Chicago, was built in two stages to designs by Burnham and Root (1891, and the superior) and Holabird and Roche (1893).
3. Editor David Harriman for Rand (1997), 235, states there were two additional paragraphs, but they were not part of the mimeographed copy in the Warner Archive. The "Key Points" are not in Rand (1997), 234–235.

Appendix B

1. Cf. Macgowan (1965), 333–334.

Appendix D

1. *State of the Union*, aka *The World and His Wife*, Liberty/MGM 1948, produced and directed by Frank Capra (Liberty), about Spencer Tracey seeking the Republican nomination for the U.S. presidency while in a verbal duel with his wife, Katharine Hepburn, about contemporary issues.

Appendix E

1. O. Walsh to FLW, 15 December 1946, Wright Archive.

Appendix F

1. *San Francisco Examiner*, 3 August 1957, 3, cols. 1–2, and quoted with their permission. A clipping of the newspaper article was part of the FBI's file on FLW, 100-240585. In August 1957 FLW was 90 years old. The Marin County supervisors voted 4 to 1 to appoint FLW as architect: "Wright denounces aid-to-reds charge," *New York Times,* 3 August 1957, clipping FBI file 100-240585.
2. On leaving the meeting FLW exclaimed, "Oh, rats!" ("Marin 'Insult' Upsets Frank Lloyd Wright," *San Francisco Chronicle*, 3 August 1957, 1, col. 5), but not before saying, "While I love the Russians as people I despise their Government" ("Wright denounces").
3. J.B. Matthews was also described as having "resigned in 1953 as staff director for the late Senator Joseph McCarthy's investigations subcommittee after writing an article accusing the Protestant clergy of supporting the Communist conspiracy" ("Marin 'Insult,'" 1, 9).

References

The basic sources on Wright are archival, principally the Wright Archive and the letters of his son, Lloyd as found in the LW Papers. Access to the Wright Archive was generously granted to this author beginning in the late 1970s by archivist Bruce Pfeiffer and assistant Indira Berndtson.

The seminal biographical study is Twombly (1979), the second edition, which is good on details of Wright's life prior to about 1932. Other biographies are based on Wright's autobiography or anecdote. That is also true of Gill (1987) who, before embarking on the biography, had said he "wanted to hear from his [Wright's] own lips … an appraisal of his ruthless behavior" (Brendan Gill, *Here at the New Yorker* [Random House, 1975], 55). Biographers Secrest (1992), Twombly (1979), Gill (1987) and others are of little help on matters architectural.

Wright's autobiographies, Wright (1932) and the second edition Wright (1943), are useful if very incomplete and impressionable. The third edition of 1977, released 18 years after his death, must be treated skeptically. I have assumed Wright was only one of many revisers and editors.

Johnson (1990) contains the most recent research about Wright on the period of the 1930s and includes city planning; see also Sergeant (1976); De Long (1996) on the 1920s; Alofsin (1993) and Smith (1992) on the 1910s; Siry (1996) from 1900–1910; and Langmead/Johnson (2000) places Wright in the national and European architectural context 1900–1935 with special emphasis on Holland. My ongoing research will clarify the period of the 1890s to 1917 relevant to architecture and city planning. The present study will assist with understanding the 1940s and 1950s.

Barbara Branden's work (1986) is based on biographical information as revealed by Rand or on intimate personal and professional knowledge. Further, Branden has stated that where the source of a statement attributed to Rand "was not specified," quotations were taken from Branden's 38 hours of audio tapes of "conversations with Ayn, or her conversations with others" at which Branden was present (p. xii). Branden/Branden (1962) contains a biography by Barbara Branden of less detail and opinion than Branden (1986). Nathaniel Branden (1989) concerns affairs post–1949.

Sadly, access to Rand's letters and other papers has repeatedly been denied to this author since the 1980s. It is not known how many other scholars and researchers have been defeated but see Sciabarra (1995), 7 and Schleier (2003), note to notes. Edited and abridged information is now available in Rand (1995), her letters, where there are minor errors, and Rand (1997), her journals.

Archival Sources Mentioned in Notes or Principal Works

Avery = Avery Art and Architectural Library, Columbia University, New York.

Burnham = Ryerson and Burnham Libraries, Art Institute of Chicago.

FBI = Federal Bureau of Investigation, Washington, D.C., information received under Freedom of Information provisions

about Frank Lloyd Wright and related Bureau files only.

G-2 = Department of Army, Intelligence and Security Command, Washington, D.C., information received under Freedom of Information provisions only as related to Frank Lloyd Wright.

LW Papers = Lloyd Wright Papers, Special Collections, Library, University of California, Los Angeles.

Stonorov Papers = Papers of Oskar Stonorov, American Heritage Collection, University of Wyoming.

U.S. Justice = U.S. Department of Justice, information received under Freedom of Information provisions only as related to Frank Lloyd Wright.

Warner Collection = Material sighted in the Jack L. Warner Collection, WB Archives.

WB Archives = Material sighted in the USC Warner Bros. Archives, including Arrowhead Productions, School of Cinema-Television, University of Southern California, Los Angeles.

Woolley Collection = Taylor Woolley Collection, University Library, University of Utah.

Wright Archive = Architectural material and letters sighted in the Frank Lloyd Wright Foundation Archives, Taliesin West, Scottsdale, Arizona, or letters as received from Archives of the History of Art, Getty Center, Santa Monica.

Principal works

Those mentioned in captions or more than once in the notes.

Abercrombie, Stanley. 1995. *George Nelson: The Design of Modern Design.* Cambridge, Mass.: MIT Press.

Albrecht, Donald. 1986. *Designing Dreams: Modern Architecture in the Movies.* New York: Harper & Row with Museum of Modern Art. London: Thames and Hudson, 1987.

Alofsin, Anthony. 1993. *Frank Lloyd Wright: The Lost Years, 1910–1922. A Study of Influence.* Chicago: University of Chicago Press.

American Film Institute (AFI). 1999. *American Film Institute Catalog of Motion Pictures Produced in the United States, Feature Films, 1941–1941, Film Entries, A–L.* Berkeley: University of California Press.

Arce, Hector. 1979. *Gary Cooper: An Intimate Biography.* New York: William Morrow.

Architectural Forum. 1948. "Frank Lloyd Wright." 88 (January).

——. 1949. "Hollywood's Fountainhead: All Dynamite Will Be Charged to Clients." 90 (June).

Baker, James T. 1987. *Ayn Rand.* Boston: Twayne.

Balio, Tino. 1976. *United Artists: The Company Built by Stars.* Madison: University of Wisconsin Press.

Barsacq. Leon. 1976. *Caligari's Cabinet and Other Grand Illusions.* Rev. ed. Boston: Little, Brown.

Bawden, Liz-Anne. 1976. *The Oxford Companion to Film.* New York: Oxford University Press.

Bentley, Eric, ed. 1971. *Thirty Years of Treason.* New York: W.H. Allen.

Berliner, Michael S., ed. 1995. See Rand (1995).

Bordwell, David, Janet Staiger and Kristin Thompson. 1985. *The Classical Hollywood Cinema: Film Style and Mode of Production to 1960.* New York: Columbia University Press.

Branden, Barbara. 1986. *The Passion of Ayn Rand.* Garden City: Doubleday.

Branden, Nathaniel. 1989. *Judgement Day: My Years with Ayn Rand.* Boston: Houghton Mifflin.

——, and Barbara Branden. 1962. *Who Is Ayn Rand.* New York: Random House.

Brooks, H. Allen. 1981. *Writings on Wright.* Cambridge, Mass.: MIT Press.

Brown, James Mason. 1965. *The Worlds of Robert E. Sherwood ... 1896–1939.* London: Hamish Hamilton.

Chase, Donald. 1975. *Filmmaking: The Collaborative Art.* Boston: Little, Brown.

Cohn, Art. 1959. *The Nine Lives of Mike Todd.*

Congress. 1971. *Guide to the Congress of the United States.* Washington, D.C.

Connelly, Marc. 1968. *Voices Off Stage: A Book of Memoirs.* New York: Holt, Rinehart and Winston.

Contemporary Authors. Detroit: Gale. 1962+.

Cowart, Jack, and Juan Hamilton. 1987. *Georgia O'Keeffe. Art and Letters.* Washington and Boston: National Gallery of Art and New York Graphic Society.

DeLong, David G., ed. 1996. *Frank Lloyd Wright Designs for an American Landscape 1922–1932*. New York: Abrams.

Den Uyl, Douglas J., and Douglas B. Rasmussen, eds. 1984. *The Philosophic Thought of Ayn Rand*. Urbana: University of Illinois Press.

Dictionary of Literary Biography (DLB). Detroit: Gale. 1978+.

DiOrio, Al. 1983. *Barbara Stanwyck*. New York: Coward-McCann.

Drexler, Arthur, and Thomas S. Hines. 1982. *The Architecture of Richard Neutra from International Style to California Modern*. New York: Museum of Modern Art.

Durgnat, Raymond. 1973. "King Vidor: Part II." *Film Comment* 9 (5 September), *Fountainhead* entry.

———, and Scott Simmon. 1988. *King Vidor, American*. Berkeley: University of California Press.

Enser, A.G.S. 1972. *Filmed Books and Plays ... 1928–1969*. 2nd ed. London: Deutsch.

Essoe, Gabe, and Raymond Lee. 1970. *DeMille: The Man and His Pictures*. New Brunswick: A.S. Barnes.

Ferber, Edna. 1939. *A Peculiar Treasure*. Toronto: William Heinemann.

Finler, Joel W. 1988. *The Hollywood Story*. London: Octopus.

Flew, Anthony. "Selfishness and the Unintended Consequences of Intended Action." In DenUyl and Rasmussen (1984).

Fusco, Renato. 1986. "Frank Lloyd Wright Storrer Residence, Hollywood." *Domus* 675 (September).

Gaines, James R. 1977. *Wit's End*. New York: Harcourt Brace Jovanovich.

Gebhard, David. 1971. *Schindler*. London: Thames & Hudson.

———, and Harriet Von Breton. 1971. *Lloyd Wright: Architect*. Santa Barbara: University of California, Art Galleries.

———, and ———. 1975. *Los Angeles in the 1930s: 1931–1941*. Salt Lake City: Peregrine Smith.

———, and Scott Zimmerman. 1988. *Romanza: The Southern California Architecture of Frank Lloyd Wright*. San Francisco: Chronicle.

Gentry, Curt. 1991. *J. Edgar Hoover: The Man and the Secrets*. New York: W.W. Norton.

Gill, Brendan. 1987. *Many Masks*. New York: Putnam.

Gladstein, Mimi Reisel. 1984. *The Ayn Rand Companion*. Westport: Greenwood. (With useful bibliography.)

Gunts, Edward. 1993. "The Fountainhead at 50." *Architecture* 82 (May).

Harriman, David, ed. 1997. See Rand (1997).

Harriman, Margaret Chase. 1951. *The Vicious Circle: The Story of the Algonquin Round Table*. New York: Rinehart.

Haver, Ronald A. 1988. *A Star Is Born*. New York: Knopf. Reprint: Harper Row, 1975.

Hay, Peter. 1989. *Broadway Anecdotes*. New York: Oxford University Press.

Hayes, Helen, with Sanford Dody. 1968. *On Reflection: An Autobiography*. New York and Philadelphia: M. Evans/Lippincott.

Heisner, Beverly. 1990. *Hollywood Art: Art Direction in the Days of the Great Studios*. Jefferson: McFarland.

———. 1997. *Production Design in the Contemporary American Film*. Jefferson: McFarland.

Henning, Randolph C., comp. 1992. *At Taliesin*. Carbondale: Southern Illinois University Press.

Higham, Charles, and Joel Greenberg. 1968. *Hollywood in the Forties*. New York: A.S. Barnes.

———, and ———, eds. 1969. *The Celluloid Muse: Hollywood Directors Speak*. London: Angus and Robertson.

Hines, Thomas S. 1982. *Richard Neutra and the Search for Modern Architecture: A Biography and History*. New York: Oxford University Press.

Hitchcock, Henry-Russell [and Frank Lloyd Wright]. 1942. *In the Nature of Materials 1887–1941: The Buildings of Frank Lloyd Wright*. New York: Hawthorn. Reprint, New York: Da Capo, 1975.

Hochman, Stanley, comp and ed. 1974. *American Film Directors*. New York: Frederick Ungar.

International Dictionary of Films and Filmmakers. 1984–87. 2nd ed. 4 vols. Chicago: St. James Press.

Johnson, Donald Leslie. 1988. "Broadacres Geometry: 1934–35." *Journal of Architectural and Planning Research* 5 (summer).

———. 1990. *Frank Lloyd Wright versus America: The 1930s*. Cambridge, Mass.: MIT Press.

Kahn, Gordon. 1948. *Hollywood on Trial.* New York: Boni & Gaer.

Kaminsky, Stuart M. 1980. *Coop: The Life and Legend of Gary Cooper.* New York: St. Martin's.

Kaplan, Mike, ed. 1985. *Variety Presents the Complete Book of Major U.S. Show Business Awards.* New York: Garland.

Karasick, Norman J. 1982. "Art, Politics, and Hollyhock House." Typescript thesis. California State University. Dominguez Hills.

Kotval, Zenia. 2003. "Opportunities Lost: A Clash between Politics, Planning, and Design in Defense Housing for Massachusetts." *Journal of Planning History* 2 (February).

Lambert, Gavin. 1990. *Norma Shearer: A Life.* London: Hodder Stoughton.

Langmead, Donald and Donald Leslie Johnson. 2000. *Architectural Excursions: Frank Lloyd Wright, Holland and Europe.* Westport: Greenwood Press.

Larkin, Oliver. 1949. *Art and Life in America.* New York: Rinehardt.

LeRoy, Mervyn, with Dick Kleiner. 1974. *Mervyn LeRoy: Take One.* New York: Hawthorn.

Lewis, Lloyd. 1949. "The New Theatre." *Theatre Arts* 33 (July).

MacCarter, Robert, ed. 1991. *Frank Lloyd Wright: A Primer on Architectural Principles.* New York: Princeton Architectural Press.

Macgowan, Kenneth. 1965. *Behind the Screen: The History and Techniques of the Motion Picture.* New York: Delacorte Press.

Macmillan Film Bibliography. 1982. New York: Macmillan.

Macmillan Encyclopeadia of Architects. 1982. New York: Macmillan.

Maltby, Richard. 1981. "Made for Each Other: The Melodrama of Hollywood and the House Committee on Un-American Activities, 1947." In Philip Davies and Brian Neve, eds., *Cinema, Politics and Society in America.* New York: St. Martin's Press, 1981.

Mandelbaum, Howard, and Eric Myers. 1985. *Screen Deco.* New York: St. Martin's.

Manson, Grant C. 1958. *Frank Lloyd Wright to 1910.* New York: Reinhold.

Marner, Terence St. John, comp. 1974. *Film Design.* New York: A.S. Barnes.

Meech, Julia. 2001. *Frank Lloyd Wright and the Art of Japan.* New York: Abrams.

Meehan, Patrick J., ed. 1984. *The Master Architect: Conversations with Frank Lloyd Wright.* New York: Wiley.

_____, ed. 1986. *Truth Against the World.* New York: Wiley.

Meredith, Scott. 1977. *George S. Kaufmann and the Algonquin Road Table.* London and Boston: Allen Unwin.

Meyers, Jeffrey. 1998. *Gary Cooper: American Hero.* New York: William Morrow.

Miller, Arthur. 1987. *Timebends: A Life.* New York and London: Grove/Methuen.

Mosby, Aline. 1949. "Real Architects Flunk Colleague Gary Cooper." *Courier-Journal* (Louisville). 28 (July). Section 2. Press clipping WB Archives.

Nash, Jay Robert, and Stanley Ralph Ross. 1986. *The Motion Picture Guide.* 12 vols. Chicago: Cinebooks.

Neal, Patricia. 1988. *As I Am: An Autobiography.* London: Century.

Neumann, Dietrich, ed. 1996. *Film Architecture: Set Designs from Metropolis to Blade Runner.* Munich: Prestel.

New Yorker. 1949. "Down with Beaux-Arts." 16 (July).

Oboler, Arch. 1958. "He's Always Magnificently Wright." *Readers' Digest* 78 (February).

Palmer, Edwing O. 1938. *History of Hollywood.* 2nd ed. Hollywood: Palmer. Reprint New York, 1978.

Park, Jin Ho, and Lionel March. 2002. "The Shampay House of 1919: Authorship and Ownership." Journal of the Society of Architectural Historians 61 (December).

Peary, Gerald, and Roger Shatzkin, ed. 1978. *The Modern American Novel and the Movies.* New York: Frederick Ungar.

Peikoff, Leonard. 1991. *Objectivism: The Philosophy of Ayn Rand.* New York: Dutton.

Pfeiffer, Bruce Brooks, ed. 1989. *Frank Lloyd Wright: The Crowning Decade, 1949–1959.* Fresno: California State University Press.

_____, and Yuko, Futagawa. *Frank Lloyd Wright.* 12 vols. Tokyo: Edita. 1984–1988. Each vol. identified by its inclusive dates, e.g. *Monograph 1902–1906* is Pfeiffer (02–06).

_____, and Gerald Norland, eds. 1988. *In the*

Realm of Ideas. Carbondale: Southern Illinois University Press.
Pohl, Constance, 1978. "The 'Unmaking' of a Political Film." In Peary and Shatzkin, eds., *The Modern American Novel and the Movies*. New York: Frederick Ungar.
Rand, Ayn. 1936a. *The Night of January 16th*. Longmans, Green; World Publishing; New American Library.
———. 1936. *We the Living*. New York: Macmillan; London: Cassell, 1937; 2nd ed. Random House, 1959; New American Library, 1959, with a forward by Rand.
———. 1943. *The Fountainhead*. New York: Bobbs-Merril; Reprint New American Library, 1952.
———, 1949. "Ayn Rand replies to criticism of her film." *New York Times*, 24 July, Section 2. Press clipping WB Archives.
———. 1957. *Atlas Shrugged*. New York: New American Library.
———. 1959. Introduction to rev. ed. of *We the Living*, Rand (1936).
———. 1969. *Anthem*. Caldwell, Idaho: Caxton, 1953, 1969. First published 1938, London: Cassell. Rev. ed., Los Angeles: Pamphleteers, 1946.
———. 1984. *The Early Ayn Rand: A Selection from Her Unpublished Fiction*. Leonard Peikoff, ed. New York: New American Library.
———. 1995. *Letters of Ayn Rand*. Michael S. Berliner, ed. New York: Dutton/Penguin.
———. 1997. *Journals of Ayn Rand*. David Harriman, ed. New York: Dutton/Penguin.
Reagan, Ronald, with Richard G. Hubler. 1965. *Where's the Rest of Me?*. New York: Duel, Sloan and Pearce.
Rosten, Leo C. 1941. *Hollywood: The Movie Colony, the Movie Makers*. New York: Harcourt, Brace.
Saint, Andrew. 1983. *The Image of the Architect*. New Haven: Yale University Press.
Schleier, Merrill. 2002. "Ayn Rand and King Vidor's Film *The Fountainhead*: Architectural Modernism, the Gendered Body, and Political Ideology." *Journal of the Society of Architectural Historians* 61 (September).
Schumach, Murray. 1964. *The Face on the Cutting Room Floor: The Story of Movie and Television Censorship*. New York: Da Capo.
Schwartz, Nancy Lynn. 1982. *The Hollywood Writers' War*. Knopf.
Sciabarra, Chris Matthew. 1995. *Ayn Rand: The Russian Radical*. University Park: Pennsylvania State University Press.
Science Fiction Encyclopedia. Peter Nicholls, ed. 1979. New York: Doubleday Dolphin.
Secrest, Meryle. 1992. *Frank Lloyd Wright*. New York: Knopf.
Sergeant, John. 1976. *Frank Lloyd Wright's Usonian Houses: The Case for Organic Architecture*. New York: Watson-Guptil.
Siry, Joseph M. 1996. *Unity Temple: Frank Lloyd Wright and Architecture for Liberal Religion*. New York: Cambridge University Press.
Smith, Kathryn. 1992. *Frank Lloyd Wright: Hollyhock House and Olive Hill*. New York: Rizzoli.
Sowers, Carol. 1990. "Wright Wronged? FBI Spied on Noted Architect." *Arizona Republic,* as reprint *Morning News Tribune*, Tacoma, 4 December 1990.
Starr, Kevin. 1990. *Material Dreams: Southern California Through the 1920s*. New York: Oxford University Press.
Storrer, William Allin. 1993. *The Frank Lloyd Wright Companion*. Chicago: University of Chicago Press.
Sturges, Preston. 1990. *Preston Sturges*. Sandy Sturges, ed. New York: Simon and Schuster.
Summers, Anthony. 1985. *Goddess: The Secret Lives of Marilyn Monroe*. London: Gollancz.
Sweeney, Robert L. 1978. *Frank Lloyd Wright: An Annotated Bibliography*. Los Angeles: Hennessey and Ingalls.
———. 1994. *Wright in Hollywood: Visions of a New Architecture*. Cambridge, Mass.: MIT Press.
Tafel, Edgar. 1993. *About Wright: An Album of Recollections....* New York: Wiley.
Torrence, Bruce T. 1982. *Hollywood: The First Hundred Years*. New York: Zoetrope.
Treasures of Taliesin: Seventy-six Unbuilt Designs. Bruce Brooks Pfeiffer, ed. 1985. Fresno/Carbondale: California State University Press/Southern Illinois University Press.
Twentieth Century Authors. 1942. New York: Wilson. First supplement, New York, 1955.

Twombly, Robert C. 1979. *Frank Lloyd Wright: His Life and His Architecture.* 2nd ed. New York: Wiley.
———. 1986. *Louis Sullivan: His Life and Work.* Chicago: University of Chicago Press.
Variety Film Reviews 1949–1953. 1953. New York: Garland.
Vidler, Anthony. 2000. *Warped Space, Art, Architecture and Anxiety in Modern Culture.* Cambridge, Mass.: MIT Press.
Vidor, King [Wallis]. 1972. *On Filmmaking.* David McKay.
Waithe, Mary Ellen, ed. 1995. *A History of Women Philosophers.* Volume 4. Contemporary Women Philosophers 1900–today. Dordrecht, Boston and London: Kluwer.
Walker, John A. 1990. *Art and Artists on Screen.* Manchester and New York: Manchester University Press.
Wallis, Hal B., and Charles Higham. 1980. *Starmaker: The Autobiography of Hal B. Wallis.* New York: Macmillan.
Warner, Jack L., and Dean Jennings. 1964. *My First Hundred Years in Hollywood.* New York: Random House.
Weintraub, Alan, et al. 1998. *Lloyd Wright: The Architecture of Frank Lloyd Wright Jr.* London: Thames and Hudson.
Wendingen. 1925. *The Life-Work of Frank Lloyd Wright.* H.Th. Wijdeveld, ed. Santapoort, Netherlands: C.A. Mees.
Wilder, Thornton. 1985. *The Journals of Thorton Wilder: 1939–1961.* Donald Gallup, ed. New Haven: Yale University Press.
Wolcott, James. 1989. "Rand Inquisitor." *Vanity Fair* 52 (June).
Woollcott, Alexander. 1946. *The Letters of Alexander Woollcott.* Beatrice Kaufman and Joseph Hennessey, eds. London: Cassell. (Selected.)
World Film Directors. John Wakeman, ed. 2 vols. New York: Wilson, 1987, 1988.
Wright, Frank Lloyd. 1910. *Ausgefürhte Bauten und Entwürfe von Frank Lloyd Wright.* Berlin: Wasmuth. Reprint Chicago, 1910, as *Studies and Executed Buildings by Frank Lloyd Wright,* and that edition reprinted Chicago: Prairie School Press, 1975. Reprint of 1919 ed., *Studies and Executed Buildings by Frank Lloyd Wright,* New York: Rizzoli, 1998.
———. 1911. *Frank Lloyd Wright ausgeführte Bauten.* Berlin: Wasmuth. Altered reprint, *Frank Lloyd Wright: The Early Work,* Horizon, 1968.
———. 1932. *An Autobiography.* New York: Longmans Green.
———. 1943. *An Autobiography.* [2nd ed.] New York: Duel, Sloan & Peerce. See companion volume, Linn Ann Cowles, *An Index and Guide to An Autobiography the 1943 Edition.* Hopkins, Minnesota: Greenwich Design Publication.
———. 1955. *An American Architecture.* E. Kaufmann, Jr., ed. New York: Pyramid Books. Horizon.
———. 1982. *Letters to Apprentices.* Bruce Brooks Pfeiffer, ed. Fresno: California State University Press.
———. 1984. *Letters to Architects.* Bruce Brooks Pfeiffer, ed. Fresno: California State University Press.
———. 1986. *Letters to Clients.* Bruce Brooks Pfeiffer, ed. Fresno: California State University Press.
———. 1987. *Frank Lloyd Wright: His Living Voice.* Bruce Brooks Pfeiffer, ed. Fresno: California State University Press.
Wright, John Lloyd. 1946. *My Father Who Is on Earth.* New York: G.P. Putnam's & Sons. Reprint altered, Mineola: Dover, 1992.
Zierold, Norman. 1969. *Garbo.* New York: Stein and Day.
Zimmerman, Scot and Judith Dunham. 1994. *Details of Frank Lloyd Wright: The California Work 1909–1974.* San Francisco: Chronicle.
Zinman, David. 1973. *Saturday Afternoon at the Bijou.* N.p.: Castle Books.
Zinn, Howard. 1998. *The Twentieth Century: A People's History.* 2nd ed. New York: HarperCollins.

Other relevant texts consulted

American Institute of Architects Journal. 1949. "The Fountainhead." *American Institute of Architects Journal* 12 (July).
Architectural Forum. 1953. "Sixty Years of Living Architecture." 99 (November).
———. 1953a. "Frank Lloyd Wright exhibits 60 years' work." 99 (October).

Architectural Record. 1953. "Wright makes New York!" 114 (October).
Barbour, Alan G. 1983. *Humphrey Bogart.* London.
Barsacq, Leon. 1970. *Le décor de film.* Paris: Seghers.
Baxter, John. 1976. *King Vidor.* Los Angeles: Monarch.
_____. 1986. *Hollywood in the Thirties.* New York: A.S. Barnes.
Black, Louis. 1981. "Program notes … *The Fountainhead.*" *Cinema Texas* (Austin), 20 April.
Carpozi, George, Jr. 1961. *Clark Gable.* New York: Pyramid.
Cinema: A Critical Dictionary. 1980. 2 vol. London.
Colville, John D. 1988. "Interior Design on Film." *Interior Design* 59 (September).
Coombs, Richard. 1980. "King Vidor." In *Cinema: A Critical Dictionary.* 2 vol. London.
Film as Art. 1941. Museum of Modern Art.
The Film Index. Vol. 1.
Gabler, Neal. 1988. *An Empire of Their Own: How the Jews Invented Hollywood.* New York: Crown.
Gerlack, John C., and Lena Gerlack. 1974. *The Critical Index: A Bibliography of Articles on Film in English, 1964–1973.* New York: Teachers College Press.
Hirschorn, Clive. 1979. *The Warner Bros. Story.* New York: Crown.
House and Garden. 1949. "A Steel House with a Suave Finish." (August).
International Federation of Film Archives. *International Index to Film Periodicals.* 1972. New York: R.R. Bowker.
Johnson, Donald Leslie. 1987. "Frank Lloyd Wright in Moscow: June 1937." *Journal of the Society of Architectural Historians* 46 (March).
_____. 1987b. "Frank Lloyd Wright in the Northwest: The Show 1931." *Pacific Northwest Quarterly* 78 (July).
Kobler, John. 1961. "The Curious Cult of Ayn Rand." *Saturday Evening Post,* 11 November.

Langman, Larry. 1984. *A Guide to American Screen Writers: The Sound Era, 1929–1982.* 2 vol. New York: Garland.
Loeb, Gerald. 1946. "House in Connecticut." *Architectural Forum* 84 (June).
_____. 1950. "A Stockbroker Meets Frank Lloyd Wright." *Architectural Forum* 93 (August).
Luft, Herbert G. 1982. "King Vidor." *Films in Reviews* 33 (December).
Mandelbaum, Howard, and Eric Myers. 1989. *Forties Screen Style.* Santa Monica: Hennessey & Ingalls.
McCoy, Esther M. 1975. *Five California Architects.* New York: Reinhold.
McGann, Kevin. 1978. "Ayn Rand and the Stockyard of the Spirit." In Peary and Shatzkin (1978).
New York Times Film Reviews (1913+). NYT/Arno Press. Compilation 1970+.
Nichols, Lewis. 1957. "Talk with Ayn Rand." *New York Times Book Review* 13 (October).
Noble, Peter. 1948. *Bette Davis.* London.
Peikoff, Leonard. 1984. *The Early Ayn Rand: A Selection from Her Unpublished Fiction.* New York: New American Library.
Rand, Ayn. "Ayn Rand, Russian Writings on Hollywood." Michael Berliner, ed. Marina del Rey: Ayn Rand Institute, 1999.
Smith, Hedrick, et al. 1981. *Reagan the Man, the President.* New York: Pergamon Press.
Summers, Anthony. 1993. *Official and Confidential: The Secret Life of J. Edgar Hoover.* London: Gollancz.
Thompson, David. 1980. *A Biographical Dictionary of the Cinema.* London: Secker and Warburg.
Updike, John. 1996. *In the Beauty of the Lilies.* London: Hamish Hamilton.
Vidor, King. 1952. *A Tree Is a Tree.* New York: Harcourt, Brace.
Walker, Alexander. 1990. *Elizabeth.* London: Weidenfeld and Nicolson.

Filmography

This is a list of motion pictures referred to in the text, captions, or notes, and arranged by release date: p = producer, d = director.

1921. *Enchantment,* Cosmopolitan/Paramount, R.G. Vignola, d.

1922. *Robin Hood,* UA, Douglas Fairbanks, p, Allan Dwan, d.

1923. *The Ten Commandments,* Cecil B. DeMille/Famous Players-Lasky/Paramount, DeMille, p/d.

1924. *Forbidden Paradise,* Famous Players/Paramount, Ernest Lubitsch, d.

L'inhumaine, Cinégraphic (France), Marcel L'Hubier, d.

1926. *Metropolis,* Universum Film/Studio Real (Germany), Fritz Lang p/d.

The Volga Boatman, DeMille Pictures/Producers Distributors, Cecil B. DeMille, p/d.

1927. *The King of Kings,* DeMille Pictures/Producers Distributors, Cecil B. DeMille, p/d.

1928. *Maldone,* Société des Films (France), Jean Grémillon, d.

1929. *Aelita,* Mezhrabprom-Russ (USSR), Yakov A. Protazanov, d.

The Broadway Melody, MGM, Harry Beaumont, p/d.

Fast Company, Famous Players/Paramount, Edward Sutherland, p, Florence Ryerson, d.

Gentlemen of the Press, Paramount, Millard Webb,. d.

The Godless Girl, Cecil B. DeMille/Pathé, DeMille, p/d.

The Jazz Singer, Vitaphone/Warner, Jack L. Warner, p, Alan Crosland, d.

The Locked Door, UA, George Fitzmaurice, p/d.

Showboat, Universal, Carl Laemmle, p, Harry Pollard, d.

This Is College, MGM.

1930. *Animal Crackers,* Paramount, Victor Heerman, d.

Der blaue Engel and *The Blue Angel,* Deutsche Universum (Germany) and Paramount, Eric Pommer, p, Josef von Sternberg, d.

Devil with Women, Fox, Irving Cummings, p, Dudley Nichols, d.

Just Imagine, Fox, Ray Henderson, B.G. De Sylv, Lew Brown, p, David Butler, d.

Waterloo Bridge, Universal, Carl Laemmle, p, James Whale, d.

What a Widow!, Gloria Production/Joseph P. Kennedy/UA, Kennedy, p, Allan Dwan, d.

1931. *Arrowsmith,* Goldwyn/UA, Samuel Goldwyn, p, John Ford, d.

Big Business Girl, First National/Warner, William A. Seiter, d.

Cimarron, RKO, William LeBaron, p, Wesley Ruggles, d.

The Easiest Way, MGM, Jack Conway, d.

The Front Page, Caddo/Hughes/UA, Howard Hughes, p, Lewis Milestone, d.

Hurricane Horsemen, Columbia, Willis Kent, p, Armand Schaefer, d.

Little Caesar, First National/Warner, Hal Wallis, p, Mervyn LeRoy, d.

Palmy Days, Samuel Goldwyn/UA, Goldwyn, p, A. Edward Sutherland, d.

1932. *I Am a Fugitive from a Chain Gang*, Warner, Mervyn LeRoy, d.

Ghost Valley, RKO, Fred Allen, d.

Grand Hotel, MGM, Edmund Goulding, p, William A. Drake, d.

Prosperity, MGM, San Wood, d.

Scarlet Dawn, Warner, Hal B. Wallis, p, William Dieterle, d.

Shanghai Express, Paramount, Josef von Sternberg p/d.

1933. *Female*, Warner, William Dieterle and Michael Curtiz, d.

Men Must Fight, MGM, Edgar Selwyn p/d.

1934. *The Black Cat*, aka *House of Doom*, Universal, Carl Laemmle Jr., p, Edgar G. Ulmer, d.

1935. *Crime and Punishment*, Columbia, B.P. Schulberg, p, Josef von Sternberg, d.

The Good Fairy, Universal, Henry Hennigson, p, William Wyler, d.

Peter Ibbetson, Paramount, Louis D. Lighton, p, Henry Hathaway, d.

The Scoundrel, Paramount, Ben Hecht & Charles MacArthur p/d and screenplay.

1936. *Dodsworth*, UA, Samuel Goldwyn, p, William Wyler, d.

The General Died at Dawn, Paramount, William LeBaron, p, Lewis Milestone, d.

It Happened One Night, Columbia, Harry Cohn, p, Frank Capra, d.

Mr. Deeds Goes to Town, Columbia, Frank Capra, p/d.

Show Boat, Universal, Carl Laemmle, p, James Whale, d.

Things to Come (England) London Films/UA, Alexander Korda, p, William Cameron Menzies, d.

1937. *Captains Courageous*, MGM, Louis Lighton, p, Victor Fleming, d.

A Day at the Races, MGM, Lawrence Weingarten, p, Sam Wood, d.

Lost Horizon, Columbia, Frank Capra, p/d.

A Star is Born, Selznick/UA, David O. Selznick, p, William A. Wellman, d.

Stella Dallas, UA, Samuel Goldwyn, p, King Vidor, d.

1938. *The Adventures of Robin Hood*, Warner/First National, Hal B. Wallis and Henry Blanke, p, Michael Curtiz, d.

Kentucky, Fox, Darryl F. Zanuck, p, David Butler, d.

Mr. Moto's Gamble, Fox, Sol M. Wurtzel and John Stone, p, James Tinling, d.

1939. *Citizen Kane*, Mercury/RKO, Orson Welles, p/d.

Gone with the Wind, Selznick/MGM, David O. Selznick, p, Victor Fleming, d, among others.

House on Haunted Hill, UA, William Castle, p/d.

Ninotchka, MGM, Ernst Lubitsch, p/d.

Stagecoach, UA, Walter Wanger, p, John Ford, d.

The Wizard of Oz, MGM, Mervyn Leroy, p, Victor Fleming and King Viodor, d.

Wuthering Heights, Goldwyn/UA, Samuel Goldwyn, p, William Wyler, d.

1940. *Abe Lincoln in Illinois*, aka *Spirit of the People*, RKO, Max Gordon, p, John Cromwell, d.

Calling Philo Vance, Warner, Bryan Fox, p, William Clemens, d.

Comrade X, MGM, Gottfried Reinhardt, p, King Vidor, d.

Escape, aka *When the Door Opened*, MGM, Mervyn LeRoy p/d.

Foreign Correspondent, UA, Walter Wanger, p, Alfred Hitchcock, d.

The Great Profile, Fox, Darryl F. Zanuck, p, Walter Lang, d.

He Stayed for Breakfast, Columbia, B.P. Schulberg, p, Alexander Hall, d.

I Take This Woman, MGM, Bernard H. Hyman and Lawrence Weingarten, p, W.S. Van Dyke II, d.

Our Town, Principal Artists/UA, Sol Lesser, p, Sam Wood, d.

The Quarterback, Paramount, Anthony Veiller, p, H. Bruce Humberstone, d.

Ride Tenderfoot, Ride, Republic, William Berke, p, Frank McDonald, d.

Waterloo Bridge, MGM, Sidney Franklin, p, Mervyn LeRoy, d.

1941. *Babes on Broadway*, MGM, Arthur Freed, p, Busby Berkeley, d.

Glamor Boy, Warner, Sol C. Seigel, p, Ralph Murphy, d.

Knockout, Warner, Edmund Grainger, p, William Clemens, d.

The Maltese Falcon, Warner, Hal Wallis and Henry Blanke, p, John Houston, d.

Meet John Doe, Warner, Frank Capra, p/d.

Moon Over Miami, Fox, Harry Joe Brown, p, Walter Lang, d.

Moonlight in Hawaii, Universal, Bernard W. Burton, p, Edward Lilley, d.

The Night of January 16th, Paramount, Sol C. Siegel, p, William Clemens, d.

Palm Beach Story, Paramount, Paul Jones, p, Preston Sturges, d.

Road to Singapore, Paramount, Harlan Thompson, p, Victor Schertzinger, d.

Sergeant York, Warner, Jesse L. Lasky and Hal B. Wallis, p, Howard Hawks, d.

She Couldn't Say No, Warner, William Jacobs, p, William Clemens, d.

Sullivan's Travels, Paramount, Preston Sturges, p/d and screenplay.

Tobacco Road, Fox, Darryl F. Zanuck, p, John Ford, d.

West Point Widow, Warner, Sol C. Seigel, p, Robert Siodmak, d.

1942. *Call Out the Marines*, RKO, Howard Benedict, p, Frank Ryan d.

Casablanca, Warner, Hal B. Wallis, p, Michael Curtiz, d.

The Man Who Came to Dinner, Warner, Hal B. Wallis, Jerry Wald and Jack Saper, p, William Keighley, d.

The Mayor of 44th Street, RKO, Cliff Reid, p, Alfred E. Green, d.

Noi Vivi, Angelike (Italy), Goffredo Allesandrini, d.

Random Harvest, MGM, Sidney Franklin, p, Mervyn LeRoy, d.

Shadow of Doubt, Universal, Jack H. Skirball, p, Alfred Hitchcock, d.

Wake Island, Paramount, Joseph Sistram, p, John Farrow, d.

Yankee Doodle Dandy, Warner, Hall B. Wallis, p, Michael Curtiz, d.

1943. *The Dark Tower*, Warner, Max Milder, p, John Harlow, d.

Five Graves to Cairo, Paramount, Charles Brasett, p, Billy Wilder, d.

For Whom the Bell Tolls, Paramount, Sam Wood, p/d.

Lady of Burlesque, aka *Striptease Lady*, Hunt Stromberg/UA, Stromberg, p, William A. Wellman, d.

Mission to Moscow, Warner, Robert Buckner, p, Michael Curtiz, d.

Sahara, Columbia, Harry Joe Brown, p, Zoltan Korda, d.

Song of Russia, MGM, Joseph Pasternak, p, Gregory Ratoff, d.

Strange Holiday, Elite/Producers Releasing, A.W. Hackell and Edward Finney, p, Arch Obler, d and screenplay.

Watch on the Rhine, Warner, Hal B. Wallis, p, Herman Shumlin, d.

Woman of the Year, MGM, Joseph L. Mankiewicz, p, George Stevens, d.

1944. *Double Indemnity*, Paramount, Joseph Sistram, p, Billy Wilder, d.

Laura, Fox, Otto Preminger p/d.

National Velvet, MGM, Pandro S. Berman, p, Clarence Brown, d.

Passage to Marseilles, Warner, Hal B. Wallis, p, Michael Curtiz, d.

The Sullivans, aka *The Fighting Sullivans*, Fox, Sam Jaffe, p, Lloyd Bacon, d.

To Have and Have Not, Warner, Howard Hawks, p/d.

1945. *Bewitched*, MGM, Jerry Bresler, p, Arch Obler, d and screenplay.

Love Letters, Paramount, Hall B. Wallis, p, William Dieterle, d.

Mildred Pierce, Warner, Jerry Wald, p, Michael Curtiz, d.

Pride of the Marines, aka *Forever in Love*, Warner, Jerry Wald, p, Delmer Daves, d.

A Royal Scandal, Fox, Ernst Lubitsch, p, Otto Preminger, d.

Saratoga Trunk, Warner (1943 production), Hal B. Wallis, p, Sam Wood, d.

You Came Along, Paramount, Hall B. Wallis, p, John Farrow, d.

1946. *The Best Years of Our Lives*, RKO, Samuel Goldwyn, p, William Wyler, d.

It's a Wonderful Life, Liberty-RKO, Frank Capra, p/d.

The Razor's Edge, Fox, Darryl F. Zanuck, p, Edmund Goulding, d.

1947. *Crossfire*, RKO, Adrian Scott, p, Edward Dymtryk, d.

Dark Passage, Warner, Jerry Wald, p, Delmer Daves, d and screenplay.

Possessed, Warner, Jerry Wald, p, Curtis Bernhardt, d.

The Senator Was Indiscreet, Universal, Nunnally Johnson, p, George S. Kaufman, d.

The Two Mrs. Carrolls, Warner, Mark Hellinger, p, Peter Godfrey, d.

1948. *All My Sons*, Universal, Chester Erskine, p, Irving Reis, d.

The Big Clock, Paramount, Richard Maibaum, p, John Farrow, d.

Gentlemen's Agreement, Fox, Darryl F. Zanuck, p, Elia Kazan, d.

I Remember Mama, RKO, George Stevens and Harriet Parsons, p, Stevens, d.

The Iron Curtain, Fox, Sol C. Siegel, p, William A. Wellman, d.

Rope, Transatlantic/Warner, Sidney Bernstein and Alfred Hitchcock, p, Hitchcock, d.

Silver River, Warner, Owen Crump, p, Raoul Walsh, d.

To the Victor, Warner, Jerry Wald, p, Delmer Daves, d.

1949. *The Adventures of Don Juan*, Warner, Jerry Wald, p, Vincent Sherman, d.

Battle Ground, MGM, Dore Shary, p, William Wellman, d.

Beyond the Forest, Warner, Henry Blanke, p, King Vidor, d.

Brimstone, Republic, Joseph Kane, p/d.

The Champion, Screen Plays/UA, Stanley Kramer, p, Mark Robson, d.

The Fan, aka *Lady Windermere's Fan*, Fox, Otto Preminger, p/d.

The Fountainhead, Warner, Henry Blanke, p, King Vidor, d.

The Hasty Heart, Associated British/Warner, Vincent Sherman, d.

Homicide, Warner, Saul Elkins, p, Felix Jacoves, d.

John Loves Mary, Warner, Jerry Wald, p, David Butler, d.

Kiss in the Dark, Warner, Harry Kurnitz, p, Delmer Daves, d.

The Red Danube, MGM, Carey Wilson, p, George Sidney, d.

The Red Menace, Republic, Herbert J. Yates, p, R.G. Springsteen, d.

White Heat, Warner, Louis F. Edelman, p, Raoul Walsh, d.

1950. *The Breaking Point*, Warner, Jerry Wald, p, Michael Curtiz, d.

The Flame and the Arrow, Warner, Frank Ross, p, Jacques Tourneur, d.

1951. *Born Yesterday*, Columbia, S. Sylvan Simon, p, George Cukor, d.

The Day the Earth Stood Still, Fox, Julian Blaustein, p, Robert Wise, d.

Go for Broke!, MGM, Dore Scharry, p, Robert Pirosh, d and screenplay.

High Noon, Kramer/UA, Stanley Kramer, p, Fred Zinnemann, d.

Show Boat, MGM, Arthur Freed, p, George Sidney, d.

1952. *Anathan*, Dalwa (Japan), K. Takimura, p, Josef von Sternberg, d.

Bwana Devil, Obler/UA, Arch Obler, p/d and screenplay.

Death of a Salesman, Columbia, Stanley Kramer, p, Laslo Benedek, d.

This is Cinerama, Todd A-O.

1954. *Dial M for Murder*, Warner, Alfred Hitchcock, p/d.

Mister Roberts, Warner, Leland Hayward, p, John Ford and Mervyn LeRoy, d.

Salt of the Earth, International Union of Mine, Mill and Smelte Workers/Independent Productions, Paul Jerrico, Sonja Dahl Biberman & Adolfo Barela, p, Herbert J. Biberman, d.

1955. *Bright Leaf*, Warner, Henry Blanke, p, Michael Curtiz, d.

The Court-Martial of Billy Mitchell, aka *One-man Mutiny*, UA, Milton Sperling, p, Otto Preminger, d.

Gaby (adaptation of "Waterloo Bridge"), MGM, Edwin H. Knopf, p, Curtis Bernhardt, d.

Helen of Troy, Warner, Robert Wise, d.

Oklahoma!, Magna Theatres, Arthur Hornblow Jr., p, Fred Zinnemann, d.

The Trouble with Harry, Paramount, Alfred Hitchcock, p/d.

1956. *The FBI Story*, Warner Bros., Mervyn LeRoy, p/d.

Giant, Warner, George Stevens and Henry Guisberg, p, Stevens, d.

The Iron Petticoat, Remus (Britain)/MGM, Betty E. Box, p, Ralph Thomas, d.

The Ten Commandments, Paramount, Cecil B. DeMille, p/d.

1957. *Around the World in Eighty Days*, Todd/UA, Michael Todd, p, Michael Anderson, d.

Omar Khyyam, Paramount, Frank Freeman, p, William Dieterle, d.

1958. *The Buccaneer*, Paramount, Henry Willcoxon, p, Anthony Quinn, d.

Cat on a Hot Tin Roof, MGM, Lawrence Weingarten, p, Richard Brooks, d.

Cowboy, Columbia, Julian Blaustein, p, Delmer Daves, d.

Gigi, MGM, Arthur Freed, p, Vincente Minnelli, d.

The Long, Hot Summer, Fox, Jerry Wald, p, Martin Ritt, d.

Separate Tables, Clifton-Joanna/UA, Harold Hecht, p, Delbert Mann, d.

Vertigo, Paramount, Alfred Hitchcock, p/d.

1959. *North by Northwest*, MGM, Alfred Hitchcock, p/d.

1960. *Cimarron*, MGM, Edward Granger, p, Anthony Mann, d.

The Half Pint, Erven Jourdan, p/d and screenplay.

1963. *Cleopatra*, Fox, Walter Wanger and others, p, Joseph L. Mankiewicz, d.

Tom Jones, Woodfall/Lopert, Tony Richardson, p/d.

1966. *Who's Afraid of Virginia Wolff*, Warner, Ernst Lehman, p, Mike Nichols, d.

1967. *Camelot*, Warner, Jack L. Warner, p, Joshua Logan, d.

1970. *M*A*S*H*, Fox, Ingo Preminger, p, Robert Altman, d.

1972. *The Cowboys*, Warner, Mark Rydell, p/d.

Hud, Paramount, Martin Ritt and Irving Ravetch, p, Ritt, d.

1974. *The Front Page*, Universal, Paul Monash, p, Billy Wilder, d.

1982. *Blade Runner*, Ladd Company/Warner, Michael Deeley, p, Ridley Scott, d.

1987. *The Belly of an Architect* (Britain), Peter Greenaway, p/d.

Index

Numbers in ***bold italics*** indicate pages with photographs.

Abbott, George 55
Abe Lincoln in Illinois 103, 126, 200n17
Academy Awards (Oscars) 56, 66, 88, 101, 103, 116, 123; British Academy 103
Adams, Ansel 110
Addams, Jane: Nobel Peace Prize 94, 99; passivism 94; radicalism and welfare 94–95
Adler, Dankmar 6–7, 10
Adler, Larry 87
Adrian 65
The Adventures of Don Juan 103, 142
The Adventures of Robin Hood 84, 153
Aelita 203n7
Agnew, Neil 200n35
Aina *see* Olsson, Anna
Alabama 31
Albrecht, Donald 158
Albright, Harrison 10
Algonquin Hotel, New York City 121; Algonquin Roundtable 65, 163
All My Sons 163
Allesandrini, Goffredo 56
Allied Architects 142
America First Committee 95; and Lindbergh 95
The American (newspaper) 123
American Civil Liberties Union (ACLU) 93, 98–99; a communist front 98; failures 98
American Institute of Architects 97; Southern California Chapter 158; Wright's Gold Medal 112
American Optical Company 167
Amkino Pictures 94
Amsterdam 9, 25, 59
Anathan (Japan) 62
Anderson, Robert 135, 200n17
Anderson, Roland 61
Anderson, Sherwood 124; *Winesburg, Ohio* 125
Angelike Films, Italy 56
Ann Freud Centre, London 205n37
Another Part of the Forest 103
Anthem ix; anticommunist/ totalitarianism 54; revision for 1946 100
antifascist 84, 116
anti–Semitism 86
"Arch Obler Plays" 116
Architectural Forum 76, 79, 91, 143, 156
architecture: Adamesque rococo 153; art and profession and technology 48–49; beaux-arts classicism 45; California modern 62, 110–120; consensual social phenomenon 51; Danish modern 143, 149–153; design process 7–8, 22; Dutch 8, 203n18; English 153, 203n18; ephemeral 19; Greaco-Roman 26; internationalism 158; Mayan and mesoamerican 12–15, 110, 191n1; as ritual 151; Southwest American Indian 12–18, 191–192n1; theoretical position 173
The Architecture of Frank Lloyd Wright 195n1
Arizona 13–14, 110
Arizona Biltmore 18
Armenia 33
Armory Show of 1913 111, 192n5
Arnold, Edward 88
Around the World in Eight Days 167
Arrowhead Productions 73–74
Arrowsmith 134
Art Deco 43, 134
Art Institute of Chicago 125
Artkino Pictures company 94
Arts and Crafts 134
Asther, Nils 56
Atkinson, Brooks 124
Atlas Shrugged 52, 159
Auer, Mischa 66
Auntant-Lara, Claude 137
Australia 16, 63
authoritarianism of left and right 20, 54
The Autobiography of an Idea 45
Ayn Rand Institute 194n3

Baas, Carole 189
Babes on Broadway 121
Bacall, Lauren 74, 87
Bach 130
Baghdad, Iraq, town plan 97
Bankhead, Tullulah 66
Baptist 5
Barnsdall, Aline 11, 129, 141,

161–162, 191n8, 204n9; left-wing Bolshevik 16; Olive Hill campus 161–162; *see also* Wright, Frank Lloyd
Barnsdall, Betty 162, 204n12
Barnsdall Park 161–162, 204n9
Barrymore, Lionel 88
Barsacq, André 137
Battle Ground 55
Bauhaus 134, 203n7
Baxter, Anne 66, 116, 195n1
Baxter, Catherine 66
Bayard, New Mexico 175
Beethoven 130
Belgian Royal Academy of Fine Art 9, 27
The Belly of an Architect 53
Benchley, Robert 122; and Wright 122
Benedek, Laso 163
Bennett, Joan 128
Benois 129
Benton, Thomas Hart 110; Wright's letter 111, 126
Benton, William 90
Berdtson, Indira 207
Bergman, Ingrid 104
Berlage, H.P. 8
Berlin, Germany 8, 9, 34
Berman, Pandro S. 86
Bessie, Alvah 87
Best Years of Our Lives 86, 87
Bewitched 116
Beyond the Forest 200n44
Biberman, Herbert 87, 175
Big Business Girls 134
The Big Clock 135, 158
Bioff, Willie 85
Biograph company 37
Biro, Lajos 66
Bison company 37
The Black Cat 134
Blade Runner 139–140
Blake, William 130
Blanke, Henry 60, 73, 80–81, 100–101, 103, 107–108, 123
Der blaue Engel 62
Blessing, Hedrich 25
Bloch, Ernst 111
Bloch, Lucienne 111
Blondell, Joan 166
The Blue Angel 62
Bobbs-Merrill publishers 56
Bogart, Humphrey 61, 74, 79, 87, 102, 107, 196nn9, 10
Bohemian circles 121–126
Born Yesterday 87
Boston Institute of Modern Art 112

Boyd, William 37; Hopalong Cassidy 37
Bradbury Building, Los Angeles 139
Branden, Barbara 35, 38, 47, 48, 69, 70, 207
Branden, Nathaniel (né Blumenthal) 48, 51
Brazzi, Rossano 56
Breaking Point 103
Brecht, Bertold 86
Brentwood Heights, California 115
Brimstone 73
Broadway 38, 55, 122–123, 125, 166; awards (Tony, Donaldson, Drama Critics) 103
Brooks, Rand 74
Broun, Heywood 44–45, 123, 124
Brown Shirts 83
Brynner, Yul 113
The Buccaneer 113
Buckland, Wilfred 153
Buell Center for Study of American Architecture 63
Buffalo, New York 7
Buffalo Bill 166
Burks, Robert 105
Burnham and Root architects 206
Butler, Nicholas 94
Butler, Samuel 130
Bwana Devil 116, 166

Cagney, James 101
Caldwell, Erskine 60
California: architecture '48–'61 110–120, 202n27; Labor School, San Francisco 95; Marin County Board of Supervisors 188–189; Marina del Ray 194n3; "Red-hunting committee" 197n1; San Rafael 188–189
California Art Club 161
Call Out the Marines 61
Calling Philo Vance 55
Camelot 101
Cameron, Rod 56
Campbell 153
Canada 176
Cannes Grand Prix (d'Oro) 123
Cantor, Eddie 154
capitalism 21
Capone, Al 85
Capra, Frank 88, 140, 185–186, 206

Captains Courageous 123
Carmel, California 138
Carrere, Edward 100, 109, 132, 135, 137–154; career 101
Carson, Jack 101, 103
Casablanca 61, 74, 84
Castle, William 139
Castro, Walter 189
Cat on a Hot Tin Roof 169
Caucasus 9, 94
Cavalcanti, Albert 136
Cézanne 111
Chambers, Whitaker 98
The Champion 123
Chandler, Alexander 18–19
Chandler, Arizona 110
Chaplin, Charlie 87, 128; anti-American 90; "premature anti-fascist" 90
Chatsworth, California 62
Cheney, Mamah Borthwick 7, 129; FLW affair 7–8, 20, 93; murder 8
Chicago 6, 8, 13–14, 16, 43, 44, 45, 62, 94, 123; Armory Show 111; buildings (except FLW's) Monadnock 206; Centenary 1934 43, 134
Chicago Tribune, 1922 competition 146
China 176
Chinchon, Spain 205n44
Cimarron 125
Cinematography, State Institute for, St. Petersburg 34
Cinerama 116, 166–167, 205n59
Citizen Kane 44
Clair, René 126–127
Clark, Lloyd 98
Clausen, Meredith 51
Clemens, William 55
Cleopatra 128
Cliff Dwellers club 163
Clurman, Harold 124
Cobb, Lee J. 163
Coburn, Charles 66
Cohan, George M. 123
Cohn, Art 169
Colbert, Claudett 142
Cole, Lester 87, 198n38
Colegio Nacinal de Arquitectura 198n53
Coleman, Ronald 140
Colescott, James, Imperial Wizard of KKK 82
Collins, Alan C. 60
Columbia Pictures 61, 62, 74, 128, 163

Columbia University 43, 63
Committee for the First Amendment 87
Communism 17, 21, 26–27, 89, 189, 202n22; as evil 33; and machine worship 90
communist 83; art 21–22, 26–27; Party, Russia 26, 33, 89–90
Communist Party of America 82, 85, 86, 87, 88, 94, 164
Comrade X 83
concrete, blocks and precast 12–17, 62–63
Congressional Quarterly 84
Connelly, Marc 121, 123, 124, 126
Conover, Alan 5, 7
conscientious objectors 94
Coonley, Mrs. Avery 125
Cooper, Gary 80, 86, 87, 88, 101, 103–105, *104*, 108, 127, 139, 144, 148, 164, 200n17; lawyer I.H. Prinzmetal's advice 107; Montana and England 104; opinion of film 106; opinions of his role 107–109
Cooper, Merian C. 166
Coronet magazine 112
Corridor of Mirrors 61
Cotten, Joseph 61
Counter Intelligence Agency (CIA) 97, 176
The Court Martial of Billy Mitchell 101
Coward, Noël 124
The Cowboys 100
Craig, Edward Gordon 129–130, 142
Craven, Thomas 126, 192n5
Crawford, Joan 103, 124
Criley, Ted 158
Crime and Punishment 62
Crimea 32, 33
Crosby, Bing 56
Crossfire 88
Crowther, Bosley 155
Cuba 84
Cue magazine 106
Cuff, Dana 50
Cultural and Scientific Conference for World Peace, New York City 95
Cummings, Robert 61
Curtiz, Michael 84
The Czarina 66

Dahl, Roald 200n17

Daily News (Chicago) 124
Daily Peoples World 96
Daily Worker 94, 96, 189
Dallas, Texas 143, 162
Danville, Connecticut 198n38
Dark Passage 101
The Dark Tower 121
Darrow, Clarence 93
Daves, Delmer 55
Davies, Joseph E. 84
Davis, Bette 103, 200n44
Davis, Stuart 111
Day, Richard 126, 133, 136, 142, 154
A Day at the Races 55
The Day the Earth Stood Still 103
Death of a Salesman 163
Death Valley, California 16
Decca Records 79
Del Rio, Delores 135
DeMille, Cecil B. 35–36, 37, 113
Dempsey, Jack 38
Derleth, August 51
design: Danish modern 143, 147; European films 133, 136–137; modern 141–155; political inferences 147–159; sets and such 132–158
Devil with Women 74
Diaghilev 129
Dial M for Murder 101, 105
Dickens, Homer 107
Dies, Martin 83–84, 85, 86, 98
Dieterle, William 61
Dietrich, Marlene 38, 62
disloyalty 83
Disney, Walt 86
Dmytryk, Edward 87, 88
Dodge Luhan, Mabel 110, 125
Dodgeville, Wisconsin 5
Dodsworth **134**, 136
Doheny, Edward 16
Dome Enterprises 167
Double Indemnity 74, 194n6
Douglas, Haldane 55
Douglas, Kirk 123
Douglas, Melvyn 83, 103
Douglas, Robert 103, 148, 154
Dove, Arthur 111
Drake, William A. 134
Dreiser, Theodore 125
Drew, Ellen 56
Drier, Hans J. 61, 135
Dudok, Willem 59, 203n18
Duncan, Isadora 110, 129–130
Dunne, Irene 102

Durgnat, Raymond 44, 155
dynamite 158

Eagle company 37
Easy Living 127
Eckstein, Gustav, Jr. 202n8
École des Beaux-Arts, Paris 43
Eddy, Nelson 142
De Eeuwige Bron ("The Eternal Spring") 59
E.F. Hutton 79
Einstein, Albert 126
Eisenhower, Dwight D. "Ike" 189
Elmer the Great 123
Enchantment 133
Ennis, Charles 16–17
Ernst, Morris 98
Erskine, Chester 163
Escape 116
Essanay company 37
Europe 20–22, 147–150
Expressionism 62, 153

Fadiman, Clifton 44–45
Fairbanks, Douglas 153
Falcon film series 55
Falkenberg, Jinx 189
Famous Players–Lasky Film Company 36, 37
The Fan 122
Farmer's Daughter 55
farming 5
Farnsworth house, Plano 24
Farrell, Barry 200n17
Farrow, John 61
Fascist views 50
Fast Company 123
Faye, Julia 37
Fayetteville, Arkansas 49
FBI *see* Federal Bureau of Investigation
The FBI Story 105
Feature Play company 36
Federal Bureau of Investigation, FBI 83–89, 90, 91, 97, 119, 123, 127, 139, 158, 163, 202n22; "listing" Wright 92; "radicals capitalize on evolution" 93; Seattle office 93; Wright's promiscuity and associations 94–96
Female 84, 139
Feosole, Italy 8
Ferber, Edna 60, 124, 125, 202n22
Fifth Amendment 198n38
Finland 34

First All-Union Congress of Soviet Architects 26
Fisher, Eddie 169
Five 201n22
Five Graves to Cairo 66
The Flame and the Arrow 142
Fleming, Victor 123
Flynn, Errol 100, 103, 142
Fokine 129
For Whom the Bell Tolls 56, 104
Forbidden Paradise 66
Ford, Henry 94
Ford, John 126–127, 148
Foreign Correspondent 84, 128
Foreman, Carl 104, 123, 200n21
The Fountainhead (book) 31, 41, 43–53, 55–59; extracts 187; reactions to 49–53; research for 43–48; Roark's "estrangement from society" 58; "stylized universe" 51; synopsis for Warners 181–183; why architect as hero? why architecture? 47–48
The Fountainhead (1944 film project): canceled 80–81; casting 73–74; film outline 179–180; preproduction 73–75; screenplay outline 60; Wright agrees to do sets 80
The Fountainhead (1949 film) 37; budget 105; casting and cast 101–105, 184; opinions of film, popular and critical 105–109; production personnel 184; revival May 1948 99–105; result of communist paranoia 100–101; rights negotiations 60; screenplay, opinions of 107–109; set designs and such 132–158; Warners set designer (Carrere?) visits Wright 100; Wright's architecture as "inspiration" 120
fountainheads 174–177
Fox 55, 60, 66, 85, 88, 100, 103, 116, 122, 126, 136, 137
Frank, Harriet, Jr. 100
Frank Lloyd Wright Foundation 78–79, 80, 101
Frank Lloyd Wright Inc. 9–10, 125
Frank Lloyd Wright versus America: The 1930s 92

free association 8
Freeman, Samuel 16–17
Fresno, California 151
Freud, Sigmund 111
Friar, Elinor 37
The Front Page 123
Fuller, Buckminster 76, 167
Fusselman, William 188

Gable, Clark 74, 83, 108
Gabor, Eva 66
Gaby 126
Garbo, Greta 74, 83, 102, 137
Garbutt, Frank J. 37
Garfield, John 103
Garland, Judy 121
Garson, Greer 202n22
Gaumot company (France) 37
Gaynor, Janet 65, 122
Geer, Will 175
Gelernter, Mark 50
Gentlemen of the Press 134
Gentlemen's Agreement 88
Gentry, Curt 84, 96, 204n30
German Academy of Fine Arts 9, 27
German Pavilion, Barcelona 24
Gershwin, Ira 87
Getty Trust, Santa Monica 195n1
Ghost Valley 55
Giachette, Fosco 56
Giant 125
Gibbons, Cedric 134, 135
Gibney, Sheridan 123
Gigi 113
Gilbert and Sullivan 166
Gill, Brendan 89, 207
Gill, Irving 10, 11–17
Gillin, John A. 162
Gilman, Charlotte Perkins 52
Gimbel Brothers department stores 91
The Girl from Leningrad 102
Glamor Boy 194n6
Goddard, Paulette 87
The Godless Girl 37
Godwin, Edward 129
Goldberg, Minna 34
Goldwyn, Samuel 36, 37, 86, 107–108, 135
Goldwyn/United Artists 123
Gone with the Wind 74, 123
The Good Fairy 127
Goosson, Stephen 137, 139
Gordon, Elizabeth 198n49
Gothic-Art Deco skyscrapers 137

Graham, Florence Nightingale (Elizabeth Arden) 79
Graham, Gloria 167
Grand Hotel **134**, 158
Grant, President U.S. 124
Grau, William 153
The Great Profile 66
Green, Aaron 98
Green Pastures 123
Greenaway, Peter 53, 148
Greene, Eve 55
Greene, Herb 188
Grémillon, Jean 137
Griffin, Walter and Marion 16, 63
Griffith, D.W. 37
Griggs, Chauncy 68
Gropius, Walter 21, 126
Gruen, Victor 156–157
Guggenheim Museum 92
Gunts, Edward 157
Gunzberg, Milton 116
Gurdjieff's Institute for the Harmonious Development of Man 129–130

The Half Pint 120
Hammeras, Ralph 137
Hammerstein, Oscar 125, 167
Handel 130
Harding, Ann 104
Hardwick, Cedric 134
Harriman, David 206
Harriman, Margaret Case 124
Harrison, Wallace K. 145
Hart, Moss 88, 122
Hartford, Huntington 201n26; house **113–114**, 115
Hartley, Marsden 111
Harvard University 126
Hastings, Thomas 44
The Hasty Heart 103, 107
Hay, Peter 124
Hayes, Helen 121, 124, 202n22
Head, Edith 113
Hearst, William Randolph 44
Hecht, Ben 61, 121, 123, 125
Heifetz, Jascha 142
Heisner, Beverly 155
Held, Ed 153
Helen of Troy 142
Hellman, Lillian 103
Hello, Dolly! 126
Hemingway, Ernest 104
Henreid, Paul 87
Henry Aldrich series 194n6
Hepburn, Katharine 206
Herland 52
High Noon 104

Hiroshige prints (*Fifty-three Stations of the Tokaido*) 122
Hiss, Alger 98
Hitchcock, Alfred 84, 105, 126
Hitchcock, Henry-Russell 21, 89, 92, 119
Hobson, Laura Z. 88
Hodiak, John 66
Hoff, Robert van't 129
Holabird and Roche architects 206
Holland 59
Hollywood, California 10, 36–37, 74, 82, 109, 163, 205n59; Chamber of Commerce 35; Committee for the First Amendment 87; Hollywood Playhouse 38; Hollywood Studio Club 35
Hollywood Bowl 141–142
Hollywood Reporter 106
Hollywood Ten 86, 87, 95, 127
Homicide 103
Honnold, Douglas 135
Hood, Raymond 44
Hoover, J. Edgar 83, 85, 86, 97, 98, 105, 148
Hope, Bob 56
Hopkins, Arthur 196n9
Hornblow, Arthur, Jr. 167
The Hot Mikado 166
Hotel Imperial 66
House Beautiful magazine 199n65
House of Mist 61
House on Haunted Hill 139
House Un-American Activities Committee (HUAC) 52, 82–88, 102, 127, 148, 158, 164, 175–176, 189, 202n22; exposing communist sympathizers 85–86; and Hollywood 1947 84–89; Rand's role 86–87; Republican dominated 85
Howells, William Dean 52
Hudd 100, 103
Hughes, Howard 176
Hugo, Victor 35
Hull, Henry 139
Hull-House, settlement house 94
Hunte, Otto 136
Hurricane Horsemen 61
Hussein, Saddam 199n95
Huston, John 87
Hyman, Elaine (Kira Markham) 141

I Am a Fugitive from a Chain Gang 73
I Remember Mama 102
I Take This Woman 62
Ibsen, Henrik 52
Ideal 38, 54, 56
Ihnen, Wiiard 136
I.M.P. company 37
Impact 194n3
individualism 20–22, 32, 59, 173–175
L'Inhumaine 134, 135
Institute of Modern Art, Beverly Hills 120
International Alliance of Theatrical Stage Employees and Moving Picture Machine Operators 85
International Conference of the Australia and New Zealand American Studies Association 197n1
International Union of Mine, Mill and Smelter Workers, Local 890 175
internationalism 24, 148–149, 158; *The International Style* 21, 68, 89, 92, 149
The Iron Curtain 88
The Iron Petticoat 83
It Happened One Night 74
Italy: Communist Party 198n57; exhibition in 1950s 91, 92; Florence 129
It's a Great Feeling 103
It's a Wonderful Life 56, 88

Jackson, Donald 176
Jackson, Attorney General Robert 83, 85
Jacksonville, Florida 37
Jaffe Productions 159
Jagger, Dean 55
Japan 22, 192n7
The Jazz Singer 203n19
Jerrico, Paul 175
Jester, Ralph 77; house 113–115; Wright's letter 113
Jews 32, 34–35, 43
John, Edwin Augustus 129
John Loves Mary 101, 103
Johnson, Adam 203n16
Johnson, Donald Leslie 92, 197n25
Johnson, H. 166
Johnson, Philip 21, 89
Johnston, Eric 88, 108
Jones, E. Fay 49
Jones, George 188

Jones, the Rev. Jenkin Lloyd 5, 94, 174, 191n2; passivism 94
Jones, Jennifer 61, 74, 103
Jones, Shirley 167
Jordan, Lee 188
Jourdan, Erven 119–120; film of Wright 120
Journal American (New York) 95
Journal of Ayn Rand 43
Journal of the American Institute of Architects 158
Just Imagine 137

Kahn, Albert 133
Kahn, Ely Jacques 43, 47, 48, 76, 156
Kaiser, Henry J. 167, 169, 205n59
Kalem company 37
Kaminsky, Stuart 108
Kapp, Jack 79
Kaufman, George S. 65, 87, 121, 122, 124
Kaufmann, Arthur C. 91, 198n57
Kaufmann, Edgar J.: Charitable Foundation & Trust 69; Fallingwater house 69, 198n50; Palm Springs house 160–161, **160**
Kaufmann, Edgar, Jr. 198n50
Kaye, Danny 87, 103
Kellaway, Cecil 56
Kelly, Gene 87
Kentucky 116
Kerensky, Alexander 32
Kern, Jerome 125
Kettelbut, Erich 136
Key, Ellen 129
The King of Kings 37
Kipling, Rudyard 123
Kiss in the Dark 105
knitlock concrete block 16
Knockout 55
Knopf, Mrs. Alfred 46
Korda, Alexander 66
Koretsky, Edna 58
Kosloff, Theodore 37
Kotval, Zenia 97
Kramer, Stanley 123, 163, 200n21
Ku Klux Klan 82, 185
Kuehl, William 101, 135, 153

Ladd, Alan 74
Ladies and Gentlemen 123
Lady of Burlesque 74

La Follett, Philip 125
laissez-faire 52
La Jolla, California 9
Lake, Veronica 103
Lake Minnetonka, Minnesota 94
Lake Tahoe 16
Lamarr, Hedy 83
Lancaster, Burt 163
Lang, Fritz 136, 137
Lang, Walter 136
Langer, Susan 151
Langyel, Melchior 66
Lardner, Ring 123; and Wright 123, 130
Lardner, Ring, Jr. 87, 123, 198n38; denied passport 164
Larkin Office Building 7
Laski, Harold 44
Lasky, Jesse L. 36
Laughton, Charles, stage productions 142
Laura 103
Lautner, John 115
Lawrence, Ellis 49
Lawson, John Howard 87
Lawyers' Guild 98
Le Corbusier 21, 22, 44, 89, 137, 156; Swiss student hostel, Paris 143
Lee, Gypsy Rose 166
Lee, Robert E. 166
left-wing radicalism 10–11
Léger, Fernand 135
Leningrad 34, 193n9; University of 34
LeRoy, Mervyn 73–74, 79, 80, 105, 116, 181
Lewis, Lloyd 124, 166
L'Hubier, Marcel 135
Liberty/RKO 88
Life magazine 80, 200n17
"Lights Out" 116
Lincoln, President Abraham 124
Lindbergh, Charles 95
Lipski, Sarah 34, 37, 56
Little Caesar 73
The Locked Door 74
Loeb, Gerald 59, 67, 76–81, 106, 120, 132, 197n33; film revival of May 1948 100–101, 138; house by FLW 77–79, **77**, **78**, 81, 113
Loew's company 85
London, England 32, 56, 112, 129
The Long, Hot Summer 100
Loos, Anita 61

Lorre, Peter 55
Los Angeles ii, 10, 11, 13–17, 23, 35–37, 62, 63, 85, 113, 115, 137, 139, 204n9; Biltmore 18; exhibitions 92, 111; FLW's disgust with 17; *Ideal* revival 55; Municipal Art Department 162, 204n23; oil boom 36; Park Department 161
Los Angeles Art Gallery 162–163, **163**
Los Angeles Times 106
Lossky, N.O. 33
Lost Horizon 134, 140, 158
Love Letters 61
Lovell, Leah 16
Loy, Myrna 108
Loyalty Order of 1947 87, 197n25
Lubin company 37
Lubitsch, Ernst 60, 66
Luce, Clare Boothe 198nn50, 54
Luce, Henry 44
Luft, Herbert 62
Luhan, Tony 125
Lupino, Ida 103

MacArthur, Charles 62, 123; and Wright's letters 123
MacArthur, General Douglas 90
MacGowan, Kenneth 120
Macmillan publishers 56
MacMurray, Fred 74
MacRae, Gordon 167
Madison, Wisconsin 5, 94, 121
Maldone 136
Mallet-Stevens, Robert 127, 137
The Maltese Falcon 61
Maltz, Albert 87
The Man Who Came to Dinner 122
The Man with the Beard 116
Mann, Thomas 87
Mann Act (White Slave Trafficking) 93, 94
Mansfield, Katherine 129
March, Fredric 163
Marin, John 110
Marin County 188–189; Board of Supervisors, interference with 98
Markham, Kira (Elaine Hyman) 141
Marsh, Fordye "Red" 159

Martin, Darwin 10, 125
Martinez, Linda 189
Marx, Harpo 124, 202n22
Marx brothers 55
*M*A*S*H* 123
masonry, hollow clay 16
Masselink, Eugene 47, 58, 201n27
Massie, Chris 61
Massy, Raymond 103, 105, 113, 134, 154
The Masterbuilder 52
The Matchmaker 126
Matisse, Henri 11
Matthews, J.B. 98, 189, 206
Maxwell, Marilyn 123
Maybeck, Bernard 76
Mayer, Louis B. 86–87
Mayer, Ray 61
The Mayor of 44th Street 61
McArthur, Albert Chase 18, 123
McArthur, Warren and Charles 18, 123
McCarthy, Joseph 90, 98, 206; attempt to expel from Congress 90; McCarthyism 88, 96–97
McCormick, Harold 68, 125
McCormick, John W. 97
McCrea, Joel 84, 127–128
Meet John Doe 88
Meier, Richard 50
Melbourne, Australia 16
Men Must Fight 134
Mendelssohn, Erich 62, 126, 198n51
Menjou, Adolphe 86
Menzies, William Cameron 156
Mercury Theater 126–127
Merrick, David 204n30
Metro-Goldwyn-Mayer *see* MGM
Metropolis 134, **136**, 137, 158
Mexico 22, 91, 110, 175–176
MGM (Metro-Goldwyn-Mayer) 37, 55, 61, 62, 73, 74, 83, 85, 86, 105, 113, 116, 181, 121, 123, 125, 126, 134
The Midwest magazine 94
Mies van der Rohe, Ludwig 21, 24
Milan, Italy 91
Mildred Pierce 84
Miles, Vera 105
Millard, Alice 16–17
Millay, Edna St. Vincent 126, 130

Miller, Arthur 86, 163–166, 204n32, 205n36; "Communist ties" 163–164; house **165**
Miller, Douglas 82
Mission to Moscow 84
Mr. Moto's Gamble 55
Mr. Roberts 73
Mock, Elizabeth 81
Modern Architects 21
Modern Movement 21, 23, 147–150, 118–151
Moll 153
Monroe, Marilyn 163–166, 204n30, 205nn36, 37
Montenegro 9
Moon Over Miami 134, **136**, 137, 140, 158
Moonlight in Hawaii 55
Moscow, Russia 26–27, 89–90, 94, 129; purge trials 84
Motion Picture Alliance for the Preservation of American Ideals 86
Motion Picture Association of America 88, 108
motion pictures 36; communist subversion of American movies 85; consensual art 51; early industry 36–37; industry strike (1946) 85; unions and guilds 85–86
Mumford, Lewis 44–45; asked to head Taliesin Fellowship 89, 122; favors communistic socialism 89
Mundt, Whitney 45
Munich, Germany 91–92
murders 8
Murphy, Dudley 37
Murphy, George 86
Murray, Dorothy Clune 161–162, 204nn20, 22
"Murus" 129
Myers, Harold 46, 202n27
Myers, Howard 76

The Naked Genius 166
The Name Above the Title: An Autobiography 185
Nancy Drew film series 55
Nation journal 96
National Broadcasting Company (NBC) 116, 159, 167
National Council of American-Soviet Friendship 95
National Fireproofing Company (Natco) 16

National Real Estate Board, Manhattan chapter 46
Navarro, Ramon 142
Navasky, Victor 96
Nazi Germany 56
Neal, Patricia 101, 103, **104**, 105, 144, 200n17; opinion of film 106; opinions of her role 107–109
Nelson, George 46, 48, 76, 156
Nelson, Paul 137
Nesbitt, John 115
Neutra, Frank 62
Neutra, Richard 16, 62–63, 159–160, 204nl; Lovell house, Los Angeles 63, 69; van Sternberg house 63–64, **63**, **64**, 145
New Deal 21, 52, 55, 89, 95
New England 5
New Haven, Conn. 49
New Masses magazine 94, 112, 127
New Mexico 13–14, 110–111, 125, 169, 175–176
New School of Social Research 44
New Statesman magazine 52
New York: Metropolitan Museum of Art 43, 195nl; Museum of Modern Art 21, 76, 81, 89, 112, 120; Public Library 44
New York City 36, 39, 43, 44–48, 67, 76, 110, 123, 126, 156, 198n50; Architectural League 46; Armory Show 111; exhibition 92; Group Theater 124; Plaza Hotel 164; Statue of Liberty 34; *Times* 155
New York Motion Picture Company 37
New York Times 56
The New Yorker 44, 58, 89, 106, 123
New Zealand 129
Newman, Alfred 142
Newman, Paul 103
News-Chronicle (London) 112
Newspaper Guild 98
Nicholls, Peter 103
Nietzschean Superman 51; rhetoric 57
The Night of January 16th 38, 108; as a film 55, 56, 135
Nineteen Eighty-Four 54
Ninotchka 83

Nitti, Frank 85
Nixon, Richard M. 86
Noble, Elisabeth 17–18, 68, 112, 113
Noel, Miriam 93; marriage with and divorce 8, 9; morphine addiction 8
Noi Vivi 56
Nolan, Doris 38
North by Northwest 105
Nowack, Marion 82
Nozaki, Albert 135

Oak Park, Illinois 7, 123; Playground Association shelters 66
Objectivism 52, 175, 194n3
Obler, Arch 116, 167, 201nn22, 24
Obma, Ed **5**
O'Connor, Frank 37, 43
Ocotillo, Chandler, Arizona 18–19
O'Gara, Francis B. 188–189
Ohmart, Carol 139
O'Keeffe, Georgia 110, 111, 125, 126; *Pelvis with Shadows and the Moon* 111
Okey, Jack 139
Oklahoma! 167
Olive Hill Foundation 161
Olmsted, Charles 191n8
Olmsted, F.L. 191n8
Olsen, J.S.O. 166
Olsson, Anna 34
Omar Khyyam 113
Oppenheimer, Dr. J. Robert 61
Ornitz, Samuel 87
Orozco, José 111
Orwell, George 54
Oud, J.J.P. 21
Our Town 126
Ouspensky, Petr Demianovich 129
Overhead Aluminum Dome 167

Page, Ben 125
Palm Beach Story 127
Palm Springs, California 160
Palmy Days **133**, 134, 137, 154, 158
Paramount Pictures 36, 37, 38, 55, 56, 57, 61, 62, 66, 74, 85, 100, 104, 105, 113, 123, 127, 128, 166
Paris, France 9, 32, 34, 43, 91–92, 129–130

Parker, Dorothy 122
Parker, Eleanor 103
Parker, George 125
Pasadena, California 49, 120
Passage to Marseilles 61
Pat and Roald 200n17
The Patricia Neal Story 200n17
Patrick, John 103
Paull, Lawrence 139–140, 203n16
Paxton, Michael (aka Palumbo) 55, 194n3
Penthouse Legend 38
Pepper, Claude 87
Pereira, Hal 61
Peter and Paul Fortress, St. Petersburg 34
Peter Ibbetson 104–105
Peters, Susan 84
Peters, William Wesley 68, 199n77
Peterson, Jay 112
Petrified Forest 196n9
Petrograd, Russia 32–33, 54; University of 33
Pfeiffer, Bruce Brooks 46, 76, 160, 169, 207
Philadelphia, Pennsylvania 91
Phoenix, Arizona 18, 110
Phoenix Gazette 98
Picasso 111
Pickford, Mary 128
Pidgeon, Walter 38, 175
Pirosh, Robert 55
Pittsfield, Massachusetts 97
Pity My Simplicity 61
Plain Talk 86
Pogany, Willy 133, 154
Portland, Oregon 49
Portnoy, Harry 34
Possessed 103
Power company 37
Prairie School 191n2
Pravda, Moscow 200n21
pre–Columbian architecture 12; fallacy 13–15; *see also* architecture, Mayan
Preminger, Otto 66
Preston, Robert 56
Price, Vincent 66, 139
Pride of the Marines 55
Princeton University 125
profound and free, "sham-aristocratic world" 128–131
pro–Soviet films 84
Prosperity 55
pro-Stalinist 84
Pruette, Lorine 51–52

publications about FLW, European 9
Pueblo Indian architecture 12–14
Pulitzer, Joseph 44
Purcell, William Gray 49, 120

The Quarterback 55
Quinn, Anthony 113

Racine, Wisonsin 23
racism 175
radical individualists 111
railroads: Atchison, Topeka & Santa Fe 110; Southern Pacific 110
Rains, Claude 116
Rand, Ayn 27, 31, 41, 82, 86–90, **104**, 112, 159, 175, 177; anti–Russian 80; in Chicago 34–35; and Communism 33, 35, 38; education 33–34; egoism 38–39, 52, 54; Fascist view 50; and Hal Wallis's movies 61–62; and HUAC 86–89; impressions of Taliensin 67–68; literary works 31, 33 (*see also* individual titles); on Marilyn Monroe 166; politics a "moral issue" 33; prosaic life 53, 92; reason 53; rejection of family and early life 31, 35; and Wright 45–47, 57–58, 67, 74–75, 79, 88–89; Wright's Rand house 67–69
Random Harvest 73
Rankin, John 85
The Razor's Edge 66
Reagan, Ronald 86, 87, 101, 103; informant for FBI 87
The Red Danube 88
The Red Menace 88
"Red Pawn" 37–38
Redding, Connecticut 76
Reed, Donna 88
regionalism 12–15, 165
Reinhardt, Bryson 188–189
Remington, Ayn 34
Rennie, Michael 103
Revueltas, Rosaura 175–176
Rex company 37
Riga, Latvia 34
The Rise of Silas Lapham 52–53
Ritt, Martin
Rivera, Diego 111
RKO Pictures 37, 55, 85, 86, 88, 101, 102, 103, 125, 126

Road to Singapore 56
Robin Hood 153
Robinson, Bill Bojangles 166
Robinson, Edward G. 103, 163–164; denied passport 164
Roche, Kevin 50
Rockefeller company 145
Rodin 111
Rogers, Ginger 202n222
Rogers, Richard 167
Rome, Italy 92
Rooney, Mickey 121
Roosevelt, President F.D. 52, 54, 83–85, 89, 126, 148; Mrs. Roosevelt 126; Wright's petition 128
Rope 105
Rosenbaum, Alissa Zinovievna 31–34
Rosenbaum, Nora 139n9
Rosenbaum, Zinovy and Anna 31–35
Rosenberg, Julius and Ethel 98
Ross, Harold 123
Ross, Kenneth 204n23
Rotterdam, Netherlands 91–92
Rousseau 111
Roxbury, Connecticut 164
Royal Institute of British Architects 27; Gold Medal 27, 112; Wright's lecture 112
A Royal Scandal 66
Ruby, Harold 142
Ruddy, Albert 159
Russia 82–83
Russian constructivism 134
Russian Empire 33, 34
Russian War Relief rally 95
Ryskin, Robert 61, 65, 86

Sabath, Adolph 82
Sahara 74
Saint, Andrew 41, 43, 59
St. Petersburg, Russia 31, 32, 49; 1917 revolution 32–33
Salt of the Earth 176
San Diego, California 10, 12–14; Panama-Pacific Exposition 11
San Fernando Valley 62, 159
San Francisco 76
Sandburg, Carl 130
Santa Barbara, California 138
Santa Fe, New Mexico 110–111, 121
Santa Monica, California 113, 117, 135

Index

Saratoga Trunk 60, 104, 125
Sartre, Jean-Paul 50
Sayre, Nora 52
Scarlet Dawn 60
Schallert, Edwin 106
Schary, Dore 181
Schenck, Joseph M. 85
Schevill, Ferdinand and Clara 125
Schindler, Rudolph 13, 17, 62; Lovell beach house 63
Schleier, Merrill 51
Schultz, Vera 189
Sciabarra, Chris 31, 88
Scopes, John 93
Scott, Adrian 87
Scott, Lizabeth 61
Scott, Ridley 139
Scottsdale, Arizona (Taliesin West) 66, 68, 69, 111
The Scoundrel 123
Screen Actors Guild 87, 175
Screen Guide for Americans 86
Screen Plays/United Artists 123
Screen Writers' Guild 85, 86
Scully, Vincent 49
Seckel, Harry 128
Selig, William 36, 37
Selznick International 113
Selznick/United Artists 122
The Senator Was Indiscreet 88
Separate Tables 142
Sergeant York 104
Shadow of a Doubt 126
Shah of Iran 165–166
Shanghai Express 62
The Shape of Things to Come 134
She Couldn't Say No 55
Shearer, Norma 116
Shelley, Percy 130
Sherman, General 124
Sherwood, Robert E. 103, 196n9, 200n17; passivism 125–126; and Wright 125–126
Shoppe 11, 23
Show Boat 125
Sidney S. Loeb Memorial Foundation 79
Siegel, Sol 55, 194n6
Silliphant, Stirling 159
Silsbee, Joseph L. 6–7
Silver, Charles 108
Silver, Joel 193n13
The Silver River 100
Singer, Paris 129–130
Sistram, Joseph 56, 194n6

"60 Years of Living Architecture" 91
"The Skyscraper" 37, 47
skyscrapers 44, 48
Skyscrapers and the Men Who Build Them 48
Smith, Kent 103
Smith, Robert 61
Smith Act 83
So This Is College 55
socialist: art 21–22; parties 199n95
Socialist Party 45
Sondergaard, Gale 175
Song of Russia 84, 86, 87
Soviet Russia Today magazine 95
Sowden, John 141
Spivey, Ludd 77
Spring Green, Wisconsin 5, 8, 17, 25, 66, 67, 76, 111, 129
Stalin, Joseph 199n77
Stalin, Svetlana 199n77
Stalinist USSR 27, 89–91
Stanislavski, Constantine 129
Stanwyck, Barbara 73–74, 79, 86, 88, 102, 196n9
A Star Is Born 122
Starrett, W.A. 48
Stasi Surveillance 177
The State of the Union 185
statism 59
Steichen, Edward 110, 111
Stein, Gertrude 110
Steiner, Max 106
Stella Dallas 74
Stern, Robert A.M. 157
Sterne, Maurice 110
Stewart, Donald Ogden 124
Stewart, James 88, 105
Sticks and Stones 89
Stieglitz, Alfred 110–111, 126; 291 Gallery 110, 192n5
Stokowski, Leopold 76
Stone, Judge Patrick T. 94–95; Wright's reaction to 94
Stonorov, Oscar 91, 198n57
Storer, John 16–17
Stowe, Harriet Beecher 52
Strange Holiday 116
Strasberg, Lee 124, 205n37
Studio Real 136
Sturgess, Preston 126–128, 130
Sugerloaf Mountain, Maryland 62
Sulgrave Manor Board 27, 112, 194n20
Sullivan, Louis 6–7, 10, 45, 49, 62, 89, 187; *The Autobiography of an Idea* 45
The Sullivans 116, 127
Sun-Times (Chicago) 124
Sutherland, Edward 133
Swann, Harold 138
Swanson, Gloria 137
Sweden 34

Taft, Senator Robert 159
Taft-Hartley Act 175
Taggart, Helen 203n19
Taliesin 8, 10, 47, 67, 68, 69, 100, 167
Taliesin Associate Architects 205n35
Taliesin Fellowship 22, 24–26, 78, 111–112, 130, 160, 166, 204n12
Taliesin of the Desert 111
Taos, New Mexico 110, 124
Taurog, Norman 86
Taylor, Elizabeth 166, 168–169
Taylor, Robert 84, 86, 102, 116
"Telephone Time" 116
Temple, Shirley 202n22
The Ten Commandments 37, 113
Tennessee Monkey Trial 93
Terry, Ellen 129
"textile" blocks 16
Thanhauser company 37
Thaxter, Phillis 116
theaters: Barnsdall 11, 191n8; Chicago "little theatre" 191n9
Things to Come 134, 158
"Think Twice" 55
This Is Cinerama 166
Thomas, J. Parnell 85, 87, 198n38
Thomas, Lowell 166
3-D movies 116; Natural Vision 3 Dimension 116
Time/Life organization 76, 80, 112
Time magazine 112
To Have and Have Not 74
To the Victor 105
Todd, Michael (Mike) 116, 166–169, 305n59; death 168–169; visits Wright 166
Todd, Mike, Jr. 169
Todd A-O 167, 205n59
Todd A-O cinema and theater **168**
Tokyo, Japan 9, 10, 163
Tolstoy, Alexei 203n7
Tolstoy, Leo 35

Index

Tolubott, Alexander 134
Tom Jones 128
Tone, Franchot 66
totalitarianism 38, 54
Toulouse-Lautrec 111
Towards a New Architecture (Le Corbusier) 44
Town and Country magazine 112
Tracy, Spencer 206
Transatlantic/Warner Brothers 105
Trouble with Harry 105
Truman, President Harry S 82, 87, 198n38
Trumbo, Dalton 85, 87, 126–127
Tucson, Arizona 110
Tugwell, Rexford 97
Tuttle, Bert 101, 135, 137, 146
Twentieth Century–Fox *see* Fox
The Two Mrs. Carrolls 196n9

Ukraine 33
Uncle Tom's Cabin 52
Union of South Africa 23
Unitarianism 5–6, 173–174
United Artists (UA) 101, 123, 126, 128, 133, 137, 139, 142
United Nations Secretariat 145
United States: Bureau of Indian Affairs 198n45; a cowardly Congress 87, 97; Department of Justice 83, 96, 97, 123, 164, 176; Department of State 91, 97; Fifth Amendment 87; House of Representatives 164; House Special Committee on Un-American Activities 83; Office of Military Government 91; Resettlement Administration 97; Senate Investigations Subcommittee 189; Smith Act 83; Supreme Court 87
Universal Pictures 37, 38, 55, 88, 125, 126, 127, 163
University of Arizona 203n16
University of Cincinnati 200n8
University of Southern California 112; School of Architecture 158
University of Washington 51
University of Wisconsin 5, 111
Urban, Joseph 125

Usonia 23
USSR 26–27, 31, 35, 83, 84, 90, 148, 176, 199n7; New York City Consulate 94

Valli, Alida 56
Vanderlip, Frank A. 113
Vanity Fair 122
Variety 56, 73
Vertigo 105
Vidler, Anthony 58
Vidor, Charles 142
Vidor, King 86, 100, 101, 103, 105, 107–109, 132, 137, 153
Vienna, Austria 62, 125
Vitagraph company 37
The Volga Boatman 37
Vollbrecht, Karl 136
von Sternberg, Joseph 38, 62; his house 63–64

Wagener, W. 59
Wagner, Otto 16, 62
Waithe, Mary Ellen 53
Wake Island 194n6
Wales 5, 8
Walker, John 51, 108
Wallace, Mike 90
Waller, Fred 166
Wallis, Hal B. 60–62, 108
Walsh, Orinda B. 187
The Waltons 175
Wanger, Walter 84, 128, 130
Wanger Productions 128
War Production Board 80
Warner, Harry 73, 80, 86, 97
Warner, Jack 60, 61, 73, 76, 79–82, 84, 86, 97, 100, 101, 108, 139
Warner Bros. Pictures, Inc 55, 60–62, 73–74, 76–81, 84, 85, 88, 101–105, 112, 119, 121, 123, 125, 132–154, 181; *see also* Rand, Ayn
Washington, D.C. 112, 174
Washington, President George 112, 166
Wasmuth publisher 8
Watch on the Rhine 61
Waterloo Bridge 126
Watson, Sir George, Chair of the Sulgrave Manor Board 27, 112, 194n20
Wayne, John 55, 86
We (Zamyatin) 54
We the Living 38, 46, 56, 108; as a play *The Unconquered* 55
Weaver, Sylvester "Pat" 167, 169

Webb, Clifton 103
Welles, Orson 44, 126–127
Wells, H.G. 134
Wenatchee, Washington 192n7
Wendingen 25, 192n6
West Germany 176
West Point Window 194n6
Weston, Marcus 95
What a Widow! 137, 158
White Heat 101
Whitehead, Don 105
Whitman, Walt 35, 111, 130
Wie Baut America? ("How Does America Build?") 62
Wijdeveld, H.T. 25
Wilde, Cornell 113
Wilde, Oscar 124
Wilder, Billy 66, 74
Wilder, Thornton 126
Wilkie, Wendell 55
Williams, Thames 73
Wils, Jan 8
Wisconsin 5
The Wizard of Oz 73
Woman of the Year 123
Woman on Trial 38; and Ely Jacques Kahn 43, 46; and Frank O'Connor 37, 43, 55, 67, 70
Wood, Peggy 124
Wood, Robin 108
Wood, Sam 86
Woodfall/Lopert company 128
Woods, Mary N. 50
Woollcott, Alexander 67, 121–125, 128, 202n8; and Taliesin Fellowship 121–122; and Wright's Hiroshige prints 122
Woolley, Tayler 8
"Work Song" viii
The World and His Wife 206
World Peace Appeal 95
Wright, Catherine 125
Wright, Eric Lloyd 203n19
Wright, Frank [Lincoln] Lloyd ii, viii, 5–27, 39, 62, 134, 177, 198nn50, 51, 206; anti-socialism/communism 20–22, 91–92, 96–97; *Architectural Forum* (1938) 46, 111, 119, 143; *Architectural Forum* (1948) 119; and Ayn Rand 43–52, 58–59; biography and architectural history 173–174; and Communism 20–22, 90, 188–189; decentralization 23, 26; design sources

12–18, 24; European honors 9; exhibitions 22, 46; and FBI 93–99; financial debts 9, 19; *The Fountainhead* (see also Rand, Ayn) 80, 101; and HUAC 82, 89–90; individual responsibilities 92; influences upon Adler 7–8; influences upon Gill 11–17; influences upon Lloyd Wright 12–17; influences upon Schindler 13–16; influences upon Sullivan 7–8; literary works: (*An Autobiography* 67, *In the Nature of Materials* 67, 119, "Life and Architecture in the USSR" 94, "Man Who Succeeded" 94, *On Architecture* 67, *When Democracy Builds* 80); lost commissions 97–99; name change 6; organic analogy 22, 23; passivism 91, 93–94; parents' divorce 6; political beliefs 20–22; revival post-1928 and the three books 20–21; "60 Years" Europe, NYC, Los Angeles 1950s 91–92; Soviet impulse 89; Unitarian principles 173; "Work Song" viii; Wright School 24; Wright style 22

Wright, Frank, buildings and projects: Aderton Court, Beverly Hills 161; all steel houses, Los Angeles 115; Arizona Biltmore 18–19, 123; Arizona State Capital 8; Bailleres house, Acapulco 165; Barnsdall Beverly Hills house 16; Barnsdall theatres 11, 191n8; Barnsdall's Olive Hill 16, 161–162; Bazett house, Hillsborough 115; Broadacre City 23, 43, 112, 126, 198n50; Chandler hotel, Chandler 18; Davidson Farm Tracts 198n65; Elizabeth Arden spa 79; Ennis house, Los Angeles *15*, 16–17, 116, 139; Fallingwater, Kaufmann country house 23–24, *25*, 26, 137, 198n50; Florida South College, Lakeland 77–78; Freeman house, Hollywood 16–17, 154; Gillin house, Dallas & Hollywood Hills 162; Guggenheim Museum, NYC 92, 119; Hanna house, Palo Alto 11, 115; Hartford house 113–115; Hartford projects 117, *118*, 119; Hollyhock (Barnsdall house) 11–16, *13*, 92, 191nn8, 1; Imperial Hotel, Tokyo 8, 203n17; Jester house, Los Angeles 77, 113–115, 165; Johnson, S.C., Admin. Building, Racine 23, *24*, 26, 112, 119, 156; Johnson's Death Valley project 16; Johnson's skyscraper project 16; Kaufmann house, Palm Springs *160*, 165; Lake Tahoe summer colony 16; Lewis house, Libertyville 124; Loeb house, Redding 77–80, 119, 165; Los Angeles Municipal Art Gallery 98, 161–*163*; Lowes house, Eagle Rock 13, *17*; Marin County Civic Center, San Rafael 98; Marin County Civic Center Government Building 188–189, 206; Midway Gardens, Chicago 8, *10*; Millard house, Pasadena *14*, 16–17; Miller/Monroe house, Roxbury 162–*165*; Monona Terrace Civic Center, Madison 98; Morris house, San Francisco *119*; Morris projects 119; Nesbitt house, Cypress Point 116; Noble Apartments, Los Angeles 17–18, 68, *69*; Obler house, Los Angeles 116, 117, 119; Ocotillo *18*, 19, 22, 24; Pauson sisters' house, Phoenix 24, *26*, 119; Point Park Civic Center, Pittsburgh 97–98; Point View Residences, Pittsburgh 69; Pope-Leighey house 201n24; Rand house, New York 67–70, *68*; River Forest Golf Clubhouse 7; Rogers Lacy Hotel 119, 143; Sachse house, Death Valley 13; San Diego cinema 192n4; San Francisco Bay bridge 98; 60 Years of Living Architecture 91–93; Spivey house, Fort Lauderdale 77–78; Storer house, Los Angeles 16–17, 62, 192n13; Sturgis house, Los Angeles *115*, 119; Taliesin West 24, 119; Todd A-O cinema *168*, 167–169; town plan and buildings, Baghdad, Iraq 97; Twin Suspension Bridges 98; Unity Temple, Oak Park 7, *9*; U.S. post office, Spring Green 97; U.S. post office, San Rafael 97; Usonian houses 198n65; Walker house, Carmel 119, 137; Wall house, Plymouth 165; Warren house, Chicago 18; Windfohr house, Fort Worth 165; Winslow house and stables 7, *8*; Wright's Oak Park house 7; Yosemite National Park restaurant 205n33

Wright, Iovanna 66
Wright, Jane 125
Wright, John Lloyd 10
Wright, Lloyd (FLW, Jr.) 10–17, 58, 62, 66–67, 113, 120, 137, 140–142, 161–162, 172–176, 203n19, 204n20; and Hartford 117; and Lautner 115
Wright, Maginel 113
Wright, Olgivanna Hinzenberg (the 3rd Mrs. FLW) 9, 20, 25, 70, 94, 129, 160, 164, 204n30
Wright School 7, 24, 191n2
Wuthering Heights 123
Wyatt, Jane 87, 139
Wyler, William 87, 127, 136
Wyman, George 140

Yale University 49
Yankee Doodle Dandy 60, 84
You Came Along 61
Young, Loretta 83
YWCA 35

Zamyatin, Yevgenii 54
Zeitgeist, rejection of 173
Zevi, Bruno 92
Zinnemann, Fred 167, 200n21
Zukor, Adolph 37, 104
Zurich, Switzerland 91